DATE DUE

~~FE 25 '99~~			
~~AG 27 '99~~			
OC 18 '99 ~~MY 24 '08~~			

DEMCO 38-296

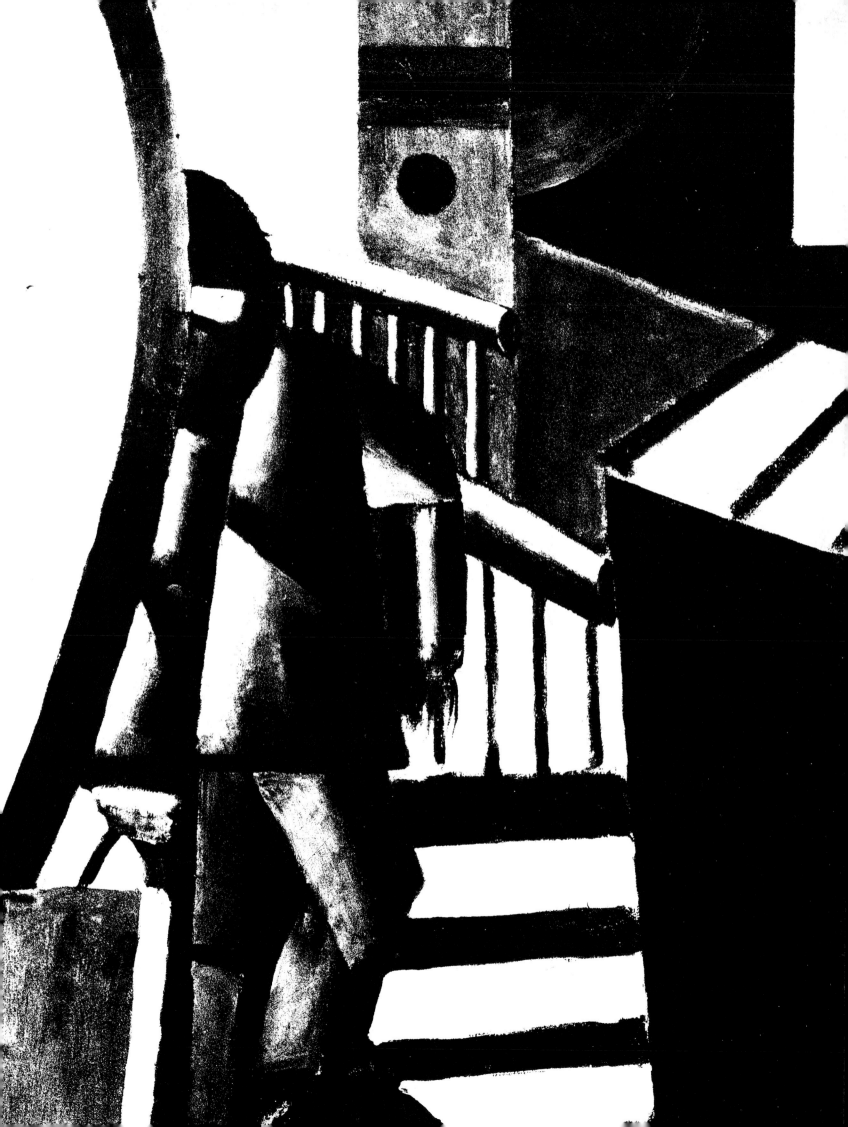

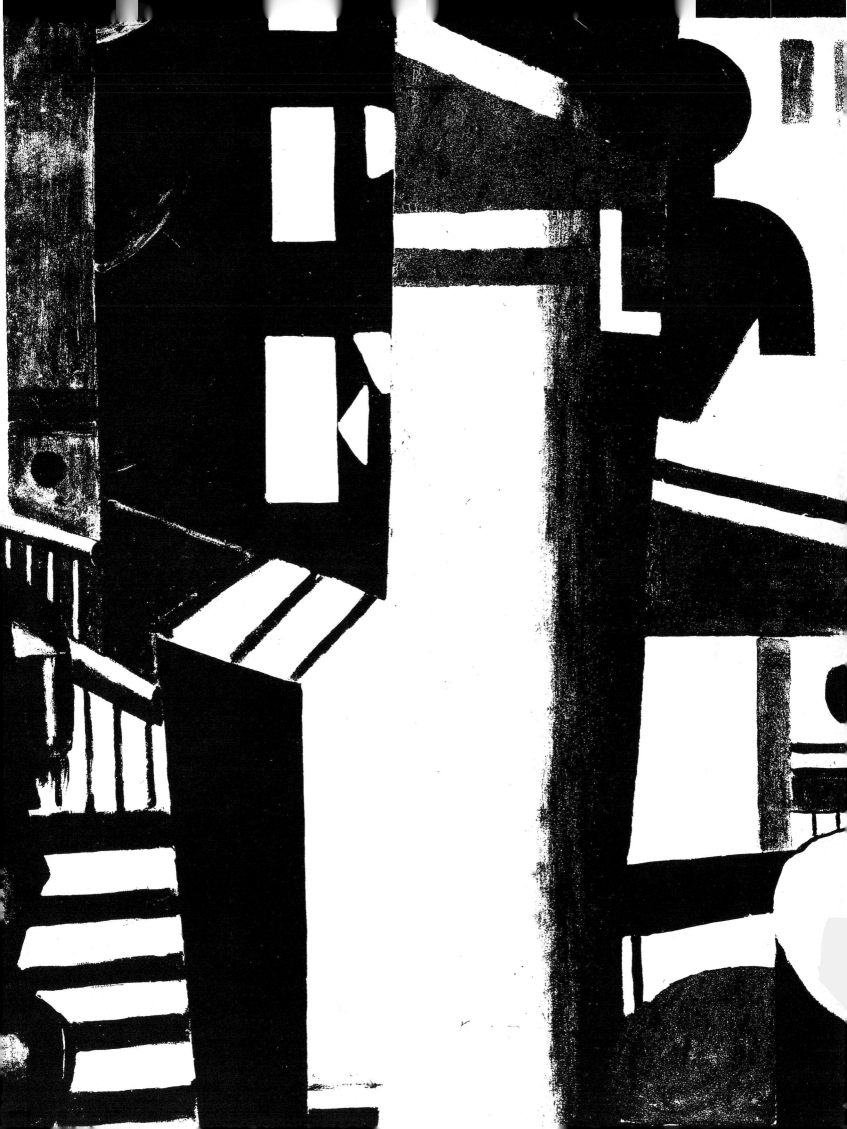

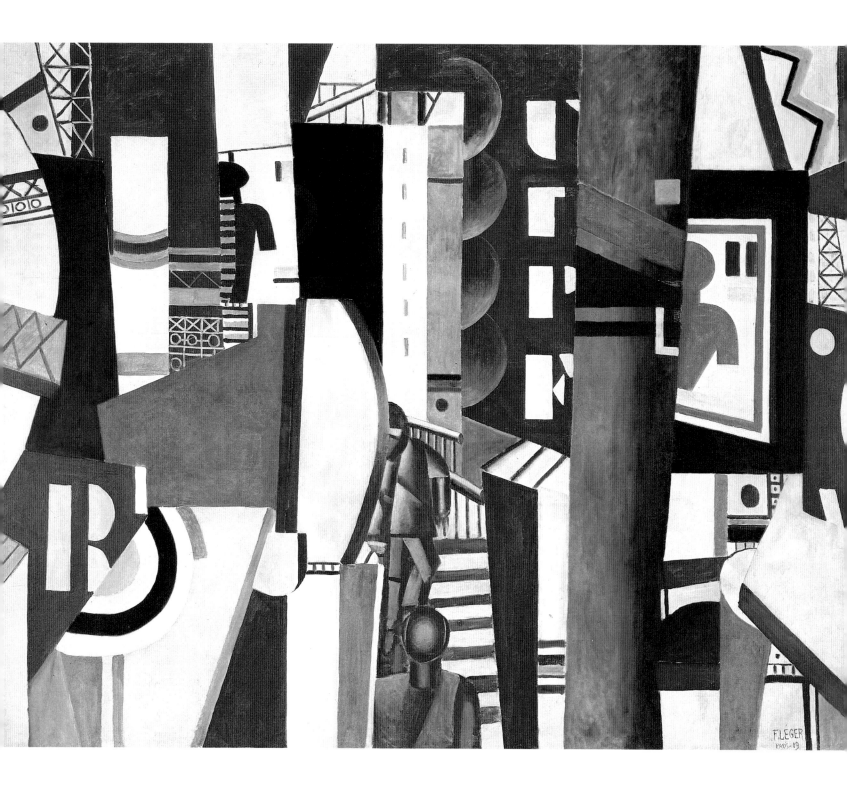

Fernand Léger

1911-1924

The Rhythm of Modern Life

Edited by
Dorothy Kosinski
and with a foreword by
Katharina Schmidt and
Gijs van Tuyl

With essays by
Christoph Asendorf
Gottfried Boehm
Hartwig Fischer
Judi Freeman
Christopher Green
Dieter Koepplin
Dorothy Kosinski
Eric Michaud
Suzanne Penn
Katharina Schmidt and
Gijs van Tuyl

Prestel

Munich · New York

...ied on the occasion of the exhibition ...nd Léger 1911-1924, Le rythme de la vie moderne' held at the Kunstmuseum Wolfsburg (29 May - 14 August 1994) and at the Kunstmuseum Basel (11 September - 27 November 1994).

© 1994 Prestel-Verlag, Munich and New York
© of works by Fernand Léger: VG Bild-Kunst, Bonn, 1994

Front cover: Les Eléments mécaniques
(Mechanical Elements), 1918-23
(detail, pl./p. 129, cat. 73)
Back cover: stills from Léger's Ballet mécanique (Mechanical Ballet), 1924 (pls./pp. 191-3, cat. 129)
Pages 1-7: details of La Ville
(The City), 1919 (pl./p. 145, cat. 42)
Photographic acknowledgements, see p. 254

Translation from the Dutch (essay by van Tuyl) by Hugh Beyer
Translation from the French (essay by Michaud) and the German (essays by Asendorf, Boehm, Fischer, Koepplin, Schmidt) by Elizabeth Clegg
Copy-edited by Robert Williams

Prestel-Verlag
16 West 22nd Street, New York, NY 10010, USA
Tel. (212) 627 8199; Fax (212) 627 9866
and Mandlstrasse 26, 80802 Munich, Germany
Tel. (89) 381 7090; Fax (89) 3817 0935

Distributed in Continental Europe by Prestel-Verlag
Verlegerdienst München GmbH & Co. KG
Gutenbergstrasse 1, 82205 Gilching, Germany
Tel. (81 05) 38 81 17; Fax (81 05) 38 81 00

Distributed in the USA and Canada on behalf of Prestel by te Neues Publishing Company, 16 West 22nd Street, New York, NY 10010, USA
Tel. (212) 627 9000; Fax (212) 627 9511

Distributed in Japan on behalf of Prestel by YOHAN Western Publications Distribution Agency, 14-9 Okubo 3-chome, Shinjuku-ku, Tokyo 169, Japan
Tel. (3) 32080181; Fax (3) 32090288

Distributed in the United Kingdom, Ireland and all remaining countries on behalf of Prestel by Thames & Hudson Ltd, 30-34 Bloomsbury Street, London, WC1B 3QP, England
Tel. (71) 636 5488; Fax (71) 636 1059

Lithography by eurocrom 4, Villorba, Italy
Typeset, printed and bound by Passavia Druckerei, Passau

Printed in Germany

ISBN 3-7913-1372-X (English edition)
ISBN 3-7913-1334-7 (German edition)

Contents

Plates

Lenders to the Exhibition

This exhibition has been made possible by the generosity of the following institutions and private collectors, and of numerous lenders who wish to remain anonymous. We are profoundly grateful to all of them.

Amsterdam, Stedelijk Museum (Rudi H. Fuchs, Director)

Basle, Beyeler Collection (Dr h.c. Ernst Beyeler)

Basle, Öffentliche Kunstsammlung Basel, Kunstmuseum (Dr Katharina Schmidt, Director)

Berne, Kunstmuseum, Hermann und Margrit Rupf-Stiftung (Dr Hans Christoph von Tavel, Director)

Biot, Musée National Fernand Léger (Georges Bauquier, Director)

Buffalo, Albright-Knox Art Gallery (Douglas G. Schultz, Director)

Dallas Museum of Art (Jay Gates, Director)

Düsseldorf, Kunstsammlung Nordrhein-Westfalen (Dr Armin Zweite, Director)

Edinburgh, National Galleries of Scotland, Scottish National Gallery of Modern Art (Timothy Clifford, Director)

Fort Worth, Texas, Kimbell Art Museum (Edmund P. Pillsbury, Director)

Houston, The Menil Collection (Paul Winkler, Director)

Houston, The Museum of Fine Arts (Peter C. Marzio, Director)

London, Tate Gallery (Nicholas Serota, Director)

Los Angeles County Museum of Art (Stephanie Barron, Coordinator of Curatorial Affairs)

Madrid, Fundación Colección Thyssen-Bornemisza (Tomás Llorens, Chief Curator)

Moscow, Pushkin Museum of Fine Arts (Irina Antonova, Director)

Munich, Bayerische Staatsgemäldesammlungen München, Staatsgalerie moderner Kunst (Dr J.G. Prinz von Hohenzollern, Director)

New York, Solomon R. Guggenheim Museum (Thomas Krens, Director)

New York, The Alex Hillman Family Foundation Collection

New York, The Metropolitan Museum of Art (Philippe de Montebello, Director)

New York, The Museum of Modern Art (Richard Oldenberg, Director)

Northampton, Massachusetts, Smith College Museum of Art (Susannah Fabing, Director)

Ottawa, National Gallery of Canada (Dr Shirley L. Thomson, Director)

Otterlo, Rijksmuseum Kröller-Müller (Dr Evert J. van Straaten, Director)

Paris, Musée National d'Art Moderne, Centre Georges Pompidou (Germain Viatte, Director)

Paris, Musée d'Art Moderne de la Ville de Paris (Susanne Pagé, Director)

Philadelphia Museum of Art (Anne d'Harnoncourt, Director)

São Paulo, Museu de Arte de São Paulo, Assis Chateaubriand (Fabio Magalhães, Chief Curator)

Solothurn, Kunstmuseum, Josef Müller-Stiftung (André Kamber, Curator)

Stockholm, Dansmuseet/Dance Museum (Erik Näslund, Director)

Stockholm, Moderna Museet (Björn Springfeldt, Director)

Stuttgart, Staatsgalerie (Dr Peter Beye, Director)

Stuttgart, Graphische Sammlung, Staatsgalerie (Ulrike Gauss, Head)

Ulm, Ulmer Museum (Dr Brigitte Reinhardt, Director)

Venice, Peggy Guggenheim Collection, Solomon R. Guggenheim Foundation (Philip Rylands, Deputy Director)

Vienna, Österreichische Galerie im Schloss Belvedere (Dr Gerbert Frodl, Director)

Winterthur, Kunstmuseum (Dr Dieter Schwarz, Director)

Wuppertal, Von der Heydt-Museum (Dr Sabine Fehlemann, Director)

Zurich, Kunsthaus (Dr Felix Baumann, Director)

Zurich, Dr Peter Nathan

Hester Diamond

Eppinghoven Collection

Collection of Sara and Moshe Mayer

Werner and Gabrielle Merzbacher

A. Rosengart Collection

Sam and Ayala Zacks Collection

and those lenders who wish to remain anonymous

Foreword

A century is drawing to its close. Attempts to define our own position while looking to the future combine with reflections on an eventful century. Out of the *fin-de-siècle* sense of crisis, attention is drawn to one of the great personalities of Modernism, an artist who reacted to profound changes with passion and energy, and in a spirit of unfailing innovation: Fernand Léger. He is the painter of the modern world. The metropolis, movement, the machine, the dynamism of man living at a new and faster pace; these are the themes central to his work. Art historians invoke Léger alongside Picasso, Braque and Gris as one of the crucial contributors to Cubism; but he readily introduced a variant of his own, infused with plastic energy and intensity of colour.

Since the great retrospective shown at the Grand Palais in Paris in 1971-72, numerous international exhibitions have been devoted to Léger, and his work has been examined from various points of view, assembling representative selections from his *œuvre*, centering on his drawings, studying particular influences on his development and focusing on his later years. Our decision to concentrate, in the present exhibition, on the crucial period 1911-24 has its justification in the fact that it was during these years that Léger evolved a style of his own. It is thereby possible to add substantially to the experience and the lessons of recent Cubist exhibitions. Attention to Léger's work will decisively enrich the current debate on Modernism.

For keen art-lovers and for an interested public, who have encountered Léger's impressive paintings in the world's great museums, this exhibition may seem to be a predictable event, and especially in Basle, where the important works given to the Kunstmuseum by Raoul La Roche provide such an excellent starting-point. The La Roche bequest was, in fact, the basis for the exhibition devoted to Braque and Picasso some years ago. Despite appearances, Léger's pictures from the most intensive period of his career must be considered extremely fragile. Many, having once found a place in one of the world's great collections, have hardly ever been moved again; thus it has not, until now, been possible to view together the groups of works we are now able to unite. The *'Escalier'* series of 1913-14, for example, could not be shown in 1971-72. It is little short of extraordinary that, after so many years, the enigmatic early work *La Noce* is leaving its home in the Musée National d'Art Moderne, Centre Georges Pompidou in Paris in order to be included in our exhibition. This painting, together with *Les Fumeurs*, the *Modèle nu dans l'atelier* and *La Femme en bleu* will offer a compelling impression of the character of Léger's work from the period before he embarked on the series *'contrastes de formes'*. With the further inclusion of *La Partie de cartes* and *Le Soldat à la pipe*, the exhibition will also unite Léger's principal paintings of the Great War period. That *La Ville*, from the Philadelphia Museum of Art, can once again be shown to the European public is in itself a cause for celebration.

These few examples suffice to reveal the extraordinary understanding and the generous support that we have received in the course of preparing this exhibition. Our efforts have been spurred in particular by the desire and the need to encourage a better understanding of this highly individual *œuvre*, which has always largely been seen – despite Léger's own intentions – as 'art for artists'. We wish to counter the strongly ingrained stereotypal notion of Léger's work that so often has obstructed our view.

The partnership between the Kunstmuseum Basel and the Kunstmuseum Wolfsburg that has made this exhibition possible may at first appear unusual, yet it has a special meaning: in Wolfsburg, a city whose name is virtually synonymous with industrial production, a new museum, the Kunstmuseum, is to be inaugurated with this exhibition. The museum's elegant architectural design, combined with the latest technology, will offer the visitor new, forward-looking experiences of art and its mediation. There is a spirit of openness, altered dimensions of real and spiritual space; everything is new, fresh and replete with possibility. The Öffentliche Kunstsammlung in Basle, the world's oldest public art collection, stands in many respects at the opposite extreme. Here, there will be less emphasis on Léger as an inspired advocate of technological progress, or as a lover of machines, or as a maker of films: rather, and in a unique way, this Museum can show Léger's pictures in the wider context of their conception and creation. Here, the essential paradox of Léger's work – *Etre-de-son-temps et Etre-de-toujours* (being of his own time and for all time) – will be brought to the fore.

We are especially fortunate in having been able to secure as the exhibition's guest curator the Basle-based American art historian Dorothy Kosinski. Drawing on her long involvement in the study of Cubism, she collaborated with us in developing the concept of the exhibition: she also took on the challenging task of editing the catalogue as well as a large part of organizing the exhibition. We are greatly indebted to her for her exceptional commitment to this project.

Our thanks are also due to Taeke Kuipers, who ensured coordination between our two museums and the participating institutions. We owe especially warm thanks to our colleagues at both museums who, in the most varied of ways, but with unfailing enthusiasm, have shared our efforts at each and every stage. All those involved in mounting this exhibition have been united in the hope that, in presenting anew the richness and the radiance of Léger's work, and in providing an occasion for fresh discussions, some of its light, its brightness and its humane force may impress itself on our own difficult times.

Katharina Schmidt Gijs van Tuyl

Preface

Fernand Léger is generally acknowledged to be one of the major figures of twentieth-century art, yet his career remains insufficiently examined and documented. This is due, at least in part, to the continued inaccessibility of important archival material, as well as to the insistent definition of the artist in terms of Cubism and the unnuanced identification of Léger with his enthusiasm for the modern world of the machine. A primary goal of our exhibition, which is devoted to the early years, during which his aesthetic concepts and formal vocabulary matured, is to challenge traditional art-historical rubrics and deadening stereotypes.

Gottfried Boehm refers to this problem in the essay he has contributed to this catalogue, pointing to an art-historical road not taken, that is, a focus not on Léger's similarities to Picasso and Braque but rather on his differences – a focus on Léger as Léger. The orientation towards Cubism was perhaps inevitable: it was the artistic currency of the first decades of our century, the kernel of contemporary critical debate. Léger himself, writing during the Great War, could not resist a bitter allusion to the 'abstraction' of his environment 'purer than Cubist painting itself'. The dealers, meanwhile, were bent on allying their artists with Cubism as they defined and sold it. It is fascinating to observe the persistent legacy of, for example, Daniel-Henry Kahnweiler's insistence on the distinct importance of Picasso, Braque, Gris and Léger; this exclusivity was later to influence the thinking of one of the great collectors and historians of Cubism, Douglas Cooper, defining his notion of *true* Cubism featured in 'The Essential Cubism' exhibition Cooper organized for the Tate Gallery in London in 1983.

Since then our notion of Cubism has been significantly refined; the collaboration between Picasso and Braque, for example, has been examined in depth and detail. Meanwhile, too, 'Cubism' has been revealed to be a term with changing valency, manipulated in various national-political and art-political agendas, its identification with the avant-garde in flux. This new picture of Cubism that goes beyond the developmental analytical-synthetic model allows, indeed, demands a corrected image of Léger. The praise given *La Femme en bleu*, Léger's monumental submission to the 1912 Salon d'Automne: the 'most authentic' of his Cubist works, a 'Cubist masterpiece', recedes somewhat in importance to a fresh and detailed reading by Katharina Schmidt, unveiling the picture's remarkable poetry and complexity.

Though the essays and the groupings of plates in this catalogue do unfold more or less chronologically, the emphasis is not on a sequential development. Rather, these essays highlight various important facets of Léger's work as well as different critical methods. Green and Michaud deal with the impact of the Great War and political readings of Léger's work, while Asendorf's essay on the propeller develops his previous richly nuanced studies of the aesthetic/historical meaning of the modern object/icon. The essays on Léger's work in theatre and film, respectively by Fi-

scher and Freeman, reveal much about his ideal of a collective aesthetic and his social consciousness as an artist. My own essay reads Léger's pictorial language within the syntax of modernism. Two essays treat major thematic groups: Koepplin's study of the genesis of the motif of the *Eléments mécaniques*, 1918-23 and Suzanne Penn's analysis of the physical alterations of *La Ville*, 1919. Interestingly, both contributions reveal how relatively little we know about Léger's working methods or about the chronology of his works (in notable contrast to the precise dates we have of works by Picasso and Braque from the same period). The future calls, then, for a thorough catalogue of the works on paper and for the compilation and cross-referencing of dating information from as yet unpublished correspondence as well as published reviews and commentaries. Though Boehm and van Tuyl approach Léger with different languages and concerns, they both deal with the potential paradox of the enduring quality of the work of an artist who was so firmly committed to contemporaneity. Indeed, our standpoint in a post-Modern, technological age, nearing the end of the century, provides a particularly stimulating vantage-point for the study of this celebrant of Modernism.

The Biography in this catalogue takes the form of a collage of citations (some from unpublished sources), giving voice to the debates in which Léger eagerly engaged. In the Bibliography special attention has been given to Léger's own extensive publications, including previously unremarked entries, important re-editions and translations, and revisions of previous data.

Just as the weights and emphases of the essays differ, so do those of the groupings of pictures, creating a rhythmic variety that mirrors Léger's own energetic collaborations with writers, film-makers and musicians, as well as his determined work as a painter. Augmented by an animated design, this catalogue seeks to capture the qualities of speed, momentum and cacophony, the aspects of the modern world that captivated Léger and emerged in his work as both theme and form.

I am grateful to Katharina Schmidt and Gijs van Tuyl for inviting me to join them as guest curator of this exciting project.

Acknowledgements

In addition to the lenders, many individuals have helped to realize this project by providing invaluable assistance in researching and procuring loans, as well as in preparing and assembling the texts and photographic material for the publication accompanying the exhibition. To them, and to others not listed here, we are profoundly grateful.

Celia Ascher, McCrory Corporation, New York; Franziska Baetcke, Basle; Susan Barnes, Deputy Director, Chief Curator, Dallas Museum of Art; Madame von Bartha, Basle; William Beadleston, New York; Claude Bernés, Paris; M.A. Bessonova, curator, Pushkin Museum of Fine Arts, Moscow; Kay Bearman, The Metropolitan Museum of Art, New York; Marie-Laure Bernadac, Conservateur, Cabinet des Dessins, Musée National d'Art Moderne, Centre Georges Pompidou, Paris; Ernst Beyeler, Basle; Bibliothèque Nationale, Paris; Laurence Blum, Basle; Prof. Dr Gottfried Boehm, Kunsthistorisches Seminar, University of Basle; Jean Sutherland Boggs, Ottawa; Emily Braun, New York; Christine Brunelle, Association André Mare, Paris; François Burkhardt, Cologne; Richard Calvocoressi, Keeper, Scottish National Gallery of Modern Art, Edinburgh; Susan Carson, London; Miriam Cendrars, Boulogne-Billancourt; M. Chevalier, Cinémathèque Suisse, Lausanne; Danielle Delouche, Association André Mare, Paris; Lisa Dennison, Solomon R. Guggenheim Museum, New York; Ronnie Dissentshik, Director, Tel Aviv Museum; Ulla Dreyfus, Basle; M. Dubouloz, Director, Bibliothèque d'Art et d'Archéologie, Geneva; Janis Ekdahl, Assistant Director, Library, The Museum of Modern Art, New York; Carol S. Eliel, Associate Curator, Twentieth Century Art, Los Angeles County Museum of Art; Gladys C. Fabre, Paris; Evelyne Ferlay, Galerie Krugier, Geneva; Michael A. Findlay, Christie's, New York; Ilaria Fischer, Paris; Sylvie Forestier, Conservateur, Musée National Marc Chagall, Nice; Judi Freeman, Curator, Portland Museum of Art; Victoria Garvin, The Museum of Modern Art, New York; Michael Govan, Deputy Director, Solomon R. Guggenheim Museum, New York; Olle Granath, Director, National Museum, Stockholm; Richard and Paul Gray, Chicago; Christopher Green, Courtauld Institute, London; Alison de Lima Greene, Curator of Twentieth Century Art, The Museum of Fine Arts, Houston; Nehama Guralnik, Curator, Tel Aviv Museum; Thora Hamilton-Dardel, Stockholm; Josef Helfenstein, Curator, Kunstmuseum, Berne; Robert Herbert, Professor, Mount Holyoke College; John and Paul Herring, New York; Geurt Imanse, Chief Curator for Research and Documentation, Stedelijk Museum, Amsterdam; Jean François Jaeger, Galerie Jeanne Bucher, Paris; Martine Kahane, Conservateur en Chef, Bibliothèque-Musée de l'Opéra, Paris; Elizabeth Kahn, Prof., St Lawrence University, Canton, New York; Marianne Karabelnik, Zurich; Christian Klemm, Konservator, Kunsthaus, Zurich; Sarah Kormind, Archivist, Sotheby's, London; K. Koutsomallis, Paris; Thomas Krähenbühl, Basle; Jan Krugier, Geneva; Hans Jürg Kupper, Basle; Sandor Kuthy, Vice-Director, Kunstmuseum, Berne; M. Kuttler, Geneva; Carolyn Lanchner, Curator, The Museum of Modern Art, New York; Hélène Lassalle, Conservateur, Musée Picasso, Paris; Quentin Laurens, Galerie Louise Leiris, Paris; Barbara Lesák, Konservatorin, Oesterreichisches Theater Museum, Vienna; William S. Lieberman, Director, Twentieth Century Art, The Metropolitan Museum of Art, New York; Gisèle Linder, Basle; Giovanni Lista, Paris; Robert Lubar, Assistant Professor, Institute of Fine Arts, New York; Nelly Maillard, Musée National Fernand Léger, Biot; Barbara Mathes, New York; Karin von Maur, Konservatorin, Staatsgalerie, Stuttgart; Sara Mayer, Tel Aviv; Stephen Mazoh, New York; Marius Michaud, Conservateur, Fonds Blaise Cendrars, Bibliothèque Nationale, Berne; Max Moulin, Chargé de Mission, Service des Arts Plastiques, Association Française d'Action Artistique, Paris; Anne Nardin, Conservateur, Musée d'Art Moderne Villeneuve D'Ascq; Erik Näslund, Director, Dansmuseet/Dance Museum, Stockholm; John H. Neff, Chicago; Claudia Neugebauer, Galerie Beyeler, Basle; David Neuman, Stockholm and New York; Suzanne Penn, Associate Conservator of Paintings, Philadelphia Museum of Art; Philippe Pétré, Bibliothèque d'Art, Brussels; Paul Pfister, Kunsthaus, Zurich; Clive Phillpot, Director, Library, The Museum of Modern Art, New York; Joëlle Pijaudier, Conservateur en Chef, Musée d'Art Moderne Villeneuve D'Ascq; Lionel and Sandrine Pissarro, Paris; Stephanie Rachum, Curator, Israel Museum, Jerusalem; Sabine Rewald, Associate Curator, The Metropolitan Museum of Art, New York; John Richardson, New York; Rona Roob, Archivist, The Museum of Modern Art, New York; Cora Rosevear, Associate Curator, The Museum of Modern Art, New York; Angelica Zander Rudenstine, Cambridge, Massachusetts; Jacques Sallois, Le directeur général, Direction des Musées Nationaux de France, Paris; Marc Scheps, Director, Museum Ludwig, Cologne; Prof. Dr Volker Scherliess, Musikakademie, Lübeck; Catherine Schmitt, Documentation, Musée National d'Art Moderne, Paris; Prof. W. Schobert, Director, Deutsches Filmmuseum, Frankfurt; Nathalie Schoeller, Documentation, Musée National d'Art Moderne, Paris; Adrian Schriel, Basle; Carla Schulz-Hoffmann, Hauptkonservatorin, Bayerische Staatsgemäldesammlungen, Staatsgalerie moderner Kunst, Munich; Hélène Seckel, Conservateur, Musée Picasso, Paris; Thomas Skalm, Archivist, Dansmuseet/Dance Museum, Stockholm; Dean Sobel, Curator of Contemporary Art, Milwaukee Art Museum; Adrian Sudhalter, The Museum of Modern Art, New York; Stephen Swid, New York; Ann Temkin, Curator, Philadelphia Museum of Art; M. & Mme Blaise Thorens, Basle; Nancy J. Troy, Research Associate, Getty Center for the History of Art and the Humanities, Santa Monica; Daniel Varenne, Geneva; Kirk Varnedoe, Chief Curator, Department of Painting and Sculpture, Museum of Modern Art, New York; Brigitte Vincens, Documentation, Musée National d'Art Moderne, Centre Georges Pompidou, Paris; Jennifer Wells, New York; Martin Weyl, Director, Israel Museum, Jerusalem; Johannes van der Wolk, Rijksmuseum Kröller-Müller, Otterlo; Prof. Dr Bernhard Wulff, Musikhochschule, Freiburg; Ayala Zacks-Abramov, Jerusalem; Eva Ziesche, Sturmarchiv, Staatsbibliothek, Berlin.

We should also like to express our gratitude to our co-authors: Christoph Asendorf, Gottfried Boehm, Hartwig Fischer, Judi Freeman, Dieter Koepplin, Eric Michaud and Suzanne Penn. It is a special honour to include Christopher Green's essay here, the latest work from one of the most important scholars of Léger.

Dorothy Kosinski

LÉGER, 1911-1924: A LANGUAGE FOR THE MODERN WORLD

It was during a relatively brief and intensely dynamic period – the years 1911 to 1924 – characterized by rapid shifts from avant-garde to *après-guerre*, from a Cubism of experimentation to one of crystalization, and from *esprit moderne* to *esprit de corps*, that Léger evolved his characteristic style and subject-matter and formulated his aesthetic views. Eschewing a method based on influence or style (accommodating Léger's Cubism to that of Picasso and Braque, for instance), my subject here is Léger's pictorial language: his vocabulary of contrast and composition of dissonance, the incorporation of dynamic rhythm or speed, and the juxtaposition of isolated fragments without narrative context. Léger's conceptual and semantic debt to the urban context, to the language of cinema and to the image of the machine will be privileged. His pictorial language animated his exploration of the non-objective while at the same time sustaining his attachment to the object; it was the source of his bold challenge to traditional genres in painting (even during his ostensibly conservative, 'classical' mode); it was the inspiration, too, for his innovatory experimentation in film, and an informing principle of his collaborative work with the Ballets Suédois (Swedish Ballet) and of his architectural-mural compositions.

'Contrastes de formes'

In the essays he wrote between 1913 and 1923, Léger elaborated the essential principles of his aesthetic: a realism of conception achieved through the dynamism of plastic contrasts. One essential tenet of this aesthetic was the equation 'Contrast = dissonance, [achieving] a maximum of expressive effect'.[1] This was Léger's battle-cry against traditional notions of pictorial realism, which were bound to sentiment, representation and popular expressions of the subject. He opposed his idea of plastic contrast to a 'sentimental literary concept'.[2] For him, the dynamic dissonance of form, line and colour was the delineation of, indeed, the direct result of, rupture and change in the modern world:[3] 'Present-day life, more fragmented and faster moving than life in previous eras, has had to accept as its means of expression an art of dynamic divisionism.'[4] The 'com-

1 Léger, 'Les réalisations picturales actuelles' (1913), *Fonctions de la peinture*, Paris, 1965, p. 25; English trans., *Functions of Painting*, London, 1973, p. 16.

2 Ibid., p. 21; English trans., p. 12.

3 'A new criterion has appeared in response to a new state of things. Innumerable examples of rupture and change crop up unexpectedly in our visual awareness'; from 'Contemporary Achievements in Painting', p. 12.

4 Léger, 'Les Origines de la peinture et sa valeur représentative' (1913), *Fonctions de la peinture*, p. 17; English trans., p. 8.

Fig. 1 *Contraste de formes* (Contrast of Forms), 1913, oil on canvas, 92×73 cm. Private collection (B50)

5 Léger, 'Les réalisations picturales actuelles', p. 20; English trans, p. 11.

6 Blaise Cendrars, 'Fernand Léger', *La Rose Rouge* (Paris), 10 (3 July 1919), p. 155 in *Œuvres complètes*, VI, Paris, 1962, p. 190.

7 'Entretiens de Fernand Léger avec Blaise Cendrars et Louis Carré sur le paysage dans l'œuvre de Léger, 1954', in *Fernand Léger,* exhibition catalogue, Galerie Louis Carré, Paris, 1956.

8 In this connection, see, for example, Robert L. Herbert's essay in *Lèger's 'Le Grand Déjeuner'*, exhibition catalogue, Minneapolis Institute of Art, 1980.

pressed' quality of the modern pictorial idiom parallels a drift away from description and narrative coherence in the verbal realm, as well: 'a modern man registers a hundred times more sensory impressions than an eighteenth-century artist; so much so that our language, for example, is full of diminutives and abbreviations.'[5]

At the same time that Léger wrote his essays of 1913 and 1914 'The Origins of Painting and its Representational Value' and 'Contemporary Achievements in Painting', he painted his most audaciously non-objective works, the group of paintings entitled *'contrastes de formes'*. During this short-lived excursion into the realm of pure abstraction, the dynamic contrast of form, line and colour supplanted descriptive, representational associations (fig. 1). Indeed, the clearest external reference in this group is to the centralized, or centrally dense, compositions of Analytical Cubism: their centres feature monumental ropes of tubular units that coil outwardly in space, or perhaps are better described as amplifying outward towards the viewer (pl./p. 90). Sometimes a shape is more that of a vertical totem of stacked drum-forms, recalling the rough, unhewn shapes manipulated by his close

friend, the sculptor Constantin Brancusi (pl./p. 92). Léger's rather sculpturesque and rounded central forms are frequently flanked by, or juxtaposed to, flat or angular shapes that cascade down in steps, like ribbons unfolding, or like a series of overlapping cards (pls./pp. 91, 93). The sheer physicality of these paintings – raw blotches of pure colour on roughly textured canvas – intensifies their radically non-descriptive quality. In his essay on Léger in *La Rose Rouge* (3 July 1919), Blaise Cendrars observed that

> Even before the War his paintings already looked 'quite different', in general terms, from the other Cubist paintings. They were direct, often brutal, without ever any attempt at prettiness, orderliness or finish, and they always remained in the realm of visual representation. [...] Léger [went] so far in his study of volumes and measures that not only did he ensure the emergence of the Russian Rayonism of Larionov, he also had a direct influence on the best of the Italian Futurist painters.[6]

In these works Léger perfected a powerful vocabulary of dynamic contrasts that was to inform and transform his subsequent works, whether figural, still-life or landscape. Indeed, years later Cendrars, in a discussion with the gallery owner Louis Carré and Léger, commented as follows on a painting of 1925 entitled *Paysage* (Landscape): 'As for me, that's what I call a landscape: it's an exterior scene. [...] It isn't a stage-set, it isn't the back of a stage-set, and, above all, it isn't the work of a landscapist.'[7] Similarly, Léger's most classical compositions, such as *Le Petit Déjeuner* of 1921 (pl./p. 177), defy traditional genre classifications and present instead a dynamic balance, or vibrant hybrid, of figure/still-life, interior/exterior, in which fragments of the bodies, ordinary objects and abstract decoration partake equally of a sense of weight or geometric monumentality, and of visual and cognitive meaning.[8]

The significance of Léger's challenge to traditional genres in his *'contrastes de formes'* of 1913-14 must be situated in the context of the general currency of this idea among the post-War avantgarde. Guillaume Apollinaire, for instance, discussed the dissolution of genres in the field of literature in an essay of 1918:

Up to now the literary field has been kept within narrow limits. One wrote in prose or one wrote in verse. In prose, rules of grammar established the form. Free verse gave wings to lyrics; but it was only one stage of the exploration that can be made in the domain of form. […] The new spirit…admits even hazardous literary experience, and those experiences are at times anything but lyric.[9]

This, of course, was the time of the Futurist attack on narrative and the representational: for Marinetti in 1909, 'Time and Space died yesterday. We already live in the absolute, because we have created eternal, omnipresent speed.'[10] The Italian Futurists adopted *parola in libertà*, suppressing syntax and punctuation, abandoning both adjectives and adverbs, and experimenting with inventive typographical presentations in order to get rid of the 'anecdotal "I" of the writer', even any visual suggestion of the sequential unfolding of narrative. This fragmentation of verbal or pictorial language was characteristic of not only the work of the Futurists, but the writings of Apollinaire, Cendrars, Pierre Reverdy, Gertrude Stein, William Carlos Williams, Ezra Pound and James Joyce. The poetry, performances and contributions to film made by Vladimir Mayakovsky, the trans-rational, or *zaum*, poetry of Velimir Khlebnikov, and the Futurist poetry of Aleksei Kruchenykh all exemplify the challenge to the rational forms or descriptive functions of language. This tendency towards fragmentation was rooted in the technological revolutions of this period, in the cacophony of the city, the speed of communication, the immediacy of cinema and the rhythm of the machine, all of which profoundly altered traditional notions concerning time and space.[11]

The Language of Rupture

For Marjorie Perloff, the 'language of rupture' of the post-War avant-garde – the destabilization of genre and other categories, the breakdown of boundaries between 'world' and 'text', the questioning of the integrity of the medium itself – is epitomized in collage and its cog-

nates: montage, assemblage, construction.[12] The Great War was, for Léger and everyone of his generation, indisputably *the* great rupture, not only because of the chaos, tragedy and destruction it caused, but in aspects that might be described as specifically modern, which challenged the belief that there existed continuity in time and in space. One notes especially in this regard, Stephen Kern's discussion of the 'Cubist War', in which, for example, developments in air travel are linked by Kern to altered notions of spatial and directional orientations of entire societies or nations. The sheer rush and immediacy of events as transmitted by telegram or communicated by cinema are identified as factors that contributed to the inadequacy of traditional diplomatic communications. Kern analyzes, as well, the collapse of the individual soldier's personal sense of time's coherent flow. A profound disorientation was provoked by certain aspects of combat: the peculiar focus on time produced, for instance, by the need for the synchronization of watches; the bizarre contrast between long, monotonous periods of passive waiting and sudden and speedy mobilizations of vast forces. The soldier functions within an environment that maintains a distorted emphasis on the present, an environment dramatically cut off from both the past and the future.[13]

The impact on Léger of various aspects of the War, not least the response elicited from him by the beauty of the .75 mm cannon's breech-block, and his admiration for the dignity and camaraderie of the average soldier in the trenches, are well known, as is Léger's chastened 'return to the subject' that followed his rejection of his own pre-War near-abstraction. But Léger's recently published wartime letters to his friend Louis Poughon offer a new, richly nuanced vision of his experiences in battle,[14] revealing a language of rupture – an insistence on fragmentation and the insufficiency of conventional description or narrative – a sense of trauma that finds its visual counterpart in his wartime collages. These are of special interest, because although they are anomalous in the work of an artist who consistently respected the integrity of the painted medium, they none the less reflect Léger's basic aesthetic principles of contrast, disson-

9 Apollinaire, 'L'Esprit nouveau et les poètes', in *Œuvres en prose complètes II*, Paris, 1991, p. 943f., here as cited in Marjorie Perloff, *The Futurist Movement: Avant-Garde, Avant-Guerre, and the Language of Rupture*, Chicago and London, 1986, pp. 192-3.

10 F.T. Marinetti, 'The Founding and Manifesto of Futurism 1909', in *Futurist Manifestos*, ed. Umbro Apollonio, trans. by Robert Brain, R.W. Flint, J.C. Higgitt and Caroline Tisdall, New York, 1973, p. 22.

11 See Stephen Kern in *The Culture of Time and Space, 1889-1918*, Cambridge, Mass., 1983, who situates the fragmentation in language in a broad cultural context of the radical technological revolutions of this period, and in a study that transcends even the ambitiously interdisciplinary, steers through the profoundly altered notions of time, speed and space.

12 Perloff, *The Futurist Movement*, p. 242. Perloff discusses this language of rupture in the broader contexts of economic and political internationalism.

13 Kern, in *The Culture of Time and Space*, 1983, also develops interesting analogies in the spatial realm between the wartime 'no-man's zone' and the significance of negative space in avant-garde typography and compositions.

14 Christian Derouet, ed., *Une Correspondance de guerre à Louis Poughon, 1914-1918*, Les Cahiers du Musée National d'Art Moderne, Paris, 1990.

Fig. 2 *La Partie de cartes* (The Card
Game), 1915, oil and pasted paper on
word, 39×26 cm. Collection of Dr and
Mrs Israel Rosen, Baltimore (B97)

15 Letter 28 (Verdun, 30 October
 1916), pp. 66-7.

16 This topic, in connection with
 Georges Bataille's deconstruction of
 the fiction of the integral body in
 his pornographic novel *Histoire de
 l'œil* (1928), and in the dissident
 journal *Documents* was the subject
 of my own paper, 'Disintegrating
 the Exquisite Corpse – Georges
 Bataille's Aesthetic of the Erotic
 Fragment', presented in the
 session, 'Surrealism – The Unfin-
 ished Project', at the CAA annual
 meeting, 1993.

ance and fragmentation, a collage mentality
that reveals itself even in his paintings.

One harrowing letter to Poughon is espe-
cially significant in this regard:

> Human remains start to appear as soon as
> you leave the area where there's still a path.
> I saw some exceedingly peculiar things.
> Men's heads, almost mummified, sticking
> out of the mud. They were quite tiny in this
> sea of mud. One would think they were [the
> heads of] children. The hands, above all, are
> extraordinary. There are some hands that
> I'd have wanted to take an accurate pho-
> tograph of. They're what's most expressive.
> Several [of the corpses] have their fingers in
> their mouths, the fingers chopped off by the
> teeth. [...] That's all there is. Neither a
> stone nor a wooden stump, [just] holes,
> mud, water in the holes and human re-
> mains. The bodies still all of a piece [were]
> the best preserved. [...] Now I wanted to
> find the German lines. There was nothing
> from which to take my bearings apart from
> human remains and objects. It was the
> boots that were my best guide. When I saw
> the high boots and the green helmets, I real-
> ized that I'd gone beyond our lines. There,
> my dear Poughon, in the sloping terrain be-
> yond Fleury, I'd got right into the part of
> the country where our shelling had done its
> worst. I just can't describe it to you. Those
> who want to are just producing literature,
> and bad literature at that; and there, what I
> said to you earlier was confirmed: Lots of
> drowned men in rose-coloured water with
> heaps of things floating in it. Here it's not
> only shells that kill you, you can drown too.
> You have to know about things like that. I
> wanted a pair of boots to make myself some
> leggings. They have stunning leather, the
> Germans. I could never find a pair [of
> boots] without legs in them. [...] They [the
> soldiers] want to make a shelter and, as
> they don't have any planks, do you know
> what they do? Now, I told you there were
> heaps of boots with legs in them. Well, they
> place 4 or 8 of them in two rows, then they
> load soil on top of them, and there you are.
> Goodbye, my old fellow, this is a long letter,
> but I wanted to tell you about my walk. It's
> done....[15]

Here Léger records the struggle to find his
bearings in a landscape devoid of delineation
beyond the clues of isolated objects and hu-

man debris, a muddy, bomb-devastated terrain
that no map could plot. Similarly, the compul-
sion to recount his experiences is thwarted by
the admitted inadequacy of description: con-
ventional narrative cedes to an accumulation,
that of body-fragment-object. The prime signif-
ier of the threatening, disjointed environment
of the war-zone is the human body disinte-
grated, distorted, segmented, truncated, frag-
mented, eviscerated. This wartime letter comes
very close to the Surrealists' *écriture corpo-
relle*, one basis of their anti-hierarchical, anti-
aesthetic programme.[16]

Especially significant here is Léger's
pointed dismissal of descriptions of war experi-
ences as *literature*, 'and bad literature at that'.
His use of pasted paper elements may be inter-
preted as a means to avoid, suppress or super-
sede narrative content in his wartime subjects,
to transfer the violence from the level of
theme or content to that of technique, a viola-
tion of the integrity of medium (fig. 2).

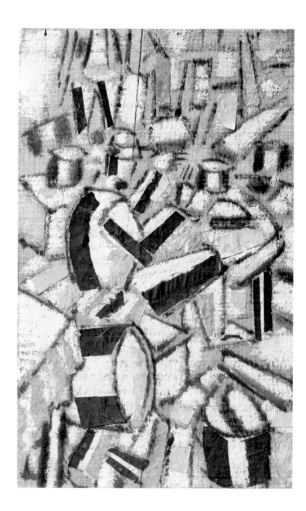

In his monumental wartime canvas, *La Partie de cartes* (The Card Game, 1917; pl./p. 119), Léger did not attempt to depict the horrors of combat but, rather, as his subject chose soldiers during a period of respite. The painting was, in fact, executed during Léger's own convalescence in 1917 at the hospital of Villepinte in the suburbs of Paris, and can be interpreted as a reflection of both a physical recuperation and a kind of artistic one, a tapping into an aesthetically fortifying tradition that re-established a dialogue with a pre-War aesthetic role-model, Paul Cézanne. *La Partie de cartes* is traditionally, and accurately, identified as a watershed painting in Léger's *œuvre*, indicating a repudiation of his own pre-War bias towards abstraction, and a rejection, too, of the idealist or hermetic tendencies of the 'crystal Cubism' that was beginning to come to the fore in Paris *c*. 1916-17. *La Partie de cartes* represents a moment of taking stock: Léger embraced the subject-matter of his time, but not within a conventional narrative context. '*Contraste = dissonance*' continued to be the basis of his 'new realism', but the fragments of his pictorial language were henceforth to be very consciously cut and pasted from the modern urban environment.[17]

The City as Anti-Narrative

Even before the War, the city constituted a major theme in Léger's painting, witness the series of compositions from 1911-12 entitled *Fumées sur les toits* (Smoke above the Roofs; pl./p. 80), *Les Toits de Paris* (The Roofs of Paris), *La Fumée* (Smoke; pl./p. 81) and *Le Passage à niveau* (The Railway Crossing; pl./p. 86). In these works, which might be labelled neo-Impressionist as well as proto-Cubist, he juxtaposed rounded plumes of smoke with a scaffolding of flat geometric passages and black linear elements signifying building façades, windows, chimneys and staircases. Smoke and the smoker, indeed, remained a leitmotif: for instance, *Le Fumeur* (The Smoker, 1914), *Le Mécanicien* (The Mechanic, 1918), *La Ville* (The City, 1919; pl./p. 145), *L'Homme à la pipe* (Man with a Pipe, 1920; pl./p. 146), *Les Trois Camarades* (Three Comrades, 1920; pl./p. 149), *Paysage animé* (Animated Landscape,

1921; pl./p. 166). Though the smoke motif in the early city compositions (1911-12) may have been inspired by the philosophical and political ideas of Jules Romains, and even be based on specific images in Romains's collection of poems *La Vie unanime* (1908), it is clear that smoke played an important role in the development of Léger's language of contrasts.[18] In crucial figural compositions of the same years – *Les Fumeurs* (The Smokers, 1911; pl./p. 82), *La Noce* (The Wedding, 1910-11; pl./p. 79), *Trois Figures* (Three Figures, 1911), *La Femme en bleu* (Woman in Blue, 1912; pl./p. 87) and *Modèle nu dans l'atelier* (Nude Model in the Studio, 1912-13; pl./p. 85) – he explored the tension between ropes of curvilinear forms and spatially ambiguous assemblages of geometric and linear elements, establishing thereby the essential principles of plastic contrasts, the basis for the radically transgressive '*contrastes de formes*' of 1913-14. Léger himself noted the importance of this motif in 1914:

> Contrast = dissonance.... I will take as an example a commonplace subject: the visual effect of curled and round puffs of smoke rising between houses. You want to convey their plastic value. Here you have the best example on which to apply research into multiplicative intensities. Concentrate your curves with the greatest possible variety without breaking up their mass; frame them by means of the hard, dry relationship of the surfaces of the houses, dead surfaces that will acquire movement by being coloured in contrast to the central mass and being opposed by live forms; you will obtain a maximum effect.[19]

Plastic contrasts characterize his post-War urban or industrial compositions too, via an assemblage of collage-like linear elements: flat areas of solid colour, stencilled letters and poster- or billboard-like shapes, as well as the juxtaposition of distinctly modelled shapes and figures.

Associating the city with contrast and dissonance was not peculiar to Léger; rather, it was then a significant theme for an international array of artists, writers and film-makers, who discovered in their reactions to the accelerated pace and incoherent environment of the modern city a loss of confidence in tradi-

17 For the political meaning of Léger's post-War work, his '*rappel-à-l'ordre*', see Christopher Green, *Léger and the Avant-garde*, New Haven and London, 1976, pp. 96-135; *idem*, *Cubism and its Enemies: Modern Movements and Reaction in French Art, 1916-1928*, New Haven and London, 1987; Kenneth E. Silver, *Esprit de corps: The Art of the Parisian Avant-garde and the First World War, 1914-1925*, Princeton and London, 1989; Robert S. Lubar, 'Cubism, Classicism, and Ideology: The 1912 "Exposició d'art cubista" in Barcelona and French Cubist Criticism', in *On Classic Ground: Picasso, Léger, De Chirico and the New Classicism 1910-1930*, exhibition catalogue ed. Elizabeth Cowling and Jennifer Mundi, Tate Gallery, London, 1990.

18 Judy Sund, 'Fernand Léger and Unanimism: Where There's Smoke', *Oxford Art Journal*, I, 1984, pp. 49-56.

19 Léger, 'Les réalisations picturales actuelles', pp. 25-6; English trans., p. 16.

20 See, especially, *Unreal City: Urban Experience in Modern European Literature and Art*, ed. Edward Timms and David Kelley, Manchester, 1985.

21 Pound, 'Review of Jean Cocteau, "Poésies, 1917-20"', *The Dial*, January 1921, p. 110, as cited by John Alexander, 'Parenthetical Paris, 1920-1925: Pound, Picabia, Brancusi and Léger', in *Pound's Artists: Ezra Pound and the Visual Arts in London, Paris and Italy*, exhibition catalogue, Tate Gallery, London, 1985, p. 107.

22 By A. Conger Goodyear, in a brochure accompanying the Léger exhibition in New York at the Museum of Modern Art and at the Art Institute of Chicago, 1935, courtesy of the Archives, The Museum of Modern Art, New York.

23 Léger characterized this work as a mural rather than easel painting, in a letter to Alfred H. Barr at the Museum of Modern Art, New York, in 1945. The correspondence is preserved in the files of the Department of Painting and Sculpture, and was published in Herbert, *Léger's 'Le Grand Déjeuner'*, 1980, p. 72.

24 For Léger, Cubism and film, see, especially, the classic work of Standish Lawder, *The Cubist Cinema*, New York, 1975.

25 Cited in Kern, *The Culture of Time and Space*, p. 119.

26 Henri-Martin Barzun, 'Voix, rythmes et chants simultanés', in *Poèmes et drames*, IV, Paris, 1913, p. 26.

tional artistic discourse, and a concomitant demand or need for aesthetic renewal or revolution. The city was the locus of simultaneity (a perception that preoccupied Léger, Delaunay, the Futurists, Henri-Martin Barzun, Apollinaire, Cendrars and many others), and perception was perforce non-sequential; in response thereto, discourse had to abandon the linear structure of narrative and adopt, instead, collage, cinematic-inspired montage – indeed a discourse that transcends genre categories and the boundaries of traditional media.[20]

The American Vorticist poet Ezra Pound, who lived in Paris 1920-25, identified the life of a village with narrative, but life in cities he described very differently: 'the visual impressions succeed each other, overlap, overcross, they are "cinematographic", but they are not a simple linear sequence.'[21] What is interesting is Pound's association of the urban experience with montage or collage, an assemblage of fragments intentionally lacking in sequential coherence. Léger's *La Ville* (1919; pl./p. 145), which he himself acknowledged to be one of the monuments of his career, is a rhythmic juxtaposition of distinct painted elements that seem to emulate cut-out forms. It has been said that Léger 'does not illustrate the city at all', remaining 'content to fix the fragments into an arabesque that should pound out rhythms to suggest the city's life'.[22] The aura of fragmentation is intensified through the standard Cubist technique of incorporating word fragments. Two human profiles resemble poster or billboard fragments. The grisaille, tubular figures at the centre of the composition suggest less a glimpsed vignette in a cityscape than they do a cut-out quotation from previous compositions within Léger's own *œuvre*. The internal dialogue with his own works, in this instance the oft-repeated motif of figures descending or ascending stairs, is characteristic of Léger's working method. The lack of perspectival or spatial coherence derives from the juxtaposition of flat unmodelled shapes against other elements articulated with shading. Because of its dimensions, this painting lacks the intimacy that one associates with true collage. Indeed, cinematographic montage may be the more apt point of reference for *La Ville*, not only because of the work's size, but because of

the compositional elements at left, right, top and bottom, all of which open outward, indicating an aspiration beyond the limits of the canvas.[23]

There is no lack of evidence for the enthusiasm of the pre-War avant-garde for cinema, a fascination based, at least in part, on sheer delight in the novel sense of speed and immediacy, and in the manipulation of transgressive tricks.[24] What is key in this context is the characterization of the urban experience as cinematographic, and the substitution of the 'eye' of the camera for the 'I' of the narrator. Stephen Kern, in his rich exegesis of the contribution of the cinema to altered perception, cites Luigi Pirandello's *Shoot: The Notebooks of Serafino Gubbio, Cinematograph Operator* of 1915, in which the substitution is surrealistically complete: 'Already my eyes, and my ears too, from force of habit, are beginning to see and hear everything in the guise of this rapid, quivering, ticking mechanical reproduction.' Gubbio no longer has an existence distinct from that of his camera: 'I cease to exist. It walks now, upon my legs. From head to foot, I belong to it: I form part of its equipment.'[25] Narrative cedes to cinematographic montage, as the nineteenth-century *flâneur* is displaced by the twentieth-century cameraman.

The poet Henri-Martin Barzun understood the city to be a proof of the existence of simultaneous voices.[26] Simultaneism was a loosely defined or multivalent term (in fact, a source of controversy among its various proponents) indebted to nineteenth-century Symbolist notions of synaesthesia, the theory of correspondences and the ideal of a non-mimetic, revelatory art. Delaunay's emphasis on pure colour was based in part on Michel-Eugène Chevreul's colour theory of simultaneous contrasts, which Chevreul had published in 1839, while the popularity of the idea of psychic duration may be attributable to Henri Bergson's essay of 1903, *Introduction à la métaphysique* (Introduction to Metaphysics). The Italian Futurists, for example, used the notion of simultaneity to express a fusion of remembered past and perceived present. For Apollinaire, Cendrars, Stein and Reverdy, simultaneity implied multiple awareness, beyond finite notions of time and space, which demanded

new aesthetic discourses: the multiple points of view of Cubism, the unconventional construction based on conflicting or contrasting elements of Apollinaire's *Calligrammes*, or the extended present established through repetitions in the writings of Gertrude Stein.[27]

Blaise Cendrars is the author of the prose poem *Profond Aujourd'hui* and of a collection of essays entitled *Modernités*, and deserves special attention because of his close friendship and collaboration with Léger. Cendrars's collaboration with Sonia Delaunay Terk on *La Prose du Transsibérien*, printed privately in 1913 by Cendrars's own Editions des Hommes Nouveaux, was described in his prospectus as the 'first simultaneous book'. His *L'ABC du cinéma* of 1919 articulates how film is the ideal aesthetic discourse of simultaneity:

> A hundred worlds, a thousand movements, a million dramas simultaneously enter the range of the eye with which cinema has endowed man. And, though arbitrary, this eye is more marvellous than the multifaceted eye of a fly. The brain is overwhelmed by it. An uproar of images. Tragic unity is displaced.[28]

Cendrars's eye/lens is not unrelated to the ceding of the 'I' to the camera in Pirandello's *Shoot*. Cendrars's *Profond Aujourd'hui* of 1917, begins with a play on drastically disparate scales: 'I no longer know if I'm looking with my naked eye at a starry sky or at a drop of water through a microscope....'[29] Cendrars's focus on simultaneous perception and renewed aesthetic discourse is apparent in *La Fin du monde, filmée par l'ange Notre-Dame* of 1919 (fig. 3), whose text is intricately interwoven with illustrations and typographic experiments by Léger. In Cendrars's destruction (rather than creation) of the world, 'An obscure eye closes on all that has been.'[30] In Book Seven, the eye opens once again as the 'film' of the destruction of the world runs backward to the world's renewal, an idea that prefigures the coda of the film *Entr'acte* (1924) by René Clair, in which Jean Börlin jumps from his coffin and through the paper scrim bearing the legend 'The End', thereby challenging, with burlesque drama, the idea of closure, and hence transgressing narrative coherence (fig. 7).

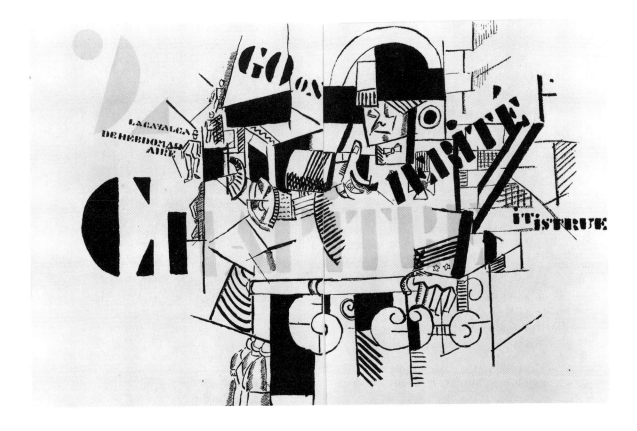

Fig. 3 Illustration for Blaise Cendrars's poem *La Fin du monde filmée par l'Ange N.-D.* (The End of the World, filmed by the Angel of Notre-Dame), Paris: Edition de la Sirène, 1919, pp. 14-15. Öffentliche Kunstsammlung, Basle: Kupferstichkabinett (inv. 1965.18)

27 Concerning simultaneity, see Kern, *The Culture of Time and Space*, p. 72 ff.; Sherry Buckberrough, *Robert Delaunay: The Discovery of Simultaneity*, Ann Arbor, 1982; Virginia Spate, *Orphism: The Evolution of Non-figurative Painting in Paris, 1910-1914*, Oxford, 1979; Dorothy Kosinski, *Orpheus in Nineteenth-century Symbolism*, Ann Arbor, 1989, especially Ch. 7 regarding Orphism and the emergence of abstraction.

28 Cendrars, 'The ABCs of Cinema', in *Modernities and Other Writings*, ed. Monique Chefdor, trans. Esther Allen with Monique Chefdor, Lincoln, NB, and London, 1992, p. 25.

29 Cendrars, 'Profound Today', in *Modernities and Other Writings*, p. 3.

30 Cendrars, 'The End of the World Filmed by the Angel of Notre-Dame', verse 41, in *Modernities and Other Writings*, p. 51.

Fig. 4. *Le Typographe* (The Typographer), 1918, oil on canvas, 248 x 182 cm. Private collection (B 146)

31 Léger, 'L'Esthétique de la machine: L'ordre géométrique et le vrai' (1925), in *Fonctions de la peinture*, p. 63; English trans., p. 62.

32 Ibid.

33 The author gratefully acknowledges Hester Diamond's insights in this regard, in a conversation, May 1993.

34 Along similar lines, *Les Disques* of 1918 (pl./p. 137, Musée de l'Art Moderne de la Ville de Paris) can hardly be adequately described as a landscape. However, a comparison of the related but more 'readable' *Les Disques* of 1918-19 (pl./p. 139, Los Angeles, County Museum) clarifies this underlying association.

35 Léger, 'Mechanical Ballet', *The Little Review*, Autumn-Winter 1924-5, pp. 42-4.

36 Léger, 'Essai critique sur la valeur plastique du film d'Abel Gance *La Roue*' (1921), in *Fonctions de la peinture*, p. 160, English trans., p. 20.

Les Eléments mécaniques

In 1925 Léger proclaimed that 'Each artist possesses an offensive weapon that allows him to intimidate tradition. In the search for vividness and intensity, I have made use of the machine as others have used the nude body or the still-life.'[31] He clarifies that his goal is not to depict, portray or 'copy' the machine but to 'invent images from machines...to create a beautiful object with mechanical elements'.[32] With his '*éléments mécaniques*', Léger invented a pictorial vocabulary that explicitly challenged traditional categories of genre, or, at the very least, defied their discreet borders. *Les Hélices* (Propellers, 1918; pl./p. 123) hardly depicts an aeroplane, or even elements of one, nor does it engage in the punning 'diagrammatic' discourse that characterized the earlier (1911-12) machine compositions of Duchamp and Picabia. One is hard pressed to situate *Nature morte aux éléments mécaniques* (Still-life with Mechanical Elements, 1918; pl./p. 130), despite its title, within the parameters of the typical still-life. The artist does establish a sense of foreground and background space, and the central conical element seems to swirl up and out from a type of base. But essentially, these mechanical shapes are more closely indebted to Léger's own earlier and almost totally non-objective '*contrastes de formes*' than they are descriptions of any identifiable subject in reality.

The upward coiling force that characterizes the forms in *Composition* (1919; pl./p. 131) possesses the dynamic *contrapposto* power of a figure sculpted by Bernini.[33] Two related works – *Le Typographe* (1918; fig. 4) and *Les Eléments mécaniques* (1918-23; pl./p. 129) – exploit this same spatially dynamic and centralized conglomeration of mechanical forms, which furiously whirl and churn against a background of flat geometric passages. The verticality of this central complex and also the extending conical 'arms' suggest a figure, an association implied by the title, 'The Typographer'.[34]

The crux of Léger's 'new realism' was dynamic tension: tension between the dramatic three-dimensional definition of the objects and the fact that they describe or copy nothing; between the suspicion of figure or still-life and the profound defiance of genres; between realism and the non-objective. Léger's characterization of his film *Ballet mécanique* (1924) is revealing: 'No scenario – Reactions of rhythmic images, that is all....Objects...the most unusual....Figures, fragments of figures, mechanical fragments, metals, manufactured objects...objective, realistic and in no way abstract.'[35]

In his review essay in *Comœdia* (1922) of *La Roue* (The Wheel), a film produced by Abel Gance, Léger privileged the 'plastic state', that aspect of the film in which 'the mechanical element plays a major role, and where the machine becomes the leading character, the leading actor. It will be to Abel Gance's honour that he has successfully presented an actor object to the public.'[36] In his enthusiasm for Gance's montage passages, Léger seems to articulate what one might describe as an 'anthropomorphization' of the machine, he expresses something like an emotional reaction to the mechanical object. This is an attitude shared, interestingly enough, by Ezra Pound, who wrote that since 'Machines are now part of life, it is proper that men should feel something

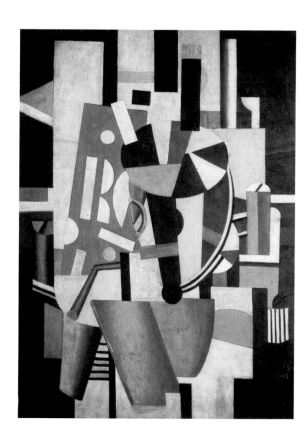

about them; there would be something weak about art if it couldn't deal with this new content.'[37]

Like Léger, Pound rejected conventional realism, emphasizing in its stead the rhythmic movement of the machine:

> Machines are musical. I doubt if they are even very pictorial or sculptural, they have form, but their distinction is not in form, it is in their movement and energy; reduced to sculptural stasis they lose their raison d'être, as if their essence.[38]

In his paintings of complex machine-objects with conical extensions, or in another distinct compositional type featuring an overall pattern of interlocking gear-like elements (pl./p. 126), Léger attempted to communicate a sense of relentless grinding motion, the impression of rhythmic movement. With the discs and arcs in his designs for Rolf de Maré's Ballets Suédois production of *Skating-rink* (1922), in the rhythmic context of Arthur Honegger's music, and animated by the motions of the dancers, Léger overcame the stasis of the canvas through the collaborative ideal of the stage production.[39]

In his important review of *La Roue*, Léger pinpointed Gance's filmic innovation: 'this new element…: close-ups, fixed or moving mechanical fragments, projected at a heightened speed that approaches the state of simultaneity and that crushes and eliminates the human object, reduces its interest, pulverizes it [fig. 5].'[40] How well, too, might this commentary on Gance's cinematic achievement describe Léger's own monumental painting, the *Elément mécanique* of 1924 (pl./p. 189). The dramatically monumentalized fragment, or that which Léger termed 'element' (liberated by the dramatic scale-manipulated apparition of the object filmed close-up), is the essence of this work. In his essay on Léger, the film-maker Jean Epstein emphasizes the importance of the fragment, especially the machine fragment, and links this aspect of Léger's discourse to cinematic techniques:

> To him, things look as if they consist of fragments.…And, in employing this process of fragmentation, Léger is in full agreement with the intellectual tendencies of the era.… The [cinema] screen spreads out the details

[of the figure] as if they were those of a monumental piece of architecture. We come to know the hand in all its drama, and as more important than the head, and thus larger, and from the centre of this head, in the background, the eye alone comes towards us like a crater formed by sorrow and borne up by tears.…Moved to split things up [in this manner], on what pretext is Léger going to offer preference to [this approach] in his painting? The mechanical object is already split up in itself. It has joints, hinges, seams, barbs.… Everything has been divided up into airtight compartments.…Thus, the interpretation of the mechanical object does not so easily transgress the limits of the probable, limits to which the majority of spectators – and even, one has to say, informed spectators – cling desperately. In the mechanical realm, the probable, in coming near to the improbable, [also] comes near to what is true.… The mechanical object, which already lends itself to distortion, thus also lends itself, and for the same reasons, to the painter's invention. For Léger does not so much deform as invent, or rather he deforms as much as he invents, or, to put it yet another way, he doesn't deform, but he deforms, constructs and manufactures new

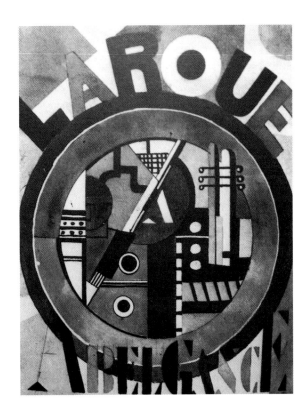

Fig. 5 Poster design for Abel Gance's film *La Roue* (The Wheel), *c.* 1922, gouache, Musée National Fernand Léger, Biot

37 Pound, 'Antheil and the Treatise on Harmony', as cited by John Alexander in *Pound's Artists*, p. 111.

38 Ibid., p. 112.

39 Léger's collaborative projects include theatre designs for de Maré (not only *Skating-rink* but *La Création du monde*); his work on Marcel L'Herbier's film *L'Inhumaine*, and with Dudley Murphy on his own *Ballet mécanique*; book illustration with Cendrars, Goll and Malraux; and architectural mural decoration including his submission to Mallet-Steven's French Embassy or Le Corbusier's Pavillon de l'Esprit nouveau (1924). All of these reflect Léger's sustained fascination with the ideals of the artist-artisan and the *Gesamtkunstwerk*.

40 Léger, 'Essai critique sur la valeur plastique du film d'Abel Gance *La Roue*', p. 160, English trans., p. 20.

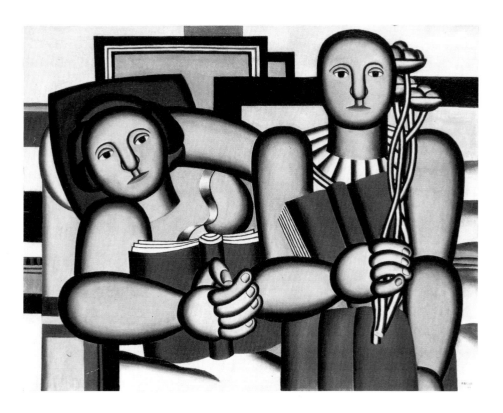

Fig. 6 *La Lecture* (Reading), 1924, oil
on canvas, 114 x 146 cm. Musée National
d'Art Moderne, Paris (B 367)

41 Epstein, 'Fernand Léger', in *Les
 Feuilles Libres*, March-April 1923,
 reprinted in *Ecrits sur le cinema*, I,
 Paris, 1974, pp. 115-8.

42 For Léger and film, see James John-
 son Sweeney, 'Léger and the Cult of
 the Close-up', *The Arts*, May 1931,
 pp. 561-8; James Johnson Sweeney,
 'Léger and the Cinesthetic', *Cre-
 ative Art*, X, June 1932, pp. 440-45;
 Standish Lawder, *Cubist Cinema*;
 Georges Sadoul, 'Fernand Léger ou
 la cinéplastique', *Cinéma '59*, 35,
 April 1959, pp. 72-82; John Alexan-
 der, in *Pound's Artists*; but particu-
 larly the works of Judi Freeman:
 'Léger's "Ballet mécanique"', in
 Dada and Surrealist Film, special
 no. of *Dada/Surrealism*, 15, ed. Ru-
 dolf E. Kuenzli, 1986, pp. 28-45;
 'L'Avènement de l'objectivité plas-
 tique: Léger's Shift from the Me-
 chanical to the Figurative, 1926-
 1933', in *Fernand Léger: The Later
 Years*, exhibition catalogue, Whi-
 techapel Gallery, London, 1987;
 'Léger Re-examined', *Art History*,
 III, 1984, pp. 349-59; and Christian
 Derouet, 'Léger et le cinéma', in
 Peinture, cinéma, peinture, exhibi-
 tion catalogue, Centre de la Vieille
 Charité, Marseilles, 1989, pp. 120-
 43.

objects, objects existing in his paintings.
These objects of pictorial reality are the
sentimental equivalent of real objects.[41]

Léger's own foray into film, his scenario-free
Ballet mécanique (1923-24; pls./pp. 191-3), jux-
taposed objects and figures, and their frag-
ments: hats, pans, bottles, arms, Kiki's smiling
lips, mannequins' legs, etc.[42] (These were dis-
torted through close-ups, and fragmented
through a prismatic lens of the type used often
by the photographer Alvin Langdon Coburn,
which had been introduced to the *Ballet méca-
nique* team by Ezra Pound.) The close-up,
about which Léger wrote so often, changed his
way of seeing: 'The hand is an object with
multiple, changeable meanings. Before I saw it
in the film, I did not know what a hand was!
The object by itself is capable of becoming
something absolute, moving and dramatic.'[43]
His intuition of the close-up relates, too, to
Purist-based notions of the evolution of the
form and function of the ordinary *objet-type*.
It also informs or forecasts the Surrealist qual-
ity of Léger's compositions in the 1930s: min-
utely scrutinized, often insignificant objects or
fragments are monumentalized through a dra-
matic manipulation of scale.[44] Most important

in our context, however, is how the monu-
mentalized fragment, the object up-close, trans-
formed even Léger's most classical paintings of
the 1920s, endowing figures and still-lifes with
unmistakable and peculiar grandeur. In *Le
Compotier de poires* (The Dish of Pears, 1923;
pl./p. 182), for instance, the simple still-life ob-
jects are 'inflated' with a sense of weight and
significance. Similarly, in *Nature morte à la
chope* (Still-life with a Beer-mug, 1921; pl./p.
178), the over-sized beer-mug is invested with
a monumentality and brilliance that counter-
balances the dynamically complex geometric
patterns and rhythms of colour of the inte-
rior.[45] The serene monumentality of *Le Petit
Déjeuner* (The Breakfast, 1921; pl./p. 177), *La
Femme et l'enfant* (Woman and Child, 1922;
pl./p. 181), or *La Lecture* (Reading, 1924; fig.
6) derives, surely, from the artist's dialogue
with the great classical tradition in French
painting. Léger, however, reworks the tradi-
tion, in that each fragment, each object – be it
eyebrow or knee-cap, cup or vase – is charged
with a pictorial weight deriving from the cine-
matic techniques of close-up and montage, a
kind of monumental presence that relates, also,
to his concern with the architecturally scaled
mural. Here, Léger's comments on Gance's *La
Roue* may provide, once again, an important
clue to understanding these paintings:

> You will see his eye, his hand, his finger, his
> fingernail. [...] You will see all those frag-
> ments magnified a hundred times, making
> up an absolute whole, tragic, comic, plastic,
> more moving, more captivating than the
> character in the theatre next door. The loco-
> motive will appear with all its parts: its
> wheels, its rods, its signal plates, its geomet-
> ric pleasure, vertical and horizontal, and the
> formidable faces of the men who live on
> it....[46]

Contrast, dissonance, fragmentation were
fundamental to Léger's aesthetic, the means of
his challenge to standard categories and
genres; yet, at the same time, they were the ba-
sis of his very personal dialogue with, and re-
newal of, tradition. Like his friend Cendrars,
whose *poèmes élastiques* 'opened onto the
boulevards', Léger was acutely susceptible to
the rhythm and texture of his urban/machine
environment and, most particularly, he was fas-

cinated by the vision of that reality projected in cinematic form. Film – simultaneous product, symbol and interpreter of modernity – constituted an ideal alternative to art-forms that seemed suddenly to be painfully inadequate means for communicating the perceived essence of modern life. Léger, unquestionably, was profoundly nurtured by, and himself contributed significantly to, the avant-garde discourse on collage, montage, close-up, simultaneity, contrast and anti-narrative. Léger's pictorial language, his generation's ideal of freedom from the scenario, tends to preclude or, at the very least, render ironic the well-rehearsed art-historical narrative concerning the heroic avant-garde of modernism.

43 Léger, 'L'Esthétique de la machine: L'ordre géométrique et le vrai', in *Fonctions de la peinture*, p. 67; English trans., p. 65.

44 Léger's transformation of the object does seem to have a good deal in common with the anti-aesthetic programme of the Surrealists. One might cite, for instance, the big toes photographed by Jacques-André Boiffard and published in the journal *Documents*. Léger's sides of beef might justify comparison with the hoofs and legs of slaughtered animals in the photographs by Eli Lotar that accompanied other articles in *Documents*. In a related way, I have explored the importance of Bataille's vocabulary of the erotic fragment for Picasso's still-lifes of the 1920s and 1930s in 'Körperdinge – Picasso und Bataille', in *Picassos Surrealismus*, exhibition catalogue, Kunsthalle Bielefeld, 1991, pp. 237-46.

45 For the role of film in Léger's still-lifes of the 1920s and 1930s, see Freeman's essay in *Fernand Léger: The Later Years*; Andreas Franzke, 'Fernand Légers Stilleben von 1925 in ihrem Verhältnis zur zeitgenössischen Architektur und zum avant-gardistischen Film', *Jahrbuch der Staatlichen Kunstsammlungen in Baden-Württemberg*, XV, 1980, pp. 155-71; Joachim Heusinger von Waldegg, 'Fernand Légers Stilleben', *Kunst und Antiquitäten*, III, 1991, pp. 40-45.

46 Léger, 'Essai critique sur la valeur plastique du film d'Abel Gance *La Roue*', p. 162; English trans., p. 22.

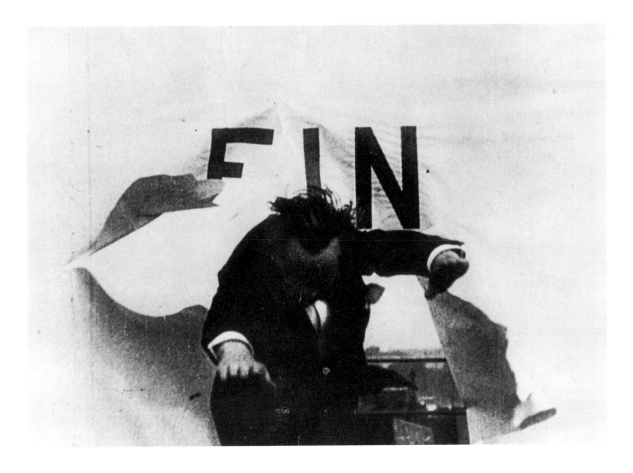

Fig. 7. Still from René Clair's film *Entr'acte*, 1924. Reproduced by kind permission of the British Film Institute, London

Gottfried Boehm

THE ARTIST AS 'HOMO FABER'

Observations on Léger's 'Modernity'

I

It is not impossible that the ageing of Modernism, of which we nowadays hear so much, will also place Fernand Léger in another light. Léger devoted himself to 'contemporaneity' like hardly any other artist of his generation (he was born in 1881), and he drew on the experience of modernity for both the subject-matter and the methods of his work. Before the Great War he had already defined the connection between his painting and the fast-changing world in which he lived in terms of a passage from *visual* to *conceptual realism*.[1] He justified this switch by invoking those transformations in the history of civilization that bring with them a shift in perception. Above all, he pointed to recent changes in the sense of time, and to the direct experience of a high degree of acceleration (for example, in the improved means of transportation): these, he argued, were apt to bring about radical shifts in the *entire* relation between things. The effects of 'modernization' were profound; they altered far more than simply the individual's awareness of life. In particular, they encouraged a new understanding of nature. Numerous statements from the early years of Léger's career reveal his thinking on this matter; but his pictures from this period prove, of course, to be at least as eloquent as his words. Even when these pictures are landscapes, the impression of the natural is dominated by that of the artificial (pls./pp. 81, 86, 97). Nature here has lost its distinctiveness, and this is not to be found again in the artist's subsequent works. For Léger, nature was merely the raw material for

use in the actions that constituted civilization. The logic of these actions had an unambiguous priority: it conferred a new appearance on reality, the essential characteristic of which Léger repeatedly termed 'contrast'.

The catchword *contrast* denoted not only the reconstruction of the real world (through the intervention of technology), it also named the chief category of Léger's painting that was to respond to this process. Léger announced 'the advent of plastic contrast',[2] which would demand a new sensibility, going beyond the visual. Essentially 'conceptual' in motivation, it would be an energy attuned to constructing and building, an intellectual impulse, in short all that can be embraced in the old term *poiesis*, the capacity for creation. Léger spoke of a conceptual realism, in order thereby to emphasize objectivity. It was not a matter of intuitive creation – Léger's pictures themselves always appear matter-of-fact and non-rhetorical – but rather of grasping the new optical manifestation in their 'creative spirit'.[3] In his early comments on his own work, Léger wrote of what can be seen as a process of production that took its orientation from the character and outward appearance of modern technology and the world of work. The pictorial logic established equivalents with its intrinsic means (forms, colours and lines); it strove to achieve a maximum amount of expression, a 'maximum effect in the result'.[4]

Léger's contemporaneity relates to the circumstances of the modern environment (in particular its technological aspects), to the latent pictorial forms of neon signs or shop windows, and, above all, to the poster (which had a strong influence on his painting),[5] and to specific working procedures (those of building, construction and so on).

But what ages more swiftly and less becomingly than the spirit of an age? Is Léger, then, an artist now in the process of 'vanishing', a worn-out example of Early Modernism whose belief in modernity and whose optimism regarding progress nobody any longer shares? Is this not especially so in an age that has had to learn that machines cause pollution, and that to regard nature as merely raw material for human work is fatally to underestimate it? Is Léger – entangled in his own historical pre-

1 F. Léger, 'Les origines de la peinture et sa valeur répresentative' (1913), in Léger, *Fonctions de la Peinture*, Paris, 1965, p. 13; translated as *The Functions of Painting*, London, 1973, p. 7.

2 Léger, 'Les réalisations picturales actuelles' (1914), in *Fonctions de la peinture*, p. 21; English translation, p. 12. In Léger's essay 'Peinture moderne' (1950), in *Fonctions…* (p. 36; English translation, pp. 167-8), a comparably global characteristic is to be found, 'because life is made up of contrasts'.

3 Léger, 'Les réalisations picturales actuelles', p. 23; cited from the English translation, p. 14.

4 Ibid., p. 24; cited from the translation, p. 15.

5 The question of the influence of poster design on the form of Léger's pictures merits separate study. The frontality and directness of his compositional ideas may be derived from this source, as also, in particular, the eschewing of all that is latent, indirect, allusive – in short, of all sublimation.

6 Léger, 'Les Spartakiades' (1955), in *Fonctions de la peinture*, pp. 194, 193; cited from the English translation pp. 189, 190.

7 See Léger, 'New York' (1931), in *Fonctions de la peinture*, pp. 186-93; English translation, pp. 84-90. The text reflects especially informatively Léger's artistic point of view (in the middle of the inter-war period) with regard to both his aesthetic and his political options. He sees the 'cancellation' of nature through human *poiesis* as a process perfected in this city: 'New York has a natural beauty, like the elements of nature; like trees, mountains, flowers. This is its strength and its variety' (p. 188; translation, p. 85). A little later he intends to remedy the 'lack of vegetation' by artificially introducing the colour green. He thinks of a tremendous choreography of clothes: 'Clothing manufacturers would be compelled to put out a group of green dresses and green suits [...] Every month, a dictator of colour would decree the monthly or quarterly colours – the blue quarter, the pink fortnight!' (p. 189; translation, p. 87). In a fantasy he imagines New York under fire from the canons of Marshall Pétain: 'What a magnificent job for an artillery barrage! [...] The Americans would be the first to applaud, and then what would you see? A little while later a new town would be built.[...] In glass, in glass!' (p. 190; translation, p. 88). Then, towards the end: 'New York ... Moscow! The two poles of modern activity...' (p. 193; translation, p. 90).

mises – now so distanced from us that he is able to elicit only our cool respect? The answer to such questions, which one viewer or another is bound to pose, demands a precise analysis of Léger's pictures. Léger himself wanted to counterbalance the contemporary value of his works with an 'eternal value' that would prove his validity independent of the spirit of his age.

How can this claim to validity be elucidated? Tracing historical influences or examining in detail the transformation of Léger's iconography will probably prove to be less effective than attempting to understand his pictorial language in its own right. This, therefore, is the method we shall use.

It is no coincidence that, especially during Léger's earlier career, he stressed the importance of pure pictorial means (form, colour, line). By what manner of syntax were these three elements connected? Their constructive, abstract purity guaranteed, in any case, that Léger's pictures in a way renewed the world they presented, an analogy to the renewal of the world itself through the process of modernization triggered by the technological revolution. Léger's approach, and its manifest results, were characterized by an evident optimism regarding those whose creative activity was bound to modern means. The protagonist in this activity may be called *homo faber* (man the maker), embodied in the modern 'craftsman/worker/designer' who feels at home when dealing with instruments and machines, who operates 'naturally' in this artificial world. He appears as a subject in Léger's pictures; but, beyound these depictions he also typifies Léger's understanding of the artist and of art.

The worlds inhabited by *homo faber*, and which so fascinated Léger, were anonymous. This is already the case with the *Nus dans la forêt* (Nudes in a Forest) of 1909-10 (fig. 3, p. 63), and later with the circus acrobats (fig. 1), the soldiers as engineers of war, the images of metropolitan agglomerations, building sites, factories and industrial plants; and it is equally true of the landscapes, interiors and groups of figures re-constructed in terms of 'sphere, cone and cylinder'. For Léger, the spirit of construction enabled him to make equal use of both abstract and realistic elements or, more to the point, to create complex syntheses be-

tween the two, embracing the possibility of creating figures or things out of pure forms, colours or lines. In his later career Léger was also preoccupied with the environment from which his protagonists came: the world of 'simple people' who were absorbed into the anonymity of modern life, in that they both processed it and inhabited it. In this connection one might mention *Les Loisirs: Hommage à Louis David* (Leisure: Homage to Louis David) of 1948-9, *Les Constructeurs* (Construction Workers) of 1950, *La Partie de campagne* (The Outing) of 1953 or *Les Campeurs* (The Campers) of the following year.

This confidence in the modern world of instruments and in its perfectly adjusted inhabitants – a people sure of their own abilities and confident that they are on the right path to bringing forth a happier civilization – probably also explains Léger's political commitment to the Left. It is not possible to do justice to this aspect of Léger's career in only a few lines. Like many artists and intellectuals of his time, he saw in an egalitarian political doctrine the guarantee of justice and social progress, of a rationalistic sobriety, that would allow people (regardless of outdated ideologies) to engage in life wholeheartedly. This vitalism is revealed in many of Léger's works. Even in the last year of his life (1955), when he attended a Communist propaganda gymnastics display at the Sokol Festival, the Spartakides in Prague, he saw it as, above all, an aesthetic event: 'miles of things, feet, raised arms, blond faces – [...] smiling in the sun.' Here too he found 'strong contrast,[...] the new values of a modern world'.[6] The history of political blindness, in which Léger certainly has a part, is yet to be written. None the less, one may give him credit for the fact that his artistic sensibility did not cease to function. He never allowed himself to be exploited as an artist in the service of a political programme. He was sufficiently open and capable of enthusiasm to be fascinated by New York, the capital of Capitalism, which he saw as the quintessence of the city engaged in giving birth to itself.[7] Léger's modernity (including its politics) is embodied in the *homo faber*: the man who, as anonymous worker, machine operator, con-

struction worker, engineer, but also as artiste or artist, constructed the world out of his own energy and according to his own logic. In Léger's understanding (and his pictures themselves lose no time in conveying this to us), only the made, and not the grown, only the built and not the begotten, possessed 'reality'. Even his female nudes do not exhibit natural beauty, aura or seductiveness; they manifest, rather, the spirit of constructive thinking within a picture. In Léger's work, people in general appear like artefacts: not having been born, they are immortal. Modernity, as understood by Léger, was associated with the continuing process of the self-liberation of humanity. Its medium was *work*.

Léger never renounced his faith in such a utopia, however slow its materialization might prove to be. His pictures testify to an ageless world; they are without tragedy and without a past. It is clear how little he engaged with the dark side of modernity or with the history of this century. He had been given sufficient opportunity to contemplate it, for example during his time as a soldier. It was precisely the artificial character of his conception of art that allowed him to disregard destruction and misery.

In this context it also becomes clear that the idea of *homo faber*, as appropriated by Léger, culminated in the image of the *artist*; and here he was also prepared to moderate his ideal of anonymity and of the collective. Creative people (in particular artists) were always only few in number – as Léger himself said.[8] In them was concentrated the capacity for production, for the anti-natural, the poetic principal of modern civilization. Painting constructed a reality out of pure elements: however much it was tied to the spirit of technological modernity, it held itself aloof from the contradictions and defeats inherent in that modernity. It generated a state of indestructible duration, of 'maximum effect'. In Léger's pictures, the spectator encounters, above all, a strong, barely modulated energy, a sense of optimism; and although frequently conveyed with poster-like clarity, these qualities remain inscrutable. At heart, this energy is an aesthetic force, one that cannot be contradicted. It does not persuade through assertions

about the world, about what is right or wrong, but, rather, through the visual plausibility that it is able to generate. The unconditional, and sometimes naïve, confidence of the artist in *homo faber* therefore retains its integrity in the end, because from Léger's perspective, *homo faber*, at his most consummate, is *homo artifex* (man as creator).

II

Not only did Léger reflect on his pictorial means: his works themselves (whatever their subjects) make the quality of those means evident. The purity of colour, form and line is the premise of his work from 1910 onwards; but he also drew on a clear idea of the syntactic connection of elements within a picture. He defined this on various occasions, for example in 1914:

> Composition takes precedence over all else; to obtain their maximum expressiveness, lines, forms, and colours must be employed with the utmost possible logic. It is the logical spirit that will achieve the greatest result, and by the logical spirit in art, I mean the power to order one's sensibility and to concentrate one's means in order to yield the maximum effect in the result.[9]

With this, Léger offered an indication as to how work with pictorial means is translated into work *on the picture*. We will attempt to interpret more precisely, in relation to specific examples, what is intimated in the artist's own sparing words, selecting, for this purpose, works from the period before the Great War, in particular the group *'contrastes de formes'* (Contrasts of Forms), produced in 1913 and 1914. What constituted a 'picture' for Léger at this time? What type of perception did it set in motion?

The usual answer to these questions is informed by the art-historical tendency to characterize Léger as a Cubist with a Futuristic accent. But the essential question is this: Is the Cubist conception of the picture, as developed by Braque and Picasso from 1907 onwards, also the basis for Léger's conception? Léger saw himself among the inventors of Cubism – an opinion with which scholars fre-

Fig. 1 *Le Clown* (The Clown), 1918, oil on canvas, 33×24 cm. Private collection (B 112)

8 Léger, 'Couleur dans le monde' (1938), in *Fonctions de la peinture*, p. 96; English translation, p. 129: 'Some of them [life's apparent 'failures'] have succeeded in crossing the barrier; these are today's creators and achievers; through energy and talent, they have asserted themselves, but mark it well that these men are from the same family as those just mentioned.'

9 Léger, 'Les réalisations picturales actuelles', p. 24; cited from the English translation, pp. 14-15.

Fig. 2 Georges Braque, *Broc et violon* (Pitcher and Violin), 1909-10, oil on canvas, 117×73.5 cm. Öffentliche Kunstsammlung, Basle, Kunstmuseum

10 F. Gilot and C. Lake, *Life with Picasso*, New York, 1964, p. 275. I am grateful to Dieter Koepplin for the reference to Gilot's account of Picasso's comment on Léger. For a discussion of Léger's Cubism see, for example, the pertinent chapters by Christopher Green, 1976, and Gilles Néret, 1990 (see Bibliography).

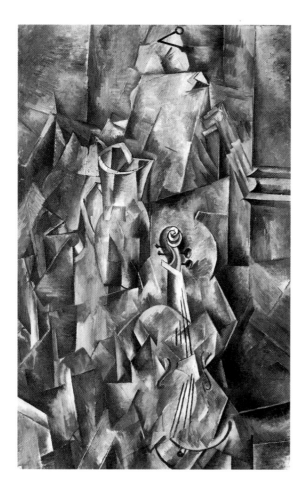

quently agree, but that Picasso (at least according to the account of Françoise Gilot) clearly contradicted: 'They [Picasso, Braque and Juan Gris] were the Three Musketeers of Cubism, and Léger, as far as they were concerned, was just Léger.'[10] One may well ask how far this estimate was coloured by personal idiosyncracies. None the less, this wish to discuss 'Léger as Léger' – to regard the deviations from the work of Braque and Picasso as more important than the stylistic similarities – should have been a fruitful suggestion for art historians to pursue.

Already Léger's early, programmatic picture *Nus dans la forêt*, produced over two years (1909-10), shows Léger to have been his own man. Here he eschewed one principal characteristic of Cubist painting, what has been called '*passage*', that is to say those hovering and sliding areas of transition that establish themselves between stereometric illusory bodies (in early Cubism), or geometric facettes (in analytical Cubism), and the indeterminate, flat 'background' of the picture. Whatever has form, tangibility, space and, above all, cer-

tainty, is rooted in these open passages. The viewer completes a process of 'realizing' the potential inherent in the picture; but does not arrive at an unambiguous or definitive goal. The picture reveals itself and materializes in a calm, temporal flow, within which it disintegrates again. Pictures such as Braque's *Pitcher and Violin* (1909-10; fig. 2) draw on inexhaustible latencies: modulations of the grey-brown colouring, changes in luminosity, continuities – however often these are interrupted or disturbed. Léger's work is quite different. If we attend, for the moment, to the temporal aspects, then already with *Nus dans la forêt* we cannot speak of a flow or a process, nor of a condition of latency. An insistent profusion dominates here, a visual competition of variously shaped, stereometric, illusory bodies that disallow '*passage*'. In their place occurs what Léger called contrast, or the law of contrasts. This is defined by abrupt, *immediate opposition*. One body emerges dramatically next to another in front of an 'invisible' background. Figures take shape by way of hints that must be deciphered by the viewer. The figures coalesce out from individual stereometric volumes, but without granting clarity or weight to the underlying structure and the surfaces of the composition.

La Noce (The Wedding; pl./p. 79) of 1910-11 and *La Femme en bleu* (Woman in Blue; pl./p. 87) of 1912 eschew a relief-like, illusionistic picture construction. Instead Léger devised a compositional format that granted presence and importance to the picture plane. In these works, strong emphasis on white, black and the various brightly coloured surface areas seems either partially to conceal, or to contrast with, the disorder of small volumes and fragments. If, in the case of the *Nus dans la forêt*, we appeared to be looking into a shallow picture-box, without having a sense of the picture plane, so we now appear to be looking at a frontally oriented, compact structure, the logic of which – albeit in another sense – is also based on contrast. The pictorial elements are now visible in their own right: surface areas, colours, forms, lines and so on do not merely serve to give visual substance to the body. *La Noce*, furthermore, has painterly passages, effects of transparency, traces of brushwork, and modulation that are also apparent

in other pictures by Léger from this year, for example, in *Le Passage à niveau* (Railway-crossing; pl./p. 86). These aspects serve to soften and moderate the severity and dryness of the contrasts. Yet there can be no doubt that Léger was concerned with putting into effect the 'law of contrasts', and allowing its pictorial consequences to unfold. In these works he was able to achieve this, in that elements – recognizable in themselves, clearly defined and not capable of substitution, one for another – none the less augment the effect of contrast. A form cannot be reduced either to colour or to line, though these may tend to be reciprocally linked. As a purely pictorial means, it represents indissoluble and irreconcilable contrast. As to their temporal quality, the contrasts in these pictures are vehement, sudden and direct, they are far removed from the 'hovering' areas of *'passages'* to be found in Cubist paintings. They unite, of course, in their own way: through form and the repetition of colour they develop a rhythm that, in turn, endows the contrasts with a certain harmonious tone.

The group of pictures *'contrastes de formes'*, painted in 1913-14, marks the high point of Léger's pre-War career, because in them Léger achieved a new compositional economy. In one *'contrastes de formes'* of 1914 (pl./p. 96), planar and spatially illusionistic elements are no longer situated on variously related interacting pictorial planes, among other things, a distinguishing characteristic of *La Femme en bleu*); rather, they are bound together. Planes, three-dimensional forms, colours and lines interpenetrate. They create optical inversions, and are to be read simultaneously as removed and near, convex and flat, part of a figure and related to the background. Cézanne's insight into the possible role of the interchange of figure and background in post-perspectival painting is realized by Léger in an astonishing manner.[11] A form that appears cubic as long as one attends to the lines forming its boundary takes on a flat appearance if one observes its colour or form, and so on. The same bit of painting (for example the compressed 'cylinder' at the centre of the picture) appears differently *at one and the same time*. According to Léger's own pictorial logic, *'contrastes de formes'* may be termed a

visual paradox, it is the *simultaneity*, and equal validity, of the irreconcilable. The individual contrasts are compressed into a picture where paradox is the pivotal point or fulcrum.[12]

Léger himself described this type of composition as an instance of 'multiplicative contrasts' (contrasts tending to multiply), a term he used to convey the simultaneous multiple meaning of individual forms, colours and lines. None the less, however much the changes in Léger's work had to do with picture construction, that is to say with the formal aspect of painting, it would be inappropriate to understand their relative importance only in pictorial terms. For the *'contrastes de formes'* are not simply painterly studies: they are also an attempt to give expression to an urgent experience of modernity. For Léger, the physiognomy of the new, technological world was stamped with dynamism and heterogeneity; and it was precisely this to which the term *multiplicative contrasts* referred. Such contrasts increased the diversity and the dynamism of the picture's impact and intensified its *reality content* too, thus approaching the pace, and the appearance, of modern life itself. It was, precisely at that point, then, when tones, lines and forms became integrated unharmonically – opposed as contrasts, that the optical wealth of a painting increased. Indeed, there can be no doubt that Léger's 'law of pictorial contrasts'[13] (at least in those years) aimed at a *shrill dissonance*. This ensured that 'maximum expressive effect'[14] that Léger repeatedly demanded. Dissonance, as in the realm of music during these years (for example in the work of Stravinsky or of Schönberg), represented a means of experiencing the picture as 'one sound'. In dissonance was found, above all, a suitable expression, in which Léger saw the real fulfilment of modern life: in this highly increased intensity merged heterogeneous impressions of racing automobiles, flashing neon signs, people rushing to and fro, gleaming shop windows, an infernal noise – all brought together into a single, strong impression.

Léger's *'contrastes de formes'* demonstrate that pictorial elements can be arranged so that they are able to act as pure energy. Forces and counter-forces, bound by the law of contrasts, make the picture comparable to a *perpetuum*

11 Cf. G. Boehm, *Montagne Sainte-Victoire* Frankfurt am Main, 1988, on the question of inversion in Cézanne's work. It is not possible here to pursue the question of Léger's interpretation of Cézanne, although it is to be clearly distinguished from that of Braque or Picasso. The conceptual schemes of all three artists make use, in a variety of ways, of Cézanne's formula regarding 'cylinders spheres and cones', found in his famous letter of 15 April 1904 to Emile Bernard.

12 The role of paradox within the pictorial history of Modernism has so far hardly been discussed in this context. The problem is posed not only with regard to Léger, of course; yet it would be worth distinguishing the various modes and functions of paradox. The volume by P. Hughes and G. Brecht, *Vicious Circles and Infinity: An Anthology of Paradox*, New York and London, 1975, is only useful as a first approach to this topic.

13 Léger, 'Note sur l'élément mécanique' (1923), in *Fonctions de la peinture*, p. 51; cited from the English translation, p. 29. Léger is here also particularly forceful on the connection of this 'law' with the maxim of 'intensity'.

14 Léger, 'Les réalisations picturales actuelles', p. 25; cited from the English translation, p. 16.

Fig. 3 Giacomo Balla, *Velocità d'auto-mobile* (Speed of a Motor-car), 1912, oil on panel, 55.6×68.9 cm. Museum of Modern Art, New York

15 Léger, 'Couleur dans le monde' (1938), p. 85; cited from the English translation, p. 119.

mobile with sufficient autonomous energy to maintain itself in motion, consuming less than it generates. This metaphor of an 'impossible machine' also helps us to see Léger's picture itself as an 'artistic machine' (made from cylinders, tubes, wheels, discs and so on) producing the sort of maximum effect that does not fade. In this respect, Léger's conception of the picture is utterly modern, for he transforms the reality of the external world, everything that is static, and quantitative, into forces and counter-forces, into a state of energy. For this reason, 'intensity', like 'contrast', became one of the artist's leitmotifs.

Léger's conception of painting becomes even clearer through his use of colour. Colour, for him, was 'a vital necessity' and 'a raw material indispensable to life'[15] – something that every painter would want to claim for his own work. Léger's use of colour in the *'contrastes de formes'* is, however, peculiar to him. It does not fit into a 'ready-made bed' of lines and forms, it constantly shies away: from a line that delimits it, from another colour, from itself. Léger interrupts the consistency of one tone (which might otherwise convey, for example, the enclosed form of a volume), be it through separating lines or through white intervening passages. These give a staccato rhythm to the colour passage (be it a powerful green, red or blue), in order to generate a sense of intensified value.

The viewer of these pictures bears witness to a remarkable ambiguity. On the one hand they appear heterogeneous, and disintegrate

into contrasting elements; on the other hand these scattered impressions combine in an increasing intensity, in a 'maximum effect'. The *contrastes de formes* produce this sudden switch from the quantitative to the qualitative. A temporal definition is inherent in them.

Where the contrasts occur, they generate an immediate exchange of attention. Red shifts directly into white, line into form and so on, and all of these together alternate between the picture plane and the picture's illusory space. Is one here concerned with a type of acceleration as cultivated by the Italian Futurists? Did Léger adopt their emphatic dynamism? The impact of the first Futurist exhibition in Paris in 1912, has frequently been demonstrated. A glance at the pictures of Boccioni or Balla (fig. 3) reveals the fascination of swift movements, and elucidates the newly found pictorial strategies for depicting these with the means available to painting. Graduated sequences of form arranged in arrow shapes, dynamic swooping lines, and the swift rendering of figural outlines, among other devices, create the illusion of movement. Futurist painting aims at the successful suggestion, at the exuberance of an experience of acceleration, its actual essence, being realized in the picture.

Léger's interest in dynamism and pictorial rhythm was different. He set out to achieve what could be termed an analysis rather than an illusion of movement. The sober clarity of the singular pictorial elements ensures that they never build up to suggestion. Rather, a sudden transformation of quantum into impact occurs, as has been mentioned. This transformation can spread evenly over the surface of a picture, but also align itself with particular motifs and figures (fig. 4). In every effect that is achieved, in every rhythm that is developed, in every intensity that builds up, the viewer always sees from which source these phenomena arise. He sees the suggestion of acceleration (by which the Futurists were fascinated) in a *slowed* form. Léger 'dismantled' dynamism, he removed it from illusion, while not halting the sense of motion. This circular combination, this self-repeating transformation has, as we have seen, a paradoxical structure. In this too, Léger's concept differs from those of his Italian comrades.

The outcome of these observations casts light on Léger's modernity, and offers, perhaps, an answer to the question posed at the beginning of this essay: If, and to what extent, Léger's pictorial concept has aged, along with the Modernism to which it relates. We now see more clearly that the painter reacted in essentially conflicting ways, and with reserve, to the impressions of modern life. The demands for an 'eternal value' which should accompany the 'contemporaneity' of his paintings already makes this ambivalence clear. Is *homo faber* at all able to find a way to resist the modern, to find peace? If he regards himself as an artist, he is indeed capable of doing so.

> Let us take our time. In this fast-moving and complex life that shoves us around, slices us up, we must have the strength to remain unhurried and calm, to work beyond the disintegrating elements that surround us, to conceive of life in its unhurried and peaceful sense. The work of art needs a temperate climate in order to be realized fully.[...] A dangerous and magnificent life for those who can swim through this beautiful chaos as if it were the sea – 'not letting it swallow them up'.[16]

Léger also used the term 'swimming' to characterize his own pictorial strategy. Like the swimmer, the artist plunged deep into the medium of the modern world, into its heterogeneities and accelerations; and he let himself be carried along and bathed by these. He was saved from drowning by his capacity for *poiesis*, his ability to arrange pictorial components, his sense of balance. It is this logic precisely that Léger follows in his paradoxical pictorial strategy: the organization of contrasts in such a way that diversity and intensity, dynamism and rest, and so on, are linked together. This paradox, of course, lacks a sense of development; it is devoid of indeterminacies, transitional areas and latencies. It is this that Picasso appears to have had in mind when he said: 'Léger puts down his colours in the required amounts and they all have the same degree of radiation. Perhaps there's nothing wrong with that, but you can stand in front of one of his paintings for an hour and nothing happens beyond the shock you register during the first two minutes.'[17]

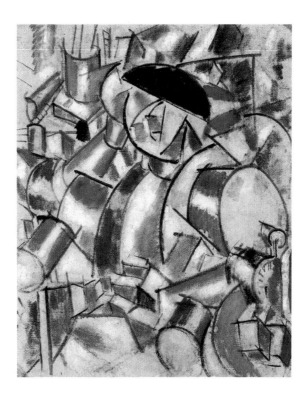

Fig. 4 *Le Réveille-Matin* (The Alarm Clock), 1914, oil on canvas, 100×81 cm. Musée National d'Art Moderne, Paris (B 88)

16 Ibid., p. 95; cited from the translation pp. 128-9.

17 F. Gilot and C. Lake, *Life with Picasso*, p. 276.

18 Baudelaire, 'Le peintre de la vie moderne', in *Œuvres complètes*, II, Paris, 1976, p. 695; cited from the English translation in P. G. Konody, *The Painter of Victorian Life: A Life of Constantin Guys*, London, 1930, p. 67. Léger's maxim that, in his own painting, the 'value of the present' was correlated with an 'eternal value' (independent of time) assumes further significance in the light of Baudelaire's statement.

Picasso's criticism, concealed within this otherwise just characterization of the experience of looking at Léger's pictures, hardly does justice, of course, to the special quality of Léger's art. Neither Picasso nor his two Cubist Musketeers, nor even Matisse (of whom Picasso said much in this context) ever engaged in so rigid a contemporaneity as did Léger. Picasso was at home in many worlds, Léger in one, the *modern* one. He took up the challenge to present this world in artistic form, and found a way to make it effective. In Léger's work, the hectic pace of modern life comes to the fore, albeit translated through analysis and the sense of duration. This moment of duration was to become ever more important in Léger's subsequent development, above all during his 'Classicist' phase in the 1920s; ultimately it was to dominate his work. With the *'contrastes de formes'* Léger managed a precarious walk on the edge. One paradox – that of his concept of the picture – revealed and resolved another. In 1863 the poet and critic Charles Baudelaire had already seen in just such a paradox the most important characteristic of modernity: 'Modernity is the transitory, fugitive, contingent half of art, the other half being the eternal and immutable'.[18]

Katharina Schmidt

'LA FEMME EN BLEU'

'For, through the mingling of black and white, the two most contrary colours, blue comes into being.'[1]

Within loosely jostling broad forms, interspersed with detailed passages, she seems hidden, as if in a picture puzzle: *La Femme en bleu* (pl./p. 87).[2] Only when looking more carefully does it become clear that the woman in blue dominates the middle area of Léger's composition. Her hands, schematically fashioned, and clasped in her lap almost in the centre of the picture, offer the clearest starting-point if one attempts to perceive the figure as a whole. She seems to be depicted frontally and at full length. The pure, flat, blue of the upper body is bordered with sequences of modelled, grey-blue cylindrical forms that can be understood as arms; these, in turn, are surrounded by blue and white segments of circles suggesting wide sleeves. The three ultramarine passages in the upper half of the picture, together with the adjacent white forms, create an ellipse, its vertical axis shifted by seventeen degrees towards the right. In the lower half of the picture, a large blue, sharply defined rectangle slopes towards the left, as though breaking away from the ellipse: it may be understood as the skirt of the seated figure as it hangs down from her bent knees. Shifted to the bottom of the picture, and positioned at an angle of about ten degrees contrary to that of the ellipse, it sets off, like a radiant surface, the detailed, fractured, grey-brown hands directly above. It is overlapped by a vertically aligned white oval, which can be taken as the loose fabric of a piece of needlework. At the lower right, cropped by the picture's edge, an irregu-

lar blue rectangle juts forth like the turned-up hem of the skirt. The woman's head is small, and unobtrusively positioned between a white semicircle to the right and a sliced black one to the left. The neck, a cone, emerges from broad, blue shoulders; it rises to the head, which appears, however, as an altogether separate entity, cut sharply from an ovoid. The deep-pink coloured face, a trapezoid, seems unusually narrow. Together with the white-grey shaded forehead it emphasizes the impression of being slightly bowed towards the right, ringed by a broad black-and-white striped band of hair. To the right of the face one is surprised to find a raised profile – nose, lips and chin – rendered in an almost naturalistic manner. Two views of one person? Two figures in one? 'You can ask Léger', wrote Guillaume Apollinaire in 1914, 'what pleasure it had given him to record a face simultaneously from the front and from the side.'[3]

The sitter's identity is established, in essence, by means of the blue of her dress. Seen as a whole, she seems to turn in different directions: whereas the head and upper body are rendered in three-quarter view, as if seen from the right, the chest, a pentagon painted in blue, is shown frontally. Though this may hardly be interpreted as a representation of movement, it does bestow an immense monumentality on the figure.[4]

The woman dominates the centre of the composition, yet to either side strong forces act upon her. Whilst slightly rounded black and white shapes enter from the left, two rectangles appear on the right, one white, one black; their aggressively diagonal positioning suggests that they are rushing towards her, their movement emphasized, furthermore, by the presence of several swelling curved forms above, thus creating the feeling of great oppression. Little in her immediate setting can be identified as 'real' objects. The legs of her chair must have been turned on a lathe; the one on the left, rendered in brownish local colour, continues up into the chair's arm-rest. Constructed from distinct, repeated units, it prefigures the earliest surviving version (made in 1918) of Constantin Brancusi's sculpture *Colonne sans fin* (Endless Column).[5] A red-topped side-table, or stool, cuts across in front

1 J.W. von Goethe, 'Nachträge zur Farbenlehre, 28. Wahres, mystisch vorgetragen, Naturae naturantis et naturatae, Mysterium in Scuto Davidico etc.' Berlenburg, 1724, cited from *Goethe's Sämtliche Werke*, XXXV, Stuttgart, n.d., p. 321.

2 The painting, a work of 1912, came into the possession of the Galerie Kahnweiler before 1914. On 13 June 1921 it was sold, as number 62 in the *Vente Kahnweiler* (sale of Kahnweiler's stock), to M. Borel, the brother-in-law of the Parisian gallery owner Léonce Rosenberg. One of the principal buyers at this sale, the Paris-based Basle banker Raoul La Roche, later acquired *La Femme en bleu* at Rosenberg's gallery. In several donations, starting in 1952, La Roche transferred a substantial part of his outstanding collection of Cubist works to the Öffentliche Kunstsammlung in Basle: *La Femme en bleu* came to the Kunstmuseum at the end of 1952 with the first set of works to be transferred (La Roche himself returned to live in Basle in 1962). See: minutes of the meeting of the Kunstkommission of 5 December 1952. I am grateful to Andreas Speiser in Lugano for supplying information on this matter. A comprehensive monograph on *La Femme en bleu* is in preparation.

3 Guillaume Apollinaire, 'Simultanisme – Librettisme', in *Les Soirées de Paris*, 25 (15 June 1914), p. 324, reprinted in *Guillaume Apollinaire: Œuvres en prose complètes*, II, Paris, 1991, p. 977.

4 Cf. the treatment of the figure in Cézanne's *Mme Cézanne en rouge* (fig. 5) of 1888/1890 (oil on canvas, 116.5×89.5 cm), Metropolitan Museum of Art, New York.

5 Brancusi's *La Colonne sans fin* (first version, 1918, wood), Museum of Modern Art, New York. Cf. also the elaborately worked legs of Giacometti's *Table surréaliste* (1933,

bronze), Musée National d'Art Mo-
derne, Centre Georges Pompidou,
Paris.

6 Cézanne's *La Femme à la cafetière,*
 c. 1890/94 (oil on canvas,
 130×97 cm), Musée d'Orsay, Paris;
 see L. Venturi, *Cézanne: son art,*
 son œuvre, Paris, 1936, I, cat. 574;
 II, plate 184.

7 As shown by the X-ray photographs
 taken in 1994, Léger made few
 changes to the definitive version of
 the painting; the passages of over-
 painting have a simplifying and clar-
 ifying effect.

8 Boccioni's *La strada entra nella*
 casa (The Street Invades the
 House), 1911 (oil on canvas,
 100×100 cm), Sprengelmuseum,
 Hanover. It was included in the Fu-
 turist exhibition held at the Galerie
 Bernheim Jeune, Paris, in February
 1912, and was thus known to
 Léger.

9 Christopher Green, in his *Léger*
 and the Avant-garde, New Haven
 and London, 1976, p. 50, assumes
 that Léger started work on *La*
 Femme en bleu in April 1912.

10 André Warnod, 'Le Salon d'Au-
 tomne', in *Comœdia* (Paris), (30
 September 1912), pp. 1-2, with a
 black-and-white illustration on p. 2.

11 J. Claude, 'Le Salon d'Automne', in
 Le Petit Parisien (30 September
 1912), p. 2

Fig. 1 Paul Cézanne, *La Femme à la*
cafetière (Woman with Coffee-pot),
c. 1890-94, oil on canvas, 130x97 cm,
Musée d'Orsay, Paris

Fig. 2 *La Femme en bleu* (Woman in
Blue), 1912, illustration from *Comœdia,*
Paris, 1912

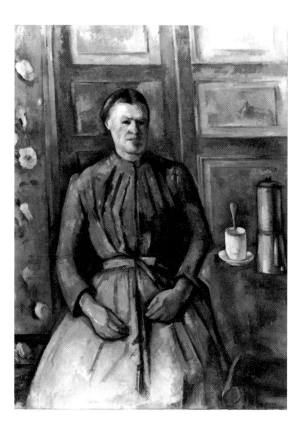

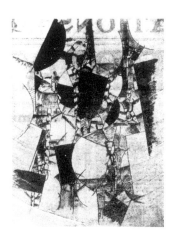

of the chair-leg; directly above is a small pair
of scissors drawn in black, a rarely noticed
clue to the woman's activity – she is sewing.
A shelf behind her right arm supports a cylin-
drical vase containing a turquoise-green
flower; on a table directly behind her left arm
is a decorated glass from which a spoon
emerges – a detail that inevitably reminds one
of the coffee-cup in Cézanne's *Femme à la ca-*
fetière (Woman with Coffee-pot, 1890/94;
fig. 1).[6] Slightly beneath the table, towards the
lower-right corner of the picture, a strip of
ornamentation – a series of dots with a wavy
line – runs down the side of a squarish object
suggesting the carved or painted surface of a
piece of furniture. The large black and white
passages, in precise balance with the blue
areas of the figure, form a plane parallel and,
indeed, almost identical with the picture's sur-
face. The intervening spaces, however, are
densely filled with detailed structure. The
sharp contours of the painting's large forms
continue as pure lines, creating overlaps and
establishing connections; innumerable divi-
sions evolve readily into perspectival foreshort-
enings, intermittently creating the impression
of spaciousness, indeed of depth extending to a

far-off realm, even though we derive no consis-
tent illusion of three-dimensionality.

The atmospheric and loosely treated area
directly above the woman's head remains
vague; a pale white-grey blends with a blueish
passage, perhaps a vestige of 'left-over' sky.
Just as the shapes are cropped by the upper
edge of the painting, and lead out of the pic-
ture's space, the lower area is also left 'open',
and seems relatively 'soft'. One is inclined to
read the beige-grey modelled forms as parts of
the base, though they offer no support, and
serve merely as an 'unfathomable ground'. The
seated woman seems to hover, suspended in
mid-air.[7] The many sequences of similar planes
and forms running both towards the woman
and away from her, detailed and abruptly taper-
ing off, seen from every point of view and
aimed in every direction, suggest restless sur-
roundings – they are the marks of a 'splinter-
ing' world. This restlessness is an integral part
of the picture's reality, albeit in contrast to the
overall rotating movement. The question of
the relationship of inner to outer space is here
irrelevant. As in Umberto Boccioni's painting
of 1911, *La strada entra nella casa* (The Street
Invades the House),[8] the interior has opened
itself to the exterior, so that the latter is force-
fully present within the interior.

Léger painted *La Femme en bleu* in 1912,[9]
as his contribution to the Salon d'Automne.
The Cubist works in Salle XI of the exhibiton
did not elicit a very positive response from the
press: commentators reacted negatively or in a
guarded manner, while the individual artists
were mostly mentioned only in passing. In the
journal *Comœdia* André Warnod remarked
about 'the *Salle infernale*': 'By Léger there is a
Woman in Blue, which we reproduce here'.[10]
(fig. 2) According to J. Claude, writing in
the *Petit Parisien,* 'M. Léger has taken his
brushes out for a stroll across the canvas, after
having soaked them in blue, black, red and
brown. It's bewildering to look at. The cata-
logue says it's a *Woman in Blue....* Poor
woman!'[11] Olivier Hourcade pointed out Lé-
ger's particular vitality and his powerful use of
colour:

> Léger is perhaps more illegible [than Le
> Fauconnier]. But if you succeed in seeing
> his woman sewing some item of undercloth-

ing in front of a table where various objects (a glass etc.) are placed, [and] if you accept the same theory of the folding back of plane surfaces as you find in the work of Gleizes, you will receive in front of Léger's canvas – even if at first glance it appears to you demented – an impression of powerful health. Léger's colouring is robust to a rare degree.[12]

Roger Allard, who, in his benevolent account of the Salon, cast a positive vote in favour of the Cubists and their contribution to art, went on to state, laconically, that 'Léger [becomes] more and more geometric'. Allard was, however, the only critic to recognize the innovative force in Léger's work:

Without any doubt, Fernand Léger's painting is the most modern. It is difficult to predict how successful it will be in its present form, and it is wiser to restrict oneself to noting the strange seduction of an art full of health and strength, to which a *landscape* testifies more clearly than does the *Woman in Blue*.[13]

Today it is generally assumed that the painting now in Basle was regarded by Léger as the definitive version of *La Femme en bleu* because it is clearly the most mature. The version now in Biot, a smaller painting also in oil on canvas,[14] makes it certain that Léger had already adopted the working method characteristic of his later career, whereby a subject was gradually developed through many stages until its final version. While the overall arrangement in the Biot picture is similar, the treatment of the subject is far less abstract. The woman is immediately recognizable as an integral form, and there is a less marked difference between large continuous surfaces and passages of detailed or disintegrated form. The brightly coloured trapezoid that rises from the stepped left shoulder towards the upper edge of the picture is an addition that still fails fully to cover the black lines drawn beneath. (In the Basle version this takes the form of the segment of a circle.) Suggestions of flesh-tone are still to be found in the face and the hands; but there are no scissors.

Virginia Spate,[15] referring to the puzzling illustration of *La Femme en bleu* mentioned by Warnod in *Comœdia*,[16] argues that the

work exhibited at the Salon d'Automne in 1912 as number 1005 with the anotation 'p.' (i.e., peinture) was actually a third, now unknown, version of this subject that neither Christopher Green[17] nor Georges Bauquier[18] takes into consideration. But the information to be found on the reverse of the Basle painting argues against this, for at the upper left it is signed, dated and inscribed (all with the brush) as follows: 'LA FEMME en BLEU/S. Automne 1912/F. LEGER' (fig. 3). (The 'S' stands for 'Salon'.) In the catalogue of the *Vente Kahnweiler* (for the sale of Kahnweiler's stock) that included an illustration of this picture, it is the Basle painting that is shown, and there is an annotation: 'Exposé au Salon d'Automne 1912'. Yet it remains unclear why Warnod reproduced a different work in *Comœdia*. To judge by the black-and-white reproduction that accompanies his article, that picture was less narrow, which would place it somewhere between the two surviving oils, probably rather closer in time to the painting now in Biot. Green also illustrates a watercolour, signed lower right with a monogram, and dated '12',[19] correctly assuming, however, that this work is really later in date and to be considered in connection with the painting of 1913, *Femme dans un fauteuil* (Woman in an Armchair; pl./p. 101).[20]

'Conceptual Realism'

As with *La Noce* (The Wedding; pl./p. 79) and *Les Fumeurs* (The Smokers; pl./p. 82), Léger decided on a monumental, vertical format for *La Femme en bleu* in order to produce an imposing 'representative' work. The high value he afterwards put on this painting makes it clear that he believed he had succeeded. Though he later emphasized the breakthrough to a radical way of working with colour – his 'bataille de la couleur'[21] – this battle was only one aspect of his efforts in *La Femme en bleu*. On 5 May 1913, Léger gave a lecture at the Académie Wassilief in Paris in which he expounded his conception of painting. He began by developing the ideal of an art that could 'lay claim to pure classicism', that is, an art that endures beyond the era of its own pro-

Fig. 3 *La Femme en bleu* (Woman in Blue), oil on canvas, 193 x 130 cm, reverse, Öffentliche Kunstsammlung Basel, Kunstmuseum, Basle

12 Olivier Hourcade, 'Le Salon d'Automne', in *Paris-Journal* (3 October 1912), p. 5.

13 Roger Allard, 'Le Salon d'Automne', in *La Côte* (4 October 1912). In referring to 'landscape', Allard had in mind the painting *Le Passage à niveau* (The Railway-crossing; pl./p. 86), also of 1912 and also exhibited at the Salon d'Automne, although in the applied arts section, in André Mare's Salon bourgeois.

14 This is Léger's *Etude pour 'La Femme en bleu'* (oil on canvas, 131×99 cm), Musée National Fernand Léger, Biot, gift of Nadia Léger and Georges Bauquier. See G. Bauquier, *Fernand Léger: Catalogue raisonné*, 1: *1903-1919*, Paris, 1990, no. 38.

15 V. Spate, *Orphism: The Evolution of Non-figurative Painting in Paris 1910-1914*, Oxford, 1979, p. 254 ff.

16 Warnod, 'Le Salon d'Automne', p. 2.

17 In *Léger and the Avant-garde* Green discusses *La Femme en bleu* principally on pp. 46-52, 53-4 and 57.

18 Bauquier 38 and 39.

19 Green, *Léger and the Avant-garde*, p. 58: the illustration is of Léger's *Etude pour 'La Femme en bleu'* of

Fig. 4 Paul Cézanne, *Portrait de Madame Cézanne cousant* (Portrait of Madame Cézanne Sewing), 1877, oil on canvas, 58×48 cm, Nationalmuseum, Stockholm

1912-13, executed in wash and gouache on paper. Formerly in the collection of Mr and Mrs Leigh B. Block, Chicago, present whereabouts unknown. Neither Green nor myself were able to examine the original.

20 Léger's *Femme dans un fauteuil*, 1913 (oil on canvas, 129.5×97 cm), Beyeler Collection, Basle.

21 D. Vallier, 'La Vie fait l'œuvre de Fernand Léger: propos receuillis par Dora Vallier', in *Cahiers d'Art*, XXIX/11 (1954), p. 149.

22 Léger, 'Les origines de la peinture et sa valeur représentative' (1913), reprinted in Léger, *Fonctions de la peinture*, Paris, 1965, p. 11. Cited from the English translation, 'The Origin of Painting and its Representational Value', in *Functions of Painting*, London and New York, 1973, p. 4.

23 Ibid., p. 13; English translation, pp. 4-5.

24 In an unpublished letter of 1907 to André Mare, Léger told Mare that 'the second revelation [was] Cézanne. Ah! my old fellow, stunning things [placed] next, of course, to incomplete things. Among other works, a canvas representing two working class chaps playing cards. It cries out with truth and completeness, do you understand, [it's] modelled in terms of values, and what facture! It's unaffected, clumsy, one would think one was looking at the work of some decent, simple man who had just invented painting two thousand years before Jesus Christ ...' (archive of the Association André Mare, Paris).

25 Léger, 'Les origines de la peinture et sa valeur représentative', p. 13; English translation, p. 5.

26 Léger's *La Couseuse (La mère de l'artiste)*, 1910 (oil on canvas, 72×54 cm), Musée National

duction.[22] The prerequisite here was that the artist genuinely create out of the consciousness of his age. Seen in contemporary terms, Léger's demand meant that a new concept of realism had to be introduced into painting. Distinguishing between 'visual' and 'conceptual' Realism, he defined as 'visual Realism' the truest possible form of reproduction: in traditional painting this was the approach most closely connected with the artist's acknowledged dependence on his subject. In this context, he recognized the contribution of the Impressionists: that they had been radical in making colour central to their concerns (in contrast to the often neglectful attitude of artists in preceding periods). As a result of the Impressionists' fascination with grasping the subtlest nuances of perception and sensation, the subject lost its dominance. 'The imitation of the subject that their work still involves is thus [...] no more than a pretext for variety, a theme and nothing more.'[23] Cézanne, whose large memorial exhibition at the Salon d'Automne of 1907 had overwhelmed Léger,[24] had recognized, according to Léger, what was lacking in Impressionist painting, for Cézanne 'understood everything that was incomplete in traditional painting. He felt the necessity of a new form and draughtsmanship closely linked to the new colour. All his life and all his work were spent in this search.'[25] Léger's 'conceptual Realism', in which all three basic elements of painting (line, form and colour) were used simultaneously and with equal weight was intended to translate the experience of the material world into a dynamic pictorial reality. It was only through the tight interplay of all means of expression that one might hope to find an equivalent for the richness of the reality of life.

As far as we can judge from the early work that survives, Léger appears to have begun by favouring neither a particular type of subject-matter nor a particular style: there are landscapes, figure paintings, portraits and still-lifes, just as there are works of an Impressionistic, Fauvist and Cubist stamp. This continued to be the case until Léger revealed his autonomous talent in *La Couseuse (La mère de l'artiste)* (The Seamstress: The Artist's Mother; fig. 6) in 1910.[26] Here, a half-figure of stiffly

simplified shapes and heavy earth tones of olive, cumbersomely fills the entire picture space. Christopher Green has shown, in part through the well-grounded comparison between this work and Cézanne's *Madame Cézanne cousant* (Madame Cézanne Sewing; fig. 4) of *c.* 1877,[27] that Léger's choice of subject was by no means original. Cézanne's picture is a prominent example from among innumerable nineteenth-century depictions of patient women or mothers (often those of the artists themselves), growing old at their solitary needlework. Léger's submissions to the Salons from 1911 gave an entirely different impression. *Nus dans la forêt* (Nudes in a Forest) of 1909-10[28] and *Trois Figures, ou étude pour trois portraits* (Three Figures, or Study for Three Portraits) of 1911[29] were deeply disturbing images on account of Léger's obsessive transformation of the whole repertory of forms into an exercise in stereometry. *La Noce* reveals Léger coming to terms with avant-garde influences. This work provoked astonishment because of the unusual pictorial invention of a centrally placed, seemingly life-size female torso, in the midst of a rough tumult.

Two questions arise: Why, in the spring of 1912, did Léger decide on a conventional subject, and one, furthermore, that was contrary to all contemporary discussion about movement and dynamism? Second, why did he choose to depict an anonymous seated figure in a blue dress? His previous, numerous drawings of female nudes, which include some seated figures, offer no real clue in this regard. It would make more sense to assume that Léger, as he embarked on a new interpretation of painting, expressly chose an ordinary subject. This would, after all, be in accordance with his claim: 'The only interesting thing is how it [the subject] is used'.[30]

Once again there emerge parallels to the portraits of Mme Cézanne. She is shown sewing, wearing a blue dress; behind her the arm of her red chair glows against an ochre-coloured wallpaper. Her hair, with its pinned-up bun, is modelled in light and dark shades of brown, sharply set off against each other, lying like a broad striped band around her forehead and temples. It is not difficult to see this as a kind of model for the radically geometrized

black-and-white coiffure of the *Femme en bleu*, on whose right cheek falls a bright light (as on the face of Mme Cézanne). With this direct allusion to Cézanne's work, Léger establishes a connection to his great mentor, a mentor from whom, however, he was also now freeing himself. In *La Femme en bleu,* a woman sewing, he also reverts to the subject he had used in 1910 to produce an encoded portrait of his mother. Only four years of age when his quarrelsome father died, Léger remained on very close terms with his mother, Marie Adèle Daunou. A pious, simple soul, she in turn followed her son's career in Paris in a spirit of both scepticism and alarm. 'My mother', he later recalled,

> was a saint who spent much of her existence rectifying the damage wrought by her husband and praying both for him and for me. When she had become a widow, she gradually lost all the family possessions and she could only look on anxiously as I devoted myself to painting.[31]

Charlotte Merlin, the wife of André Mare, Léger's friend, later remembered that

> when Léger was accepted at the Beaux-Arts [sic], his mother sent him five francs. He

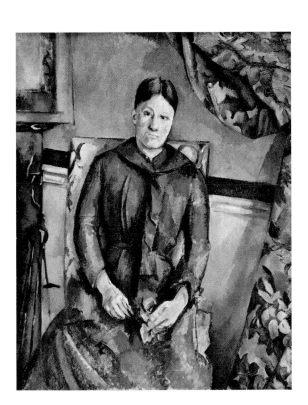

spent this sum on drinks the very same evening in the local cafés. With Louise, Mare and three other friends, he drank away the good old five francs of *my holy mother,* as Léger – who had great respect and affection for her – had the habit of calling her.[32]

There is a photograph that shows Léger with his mother in front of her house in Argentan, whose garden with its flowerbeds had been the first subject he had painted. She sits next to him in a dark, high-necked, long-sleeved dress, with her hands folded in her lap, tranquil, unassuming, calm – as if from another age (fig. 7).[33]

Only a glance back at the complex figure in *La Femme en bleu,* deconstructed into large planes of colour and ropes of small cylindrical forms, entangled in an almost abstract structure of lines and masses, allows us, once again, to put aside associations of this sort.

The Struggle with Colour

The far-reaching renunciation of colour, the '[painting] with spiderwebs'[34] of Analytic Cubism, was for Robert Delaunay and Léger very unsatisfactory. In the spring of 1912 they both began – Delaunay in his series of *'Fenêtres'* (Windows), Léger, among other works, in *La Femme en bleu* – to employ colour as their definitive means of expression. The various procedures they adopted led in different directions; but, as far as their respective concepts of colour theory were concerned, both artists found their starting-point in the research carried out by Michel-Eugène Chevreul in the 1830s.[35] Two phenomena that had been recognized as essential even before Chevreul's time now also came to play a special role. The first of these was the concept of 'counter-effect', found in Goethe's *Farbenlehre* (Theory of Colours) of 1810, according to which each colour 'demands' the presence of a particular further colour.[36] The second was the concept of simultaneity first used by Charles Blanc, who demanded that painters be introduced to the 'phenomenon of the simultaneous perception of colour'.[37] Chevreul offered an exhaustive treatment of the subject of simultaneous contrast: various zones of colour, in close proxim-

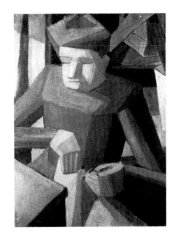

Fig. 5 Paul Cézanne, *Madame Cézanne en rouge* (Madame Cézanne in Red), *c.* 1890, oil on canvas, 105.9 x 88 cm, The Metropolitan Museum of Art, New York

Fig. 6 *La Couseuse (La Mère de l'artiste)* (The Seamstress: The Artist's Mother), 1910, oil on canvas, 73 x 54 cm, Musée National d'Art Moderne, Paris

d'Art Moderne, Centre Georges Pompidou, Paris; see Bauquier 19.

27 Cézanne's *Madame Cézanne cousant, c.* 1877 (oil on canvas, 58 x 48 cm), Nationalmuseum, Stockholm; see Venturi, *Cézanne,* I, cat. 291; II, plate 79.

28 Léger's *Nus dans la forêt,* 1909-10 (oil on canvas, 120 x 170 cm), Rijksmuseum Kröller-Müller, Otterlo; see Bauquier 20.

29 Léger's *Trois Figures ou étude pour trois portraits,* 1911 (oil on canvas, 195 x 114 cm), Milwaukee Art Center; see Bauquier 24.

30 Léger, 'Les réalisations picturales actuelles' (1914), reprinted in Léger, *Fonctions de la peinture,* p. 26; cited from the English translation, 'Contemporary Achievements in Painting', in *Functions of Painting,* p. 17.

31 See P. Descargues, *Fernand Léger,* Paris, 1955, p. 7; cited from *Fernand Léger,* exhibition catalogue, Kunsthalle, Berlin, 1980, p. 9.

32 Annotation made by Charlotte Merlin-Mare on a letter of 1907 from Léger to André Mare (the transcription of the letter and the note is in the archive of the Association André Mare, Paris).

33 Léger's early paintings are *Le Jardin de ma mère,* 1905 (Biot, Musée National Fernand Léger), Bauquier 5, and a now untraced version of the same subject, Bauquier 6. When looking together with Léger at the first painting, Blaise Cendrars recalled a photograph (perhaps the one mentioned above) that

showed Léger sitting next to his mother on her garden bench. Asked about this, Léger replied: 'Yes, next to her on the bench. She was waiting for her toad [pet name for her son]. Cendrars: 'She was waiting for her toad among the flowers' Léger: 'The flowers … All the flowers there were exclusively for the Virgin.' Léger's mother used to bring flowers to her local church for use in its decoration. Cited from 'Entretien de Fernand Léger avec Blaise Cendrars et Louis Carré sur le paysage dans l'œuvre de Léger' (1954), reprinted in Blaise Cendrars, *Œuvres complètes,* VIII, Paris, 1965, p. 503.

34 D.-H. Kahnweiler, *Mes galeries et mes peintres: Entretiens avec Francis Crémieux*, Paris, 1961, p. 127; cited from English translation, *My Galleries and Painters*, London, 1971, p. 84: 'As for Léger, he certainly thought a lot of Picasso. But there is that remark by Delaunay, which he quoted himself: "But those boys paint with spiderwebs" – in other words, the reproach of the absence of colour.'

35 M.-E. Chevreul, *De la loi du contraste simultané et de l'assortiment des objets colorés, considéré d'après cette loi dans ses rapports avec la peinture, les tapisseries des Gobelins …*, Paris, 1839. Translated (by C. Martel) as *The Principles of Harmony and Contrast of Colours, and their Applications to the Arts*, London, 1854.

36 J. W. von Goethe, 'Nachträge zur Farbenlehre, 4: Komplementäre Farben', in *Goethes Sämtliche Werke,* Stuttgart, n. d. [1880 ff.] XXXV, p. 293: 'Now we also recall that, just like light and dark, colours too require their direct opposites; this is to say that, as with a proposition and its antithesis, all [colours] are always simultaneously present. For this reason, and not unjustly, the colours that are required have been termed *complementary,* for their effect and counter-effect together constitute the complete colour circle. If then, along with the painters and colourgrinders, we assume yellow, blue and red to be the primary colours, all three are always present in the following opposed pairs: yellow – violet; blue – orange; red – green. Of this phenomenon we recall some specific cases, on account of particular circumstances that make them remarkable.'

37 C. Blanc, *Les Artistes de mon temps,* Paris, 1867, p. 62.

38 Vallier, 'La Vie fait l'œuvre de Fernand Léger', p. 154.

39 S. Paas: '"… und ist in ihrer höchsten Reinheit gleichsam ein reizendes Nichts": Betrachtungen

ity alter in terms of their values when simultaneously perceived by the eye. Simultaneous contrast is most clearly demonstrable in the change in our impression of how light a colour is. A light colour, placed next to a dark one, will appear lighter, and vice versa. White placed alongside a colour brings about an increase in the intensity of that colour. Black placed alongside a colour reduces its intensity and, in effect, 'absorbs' it. The various modifications through which a colour is capable of passing, between the extremes of its lightest and darkest intensity, are termed its various 'tones'. The modifications that a colour undergoes as a result of the slight addition of any other colour are termed its 'nuances'. Léger's prominent use of the strongest colour contrast, that of black and white, is one of the most striking characteristics of *La Femme en bleu*. In this work we find perfect balance, a taut harmony: by means of repetitions, he intensified the contrast of incisive straight lines and distinct curves, radically increasing the desired effect through the confrontation of black and white. 'I use two extremes', he said in 1954 in conversation with Dora Vallier:

white and black. The rest is orchestrated between those two. Black is of enormous importance for me. At the start I used it for lines – to fix the contrast between those that were curved and those that were straight. The brushstrokes in my paintings grew ever stronger, and for emphasis black was enough for me; relying on that, I could free myself from colour.[38]

At the centre of the large circling movement we sense in *La Femme en bleu* is the woman herself. The ultramarine planes of her dress take on an intense radiance under the impact of the pure white forms at her shoulders and the white material lying across her lap, though they are at the same time subdued through the strong black outline that grips the various parts of the picture and underscores their 'decomposition'. The force of the ultramarine, which draws the eye into the picture, is countered by white. A similar balance of forces is achieved with white borders and the deep pink of the face. The figure appears thereby to stay close to the picture surface,

while the head does not seem 'submerged', but rather 'crowns' the revolving, highly articulated whole, thus ensuring its coherence. With economy and deliberation, Léger added accents in the other two primary colours around the large blue forms. Though they appear like incidental elements, their placing is very exact: a glowing red appears symmetrically, to both right and left of the woman, in an irregular splintering of forms. At the extreme lower left of the picture there is a flat rectangle of deep pink and, further above, a plane of yellow ochre. Above this, in turn, there is a plane of lighter pink, subdued through its proximity to black, but supplemented by traces of a sparkling turquoise. The complementarity of turquoise and deep pink recurs in the modelling of the hands, and it finds an echo in the small rectangle situated in the left foreground. Equally recurrent is the tone of warm yellow: it lights up the left sleeve of the blue dress in the form of a tiny pentagon, and here one can also find smaller patches of green as well as traces of turquoise. On the fine weave that this particular canvas has, Léger applied a very thin, preliminary layer of paint as his overall primer, allowing it to trickle off, at the edges, into a grey-brown tone. He then drew in his lines with black paint and filled in the coloured planes. An opaque black, a yellowish, greyish, or pure white (in places painted over with a grey used for modelling), and ultramarine – these are the dominant colours. The rest – the fragmentary presence of cadmium red, yellow ochre, the small amount of green, the appearance together of deep pink and turquoise – creates an impression of rich sparkle among the large planes and their brown or grey (albeit nuanced) interstices.

Amid the contrasting structure of black and white on one hand, and the 'zones of fragmentation' on the other, Léger accorded primacy to ultramarine – it is even alluded to in the picture's title. According to one recent commentator, 'The pure, deep blue that Goethe describes as the colour of the sky and its reflection on water, is connected in psychology, with "lingering tenderness, devotion, security, absorption in a connection with the past" but also with a religious , philosophical, meditative attitude'.[39] The Christian icono-

graphical tradition has led to the Virgin Mary being termed the 'Blue Woman' on account of the colour of her clothing, for she was frequently depicted in the primary colours, the 'heavenly triad': usually blue for the dress, red for the cloak and yellow or gold for the background. The 'earthly green' was then employed for the landscape – often a grove or a small enclosed garden.

Léger regarded himself as a slow worker who usually progressed through a number of preliminary stages towards a 'definitive' version of a composition. Despite his desire to be an artist of his own time, he also aimed to produce work that would outlast its own era; indeed, he saw the one as a precondition for the other. For him, the most remarkable phenomenon in a world in upheaval was 'contrast'. The intensification of the experience of this world through a simultaneous perception of contrasting elements – an approach familiar to Léger from colour theory and its application in the work of the Impressionists and Neo-Impressionists – was invested by him in all available pictorial means in order to achieve an effect appropriate to the dynamism he now found pulsing through everything. This notion of vitality owed much to the work of the philosopher Henri Bergson, who had begun teaching at the Collège de France in 1900 and whose arguments and style, levelled against the intellectual traditions of Positivism, had an enormous influence throughout Europe. According to the German philosopher Max Scheler:

> Bergson's true greatness lies [...] in the force with which he was able to give a new direction [...] to man's attitude towards the world and towards the soul. [...] This new attitude [...] may be termed an abandoning of the self to the reality of things as perceived by intuition; the emergence of a deep trust in the irrevocability of a simple and evident 'given'; a courageous releasing of the self into the act of observing and into a benevolent turning towards the world as it offers itself to our contemplation. This philosophy bears towards the world the gesture of the open, demonstrating hand, of the wide and candidly opening eye.[40]

Léger's 'conceptual Realism', which preserved a relation to the object only in order to transform it, becomes more comprehensible in the context of Bergson. But in their pictorial recording of sensations derived from contemplation, Léger and Delaunay followed diverging paths. Léger did not subsequently pursue the degree of abstraction he had attained in *La Femme en bleu,* for, in the end, the 'non-representational world' did not correspond to his artistic ideal. With the 'battle for colour' on which he embarked in *La Femme en bleu* (which inaugurated the triumphal procession of the primary colours in the art of the twentieth century), Léger named only one of its innovatory approaches, not even mentioning the perfect harmony in which he combined all three pictorial elements – line, form and colour. The forward-looking potential of this picture was also to prove fruitful for other genres and for other artists; and it retains its significance in the context of the contemporary, mixed-media concept of art.

The return to a subject that for Léger had associations with his own mother (whose pious nature reminded him of the Virgin) and to a treatment so clearly influenced by Christian iconography, strengthens the notion that with the figure of the *Femme en bleu* the artist was 'dismantling' a traditional, idealized mother-image. Thus the purely formal contradiction existing between a static subject and a simultaneous need for the expression of dynamism runs parallel to the reworking of an apparently banal subject that in reality harbours profound meaning and emotional significance.

In 1922, the year Léger's mother died, and ten years after his painting for the Salon d'Automne of 1912, he produced *La Femme et l'enfant* (Woman and Child; pl./p. 181), a work in a quite different style, but once again on a large scale, and depicting a woman, a mother, dressed in blue. She wears a glowing ultramarine dress with a high collar and wide sleeves. Relaxing in a deck chair, she has raised her head from her book and serenely meditates, with wide-open eyes. The boy, meanwhile, painted entirely in black and white, leans across her lap to offer her a daisy.

Fig. 7 Léger with his mother in the garden of their house in Argentan

zu Blau in der Malerei des 19. Jahrhunderts', in *Blau: Farbe der Ferne*, exhibition catalogue ed. H. Gercke, Heidelberg, 1990, p. 152.

40 Max Scheler, 'Versuche einer Philosophie des Lebens' (1913-14), *Vom Umsturz der Werte*, translated here from the 4th edn, Berne, 1955, pp. 324-5.

I am indebted to Hartwig Fischer for his help with documentation and assembling archival material.

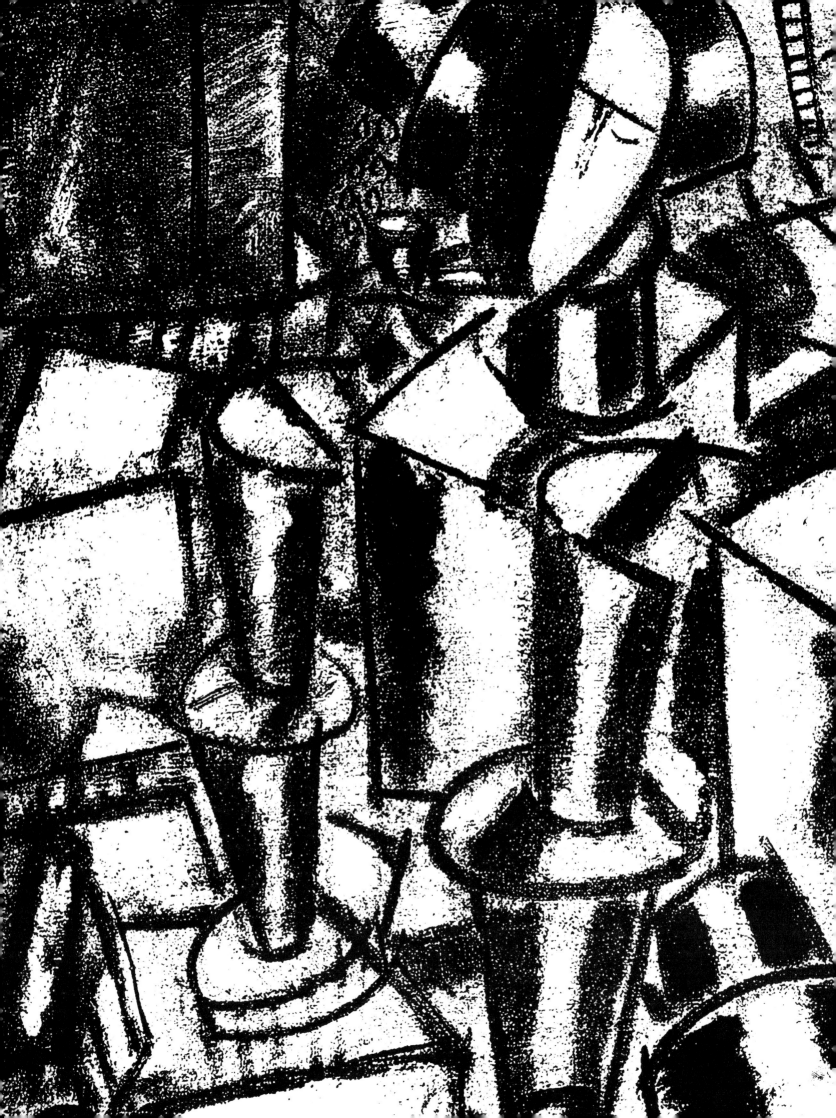

Christopher Green

OUT OF WAR: LÉGER'S PAINTING OF THE WAR AND THE PEACE, 1914-1920

Like those of most Frenchmen of his generation, Léger's life between 1911 and 1920 was dominated by a single, long-drawn out event that changed both him and the world in which he worked: the Great War. In his painting, the period is bracketed by peace-time images of the city. His large-scale anthology of urban images, *La Ville*, 1919 (pl./p. 145), responds across eight years to the small-scale series of 1911, *Fumées sur les toits* (Smoke over the Roofs; fig. 1); the one, a Simultaneist synthesis of fragments, the other a single, encompassing view across the Latin Quarter to Notre-Dame.[1] At the heart of *La Ville*, smoke rises between buildings and advertising letters, as if to make the link across the War years, but beneath it two mechanized figures descend a staircase; they introduce a new human, yet inhuman, element.

> I left Paris right in the middle of an abstract style, a time [for me] of pictorial liberation. Without any period of transition I found myself on a level with the whole of the French people; thrown into the Engineers, I found that my new mates were miners, navvies, woodworkers and ironworkers When I'd bitten into this reality, a concern with real objects never left me.[2]

1 The view is from the roof at 13 Rue de l'Ancienne Comédie. For a photograph of this view, see Christopher Green, *Léger and the Avant-garde*, New Haven and London, 1976, p. 29.

2 Léger, cited in *Fernand Léger, 1881-1955*, exhibition catalogue, Musée des Arts Décoratifs, Paris, 1956, p. 30.

3 I stress this myself in *Léger and the Avant-garde*. On 11 December

Fig. 1 *Fumées sur les toits* (Smoke over the Roofs), undated, oil on canvas, 46 x 55 cm. St Louis Art Museum (B 25)

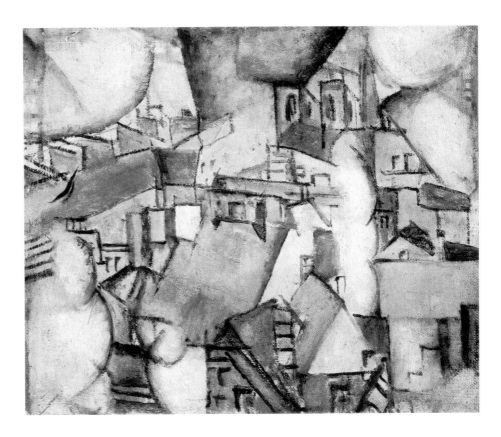

1919 Léger wrote to Kahnweiler stressing what he already dubbed 'the return to the subject'. See D.-H. Kahnweiler, 'Un grand Norman roux', *Hommage à Léger*, special number of *XXe Siècle*, Paris, 1971, p. 4.

4 The role of the smoke-forms in Léger's work of 1912-13 is fully discussed in my *Léger and the Avant-garde*.

5 Léger himself clearly saw *La Partie de cartes* as a key work. In December 1917, with the canvas hardly completed, he wrote to Louis Poughon that it was 'an important work' and 'the basis of the deal' that he was at that moment negotiating with Léonce Rosenberg. See Letter 42 (Paris, Friday 7 December), in Christian Derouet, ed., *Fernand Léger: Une Correspondance de guerre à Louis Poughon, 1914-1918*, Les Cahiers du Musée National d'Art Moderne, Paris, 1990, p. 84. In the reviews of the Galerie de l'Effort Moderne exhibition it was picked out for discussion, and is reproduced, with the important series of artists' statements, including one by Léger, sent by Rosenberg for publication in *Valori plastici* (Rome), February/March 1919.

6 Cited in Dora Vallier, 'La Vie fait l'œuvre de Léger: Propos de l'artiste recueillis par Dora Vallier', *Cahiers d'Art* (Paris), 1954, p. 151.

Fig. 2 *L'Escalier* (The Staircase), second version, 1914 (cat. 130), oil on canvas, 88 x 124.5 cm. Fundación Colección Thyssen-Bornemisza, Madrid (B 70)

The change in Léger and his work produced by his experience of war has consistently been represented as a 'return to the subject'; he himself saw it as such at least as early as 1919.[3] Out of the pre-War images of the city, and especially out of the indefinition – the semantic openness – of the smoke-forms among the roofs of the *Fumées*, is seen to emerge an art that marginalizes the subject, whose purest manifestations are the *'contrastes de formes'* of 1913.[4] Out of war is seen to emerge an insistence on the subject, with the human figure at the centre. *La Ville* becomes the peacetime sequel to the War painting *La Partie de cartes* (The Card Game, 1917; pl./p. 119), the focal work in Léger's exhibition of February 1919 at Léonce Rosenberg's Galerie de l'Effort Moderne, one that conflated the image of the machine-man with the image of the French common soldier, the *poilu*.[5] The figures on the staircase in *La Ville* were easily read, in 1919, as *poilus*, who, like Léger, had returned from the Front.

Léger may well have declared in 1954 that *Partie de cartes* was 'the first picture for which I deliberately took my subject from what was going on around me',[6] but it is clear that in the last months before he was called up in August 1914 he had already begun to shift his attention away from the 'abstract' to subject-matter. This shift is clear enough in

the second of his Académie Wassilief lectures, in which Léger noted that 'contemporary achievements in painting are the result of the modern mentality, and are closely bound up with the visual aspect of external things',[7] where they are linked especially to the experiences of speed and of advertising hoardings in the countryside; but it is incontrovertibly a fact in his work, in the series of still-lifes, villages and trees and, most tellingly of all, in the series of *Escalier* (Staircase) paintings. The machine-man on a staircase is the subject of the *Escalier* paintings, and in two cases the setting is outside, in the modern city. It seems that here Léger 'deliberately' extracted his subject from 'what was going on around me'. He did so in a way explicitly echoed in *La Ville* after the War; and he did so before the War.

One of the two *Escalier* paintings where mechanized figures are placed outside in an urban space is a work that has been known as *Le Balcon* (The Balcony; pl./p. 105) since it was sold in the Kahnweiler sales of the early 1920s. That it is to be treated as one of the series is underlined by the fact that Kahnweiler, into whose stock it came in 1914, originally titled it *L'Escalier*; a gouache study for it, dated '13' (pl./p. 104), adds a staircase to the balcony setting.[8] *Le Balcon* is closely related through the gouache study to the 'second state' work: *L'Escalier, 2ème état* (fig. 2). In the *2ème état* Léger added, as in the gouache, the stepped forms on the right to say 'staircase', and, to say that the figures are 'descending', he added the hand of a figure entering from above and the heads of figures exiting below. In *L'Escalier, 2ème état* the windows of buildings on the left unmistakably situate this staircase alongside a balcony with a view onto the street and the city.[9] Léger places his mechanized figures in a modern-life context with an established modernist pedigree. He takes the Duchampian theme of the staircase and figures descending, renders it directly confrontational by making the figures move outwards towards the spectator rather than across the picture-plane, and connects it with the balcony-view theme given currency above all by the Futurists – Boccioni, Carrà and Severini.[10]

On 14 November 1915 Léger wrote to the Scandinavian artist Nils de Dardel, who, as rep-

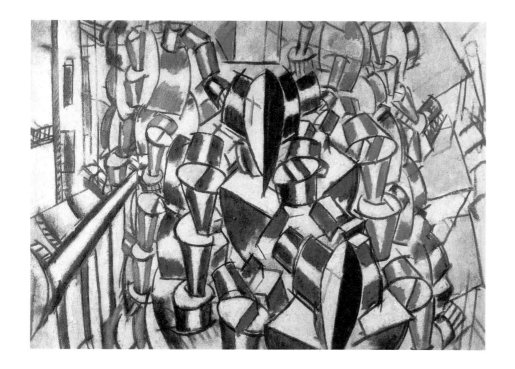

resentative of de Maré, showed interest in buying from him. Léger confessed that he needed to sell his work, but raised a difficulty:

> Only a few, painted a month before the war in Normandy, are still at my disposal. I gather that you would be interested in seeing them. They are attempts at something rather abstract (contrasts of forms and colours) that I was trying to carry out in a large painting which would have been called *L'Escalier*. I was taken over by the war and so I was prevented from achieving what I had wanted to do.[11]

This is an interesting passage because it suggests that, despite the clearly declared machine-man, urban subject-matter of the *Escaliers*, Léger thought of them still as 'attempts at something rather abstract'; they were, after all, developed from the *'contrastes de formes'*.[12] Here, however, it is most significant because of what it tells us of the fate of some of the *Escalier* series during the War.

The paintings referred to are obviously the three *Escalier* compositions that did not enter Kahnweiler's stock in 1914: the Basle, Stockholm and New York variants (pls./pp. 103, 107 and 108). While *Le Balcon, L'Escalier, 2ème état* and the Zurich variant (which is dated 1913; pl./p. 106) were painted before the summer, these three canvases were, it seems, painted in the summer of 1914, just before the outbreak of hostilities, and Léger kept them. A photograph of Jeanne Lohy, Léger's future wife, taken during the War, shows her seated in front of an *Escalier* painting (fig. 3). The lower head, especially, links it to the Basle picture, but there are many differences. It is either another variant, now lost, or evidence that Léger actually reworked at least one of the canvases after 1914.[13] The Stockholm variant was almost certainly sold to Rolf de Maré by the beginning of 1916, and the New York one may have been sold by 1917 to Diaghilev or Léonide Massine, but the Basle variant certainly remained in Léger's studio at 86 rue Notre-Dame-des-Champs until his contract was finalized with Léonce Rosenberg in the summer of 1918, and perhaps for longer.[14] Not only, then, did the *Escalier* series announce the theme of the machine-man in the city, which becomes the central human element in *La Ville*, but it re-

mained continuously available to Léger for reconsideration throughout the War; he may even have worked on it during his leaves in Paris. The series was a tangible, ever-present link between the pre- and post-War years.

The question must follow: if the 'return to the subject' was thus anticipated before Léger found himself a sapper in the Forêt d'Argonne, and if the *Escalier* theme establishes a continuity between 1914 and 1919, what was so fundamental about the change that those years have always marked for Léger and his commentators? What was so much less 'abstract' about the work of 1917-20? With that question goes others. Were distinctly different meanings carried by Léger's 1914 and 1917-20 modern-subject paintings? And how was the experience of the War a factor in Léger's return to the city theme after *La Partie de cartes*?

Answers to these questions are made less difficult now, with Christian Derouet's publication of Léger's wartime correspondence with his friend from childhood, Louis Poughon.[15] This correspondence has revealed inaccuracies in my own earlier account of Léger's war and has significantly modified the picture of Léger's attitudes and responses to life as a *poilu*.[16] Taken in the context of other writings (both private and public) produced by survivors from the Front, and of Jean-Jacques Becker's work on French morale during the War, Léger's letters to Poughon allow a fresh and more acute analysis of his 'return to the subject', one that brings out more sharply the distance between the *Escaliers* and *La Ville*.[17] I believe, moreover, that it becomes possible as a result to modify the now dominant view of a post-War Parisian avant-garde frozen into the rigid, 'disciplined' postures of the nationalist Right.[18]

Later, Léger was repeatedly to return to the importance of his engagement with 'the whole of the French people' at the Front: 'miners, navvies, woodworkers'. The letters confirm his admiration of the ordinary *poilus*. Like Henri Barbusse, the socialist author of the hugely successful war novel *Le Feu*, Léger remains the observer, slightly apart, the intellectual collecting documentation like a journalist, but he, too, clearly thinks of his immersion in a society of peasants and workers as a privilege.[19]

Fig. 3 Jeanne Lohy photographed during the War in front of one of the *Escalier* paintings

7 Léger, in 'Les réalisations picturales actuelles', lecture given at the Académie Wassilief in 1914 (see *Les Soirées de Paris*, 25, 15 June 1914); reprinted in *Functions of Painting*, London, 1973, p. 11. I have discussed this shift in *Léger and the Avant-garde*, pp. 93-5.

8 'Escalier' is the title given in the albums of the Galerie Kahnweiler in the Galerie Louis Leiris, Paris. 'Le Balcon' is the title given in the catalogue of the third Kahnweiler sale, Hôtel Drouot, Paris, 4 July 1922, no. 104.

9 My comments on the *Escalier* series have come out of work pursued for my catalogue of French and Western European paintings *c.* 1904-*c.* 1966 in the Thyssen-Bornemisza Collection, to be published by Philip Wilson, London. *Escalier 2ème état* will be more fully considered there.

10 It is likely that Léger was aware of a Duchampian reference, since his *Nude Model in the Studio* (pl./p. 85), shown at the Indépendents exhibition of 1913, was probably conceived in oppositional response to Duchamp's *Nude Descending a Staircase*; see my *Léger and the Avant-garde*, p. 54. Most relevant in relation to the balcony theme are Boccioni's *The Street Enters the House* of 1911, Carrá's *Simultaneity* of 1913, and Severini's lost *Woman on a Balcony* of 1914.

11 Léger to Nils de Dardel, 14 November 1915, in Christian Derouet, *Léger och Norden*, exhibition catalogue, Moderna Museet, Stockholm, 1992-3, p. 25.

12 Both the figurative cylinders and the 'steps' have their origins in the *'contrastes de formes'*. I have argued elsewhere that the migration of formal configurations between pictorial series, both abstract and those with 'subject-matter', demonstrates the marginality of the subject for Léger in 1914, as in 1913. The relationship between the *Escalier* series and the still-lifes of 1914 underlines this point. Despite the stress on the abstract in Léger's letter, I feel now, however, that I overstressed the 'purity' of the *Escalier* paintings, in particular in my previous discussion of them in *Léger and the Avant-garde*, Ch. 3, esp. pp. 85-91.

13 If it is the Basle variant, the canvas has been cut down by a few millimetres along the bottom edge.

14 In a letter of 29 January 1916 Léger definitively reported that 'Janot' had sold a painting for 1600 *francs*. He also reported that she sold 'some pictures' for 1600 *francs* to 'the Swedes' in a letter that must be of 22 January of the same year. This latter one is dated 22 January 1915 in Derouet, ed., *Correspondance … à Louis Poughon*, 1990, but in view of the letter to Dardel dated 14 November 1915, from which it appears that Léger is only beginning negotiations, this must be wrong; see Letters 22 and 23, pp. 53-4, 58. In a letter to Poughon of February 1917, Léger wrote that he had 'just sold a pre-war picture and two drawings of Verdun to Diaghilev'. The Museum of Modern Art's *Escalier* is known to have been in the collection of Léonide Massine. It could have been sold directly to Massine at about this time, when he was building up a collection, or it might have been passed to him from Diaghilev, in which case the mention in the letter of 'a pre-war picture' would be a reference to it. See Letter 17, *Correspondance … à Louis Poughon*, p. 80. The first collection given in the provenance of the Basle variant is Léonce Rosenberg. See also Georges Bauquier, *Fernand Léger: Catalogue raisonné de l'œuvre peint, 1903-1919*, 1, Paris, 1990, nos. 69, 71 and 73.

15 Published in 1990; see note 5, above.

16 Most important among the inaccuracies revealed are the following: Léger had made the switch from sapper to stretcher-bearer by October 1915, long before he went to Verdun; he did not make drawings on the Aisne front; he did not leave the Argonne front until September 1916, and so only figured in the final stages of the Battle of Verdun; and he was first hospitalized in August 1917, not as a result of being gassed, but because of 'an

His letters totally lack the nobility and vision to be found in those Barbusse wrote to his wife, but Léger is, in fact, in some senses closer to the *poilus* of his squad: his highest priority, like them, is day-to-day survival, and he spent his time trying every trick in order to secure greater personal comfort and avoid the dangers of the firing-line.[20] Where Barbusse's letters reveal an irritable dislike of the pilfering, trafficking 'canny soldier', Léger was affectionately appreciative of the black-bearded 'type from central France' who immediately on returning from murderous action at Verdun begins trading looted *boche* (German) trinkets for wine.[21] The petit-bourgeois side of Léger that so enjoyed the deals made with 'the Swedes' and Léonce Rosenberg, identified readily with the petty profiteering of his companions. Yet, if there is no glimpse of a strong socialist perspective like Barbusse's – indeed, there is hardly any explicit mention of politics at all – there is no mention either of the Union Sacrée (the 'Holy Coalition' that was supposed to have suppressed political difference in the interests of victory), and Léger's letters often suggest broad sympathies with the Left. He was obviously moved by the assassination of the politician Jean-Léon Jaurès a few days before the Great War began; he betrays an intense hostility to bourgeois mores and a sharp awareness of class difference.[22] In May 1915 he even went so far as to make a simple socialist parallel between the War and 'the financial struggle in peacetime'. War, he said, took things a little further: 'instead of ruining the fellows, it kills them'.[23]

Further, Léger shared with Barbusse, and with the other 'realist' novelists of the War, a set of attitudes that plainly condradicts the triumphalist attitudes of Maurice Barrès, Léon Daudet, the journalists of *L'Echo de Paris* and the other champions of the nationalist Right.[24] Even fundamentally conservative members of the officer class, like Delvert, who published his diary of November 1915-June 1916 as *Histoire d'une compagnie* (Story of a Company), despised the propaganda of the Right and the sabre-brandishing image of the hero.[25] Geneviève Colin has noted the common contempt for the propaganda of patriotic heroism among the 'realist' writers from the Front.[26] The story

of 'La Dame en vert' (The Lady in Green) in Duhamel's *Civilisation 1914-1917* culminates in the helpless mirth of an otherwise unsmiling *poilu* when confronted by the patriotic platitudes of a lady visitor to the wounded.[27] A *poilu* who contemplates the new dawn in the sea of mud and bodies at the end of *Le Feu* will not accept that he is a hero, one of a species of 'remarkable people, idols'.[28] Just as Barbusse tried to redefine heroism as the calm control of the disciplined soldier reduced by modern war to an automaton, so too, for Léger, it was to be redefined as the capacity to tolerate killing 'to order' when 'individual action is reduced to a minimum'.[29] Léger scorned the Italians who leapt from their trenches into the machine-gun fire crying *'Viva la Francia!'* ('in a war like the one we're waging their way of behaving seems old-fashioned'); and he relished the failure among his companions on the Front of 'Monsieur Barrès'.[30] The patriotic appeal of the novelist and politician Maurice Barrès and his ilk to 'nobler' chauvinist feelings, especially concerning the values of (French) civilization, was an insulting irrelevance.

In Barbusse, the rejection of the propagandist view of heroism went with a passionate rejection of nationalism. The letters to his wife make it clear that, though he fought to defend France, he still believed French nationalism bore a significant portion of the blame for the War. *Le Feu* was written as a tract against not merely war, but the nationalism (of all colours) that, for Barbusse, would always lead to war.[31] 'L'Aube' (Dawn), the famous last chapter of the novel, is a passionate plea for an internationalism that would bring the French and the Germans together, an internationalism that would end war, to be set in motion by the working men and the peasants who were fighting at the Front. Barbusse was very much not alone as a socialist and a pacifist who fought (to prevent a victory for German militarism), and the success of his book indicates that his position was one with broad appeal, at least between 1916 and 1918; he was not, of course, a defeatist, but he abhorred triumphalism.[32] Of the 'realist' war writers, neither Duhamel nor Dorgelès set out explicit internationalist credentials, but, as Colin has remarked, their

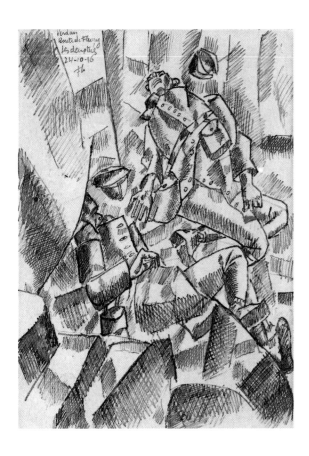

the obstinate combativeness of the French *poilu*, but he did not do so as one who shared that feeling.[36] The Léger of these letters cannot unequivocally be said to be an anti-nationalist and a man of the Left, but one can say unequivocally that he is not an *Echo de Paris* reader either. In the same way, it can be said, as will become clear, that his immediately post-War work was unavailable to the sympathies of the nationalist Right.

If nationalism and internationalism are no more than subterranean themes in Léger's letters to Poughon, there is one major theme that surfaces powerfully in the letters he wrote from the Argonne and Verdun in 1915-16; it finds strong echoes especially in the writing of Barbusse and is very directly to be related to the shift between the 'abstraction' of his pre-War work and his post-War 'return to the subject'. It emerges in a set of oppositions that are exhaustively discussed. These oppositions are between the senses and the intellect, between 'primitive' basics and controlled order, between 'reality' and the 'abstract'. Léger represents the War as controlled by the abstract order of intellect, but also as the stimulus to a heightened sensibility, the second the product of the first but also its negation.

The experience of bombardment and its effects is a recurrent motif in virtually every war novel, journal, memoir or correspondence from 1914-18 published in France. The dominant metaphors usually found to describe it are ironically musical (the 'concert' of guns) or melodramatically natural (the 'storm' of guns).[37] More rarely they are mechanical, as in the following passage from *Le Feu*:

> And always, in its frantic monotony, it continues – the burst of gunfire and yet more gunfire. The shrapnel shells with their hissing explosion, crammed with a furious metallic core; and the heavy shells, thundering like a train going flat out, which suddenly smash against a wall The air ends up opaque and congested, crossed by sluggish winds; but, all around, the slaughter of the earth goes on, deeper and deeper, increasingly thorough.[38]

In Léger's letters to Poughon, it is precisely with a mechanized image of the destructive power of the artillery that the 'abstract' is asso-

texts are free both of any sense of the superiority of the French or of any hostility to the German 'enemy'.[33] Those who read in such numbers Dorgelès's *Les Croix de bois* (Wooden Crosses) or Duhamel's *Civilisation*, like those who read in even greater numbers *Le Feu*, found the most powerful of antidotes to the simple picture of a 'civilized' France and a 'barbaric' Germany propagated by the Right.[34]

Léger makes no mention of any of these writers in his letters to Poughon, and there is no trace of internationalism as such to be found in them, but his dismissal of Barrès accompanies a readiness to deal with the French and the Germans as neither better nor worse than each other. In the same letter of May 1915 as his aside on 'Monsieur Barrès', he writes of the 'intelligence' of those running the War as something to be found 'as much on one side as on the other'. For him in this letter, both the Germans and the French are equally 'modern', orderly and without 'spirit'. The 'Latin' qualities of discipline and logic are not the exclusive preserve of the French.[35] He accepted the depth of *revanchiste* feeling against 'the Prussians' as a major reason for

Fig. 4 *Les Deux Tués* (The Two Slain Men), 1916, brown wash and pencil on a postcard, 12.3 x 8.9 cm. Present whereabouts unknown

attack of rheumatism', remaining there because of 'nervous gastritis'. The details of his leaves are also clarified (19-26 August 1915; late January or early February 1916; second half of August 1916; possibly December 1916; and the end of July 1917). For a chronology, see Derouet's edition of the *Correspondance ... à Louis Poughon*, p. 6.

17 Jean-Jacques Becker, *Les français dans la grande-guerre*, Paris, 1983; English edn trans. Arnold Pomerans, with an introduction by Jay Winter, as *The Great War and the French People*, Leamington Spa, Heidelberg and Dover, NH, 1985.

18 This view of the avant-garde in the immediate post-War period is one feature of the thesis advanced in my own work; see Christopher Green, *Cubism and its Enemies: Modern Movements and Reaction in French Art, 1916-1928*, New Haven and London, 1987. It is a central theme in Kenneth E. Silver, *Esprit de corps: The Art of the Parisian Avant-garde and the First World War, 1914-1925*, Princeton and London, 1989. I was not aware of Becker's work early enough to modify my text, and Silver's text seems not to take account of the picture presented by Becker of a changing, far from monolithic, French population, increasingly open to different political positions and increasingly capable of treating propaganda with contempt.

19 I have discussed Léger's drawings in the context of photo-journalism and Barbusse's *Le Feu* in *Léger and the Avant-garde*. Barbusse used a camera at the Front to record the *poilus* and their life, and continually refers to his 'documentation' in the letters to his wife. This 'documentation' was the basis for *Le Feu* (*Journal d'une escouade*), Paris, 1916 (translated as *Under Fire: The Story of a Squad*, London and Toronto, 1917); see Henri Barbusse, *Lettres de Henri Barbusse à sa femme 1914-1917*, Paris, 1937. He writes of having photographed 'my mates in the squad' on 8 March 1915 (p. 83). *Le Feu* began to appear in serialized form in *L'Œuvre* in August 1916. By July 1918 it had sold 200,000 copies, having won the Prix Goncourt in 1916.

20 As Derouet has pointed out, the central theme of Léger's letters to Poughon is his hope that his well-connected lawyer-friend can use his influence to have him transferred to safer duties. From September 1915, Léger's main hope was to be transferred to the Camouflage section.

21 See the letter of 21 June 1915 in *Lettres de Henri Barbusse*, p. 150; also Léger's Letter 29 (Verdun, 7 November 1916) in *Correspondance ... à Louis Poughon*, p. 70.

22 For Jaurès, Letter 2 (21 August 1914), *Correspondance ... à Loius Poughon*, p. 10. For Léger's hostility to the bourgeoisie and his awareness of class difference, Letters 2 (21 August 1914), p. 10; 33 (Champagne, 13 February 1917), p. 76; 41 (Hôpital St Joseph), pp. 83-4; and 44 (incomplete), p. 86.

23 Ibid., Letter 13 (Maison Forestière, 30 May 1915), p. 36.

24 Geneviève Colin, in 'Writers and the War', the chapter (11) that she contributed to Becker's *The Great War and the French People*, 1985, distinguishes clearly between, on the one hand, the purveyors of 'eye-wash' and nationalism from the Right, headed by Barrès, Daudet, Loti and Paul Bourget, or those, like René Benjamin, who sustained the myth of the patriotic *poilu* in his 1915 novel *Gaspard*, and, on the other hand, those who aimed to convey the reality of war. She treats the politicized 'realism' of Barbusse as a separate category, but includes as 'realist' the non-politicized writings of Roland Dorgelès, Georges Duhamel and Pierre Chaîne.

25 Capitaine Delvert, *Histoire d'une compagnie (Main de Massiges – Verdun, novembre 1915-juin 1916)*, Paris and Nancy, 1918. Delvert was a product of the Ecole Normale Supérieure, who saw the pre-War generation (of 1880-1910) as 'rather decadent'. His taste when on leave in Paris was for walks in the Bois de Boulogne and the parc de Monceau, and dinner at the 'Bœuf à la mode'. For his attacks on the propagandists, see pp. 60, 76 and 199.

26 In *The Great War and the French People*, Ch. 11.

27 Denis Thévenin (Georges Duhamel), *Civilisation 1914-1918*, Paris, 1918; available in Georges Duhamel, *Souvenirs de la Grande Guerre*, London, 1985, pp. 111-14.

ciated, and, just as in the above passage from Barbusse, it is opposed to 'life' in nature, to 'the earth' that it destroys.

It is in his discussion of May 1915 concerning the 'intelligence' of those directing the War that the theme first emerges fully, though it is prefigured in his earlier discussion of dehumanization and heroism. For Léger, the War altogether is 'intelligent to its fingertips'. And that intelligence is focused on mechanical killing: 'It's linear and dry like a problem in geometry. So many shells over so much time over a certain surface, so many men per metre and at the appointed time and in an orderly fashion'. It is mechanical and Cubist. 'All this is set off mechanically. It's pure abstraction, purer than Cubist painting "itself".'[39] It is to be admired for its modernity ('I don't deny that I'm drawn to it') and it is at the root of the anti-sentimentality that Léger goes on to praise for supplying the strength to resist 'Monsieur Barrès'. Yet, already here an ambivalence is clear in Léger's appreciation of its murderous function. It is in this letter that he represents the War as the extreme conclusion to 'the financial struggle' in its modern capitalist form.

There is almost no ambivalence when the theme re-emerges in a remarkable letter written from Verdun in November 1916; the work

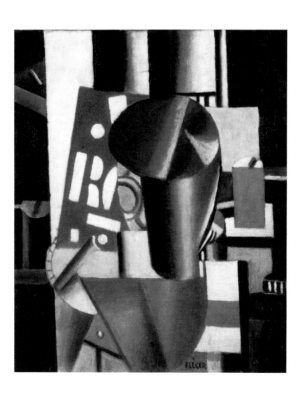

Fig. 5 *Le Typographe* (The Typographer), 1919, oil on canvas, 54 x 46 cm. Rijksmuseum Kröller-Müller, Otterlo (B 189)

of the artillery is the very paradigm of abstract intelligence, and it reduces everything to nothing. It is abstraction as death. The letter is Léger's account of a day and a night spent in a shell-hole and his return to the relative safety of Verdun. It complements a group of 'war drawings' dated 24 October 1916, the date of the retaking of Douaumont, which includes *Les Deux Tués* (fig. 4), though it was written a few weeks later, after another advance. It begins with a description of the sector between Fleury, Vaux and Douaumont, which Léger could see from the shell-hole he shared with the corpse of a dead Frenchman: 'ten square kilometres transformed into a desert of unvarying brown earth', in which the living and the dead are 'ants' and over which the artillery – 'fearsome, intelligent, striking where required, heartbreaking in its regularity' – has taken control. The gunners, he says, 'have reached an absolute result: making a stretch of territory impassable by destroying everything to a depth of three metres'.

Léger's account of his return to Verdun is the record of a return to life from the desert produced by 'intelligence'. First there are the trunks of trees, then patches of grass, then trees with branches. 'Well then, my old friend, moral anguish disappears, so one can get back to one's life, to tasting life intensely, as children do.'[40]

This experience of heightened and intensified sensibility as the antithesis of destruction is as commonplace in war memoirs as it is in the writings of the wartime 'realists' in France. Delvert, Dorgelès, Duhamel and Barbusse all describe its impact; it goes with a raised sense of the value of the simplest things, a return to basics, what Barbusse describes as a return to the 'simplified character' of a 'primitive state'.[41] 'I come back into the main room', Dorgelès has his narrator say in *Les Croix de bois*, describing the return from an attack to a farmhouse billet: 'There is *my* bowl, there are *my* wooden shoes, *my* little bottle of ink. It seems so good to find again these things of one's own'.[42] More than once Léger describes his life at the Front as the return to a savage state, and the revaluation of simple things is a recurrent feature of his letters.[43] A letter of April 1915 indissolubly links

this intensification of the 'real' with Paris, for it is ultimately to Paris that Léger dreams of returning, and in Paris that he imagines he will most acutely grasp the new value he finds in 'things':

> One has to have lived in the mud and the night for nearly a year to [be able to] discover Paris. How I'll gobble Paris up, if I'm lucky enough to go back there! I'll fill my pockets with it, and my eyes. I'll walk about in it like I've never before walked about there.... I don't think I'll waste any more minutes like I used to waste them for months at a time, because I'll see in things their 'value', their true, absolute value, for Christ's sake! I know the value of every object, do you understand, Louis, my friend? I know what bread is, what wood is, what socks are, etc. Do you know that? No, you can't know that because you haven't fought a war.

Léger pities Poughon as one who will always remain 'a pre-War man'; he, Léger, with his heightened experience of 'things', and especially of Paris, will be – 'if my mother's God allows me' – 'one of the *post-War* generation'.[44]

Léger's letters to Poughon thus reveal the emergence of the 'realist' imperative as an integral part of his wartime experience, and one that is situated within a binary structure of oppositions that sets sensibility/'things'/life against intelligence/'abstraction'/death. While at the heart of the return to 'things' and the escape from abstraction-as-death is placed the experience of the city – Paris. The artillery was *the* manifestation of the destructive 'intelligence' of the Great War, as Léger saw it; there is a profound irony in his post-War celebration of the .75 artillery piece as symbol of his 'return to the subject', to 'things'.

It is paradox of another sort that Léger's 'return to the subject' in 1918-19 involved, at the outset, as much a return to abstraction as to 'things'. The paradox is compounded when one realizes that the theme of *La Ville* – Paris represented as the focus for an intensified experience of life in modernity – had, to some extent, its beginning in abstraction. I have elsewhere shown how the first *Ville* idea, which culminated in *La Ville, fragment, 3ème état* in

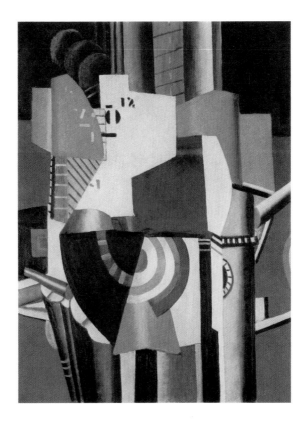

Fig. 6 *La Ville* (The City), fragment, third version, 1919, oil on canvas, 133.4 x 99.6 cm. Philadelphia Museum of Art, The Louie and Walter Arensberg Collection (B 159)

1919 (fig. 6), re-used a range of pictorial elements initially brought together in the *Typographe* series (fig. 5), which itself was the result of a process of abstraction whose starting-point was two drawings of *poilus*.[45] That first series of *Ville* paintings also gave a central role to an 'abstract' motif that for Léger was entirely new, the disc; it was to remain a major feature in the final version of *La Ville*.

By abstracting the *poilu* of his 'war drawings' and recycling his pictorialized elements as the elements of the city, Léger took him from war into peace – he pacified him. Léger's introduction of the disc into his repertory was equally a factor in the pacification of his work. Recent research on the small painting *Composition: Le Disque* (Composition: Disc; pl./p. 138), in the Thyssen-Bornemisza Collection has established the likelihood that it was Léger's first attempt to give his own post-War stamp to a motif that he knew well enough had been a central pre-War feature of the 'pure painting' of the Delaunays.[46] *Le Disque* is dated on the verso October 1918, and an X-ray has revealed that the present composition is a modification of a first version, over which it was painted.[47] This first version used all the

28 *Le Feu*, p. 376.

29 *Le Feu*, p. 263; for Léger, Letter 7 (Neufour, 30 km from Verdun; 8 November 1914), in *Correspondance ... à Louis Poughon*, p. 22.

30 See Letters 10 (Argonne, 1 January 1915) and 13 (Maison Forestière, 30 May 1915), in *Correspondance...à Louis Poughon*, pp. 28, 36

31 For his anti-nationalism in the *Lettres de Henri Barbusse*, see the letters of 19 January and 14 April 1916, pp. 189-90 and 201-2.

32 Becker considers at length the fortunes of the pacifist and defeatist positions during the War in *The Great War and the French People*.

33 Colin, 'Writers and the War', in *The Great War and the French People*, p. 168.

34 It has been argued that the pervasiveness of nationalism through the War is demonstrated by the rise in the circulation of *L'Action française*. Certainly *L'Action française* was taken seriously, and its circulation did indeed rise to 156,000 copies in 1917, but not all of its subscribers were necessarily sympathizers. In a letter of 9 July 1917, Barbusse considers subscribing himself, because he wants to know what 'those dangerous brutes' are saying. See the *Lettres de Henri Barbusse*, p. 255.

35 Letter 13 (Maison Forestière, 30 May 1915), in *Correspondance...à Louis Poughon*, pp. 35-6.

36 Letter 37 (Champagne, ?1917), ibid., p. 80.

37 For 'concerts', see Delvert, *Histoire d'une compagnie*, p. 212; for natural metaphors, ibid., pp. 209, 215, and *Le Feu*, pp. 7, 227.

38 *Le Feu*, p. 235.

39 Letter 13 (Maison Forestière, 30 May 1915), in *Correspondance...à Louis Poughon*, pp. 35-6.

40 Letter 29 (Verdun, 7 November 1916), ibid., pp. 67-72.

41 *Le Feu*, p. 19.

42 Roland Dorgelès, *Les Croix de bois*, Paris, 1919, pp. 103-4; translated as *Wooden Crosses*, London, 1920, p. 85.

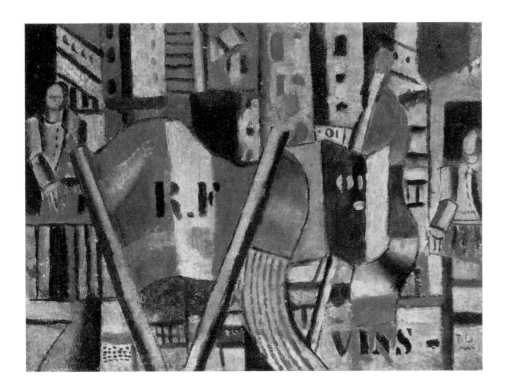

Fig. 7 *Le 14 Juillet 1918 à Vernon*
(14 July 1918 at Vernon), 1918, oil on
canvas, 27.5×33.2 cm. Private collection,
Brazil (B 105)

43 See Letters 3 (5 October 1914), pp.
10-12, and 33 (Champagne, 13 Feb-
ruary 1917), in *Correspondance…à
Louis Poughon*, p. 76. For an excel-
lent exploration of this topic and its
implications for Léger's involve-
ment with *La Création du monde*
and the development of his notion
of the 'modern primitive' after the
War, see Jennifer Krasinsky, 'The
Recreation of the World: Fernand
Léger and the Birth of the Mechan-
ized Primitive', report submitted
for the degree of MA, Courtauld In-
stitute, University of London, 1993.

44 Letter 12 (Argonne, 12 April 1915),
in *Correspondance…à Louis
Poughon*, p. 35.

45 The process of abstracting from the
poilu drawings and the relationship
between the first *Ville* series and
the *Typographe* series are analysed
in detail in my *Léger and the
Avant-garde*, pp. 153-7, 174-7.

46 This new research is, like my new
work on the *Escaliers*, associated
with my projected catalogue of the
French and Western European paint-
ings of *c.* 1904-*c.* 1966 in the Thys-
sen-Bornemisza Collection (see note
9, above). The problems raised by
the *Disques* as a series and of *Le
Disque* in particular will be dis-
cussed in much greater detail there.

same elements and also centred on the disc; it
could have been painted as early as mid- or
late summer, possibly at Vernon, where in
July, after leaving hospital, Léger rented a riv-
erside house.

At Vernon Léger painted one of the few
openly patriotic pictures he produced during
the War, *Le 14 Juillet à Vernon* (fig. 7); it
came immediately after the halt of the German
summer offensive, and as French morale
picked up.[48] There were, in fact, two: the
other is *L'Armistice* (fig. 8), painted at the mo-
ment of Allied victory. They are both, literally,
flag-waving paintings. *Le 14 Juillet à Vernon*
sets the flat colour of the flags against deep
blue; in very much the same way, the satur-
ated colour of the disc in *Le Disque* is set off
by blue depths, while the undulating band
clearly echoes the lines of draped flags. *L'Ar-
mistice*, painted, as it obviously was, after 11
November 1918 (Armistice day), is the sequel
to *Le Disque*, which opened the way to a series
of paintings of 1919-20, where the disc motif
accompanies vertical strips with colour bands
in an urban setting of buildings with bal-
conies.[49] These disc paintings are comparable
with, but less elaborate than, the major compo-
sition, *Les Disques* (pl./p. 137); in them, the

disc and the vertical strips with colour bands are
direct replacements for the flags of *L'Armistice*.

The emergence of the disc as a motif in
Léger's work is not simply to be understood, of
course, as the discovery of a substitute for the
tricolore. Also in 1918, it is found standing in
for the face of one of Léger's *Les Acrobates
dans le cirque* (Acrobats at the Circus; pl./
p.157), and the way Léger uses it in city set-
tings clearly echoes the passage from Blaise
Cendrars's *Profond Aujourd'hui*, which placed
the disc motif, with the Delaunays very much
in mind, in the context of the red and blue
signal-lights that flashed from the top of the
Eiffel Tower.[50] Yet, the way that Léger used it
to replace the flags of his two little patriotic
paintings of 1918 underlines the *lack* of ex-
plicit patriotic reference to be found in the
stream of pictures he produced after *La Partie
de cartes*. The abstraction in Léger's work in
1918-19 may seem anomalous in a develop-
ment said to be dominated by the 'return to
the subject', but it served the purpose of de-
taching his painting both from the War and
from the triumphalism of patriotic zealots.
The cylinder paintings, like the *Typographe*
series, extract the *poilus* of the 'war drawings'
from the context of war, so that even the
studies for *La Partie de cartes* (fig. 11) painted
as sequels to his major war painting are no
longer, explicitly, war paintings.[51] In 1916
Léger considered working towards an exhibi-
tion of his 'war drawings' for the Peace.[52] In
fact, when he showed at the Galerie de l'Effort
Moderne in February 1919, despite the central
importance given *La Partie de cartes*, war and
victory had been excised as themes from his
painting. Even *La Partie de cartes* itself was
not necessarily to be read in triumphalist or
nationalist terms, despite the fact that the sol-
diers' *képis* explicitly identify them as French.
The French *poilu*, heroic in his anonymity,
had, after all, been celebrated in *Le Feu* as the
potential leader of an internationalism to end
war. Perhaps, as Léger left behind him the
images and the emblems of the War and
moved through 'abstraction' into images of
peacetime, he heeded the 'sombre soldier'
whom Barbusse has murmur: 'It would be a
crime to exhibit the fine side of war, even if
there were one!'[53]

Le Disque of October 1918 (pl./p. 138) is the most abstract of all Léger's disc paintings: the rest more or less clearly place the disc motif in a city setting, and the sequel to *La Ville* was to be a conflation of *La Ville* with *Les Disques* – *Les Disques dans la ville*. *La Ville* (pl./p. 145) is unequivocally a peacetime painting with a peacetime subject: Paris. If it is clear enough that the simultaneist panorama of *La Ville* carries echoes of the Delaunays' pre-War literary simultanism, it is also clear, however, that the fracturing of its space, which allows the piling up of its city elements, has its origins in a group of Léger's 'war drawings': his drawings of a city destroyed, Verdun (figs. 9 and 10).

These drawings were made, each one at speed and with great intensity, during the brief period of respite after Léger's return to Verdun from his day and night in the 'wilderness' of the Douaumont sector in November 1916; they are the immediate product of that moment of return which allowed him to 'taste life intensely, as children do'. I have elsewhere commented on their shattered, proto-simul-

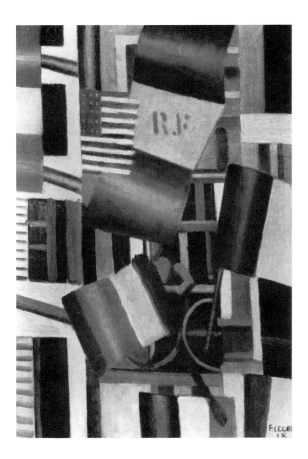

taneist character, and on the fact that this seems to have been 'the direct consequence of Léger's subject'.[54] A letter of 23 November to Poughon gives confirmation.

> In this Verdun there are subjects that are entirely unexpected and sure to delight my Cubist spirit. For example, you come across a tree with a chair perched up in its branches.[...] All you'd be doing is copying [what you'd seen]. Verdun sanctions a painter's every whim.[55]

What the shattered compositions of these tiny drawings gave Léger was the key to a large-scale mode of composition that could contain the intensity of his experience of 'things'; this would allow him, as it did in *La Ville*, to accumulate one *thing* after another, each of which is given an equivalent value: smoke, steel structures, advertising hoardings, lights, buildings, staircases, people – mechanized and in movement.

Perhaps the defining feature of the simultaneist mode developed for *La Ville* is its enumerative character. The elements of Léger's experience are, each one, identified, recorded and made a part of a celebration of the city in terms of 'things'. The pre-War *'escaliers'* subordinate still their machine-man subjects to pictorial imperatives: they are built from a vocabulary of geometric solids used equally to construct still-lifes and derived from subjectless experiments.[56] In *La Ville* the enumeration of the elements of the subject establishes its overriding value – 'things in their "value"'; the composition is built following a mode that is the direct consequence of a city subject, even if that subject was Verdun. The simultaneist mode, allied to Léger's continuing application of his law of contrasts, allows, moreover, a sustained intensity of pictorial pitch across the entire surface of the painting far beyond that of the *Fumées sur les toits* (fig. 1).

After the return to the calm of Verdun from the 'intelligent' destruction wrought by the artillery, came the return to Paris. *La Ville* witnesses the keeping of Léger's promise to Poughon that, 'if my mother's God allows me [...] I'll walk about [in Paris] like I've never before walked about there.'[57]

What then of the machine-men who descend the staircase in the very centre of the

Fig. 8 *L'Armistice* (The Armistice), 1918, oil on canvas, 55 x 37.5 cm. Private collection (B106)

47 The X-ray, supplied by Emile Bosshardt of the Fondación Thyssen-Bornemisza Collection, Lugano, will be published and analysed in relation to the final painting in my catalogue (see note 46, above).

48 See Becker, *The Great War and the French People*, pp. 314-16.

49 Georges Bauquier, *Fernand Léger: Catalogue raisonné de l'œuvre peint, 1920-1924*, II, Paris, 1992, nos. 152, 153 and 154.

50 For a discussion of the disc motif in Léger in the context of *Profond Aujourd'hui*, see my *Léger and the Avant-garde*, p. 185.

51 Interestingly, they combine the cylinder with the staircase motif.

52 'I hope later to put on an exhibition of the drawings I made at the Front', Letter 30 (Verdun, 23 November 1916), in *Correspondance...à Louis Poughon*, p. 72.

53 Barbusse, *Le Feu*, p. 376 (English translation, p. 342).

54 Green, *Léger and the Avant-garde*, p. 109.

55 Letter 30 (Verdun, 23 November 1916), in *Correspondance...à Louis Poughon*, p. 72.

56 I discuss the relationship between the *Escaliers* and specific still-lifes in *Léger and the Avant-garde*, pp. 85-90. See also note 12, above.

57 Letter 12 (Argonne, 12 April 1915), in *Correspondance...à Louis Poughon*, p. 35.

Fig. 9 *Verdun*, 1916, pencil on paper,
20.2 x 16 cm. Musée National d'Art
Moderne, Paris. Bequest 1985,
AM 1985-421 D

Fig. 10 *Verdun*, 1916, pencil on paper,
20 x 13.8 cm. Musée National d'Art
Moderne, Paris. Bequest 1985,
AM 1985-422 D

58 Letter of 14 April 1916, in *Lettres
de Henri Barbusse*, p. 202.

59 Ibid., letters of 13 and 26 October
1916; pp. 226, 234.

60 These strikes are discussed in
Becker, *The Great War and the
French People*, Ch. 17.

city? They obviously were not to be read as the machine-men of the *'escaliers'* paintings could have been in 1914; these were not the quasi-Futurist models for the men of a mechanized future to whom war would be *sola igiene del mondo* ('the only purifier of the world'). But were they to be read, on the other hand, simply as surrogates for Léger's 'great *post-War* generation', and thus as open still to essentially positive responses, this time of a constructive rather than a destructive kind? The likelihood must be that in 1919-20 they carried with them, in fact, the ambivalence of Léger's wartime attitude to the abstraction of mechanization in modernity. They are modern and de-sentimentalized, and, certainly, therefore thoroughly resistant to the nationalist rhetoric of Barrès, but they have also been made subject to the power of the 'intelligent' men, those who controlled the War as an 'abstraction'. Their construction, as if out of the working parts of artillery pieces, said so. In the context of 1919, a year when widespread industrial unrest accompanied the election of the deeply conservative 'blue horizon' chamber, they cannot have carried solely positive meanings, especially for those on the Left.

As early as April 1916, Barbusse was writing to his wife of 'the very great pains that are taken, despite the Union Sacrée, to slow and destroy the endeavours of the Socialists'.[58] In a letter from hospital that October, he wrote of the 'fierce, stubborn, insuperable hatred of Socialism' that he found in *La Revue Hebdomadaire* and *L'Echo de Paris*, and later remarked: 'I am very aware of how *Le Feu* is being praised because of the big role this book may play in the battle of ideas'.[59] Despite the increasingly raised voices of the nationalist propagandists given such weight by Kenneth Silver, from 1916 and especially from spring 1917, as Becker has shown, the voices of the internationalists and the pacifists were increasingly heard also. The strikes of May and June 1918 in Paris, the Isère and the Loire are evidence of a real strengthening of pacifist-socialist feeling at a moment when anxieties were strong as a result of the German offensives of the spring.[60] The Left might have lost the elections of 1919, but long before them the Union Sacrée had fractured enough for a 'battle of ideas' to have significantly modified the ideo-

logical topography of French society. Léger's refusal of explicit war subjects and patriotic French imagery closed off his work from explicitly nationalist readings. Equally, his refusal (at least at that moment) of the Platonic 'call to order' that he found dominant among the Cubists of L'Effort Moderne in Paris, closed off his work from the kind of implicitly nationalist readings that went with Léonce Rosenberg's intellectual priorities.

Rosenberg held up the logical thinking of Maréchal Foch (one of the 'intelligent' men who had controlled the War) as a model for Juan Gris and, indeed, for Léger too; as we have seen, it was precisely the 'abstraction' of Foch and his like that Léger rejected in favour of 'things'.[61] What Léger produced in 1918-20 cannot be called socialist or internationalist painting, but, where it was closed to those who responded to the warlike passion of Barrès, it was open to those who responded to the pacifist passion of Barbusse. It represented Léger's faith in the *post-War* generation.

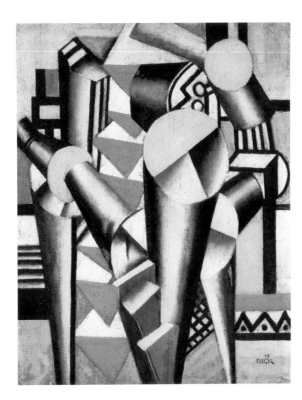

Fig. 11 *Etude pour 'La Partie de cartes'* (Study for 'The Card Game'), 1919, oil on canvas, 92 x 73 cm. Staatsgalerie Stuttgart (B 173)

61 In a letter of 25 August 1918 to Léonce Rosenberg, Juan Gris mentions 'the book by Foch that you told me about', and asks for a copy to be sent to him. According to Derouet, Rosenberg later recommended Foch to Léger as well. The book in question is Ferdinand Foch, *Des principes de la guerre*, Paris and Nancy, 1917 (translated as *The Principles of War*, London, 1918). See C. Derouet, ed., *Juan Gris: Correspondance, Dessins, 1915-1921*, IVAM, Centre Julio Gonzalez; Musée National d'Art Moderne, Paris, 1990-91, Letters 33, 34 and 38 written at Beaulieu 25 and 30 August and 1 October 1918 (pp. 53, 57 and note 33, 1, p. 83).

Eric Michaud

ART, WAR, COMPETITION: THE THREE BATTLES OF FERNAND LÉGER

'Above all', wrote Apollinaire in 1908, 'artists are men who want to become inhuman. Arduously, they look for the trail of inhumanity, a trail that is nowhere to be found in nature'.[1] Three years later Léger showed his *Nus dans la forêt* (Nudes in a Forest; fig. 3) among the Cubist paintings of the notorious Room 41 at the Salon des Indépendants. Apollinaire, discerning in this work 'the brutal semblance of stacked-up tyres', noted tersely that it was Léger's work that was 'the least human in appearance of any in this room'.[2] In 1913, recalling the same work, he observed how 'the woodcutters themselves bore traces of the blows their axes had left on the trees'.[3] It was, accordingly, in these scars shared by the trees and their torturers, that Apollinaire could detect an inhumanity that was not something natural, but rather a quality *added*, secreted by the artist as a sign of his own spiritual direction.[4]

Whereas Picasso had peopled his own woods with female figures of a sacred eroticism,[5] by turns welcoming and threatening, Léger's forest was inhabited by creatures of a very different sort of 'otherness': in a 'deep and greenish light', one could hardly tell the men at work from the objects of their toil. Everything in the picture was sliced through in the same way by colour, light and volume, as if work itself necessarily unified active and passive elements in the scene. 'I had been overcome by an obsession', said Léger; 'I wanted to dislocate those bodies'. Just as he saw a heroic

'battle of volumes' in the work of these men against nature, so he envisioned his own work as a painter in terms of a long and difficult battle against tradition: 'I spent two years grappling with the volumes of *Nudes in a Forest*, which I finished in 1910.'[6]

It is no exaggeration to claim that Léger thought of all his work as a battle: it was a battle against tradition, opinion and custom, and against its slow progress. 'It was on my feet', he was later to write, 'warring against society, that I conceived and made these living works'.[7] The theory of 'multiple contrasts' (*contrastes multiplicatifs*) that he set forth in 1914 was intended not only to vindicate the character of his latest works, which were based on the principle of 'dissonances'; clearly influenced by Futurism, this theory was also a profession of faith in 'modern life' that saw artistic activity as a struggle against 'bourgeois taste'. In Léger's view, every battle of volumes, every dissonance of forms and colours necessarily bore the mark of the dynamics of society: 'Contrast has always frightened peaceful and complacent people; they remove it from their lives as much as possible; and as they are unpleasantly startled by, say, some billboard, their lives are organized so as to avoid all such uncouth contact.'[8]

None the less, Léger proclaimed 'present-day life, more fragmented and faster moving than life in previous eras', forcing people to register 'a hundred times more sensory impressions than [did] an eighteenth-century artist'. It cannot help but forcefully condense the subject-matter of a picture painted today in the same way that it now breaks up language, which is accordingly 'full of diminutives and abbreviations'.[9]

It is in this sense that the Great War was, for Léger, the expected revelation of an otherness for which he had already yearned; it too unsettled tradition, custom, landscapes and forms, and hastened the advent of a dynamism that, up to this point, only artists had been able to discern. In the logic of the avant-garde, the artist occupied a position that was in advance of others in society both in terms of space and in terms of time; that was why he was not simply a soldier, but a seer. Just as Gleizes and Metzinger contrasted the artist's vision as a matter of course with the blindness

1 Guillaume Apollinaire, *Méditations esthétiques*: *Les peintres cubistes* (1913), ed. L. C. Breunig and J.-Cl. Chevalier, Paris, 1965, p. 48. This first part of the text ('Les trois vertus plastiques') had originally been published in June 1908 in the catalogue of the third exhibition of the *Cercle de l'Art moderne*, held at the Hôtel de Ville in Le Havre. See G. Apollinaire, *Chroniques d'art 1902-18*, ed. L.C. Breunig, Paris, 1981, p. 74; quotation here adapted from English translation: *Apollinaire on Art: Essays and Reviews 1902-18*, New York, 1972, p. 49.

2 G. Apollinaire, 'La jeunesse artistique et les nouvelles disciplines', in *L'Intransigeant*, 21 April 1911; reprinted in Apollinaire, *Chroniques d'art 1902-18*, pp. 211-12; English translation p. 151. At that time this work was called *Nus dans un paysage*.

3 Apollinaire, *Méditations esthétiques*, p. 85; adapted from English translation: *The Cubist Painters: Aesthetic Meditations*, New York, 1949, p. 43.

4 Apollinaire was here perpetuating an image of the artist he had inherited from Baudelaire: wound and knife at one and the same time, the victim his own executioner; see Charles Baudelaire, 'L'Héautontimorouménos' in *Les Fleurs du mal*, Collected in *Œuvres complètes*, I, ed. Cl. Pichois, Paris, 1975, pp. 78-9.

5 See the two works in gouache of late 1907 both with the title *Cinq femmes* (*Baigneuses dans la forêt*) in the Sprengel Museum, Hanover, and the Philadelphia Museum of Art, Collection of Samuel S. White

III and Vera White, reproduced in the catalogue raisonné by P. Daix and J. Rosselet, *Le Cubisme de Picasso*, Neuchâtel, 1979, nos. 127 and 128, as well as the watercolour of spring 1908 in the Hillman Collection at the Museum of Modern Art in New York (Daix and Rosselet, no. 126). See also *La Dryade (Nu dans la forêt)* of 1908 in The Hermitage, St Petersburg (Daix and Rosselet, no. 133), and *Paysage aux deux figures* of late 1908 in the Musée Picasso, Paris (Daix and Rosselet, no. 187).

6 Cited in *Fernand Léger, 1881-1955*, exhibition catalogue, Musée des Arts Décoratifs, Paris, 1956, p. 78.

7 Léger, 'C'est comme ça que cela commence', in *Les Lettres Françaises*, no. 582, 25-31 August 1955.

8 Léger, 'Les réalisations picturales actuelles' (1914), in *Fonctions de la peinture*, Paris, 1965, pp. 22-3; quotation here adapted from English translation, *Functions of Painting*, London, 1973, p. 13.

9 Léger, 'Les origines de la peinture et sa valeur représentative' (1913) and 'Les réalisations picturales actuelles', in *Fonctions de la peinture*, pp. 17 and 20; English translation, pp. 8 and 11.

10 A. Gleizes and J. Metzinger, *Du 'Cubisme'* (1912), Sisteron, 1980, p. 45; adapted from the English translation, *Cubism*, New York, 1913, p. 22.

11 Léger, 'Les réalisations picturales actuelles' (1914), in *Fonctions de la peinture*, p. 21; adapted from English translation, p. 12.

12 Cited by Christian Derouet in his excellent edition of letters written by Léger: *Fernand Léger: Une correspondance de guerre à Louis Poughon, 1914-1918*, Paris, 1990, p. 97, n. 23/3.

13 Letter 30 (23 November 1916), *Correspondance ... à Louis Poughon*, p. 72. Jean Cassou had observed how 'the guns, the wheels, the cannons, the blueish grey of metal must have *given form* to the schematic world his [Léger's] imagination, [must have seemed to] *embody his Cubism*'; cited in *Fernand Léger, 1881-1955*, p. 13. My italics.

14 In *Fernand Léger, 1881-1955*, p. 112. Léger continued: 'Everyone "heard" the war. It was a vast symphony that no musician or composer has yet equalled: "Four Years without Colour".' And in the 1950s:

Fig. 1 *Le Soldat à la pipe* (Soldier with a Pipe), 1916, oil on canvas, 130×97 cm. Kunstmuseum Nordrhein-Westfalen, Dusseldorf (B 100)

of the crowd ('to the eyes of most people the external world is formless'[10]), Léger said that 'the artist's sensibility is always far in advance of the visual norm of the crowd.'[11] Two years later, the artist and the 'crowd' were none the less sharing one and the same world. In March 1916, while he was at the Front in the Forêt d'Argonne, Léger had the following text published in the *Mercure de France*:

> It certainly looks as if the ultra-modern vision of life could not be affected by the spectacle of war, although many feel that the current direction of events is a regression in terms of human progress. The Cubist painters, almost all of whom are now at the Front, are fighting two battles – one military and one artistic. And their works have found new and enthusiastic admirers there, from the common soldier of the second-class to the highest ranks among the staff officers.[...] The decorative capacities of the artist [Léger], which have perhaps been even more stimulated by eighteen months of the Argonne, do not appear at all revolutionary to all these 'stout hearts' who, free of any great obsession with yesterday, are engaged in forging for us the beauty of tomorrow.[12]

Thus, not only had the experience of fighting at the Front ensured the emergence of views in common with those of the artistic avant-gardes, confirming their 'ultra-modern vision of life'; the dynamism of the War had also transformed the soldiers themselves into creators of the new beauty. A few months later, a letter from Léger to his friend Louis Poughon stressed the ultra-modernity of the 'spectacle of war', full of 'multiple contrasts': 'In this Verdun there are subjects that are entirely unexpected and sure to delight my Cubist spirit. For example, you come across a tree with a chair perched up in its branches. So-called "sensible" people would treat you like an idiot if you offered them such a composition. And yet all you'd be doing is copying [what you'd seen]'.[13]

There is, none the less, an element of paradox in Léger's comments. Even though he recognized how the 'Cubist vision' had anticipated a war that now gave it reality, he was often to insist on what was, strictly speaking, the *invisible* character of this conflict: 'A

life of blind men where everything that the eye might record and discern had to hide and vanish. No-one saw the war – [it was] hidden, concealed, going about on all fours, the colour of mud, useless eyes saw nothing.'[14] During these years 'without colour', their grisaille absorbing all the bodies just as, once, the 'deep and greenish light' had absorbed those in *Nus dans la forêt*, Léger's drawings of the destroyed Verdun, as also his gouaches of this time, described a world that was certainly shattered, but that was also less confused and even less fragmented than that of his still-lifes of 1913-14. Paradoxically, the figures of soldiers, living or dead, were more of a piece and more 'glossy' than the figures Léger had painted in peacetime. The *Soldat à la pipe* (Soldier with a Pipe; fig. 1, pl./p. 115), his only large canvas from 1916, not only has greater 'stability'[15] than *Le Fumeur* (The Smoker; fig. 2), painted just before the outbreak of the War: the soldier's body is more complete, the articulation of his limbs less encumbered. A limit had been reached by the War itself in terms of the disintegration of forms, and this was a disintegration that no Cubist artist seemed willing to recapture – 'No-one saw the war'.

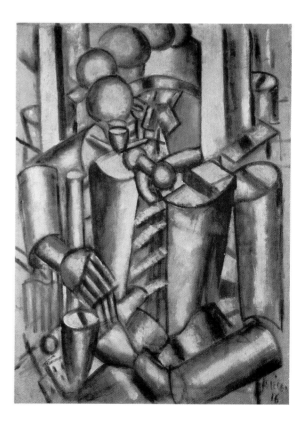

It is certainly more through the *words* contained in Léger's letters from the Front than through his subsequent work as an artist that we can grasp a sense of the realization of a 'Cubist vision', hastened by the War:

> Human remains ... men's heads, almost mummified, sticking out of the mud ... many of them with their fingers in their mouths, the fingers chopped off by their teeth ... the remains of men and [of] objects ... I could never find a pair [of their boots] without legs in them.[...] I stayed long enough to have a good look, to look again, to see the full horror of the spectacle, to have a sure grasp on it, to have an absolutely and rigorously clear idea of this drama. I've [now] had my fill of it.[16]

Clearly, though, Léger the painter chose not to see what Léger the soldier and stretcher-bearer saw: these pairs of boots with their legs serving as a shelter for the survivors, 'this mixture of rotten meat and mud'. Drawing on the intense 'passion for survival' described by Elias Canetti, what Léger and numerous other soldiers remembered of their experience at the Front had less to do with rotting flesh and death than with the vast deployment of energy to which the War gave rise.

In his *Ecrits du temps de la guerre*, Teilhard de Chardin perceived that 'the Front is not only the line of fire, the corroded surface of two nations engaged in attacking each other, but also in some sense the "front of the wave" bearing humanity on towards its new destinies. [...] It seems that [in war] one finds oneself at the extreme limit of that which has been achieved and that which is in the process of coming into existence.'[17] It was this same energy and the means by which it propelled man towards an extreme limit of action that fascinated Léger at Verdun. He wrote:

> [Here, in this landscape,] entirely transformed by the effect of shell-fire [...] what one has to watch is the work that men are doing. Just think of that, you happy civilian: the work that these men will have done during these dreadful years. One forgets about that in thinking only in terms of the fighting.[...] One needs a disaster like this in order to [be able to] assess values to the full, the value of a 'man' is extraord-

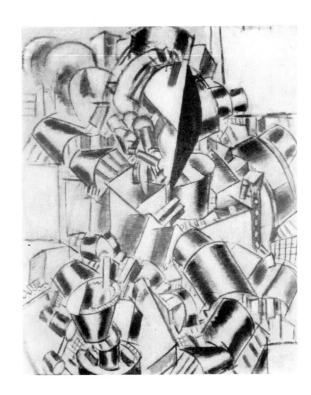

inary.[...] The transformation, the incredible work that is achieved. I didn't know about all that, above all I hadn't seen it at close quarters.[18]

In the same letter Léger again described how this incredible work appeared as the embodiment of a rhythm – a rhythm dictated by the engines of war and which swept all men along in a single movement, absorbing and reconciling social classes and nations normally hostile to one other:

> It was work perfectly done. I know something about that. I've still got earache and a headache. I ache all over. It's impossible to describe to you that feast of noise.[...] The orchestra is very full here.[...] With heaps of prisoners], Germans and French all mixed up together, we took part in one of the fiercest artillery assaults we've had here at Verdun. The gunners were like madmen. They bawled with excitement. Just think, they were given orders to *fire faster*. I saw officers in their shirt-sleeves passing shells down the line *so as to hurry things along*! I was really struck by it all, [and] the Germans were as well.[...] I could just see the moment coming when they were going to help our gunners too!¹⁹

It was this rhythm, as much aural as it was visual, that bound men to machines and

Fig. 2 *Le Fumeur* (The Smoker), 1914, oil on canvas, 100 × 81 cm. Private collection (B 92)

'Fifteen months of the Argonne, three months of Verdun.... Like everyone in the Engineers, I was in the trenches. I saw nothing. It's lucky that there's that film by [Léon] Poirier: Verdun [visions d'histoire, 1927]; that showed us the battle!' Cited in *Correspondance ... à Louis Poughon*, p. 95, n. 10/1.

15 See Christopher Green, *Léger and the Avant-garde*, New Haven and London, 1976, p. 118.

16 Letter 28 (Verdun, 30 October 1916), *Correspondance ... à Louis Poughon*, pp. 66-7.

17 Teilhard de Chardin, *Ecrits du temps de la guerre*, Paris, 1965, pp. 201-2.

18 Letter 27 (Verdun, 25 October 1916), *Correspondance ... à Louis Poughon*, p. 64.

19 Ibid., p. 63.

20 Léger, 'Chicago', in *Plans*, no. 11, 1932, cited in *Correspondance … à Louis Poughon*, p. 95, n. 10/1.

21 Gerd Hardach, 'Guerre, Etat et main d'œuvre', French translation by E. Shalgian, in L. Murard and P. Zylberman, eds, *Le Soldat du travail*, *Recherches* no. 32/33, Paris, 1978, p. 290.

22 *Sic – sons – idées – couleurs – formes*, nos. 8-10, August-October 1916, reprinted Paris, 1980, p. 73. Drieu La Rochelle, who became committed to Fascism in 1934, was himself to define the ambiguity of his stance: 'I always wanted to combine contrary ideas: the nation and Europe, socialism and aristocracy, freedom of thought and authority, mysticism and anti-clericalism' (*Récit secret*, Paris, 1961, p. 58); cited from the English translation, *Secret Journal and Other Writings*, Cambridge, 1973, p. 38.

23 'Français! / La première place est à prendre / Prenons la. / Après la guerre il faut qu'on dise de par le monde: / Où fait-on le commerce le plus intense? / En France / Où sont les plus puissantes usines? / En France / Où fait-on les machines les plus perfectionées? / En France / Où sont le mieux accueillis tous les inventeurs? / En France / Ou sont les créateurs? / En France / Où est la vie? / En France / Pour cela que faut-il? / Aimer l'idée neuve' (*Sic – sons …*, pp. 68-9).

24 'Les tendances nouvelles: Interview avec Guillaume Apollinaire' and 'Réflexion XXVI', both in *Sic – sons …*, respectively pp. 58 and 67.

25 *Hissage de forme mobile* (1916, Collection of Henriette Gomès, Paris) is reproduced in D. Cooper, *Fernand Léger: Dessins de Guerre 1915-1916*, Paris, 1956, no. 43. The three *Foreurs* drawings (1916, Musée National d'Art Moderne, Paris) are reproduced in *Correspondance … à Louis Poughon*, pp. 43-5.

26 See R. Garaudy, *Pour un réalisme du XXe siècle, dialogue posthume avec Fernand Léger*, Paris, 1968, pp. 167-8.

27 Léger, 'L'esthétique de la machine, l'ordre géométrique et le vrai' (1925), in *Fonctions de la peinture*, p. 63; adapted from English translation, p. 62.

28 Ibid., p. 65; adapted from English translation, p. 64.

29 'It [the white race] knew only a single dogma from then on – work, anonymous work, disinterested work, that is to say art'; Blaise Cendrars, *Le Principe de l'utilité*

bestowed on the War its character of rhythmical work, absorbing the totality of being. In Léger's memory, war and work were still inextricably connected fifteen years later:

> MacCormick – the assembly shop with the power-hammers. I listen. I know that sort of sound, a dry and hurried din. In a second I'm back at Verdun. It's 1917. The French advance – preparing to attack with the .75 mm cannons, exactly the same rhythm.[20]

The war economy that transformed Europe demanded that the same men sometimes had to fight alternately on two fronts – the military and the industrial: as early as 1915, some 500,000 French soldiers came back to work in the munitions factories. The socialist Albert Thomas organized the 'war of industry', proudly announcing that 'the whole of France is one huge factory'.[21] The artistic avant-garde echoed him in its Paris reviews. In 1916 the journal *Sic*, edited by Pierre Albert-Birot, published 'Usine = Usine', a poem by Pierre Drieu La Rochelle, who was at that time close to Jean Cocteau and Charles Maurras:

> *Comme les coorroies de transmission dans*
> * l'usine familière,*
> *Les obus*
> *croisent le réseau industrieux de leurs*
> * trajectoires*
> *par-dessus la tête des Hommes –*
> *Les Hommes,*
> *rompus séculairement aux besognes qui,*
> *dans les horizons et les années,*
> *tournent en cercle,*
> *tranchent la Terre de leurs rangs frangés de*
> * pioches*
> *Et la volonté des maîtres siffle entre eux,*
> * insinuant coup de fouet.*[22]

> Like transmission belts in the familiar
> factory,
> Shells
> cross the industrious net of their
> trajectories
> above Men's heads –
> Men,
> inured, through the centuries, to the tasks
> that
> in the horizons and the years,
> turn in a circle,
> stand as rows fringed with picks as they
> break up the Earth

> And the will of their masters' whistles
> among them, an insinuating lash
> of the whip.

France, then, was at work; it worked well and with ever greater speed, producing more and more, thanks to the increasingly rational manner in which labour was organized. Albert-Birot had already anticipated a total victory, identifying incipient French power with the triumph of the avant-gardes:

> Men of France! / The first place is for he who takes it / Let's seize it. / After the war, we want them to say, all over the world: / Where do they put the most into doing business? / In France / Where are the most productive factories? / In France / Where do they make the most perfect machines? / In France / Where are inventors made the most welcome? / In France / Where are the true creative spirits? / In France / Where is life? / In France / To this end, what do we need to do? / *Love the new idea.*[23]

Apollinaire, writing in the same issue of *Sic*, said that the War 'had shown the necessity of not lagging behind'; he argued that it 'should modify these movements [of the avant-garde] and shift their attention towards something beyond perfection'. The same demand was expressed in a slightly different form by Albert-Birot: 'A work of art should be composed like a precision machine.'[24]

As for Léger, he had of course made some drawings of fellow soldiers from the Engineer Corps at work, as in the case of *Hissage de forme mobile* (Hoisting a Mobile Form) or the three crayon drawings, *Foreurs* (Drillers), in which he saw the subject-matter for a large picture that he would be able to paint when 'away from the Front'.[25] None the less, the fact that Léger abandoned this planned work in favour of his celebrated *La Partie de cartes* (The Card Game; pl./p. 119), a painting of a moment of relaxation and play, makes clear that the representation of mechanized work was much less important to him than being able to paint a work of art 'composed like a precision machine'. It is certainly as difficult, if not impossible, to see in these people playing cards any censure of the way the War had transformed soldiers into robots, as it is to see in this work a profession of faith in the human

ability to create and control.[26] Léger's ambition, born from the heart of the War, was without doubt much more simple, more terrifying in its naïvety: he wanted to fit his own work as a painter, set off to best advantage, into the great process of production, aiming at the maximum efficiency so as to make each picture into a machine of war. This, he believed, would allow him to survive within an 'ultra-modern' world, where economic competition had taken over from armed conflict. While he compulsively repeated that the breech-block of a .75 cannon lying in the midday sun had taught him more than had all the museums in the world, none the less he felt himself, after the War, to be constantly under threat from the 'manufactured object, utterly polychrome, clean and precise, beautiful in itself' – 'the most terrible competition the artist has ever been subjected to. A matter of life or death [...]'. Thus, in his paintings Léger used the mechanical element like 'an offensive weapon that allow[ed] him to brutalize tradition', as 'a means of succeeding in conveying a feeling of strength and power'.[27]

Something aggressively victorious and self-assured exudes from the pictures Léger painted from 1917 onwards, recalling that tendency to 'inhumanity' detected by Apollinaire in the artist's work before the War. But the element of the 'inhuman' that now dwelt in Léger merged with that of a 'humanist' era – realizing its own negativity.

Convinced that 'modern beauty is almost always identified with practical necessity',[28] Léger came to adopt the 'principle of utility' (*principe de l'utilité*) of his friend, the poet Blaise Cendrars, for whom art was to be identified with the anonymous work of the new industrial production, 'a formidable force that nowadays has the whole world in its grasp, shaping it and kneading it'.[29] Such an idea was of course not new – not even for Léger, who remembered that, already in 1912, when visiting the Paris Air Show with Constantin Brancusi and Marcel Duchamp, the latter, standing among the engines and propellers, had exclaimed: 'Painting is finished! Who can do better than this propeller? Tell me, can you do that?'[30] Ten years later Léger replied: 'We must do as well or better'.[31]

At the beginning of the twentieth century, the philosopher and social theorist Georges Sorel began asking whether art in our society was now no more than a relic of times past. The revival of the industrial arts had for its corollary, he said, a certain decline in the fine arts, and one should perhaps now apply to these 'the law of universal work'. Work, becoming ever more intensive and more engrossing, determined the emergence of a society of producers, harnessed to ceaseless toil, their sole concern the unremitting increase of the domain of human power. Well before Le Corbusier, Gropius or Léger himself had recognized that 'beauty is everywhere, in the arrangement of a set of saucepans on a white kitchen wall as well as in a museum',[32] Sorel had concluded that the form of modern art most worthy of attention was that which made 'beauty descend entirely into the useful'. Already in 1901 Sorel had been willing to see artistic value in the work of labourers, and he had insisted on the pleasing volume, the fine proportions and the dignity that were now to be found in the design of large machines: 'they are regarded with love, as man in Antiquity looked upon his temples'. As a 'Proudhonist' Hegelian, Sorel saw modern art thus becoming the revelation of the spirit through work, and so ceased to identify the law of work with a law of slavery and degradation.[33] The same convictions emerged at this time, of course, in Italy – where the importance of Sorel's ideas for Marinetti, as for Mussolini, is recognized – as also in Germany, where Joseph Dietzgen had already conceived work as 'the saviour, the emancipator of the human race'.[34]

Thoroughly imbued, albeit unconsciously, with Sorelian ideology and with its corollary – Bergsonian dynamism – Léger believed, like Sorel, in the 'right of art to uphold the cult of the 'will for power'.[35] Sorel, who saw art as 'an anticipation of the highest and technically most perfect forms of production', regarded the morality of producers as the felicitious combination of the 'forces for enthusiasm' with 'the ethics of good work'.[36] Likewise, in the early 1920s, Léger wanted to recapture the professional conscience of the Early Masters, to make paintings that were *neat*, and that possessed *finish*. He too sought to create *le bel*

(dedicated in 1924 to Henry Ford), Paris, 1925, in *Œuvres complètes*, IV, Paris, 1960, pp. 167-76. In 1919, recalling Léger's recent works, Cendrars wrote that the painter never forgot 'this complex Unity born of the war, the Power of today, the Spirit and the Letter of Profundity'; see Cendrars, 'Fernand Léger', in *La Rose rouge* (Paris), 10 (3 July 1919), in *Œuvres complètes*, IV, Paris, 1960, p. 191.

30 Cited in D. Vallier, 'La Vie fait l'œuvre de Léger: Propos de l'artiste recueilles par Dora Vallier,' *Cahiers d'Art* (Paris), 1954, p. 140.

31 Léger, 'Note sur l'élément mécanique' (1923), in *Fonctions de la peinture*, p. 51; adapted from English translation, p. 29.

32 Léger, 'L'esthétique de la machine, l'ordre géométrique et le vrai'; pp. 64-5; adapted from English translation, pp. 63-4.

33 Georges Sorel, 'La valeur sociale de l'art', in *Revue de Métaphysique et de Morale*, IX, 1901, pp. 251-78.

34 Joseph Dietzgen, 'Die Religion der Sozialdemokratie' (1870-75), Leipzig, 1895; English translation 'The Religion of Social Democracy', in *Joseph Dietzgen: Some of the Philosophical Essays*, Chicago, 1914, pp. 90-155.

35 What excited Léger, Kahnweiler observed, '[was] the picture's will for power; its supreme sovereignty victoriously exerting itself'. *Confessions esthétiques*, Paris, 1963, p. 56.

36 Georges Sorel, *Réflexions sur la violence* (1907), reprinted Geneva and Paris, 1981, pp. 306, 321 and 328; cited from English translation: *Reflections on Violence*, Glencoe, Illinois, 1950, pp. 271, 276.

37 Léger, 'L'esthétique de la machine, l'ordre géométrique et le vrai', p. 63; English translation, p. 62. In the same spirit, Léger was later to say: 'I do my job, study by study, bit by bit, just as one puts an engine together or builds a house'; cited in André Verdet, *Fernand Léger: Le dynamisme pictural*, Geneva, 1955, p. 60.

38 Georges Charensol, 'Chez Fernand Léger', in *Paris-Journal*, December 1924, cited in Green, *Léger and the Avant-garde*, p. 245, where this method of production is located precisely in the context of the standardization then employed by Le Corbusier.

39 Léger, 'L'esthétique de la machine, l'objet fabriqué, l'artisan et l'artiste' (1923), in *Fonctions de la peinture*, p. 59; English translation, p. 58.

40 Léger, 'Note sur la vie plastique actuelle' (1923), and 'L'esthétique de

la machine …', both in *Fonctions de la peinture*, respectively pp. 46 and 55; adapted from English translation, pp. 25 and 54-5.

41 Léger, 'Le spectacle. Lumière, couleur, image mobile, objet-spectacle' (1924), in *Fonctions de la peinture*, p. 143; English translation, p. 46.

42 Léger, 'L'esthétique de la machine …', p. 57; English translation, p. 56.

43 Léger, 'Le spectacle. Lumière, couleur, image mobile, objet-spectacle', p. 141; English translation, pp. 44-5.

44 Léger, 'L'esthétique de la machine…', p. 61; adapted from English translation, p. 60.

45 R. Canudo in *Montjoie!*, April-June 1914, cited in John Golding, *Cubism: A History and an Analysis 1907-1914*, 3rd edn, London, 1988, p. 22. See N. Blumenkranz-Onimus, 'Montjoie! ou l'héroïque croisade pour une nouvelle culture', in L. Brion-Guerry, ed., *L'Année 1913*, Paris, 1971, III, pp. 1105-16. Léger was to work again with Ricciotto Canudo in 1922 when he painted *Skating-rink* for Rolf de Maré's Ballets Suédois; see Judi Freeman, 'Fernand Léger und die Ballets Suédois', in D. Bablet and E. Billeter, eds, *Die Maler und das Theater im 20.Jahrhundert*, exhibition catalogue, Schirn Kunsthalle, Frankfurt am Main 1986, pp. 89-97.

46 Léger, 'Les origines de la peinture et sa valeur représentative' (1913), in *Fonctions de la peinture*, p. 16; adapted from English translation, p. 8. The scorn felt by 'the Left' for the *masses* and for their attachment to the 'sentimental conception' (that is to say, to the 'subject') had been inaugurated in France by Zola's celebrated phrase 'Le sujet pour eux [les peintres] est un prétexte à peindre, tandis que pour la foule le sujet seul existe' (For them [the painters] the subject is a pretext for painting, while for the crowd the subject is all there is), in his article 'Edouard Manet', in *La Revue du XIXe siècle*, 1 January 1867; reprinted in J.-P. Leduc-Adine, ed., *Emile Zola: Ecrits sur l'art*, Paris, 1991, p. 159.

47 Cited in Michel Sanouillet, *Dada à Paris*, Paris, 1965, p. 574.

48 Léger, 'L'esthétique de la machine, l'objet fabriqué, l'artisan et l'artiste', p. 65; adapted from English translation, p. 64.

49 Léger, 'Le spectacle, Lumière, couleur, image mobile, objet-spectacle', pp. 134-5; adapted from English translation, pp. 38-9.

objet, comparing himself to a worker who would never 'dare to turn in a part that was anything less than cleaned, polished and burnished'.[37] He too, at this time, was producing paintings in series, working on as many as twelve canvases at any one time.[38] The works of Léger's 'mechanical period' – and beyond – reveal a perpetual mimetic rivalry with the mythical figure of the worker, the highly moral producer of *le bel objet* or of *la belle machine*. For Léger, however, this rivalry was a form of competition that he perceived to be the struggle for life that was the continuation of the War: 'Two producers then face each other. Are they going to destroy each other?' He found the answer to this question in the law of supply and demand: 'The demand for Beauty is enormous, three-quarters of our daily gestures and aspirations are plagued with the desire for it. Here too, the law of supply and demand functions….'[39] That was why artists were 'still very useful "as producers"', as 'the manufactured object rarely competes on the level of the beautiful', and as 'chance alone governs beauty's occurrence in the manufactured object'.[40] Furthermore, while Le Corbusier, in *L'Esprit nouveau*, defined types of need (*besoins-types*), to which types of object (*objets-types*) should correspond, Léger viewed colour as a vital necessity, one that he felt he had to distribute and apportion wisely within the world of work, the only world that was of genuine interest, in order to give this world a manifest serenity in artistic terms.[41]

Léger's remarks were disconcerting because of their ambivalence. Still swept along by the ultra-modern rhythm of mechanical war, he was full of enthusiam for Abel Gance's film *La Roue* (The Wheel), praising its speedy rhythm, but he also called for calm, rest and the sense of slowing down. Fascinated by the accidental occurrences and the disorder in the spectacle of modern life, he none the less thought that it was the social function of the artist to put order into society through concentrating the modern beauty that had been scattered by chance. Though anti-liberal, he still admired the new urban world, totally controlled by the law of supply and demand, where every storekeeper was consumed by a violent desire to attract more attention than his neighbour.[42]

Though anti-capitalist, he sought his own artistic salvation, none the less, by attracting attention to the states of intense organization in his pictures. Beauty, for Léger, was an 'artistic and commercial plus value', but produced by chance, and unconsciously, by the People. It was raw material, and it was his own task, he thought, to concentrate and organize it in a series of violent contrasts, in order to satisfy the enormous demand for Beauty.

Léger's 'socialism' found its limits in his cult of beauty[43] and in his scorn for the taste of the masses. Both attitudes had a corollary in the artist's redoubtable élitism. Léger believed that there were, above the craftsman, 'some men […], very few,… capable of raising him […] to a height that towers above the primary level of Beauty'. The craftman's 'raw material' could then be 'ordered, absorbed and fused in their brains, with a perfect balance between the two values: the conscious and the unconscious, the objective and the subjective'.[44] Before the War this élitism was something that Léger already shared with Ricciotto Canudo, who had founded the review *Montjoie!*, 'Organ of French Artistic Imperialism'. This publication aimed at providing the élite with an intellectual direction and declared itself against all sentimentality in art and in life.[45] This was a point of view defended by Léger in his first lecture at the Académie Wassilief, which he published in May and June 1913 in Canudo's review (where Gleizes was praising the old Celtic traditions of order, force and discipline). 'The sentimental notion in the visual arts is certainly the one closest to the hearts of the masses.'[46] From 1920 Léger shared the same fierce élitism with his friends from the *Esprit nouveau* circle; it was an attitude that only the urgent need for national unity in the war effort had seemed, for a while, to mitigate. Anti-sentimental and anti-bourgeois, this predator in the 'jungle' of the city sought, in 1921, to 'breathe a little' and went back to live in the country. The following year he asked himself if he was living in a state of war or in one of peace: 'If there's a state of war (exaggeration of the means of attack and of defence), does it permit a revision of human values?'[47] As far as he was concerned, 'the state of war [was] much more normal

and more desirable than the state of peace'. 'Naturally', he added, 'everything depends on the position from which you look at it – whether hunter or prey. From the sentimental point of view, I [must] seem to be a monster. [But], throughout my life, I want to know nothing of that point of view. It is an intolerable burden for anyone creatively engaged in the visual arts.'[48] He raged against the individual as king, who, in his pictures, his films and his stage-shows, would have to become, in Léger's view, a means just like the rest, a raw material to be modelled, processed, polished and adjusted. He wanted 'to make the individual disappear in order to use the human material'.[49] Léger's anti-humanism now seemed as if it were a counterpart to his humanist yearning for 'a society without frenzy, [one that was] calm, ordered, knowing how to live naturally within the beautiful without exclamation or Romanticism' – a religion that he believed to be both useful and beautiful.[50]

Thus it is not surprising that Léger often came close in his ideas to a sort of socialism that had lost its bearings, that of French Fascism 'neither of the right, nor of the left' that characterized the review *Plans*, to which he contributed in 1931-2.[51] Le Corbusier, Hubert Lagardelle, François de Pierrefeu and Pierre Winter made up the editorial board of this review, which was edited by Philippe Lamour. All, whether directly or otherwise, were disciples of Sorel, and gathered together to affirm their belief in 'real man', as opposed to the 'abstract man' of 'individualist democracy'. Lagardelle, Winter and Lamour had joined the *Faisceau*, founded in 1925 by Georges Valois, the first Fascist organization to be established outside Italy.[52] In the pages of *Plans*, Pierre Winter pursued the apologia on which he had embarked in *L'Esprit nouveau* in 1922,[53] and continued in the Fascist journal *Le nouveau siècle* in 1927: an apologia for a 'new body' (*corps nouveau*), in full bloom both at work and at leisure in a rationally organized society.

In painting these bodies at rest, powerful and healthy, reconciled with their environment – an environment both mechanical and natural – Fernand Léger was responding to the types of need (*besoins-types*), dubious and contradictory, of an artistic and intellectual 'élite'.

This was an élite both fascinated and repulsed by a world of work which, though perhaps the only one worthy of serious interest, also appeared increasingly boisterous and threatening. Léger also preferred to describe his own work as an artist as a battle against forces that were natural rather than social: 'Let us [...] look, with our eyes wide open, at contemporary life as it rolls along, shifts and brims over beside us. / Let us try do dam it up, to channel it, organize it artistically. / An enormous task, but one that can be accomplished'.[54] Without doubt, Léger recognized himself as a member of this élite; he was aware of belonging among those masters whose genius consisted, in Hippolyte Taine's phrase, in *creating a race of bodies.*

Fig. 3 *Nus dans la forêt* (Nudes in a Forest), 1909-10, oil on canvas, 120×170 cm. Rijksmuseum Kröller-Müller, Otterlo (B 20)

50 Ibid., p. 143; adapted from English translation, p. 47.

51 In the first issue of this determinedly avant-garde review, Léger extolled the cinema as 'young, modern, free and without traditions'; see 'A propos du cinema', *Plans*, no. 1, 1931, pp. 80-84; reprinted in *Fonctions de la peinture*, pp. 168-71; English translation, pp. 100-104. In issue no. 11, in 1932, Léger published the text 'Chicago' (see note 20).

52 See the outstanding book by Zeev Sternhell, *Ni droite, ni gauche: L'idéologie fasciste en France* (1983), 11th edn, Brussels, 1987; English translation (from 1983 edn) *Neither Right nor Left: Fascist Ideology in France*, Berkeley, Los Angeles and London, 1986.

53 See Karin von Maur, 'Rhythm and the Cult of the Body: Léger and the Ideal of a 'New Man', in *Fernand Léger: The Later Years*, exhibition catalogue, Whitechapel Art Gallery, London, 1987, pp. 33-42.

54 Léger, 'Le spectacle. Lumière, couleur, image mobile, objet-spectacle', p. 142; adapted from English translation, p. 46.

55 H. Taine, *De l'idéal dans l'art*, Paris, 1867, p. 81; cited from the English translation, *The Ideal in Art*, New York, 1870, p. 90.

Fig. 1 Léger on the laboratory set he designed for Marcel
L'Herbier's film of 1923, *L'Inhumaine*

Biographical Notes, 1911-1924

1911

Moves from 14 Av. de Maine into his own studio at 13 Rue de l'Ancienne-Comédie near the Carrefour de l'Odéon. Completes *Nus dans un paysage* and begins *Essai pour trois portraits, Les Fumeurs, La Noce* and the group of paintings '*Fumées sur les toits*'.

April to June: 'The Cubist explosion at the Salon des Indépendants': Léger exhibits *Nus dans un paysage*. According to Apollinaire, 'His work is difficult.[...] The discipline to which he submits himself will order his ideas, and one can already detect the novelty of his talent and of his palette'.[1]

Friendship with the poet Blaise Cendrars begins. Like Apollinaire, Cendrars has links, as critic and friend, with many artists of the avant-garde; but he becomes especially close to Léger.

Léger takes part in the Tuesday meetings organized by the poet Paul Fort at the café-restaurant La Closerie des Lilas, and in the gatherings arranged by the painters Albert Gleizes and Jean

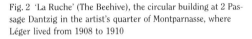

Fig. 2 'La Ruche' (The Beehive), the circular building at 2 Passage Dantzig in the artist's quarter of Montparnasse, where Léger lived from 1908 to 1910

Fig. 3 Guillaume Apollinaire, *c.* 1914

Metzinger. Also attends the meetings at the studio of Jacques Villon (brother of Marcel Duchamp) in suburban Puteaux that leads, the following year, to the exhibition of the 'Section d'Or'.

October-November: Shows *Essai pour trois portraits* in the Cubist room at the Salon d'Automne. Is praised by the poet and critic André Salmon: 'Fernand Léger ... was the first to dare to paint with colours chosen freely and logically. ... Even if his rivals should crush him, Fernand Léger will nonetheless have been their liberator'.[2]

1912

February: The Italian Futurists visit Paris; an exhibition of their work is held at the Galerie Bernheim-Jeune. Fierce polemic against the Cubists.

February-March: Shows *Essai pour trois portraits* at the 'Jack of Diamonds' exhibition in Moscow, alongside pictures by Matisse, Picasso, Delaunay, Gris, Kandinsky and Malevich. His picture attracts the attention of Russian avant-garde artists.

Takes part in the dinners of the 'Artistes de Passy', an association of writers, musicians, architects, set designers, sculptors and painters, chaired by Paul Fort.

August: To André Mare, then engaged in organizing the decoration of the 'Maison Cubiste' for the Salon d'Automne: 'If you have any influence on the placing of works within the Salon d'Automne, exert it, it's important.... I'm asking a lot of you, but the fun is beginning, and for you – and for me too – it's crucial to be there, and with determination'.[3] The Salon hanging committee, of which Léger is a member, compels Marcel Duchamp to withdraw his picture *Nude Descending a Staircase*. Shows two works: 'In 1912-13 it had been a battle to leave Cézanne behind. The effort one had

to make was so enormous that, in order to break away, I had to resort to abstraction. At last, in the *Femme en bleu* and the *Passage à niveau,* I felt that I had freed myself from Cézanne and that, at the same time, I had gone very far from the Impressionist tune'.[4]

October: Takes part in the 'Section d'Or' exhibition at the Galerie de la Boëtie. For Raynal, 'The principal characteristic of the exhibition "La Section d'Or" was probably that it brought together, for the first time and in a representative fashion, all those artists the 20th century was to distinguish from the rest.... Léger appears to be one of the artists of this group who is most deserving [of attention] in that, gifted with a riotous imagination and a violent temperament, he is forced to restrain these as much as possible in order to counterbalance them by precision and reason.'[6]

November: The first book on Cubism, *Du 'Cubisme'* by Gleizes and Metzinger, is published.

3 December: The *Chambre des Deputés* lodges a formal appeal that the Grand Palais no longer be made available as a venue for exhibitions by the Cubists for these were bringing disrepute on the good name of France. Léger later says: 'showing at the Salon d'Automne, I had the advantage of being next to the Aviation Show, which was about to open. Through the partition, I listened to the hammers and the mechanics' songs.[...] I left vast sur-

Fig. 5 The Paris Air Show, an annual event that made a great impression on Léger

faces, dismal and grey, pretentious in their frames, for beautiful, metallic objects, hard, permanent, and useful, in pure local colours [...] The power of geometric forms dominated it all.'[5]

1913

Le Modèle nu dans un atelier completed. Starts work on the large group of the *'contrastes de formes'.*

In his lecture 'La Peinture moderne', Apollinaire calls Delaunay, Francis Picabia and Duchamp exponents of Orphism: 'This dramatic movement in art and in poetry is becoming stronger and stronger in France; it is represented, above all, in the works of Fernand Léger, whose endeavours are highly appreciated by the young painters.'[7]

Shows fifteen pictures at the Galerie Berthe Weill – the largest exhibition of Léger's work before the Great War.

Takes part in the *soirées* organized by Ricciotto Canudo's journal *Montjoie!,* 'where eveyone could be seen once a week. Rodin, Loïe Fuller, all the celebrities of that time were there, but also the men of today and, among them, Léger.'[8]

Works by Léger are included in the touring 'International Exhibition of Modern Art' in New York's 'Armory Show' and in Chicago and Boston.

5 May: Lectures at Marie Wassilief's *Académie* on 'Les origines de la peinture et se valeur representative': 'The *realistic* value of a work of art is completely independent of any imitative character. This truth should be accepted as dogma and made axiomatic in the general understanding of painting.[...] Pictorial realism is the simultaneous ordering of three great plastic components: Lines,

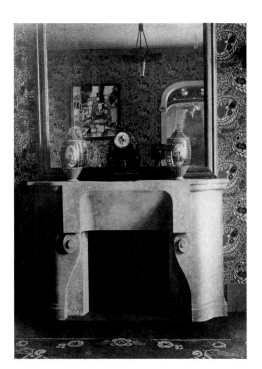

Fig. 4 The 'Salon Bourgeois' in André Mare's 'Maison Cubiste' at the Salon d'Automne of 1912. The fireplace was designed by Roger de la Fresnaye, the painting (reflected in the mirror) is Léger's *Passage à niveau* of 1912 (pl./p. 86)

Forms and Colours.[...] the modern concept is not a reaction against the impressionists' ideas but is, on the contrary, a further development and expansion of their aims through the use of methods they neglected.[...] Present-day life, more fragmented and faster moving than life in previous eras, has had to accept as its means of expression an art of dynamic divisionism; and the sentimental side, the expression of the subject (in the sense of popular expression), has reached a critical moment.[...] The modern conception is not simply a passing abstraction, valid only for a few initiates; it is the total expression of a new generation whose needs it shares and whose aspirations it answers.'[9]

20 October: The Galerie Kahnweiler becomes the sole representative for his work.

Establishes his studio at 86 Rue Notre-Dame-des-Champs, the same building as Mme Hamelin's Academie Moderne.

1914

'Escalier' and *'Maisons dans les arbres'* series completed, as are *Le Reveille-Matin* and *Le 14 Juillet.*

Meets Jeanne Lohy (1895-1950), whom he later marries.

9 May: Gives his second lecture at the Académie Wassilief, on 'Les réalisations picturales actuelles'.

1 August: Mobilization. At the end of the month he is sent to the Front.

5 October: Writes to his childhood friend Louis Poughon: 'As an impression, it's extraordinary; I say "extraordinary" because, for me, the phase of being horrified has long passed. One gets used to everything.[...] It's the squad, this little family of

ten fellows, that is the backbone of the whole machine.[...] It's truly splendid, with these men you have no sense of effort, they're so good at the job [...] I remain an uprooted civilian, and someone who exhibits surprize and admiration that are inexplicable to them.'[10]

Fig. 7 Fernand Léger, *Jeanne Lohy*, 5 August 1914
Fig. 6 Daniel-Henry Kahnweiler in Picasso's studio in Boulevard de Clichy, *c.* 1910, photographed by Picasso

During the lulls in combat he sketches on sheets of notepaper and pieces of cardboard. From October he serves as a stretcher-bearer.

17 November: To André Mare: 'When I hear our French bourgeois howling because they [the Germans] have hit Reims Cathedral, I find it idiotic. Either we're at war or we're not. From the moment you cease to have any regard for human life, you're not going to be much bothered about a fine monument or a private house'.[11]

Galerie Kahnweiler closes; Kahnweiler remains in exile in Switzerland until 1920. The collections of Kahnweiler and Wilhelm Uhde are confiscated by the French state as enemy property, including over forty pictures by Léger, about two-thirds of the work he produced during the period 1911-14.

1915

28 March: To Jeanne Lohy: 'You can tell all those nitwits who wonder if I am *still a Cubist,* or will be when I return, that I'm now more [Cubist] than ever before. There's nothing more Cubist

than a war like this one: it pretty neatly cuts a fellow up into several pieces for you and sends them to the four corners of the earth.'[12]

12 April: To Poughon: 'I'm sure that this war will have taught me how to live.[...] You, you'll remain a pre-war man and that will be your punishment, Louis, my old friend, and I – in spite of my 34 years, in spite of my having embarked on both my life and my career, and having had both broken in two by this tragedy – all the same – I'm still young enough, alive enough to be [...] one of the great post-war generation.'[13]

July: Is lightly wounded, and given a short period of leave in Paris. Despite the efforts of Poughon and Mare, he is not transferred to a camouflage unit, in which many artists serve.

Nils de Dardel acquires a collage made by Léger during the War. Léger writes to Dardel about the few pictures still in his own possession: 'They are attempts at something rather abstract (Contrasts of forms and colours) that I was trying to carry out in a large painting which would have been called *L'Escalier.* My energies were totally absorbed by the war and so I was prevented from achieving what I had wanted to do.[...] The war came too late [in my career] to have any influence on me. I'll go on with the same effort [and] the same tendencies.'[14]

Fig. 8 Léger's *Autoportrait* of 1914. Both drawings were made in a notebook shortly before Léger left for the Front

1916

22 January: To Poughon: 'And I know that, behind my back, the artistic life, the life that used to be mine, is starting up again. They all got out

of fighting. All of them, they knew what strings to pull when it became necessary. All of them, I tell you. In Paris they're painting, working and selling even more than before'.[15]

Late January to early February: Second leave in Paris. Paints *Le Soldat à la pipe*. In company with Apollinaire, sees his first Chaplin film.

Rolf de Maré buys *Le Fumeur*.

September: Proposes to paint a large picture while at the Front – *Les Foreurs*.

October to December: Camped outside Verdun. Writes to Poughon about German prisoners-of-war taken after the bombardment of Douamont: 'It's a parade that I'll always remember, those lumps of mud with gaunt faces and dead eyes.... You can't beat that for misery, for mental and physical suffering.... For me this day provided one of the strongest emotions of this war.'[16]

11 December: To Jeanne Lohy: 'It's a wilderness, you know, Verdun, a wilderness created by modern artillery, where there is nothing left but broken-up earth with the remains of men mixed into it. And one has to live in that! One has to live in that!'[17]

1917

From January: At the Front in Champagne.

25 February: To Charlotte Mare: 'Thank you for the information about exhibitions, but I've already parted with too many things, in view of the little that I paint, and I think that at the moment one still sells more in Paris. Diaghilev has just bought from me one picture and some drawings [...] So I hesitate to part with everything. A month ago I did some quite large watercolours, I think you'll see them at Barbazanges in May'.[19]

28 February: A newspaper article announces an exhibition in Paris: 'One will be able to admire there the works of Matisse, of Picasso, of [André] Derain [...] and of the sapper Fernand Léger who paints, in the trenches, under shell-fire and who – a clever and affecting detail – sticks small scraps of paper to his canvas to make up for the colours that he lacks'[18]

July: On leave again, when he falls ill. For the next eleven months is in various hospitals in and near Paris.

December: To Poughon: 'Paris is incredible, with the short skirts and the khaki uniforms! A dazzling sexuality! Oh! – those not engaged in making war, how keenly they've been making love, it's pretty normal, after all. Prostitution is everywhere, encroaching on everything. Ah, the

restrictions [on a soldier's behaviour]. I'm waiting to see what decree they issue regarding this fine industry. As for me, I adore it all, for these are splendid contrasts.'[20]

Produces his principal work of the War years, *La Partie de cartes*, 'the first picture where I deliberately took my subject from what was going on around me'.[21]

The gallery owner Léonce Rosenberg, who has established himself as one of the leading modern art dealers in Paris following Kahnweiler's exile, becomes Léger's sole agent (formal contract registered 9 August 1918): 'It's an agreement for three years, starting as soon as the war is over, or as soon as I can work if I am invalided out. It brings me between 20,000 and 25,000 francs per annum. [...] So that's me set up for the post-war years'.[22]

1918

Hopes to be discharged. Writes to Rosenberg on 9 January: 'For me this is the crucial moment. If I get out [of the army] I'll be able to paint! I'll be able to work! My horizon stops there, it's the best thing that I know!'[23] Is provisionally released from military service and moves to Vernon (Eure *département*). Makes the metropolis, technology and machines his subject-matter: *Les Hélices, Les Disques, Le Mécanicien, Le Typographe* and *Le Cirque*.

Fig. 10 Blaise Cendrars in uniform after having his arm amputated, 1915-16

To Rosenberg: 'As soon as I was freed, I started to profit from those difficult years; I've reached a decision, and I'm modelling in pure, local colour and on a large scale without making any concessions.[...] The war made me what I am, I'm not afraid to say so.'[24]

Provides five drawings as illustrations for Cendrars's book about the War, *J'ai tué*.

11 November: Armistice.

Amedée Ozenfant and Le Corbusier publish their manifesto of Purism, *Après le Cubisme*.

Fig. 9 Invitation to Léger's first one-man show at Léonce Rosenberg's Galerie de l'Effort Moderne in 1919

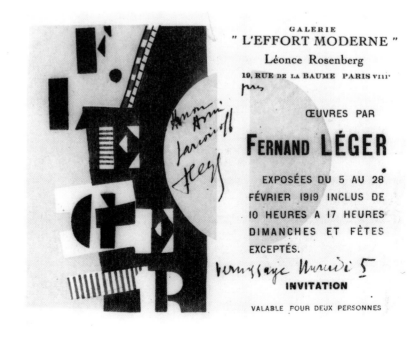

1919

Begins the series *Le Déjeuner*; Paints *La Ville*: 'In technical terms, this picture is a revolution in three-dimensionality. It was possible to achieve a depth and a dynamism without using chiaroscuro or modulation.[...] Colour was free. It was a reality in itself. It had an action that was new and completely independent from the objects which, before this time, had been entrusted to contain it or to bear it.'[25] According to Ivan Goll: *'La Ville* is the sensation of a primitive travelling for the first time on an electric tram. It is a creature that screams at us, with unscaleable giant verticality, unapproachably threatening. Crash. Shriek. Movement. Everything for this "movement" that, for an entire generation of poets and painters, appears as the primal element.'[26]

February: First one-man show, in Rosenberg's Galerie de l'Effort Moderne.

Illustrates, and also designs, Cendrars's *La Fin du Monde, filmée par l'Ange Notre-Dame.*

Resumes contact with Herwarth Walden in Berlin. On 7 September writes to Walden: 'Now, is your Autumn Salon going to open all right? Do you see a possibility for paintings by French artists to be included in it without the fear of complications? On what date [is the opening]? I put myself at your disposal, I'll be glad to organize painters and works into groups for you.[...] Then again, I'm on the Committee of the Salon des Indépendants. We intend to have a stupendous re-opening in March or April 1920. I've had very serious discussions with [Paul] Signac, the president [of the Committee] on the question of foreign artists [in the exhibition]. I said that if some progressive painters had agreed to join the Committee, it was *only on condition* that there would be no restrictions regarding foreigners, *whoever these might be.'*[27]

30 October: Travels (with Thorvald Hellesen) to Oslo, and then on to an exhibition in Stockholm, where the Nationalmuseum acquires a drawing and a watercolour. The two are back in Paris by late November.

2 December: Marries Jeanne Lohy in Paris; Thorvald Hellesen and his wife act as witnesses.

11 December: To Kahnweiler, in Switzerland, preparing to return in Paris, he sends him notes for an essay: 'Bearing in mind that a picture ought to be materially the opposite of a wall on which it hangs, it should personify movement and life in all its power, everything ought to look dull alongside it'.[28]

Seeks in vain to prevent the compulsory auction of Kahnweiler's stock. Equally unsuccessful is his attempt to buy back his own pictures.

1920

Les Trois Camarades, Le Mécanicien, Le Remorqueur and *Les Disques dans la ville.*

February: Kahnweiler arrives in Paris; three months later he resumes his ties with Léger as dealer. In a 'Brief Consideration of the Contemporary Artistic Existence', Léger defines his new position: 'Clear, true, impartial judgement, the creation of works that will last, an art related to its setting, away from extremes.[...] The appearance of cities – geometric, horizontal, vertical.[...] The concept of colour as an external value belonging to architecture. To make a city sculptural, lively, to permeate and illuminate it with colours. To comprehend the whole in a beneficial and social

Fig. 11 Design for the cover of a volume *c.* 1922 of the journal *L'Esprit Nouveau* (founded in 1920)

Fig. 12 Illustration by Léger for Ivan Goll's volume of 1920, ▷ *Die Chapliniade*

spirit. To divert people from their enormous and often arduous exertions, to envelop them in a vividly new and decisive manner and to make them live.'[29]

Rosenberg wishes to publish a book with Léger on the circus. Léger asks Cendrars to join the project. On 14 March Cendrars responds: 'I'd have preferred some other subject than the circus. It's too literary, Picasso etc. Why not openly tackle a subject and objects that are newer! Machines, pistons, wheels, mechanics. Or the extraordinary spectacle of the street (of which we've talked such

a lot) and call your album "Paris".'[30] The planned volume never appears.

Provides illustrations for Ivan Goll's volume *Chapliniade*, published in Dresden.

Le Corbusier and Ozenfant found the magazine *L'Esprit Nouveau.* Becomes a friend of Le Corbusier and works with him.

At Rosenberg's gallery, sees pictures by Piet Mondrian, Theo van Doesburg and the *De Stijl* group.

24 July: Alfred Flechtheim writes to fellow dealer Paul Westheim: 'Among the people at the Section d'Or, Léger is the only one that interests me, though there's also perhaps Archipenko, who has already contacted me.[...] I want my name associated only with those artists I can support with complete conviction.'[31] In an article Kahnweiler writes of Léger: 'He understands the concept of dynamism not as the Futurists do, though they also termed their paintings "dynamic". They spoke of "dynamism" because they wanted to represent movement – of an automobile or of a train, for example. This ambition is quite alien to Léger. What he intends is that his picture should be in itself dynamic, hectic, lively.'[32]

December: In a letter to Kahnweiler, Flechtheim takes exception to the fact that Braque, Gris, Laurencin, Léger and Picasso were represented at the Section d'Or exhibition at the Galerie de la Boëtie. Kahnweiler informs Flechtheim that he too has refused to show the works of these artists, but that the organizers had 'begged together' works reflecting various artistic directions.[33]

1921

Series of *Paysages animées* and *Le Grand Déjeuner.*

Ivan Goll writes of Léger's new pictures: 'He still has no chance to give voice to the walls of large public buildings, so that they speak with light and power, with hope and beauty.[...] At the moment he acts in accordance with the discipline of inner principles; he again paints 'pictures': still lifes, nudes, people.[...] *Le Déjeuner* is perfectly resolved. Now his works are self-contained units and profit in every way from his attainment of light and power. Calm planes of colour alongside modelled movements: the structure of life in the storm of appearances: man in the world.'[34]

Rosenberg brings together works by Ozenfant and Le Corbusier with those by Gris, Metzinger, Severini, Picasso, Henri Laurens and Léger in the exhibition 'Les Maîtres du Cubisme'.

13 and 14 June: First compulsory auction of Kahnweiler's stock, including seven pictures by Léger. With the help of Flechtheim and others, Kahnweiler is able to buy back three works by Léger: *Nature morte, Maison sous les arbres* and *Les Toits.*

Illustrates and designs André Malraux's volume *Lunes en papier* (Paper Moons), to be published by Kahnweiler. According to W. George, 'This volume, where the printed characters occur not only as the signs of a conventional language, but also as a symbolic means of expression, had a decisive impact on the aesthetics of advertising.'[35]

15 July: Contract with Rosenberg ends, but he remains in commercial association with Rosenberg until 1926.

September: Some of his works are included in the hundredth exhibition of Walden's Sturm gallery in Berlin.

The 'Grand Roue', the large Ferris wheel in Paris, is demolished. Cendrars writes to Léger: 'Add my name to your letter of protest. It's sad that the *Grand Roue* should disappear. Along with the *Galerie des machines,* it's still one of the best aesthetic monuments of Engineering that the stupidity of the Aesthetes will send crashing to the ground'.[36]

September-October: Kahnweiler and Flechtheim discuss the work of Léger and Gris. Kahnweiler writes: 'I must forcefully … insist that you defend Gris and Léger and lend them your support. In our [situation of] solidarity, the interests of all the artists of the Galerie Simon [i.e. Kahnweiler's gallery] must be defended. This politics of opportunity regarding the "sellable", yes for Heaven's sake, if only it were only a question of selling the "sellable".'[37]

Fig. 14 Woodcut design by Léger for the cover of André Malraux's volume of short stories *Lunes en papier,* published in Paris in 1921 by Kahnweiler's Galerie Simon ▷

Fig. 13 View of one of the rooms in the villa designed in 1924 by Le Corbusier for Raoul La Roche, in the Passy district of Paris, with works by Léger (*La Femme et l'enfant,* 1922; pl./ p. 181), Jacques Lipchitz (*Composition,* c. 1920) and Georges Braques (*The Musicians,* 1917-18). All three works were later given by La Roche to the Kunstmuseum Basel

7 October: Flechtheim to Kahnweiler: '[Works by] Léger are flooding the market in Germany – early, unsaleable pictures at the *Sturm* gallery, "at Neumann's", and at a series of smaller dealers. I don't know where all these pictures come from. Without doubt, Léger is here counted as one of the members of the *Novembergruppe.* Through his affiliation with *Sturm* – the *Sturm* still goes on insisting that Léger is a *Sturm*-artist – he has done extraordinary damage to his reputation. People who buy the Cubists prefer to have a Picasso or a Braque.'[38]

Exhibits *Le Grand Déjeuner* at the Salon d'Automne. On 11 November Cendrars tells him: 'I find it solid, powerful, I'm really impressed by it. It has the qualities of cinema.'[39]

17-18 November: Second compulsory auction of the Kahnweiler stock, including ten pictures by Léger.

ANDRÉ MALRAUX

LUNES EN PAPIER

« PRENEZ GARDE, DIT L'ORFÈVRE, CAR VOUS AVEZ AFFAIRE ICI A DES GENS ASSEZ CURIEUX » *nommes (le choix d'une fiancée)*

1922

Femmes dans un intérieur and *La Femme et l'enfant.*

Léger completes the set and costumes for *Skating-rink,* performed by Rolf de Maré's Ballet Suédois on 20 February. When the production visits Berlin later the same month, Carl Einstein writes: 'Léger's talents are enough to justify the very existence of a ballet.[...] The masks and costumes are uncanny and engaging.[...] The professional reporter mentions a strong stylization. The people [here] have already looked like something out of Léger for some time; [so] I was wildly

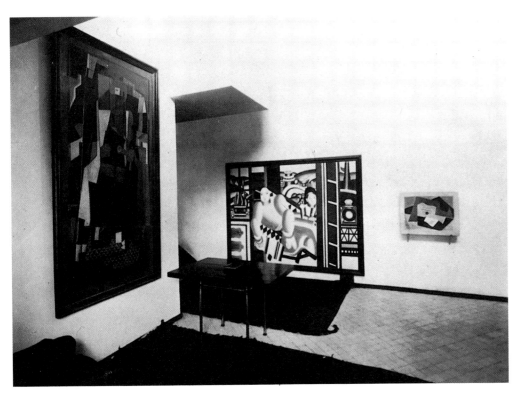

pleased by what was in fact the "realism" of the Leger-style get-up!'[40]

April: The exhibition '… et du Cubisme vers une Renaissance plastique' at Rosenberg's Galerie de l'Effort Moderne, with works by Braque, Gleizes, Gris, Le Corbusier, Ozenfant and Picasso.

Designs the cover for Ilya Ehrenburg's volume *Et pourtant elle tourne*.

July: Third compulsory auction of the Kahnweiler stock, including eight pictures by Léger.

13 September: Einstein wishes to publish a book with Léger and writes to Kahnweiler: 'It's about the setting up of a factory for the production of automata that are more beautiful, better and more intelligent than humans. A sort of joint stock company for fetishes. Humans realize their own seedy inferiority to the automata.[…] Humans are no longer able to keep up with the speed of their perfected automata, and get exhausted. And then as the underlying theme: the perfected things are mechanical. Men ultimately want to get away from being men, they want to

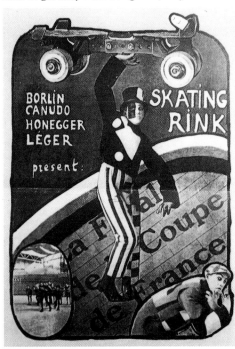

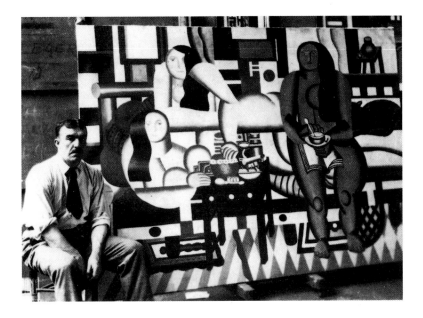

Fig. 16 The artist with his picture of 1921 *Le Grand déjeuner*

based on a scenario by Cendrars and with music by Darius Milhaud. 'In 1923-1924 Blaise Cendrars had been to Africa and South America, and had recently translated a book of primitive Negro songs and poems. He brought with him to Mariette's [Mariette Mills] parties explorers, scientists, and anthropologists. The ambition of the moment seemed to be to become as African-Negroid as possible, and after dinner, when guests congregated in the studio, a great deal of stamping and shouting, and primitive dancing and singing, took place. Brancusi, a Rumanian peasant with a patriarchal beard and mild kind eyes, had lately procured a phonograph and a few records. Brancusi loved Americans and things American, and pranced about as the spirit of the jazz age, although at times wearing his wooden sabbots. Léger and Heyworth and Cendrars stamped and hooted and catcalled until Mariette quieted them down so that Suzanne Penoit could sing selections from Satie in her thin, high, clear voice.'[42]

14 December: First complete screening of Abel Gance's film *La Roue*. According to Léger, 'With *La Roue* Abel Gance has elevated the art of film to the plane of the plastic arts.[…] Whether it be the infinite realism of the close-up, or pure inventive fantasy (simultaneous poetry through the moving image), the new era is there with all its implications.[…] The mere fact of projection of the image already defines the object, which becomes spectacle.'[43]

The Russian poet Vladimir Mayakovsky visits Paris. In *A Seven-day Survey of French Painting* he names his friend Léger as the only avant-garde artist of the pre-War period who has become neither a classicist nor a reactionary.

Fig. 15 Poster for the ballet *Skating-rink* first performed by Rolf de Maré's Ballets Suédois in Paris in 1922 with sets and costumes designed by Léger

do something else.[…] The book can turn out well with Léger.'[41] Flechtheim advertised the book as '*Die Automaten, Eine Groteske*' with lithographs by Léger, but it never appears.

Mother dies. He inherits a farm at Lisores near Vimoutiers, in Normandy, and from this time on, often retires there to work.

Starts work on the costume and set designs for the ballet *La Création du monde (Ballet nègre)*,

1923

Le Grand Remorqueur and *Les Eléments mécaniques*.

In an essay on Léger, the film director Jean Epstein writes: 'In Léger's pictures there is a secret hurricane, which makes them shake like a flimsy hut in a storm. The canvas vibrates, moves,

Fig. 17 Léger's design for the cover of Ilya Ehrenburg's volume *Et pourtant elle tourne*, published in Moscow in 1922

quivers, buckles, stretches, sprouts, grows and ripens within a frame that cracks at its joints. The visual synthesis is not […] completely achieved in this [sort of] painting.[…] The definitive and overall ensemble remains to be constructed. The spectator is placed in the presence of all the elements of

calculation, and he is even given some indications that will help him to find the solution, but the calculation remains nonetheless still to be carried out.[...] The fragmentation used by Léger, like the best of psychological techniques, has no other aim but poetic provocation, the magical invocation of the intimate art of the spectator.'[44]

Shows his work, together with Josef Csaky, at the Salon des Indépendants, including for the first time a coloured architectural composition (destroyed).

Fig. 18 Fernand Léger, *Jean Epstein*, 1922

Kahnweiler and Léger break off their business agreement. Rosenberg complains that Léger's pictures do not sell.

7 May: The fourth, and last, compulsory auction of Kahnweiler's stock, including eighteen paintings and 204 drawings by Léger.

1 June: Lectures on 'L'esthétique de la machine, l'objet fabriqué, l'artisan at l'artiste': 'The street has become a permanent spectacle of increasing intensity.[...] The *beautiful machine* is the modern *beautiful subject*; it too is uncopiable.[...] *What definitive conclusion can be drawn from all that?* That the artisan is everything? No. I think there are some men above him, very few, who are capable of raising him through their visual concept to a height that towers above the primary level of Beauty.'[46]

21 August: To Rosenberg: 'One goes on, but for whom? For onself – for that extraordinary egoism

that makes one do this, and not other things, there's no way of doing something else! One is not permitted to say that one is working for posterity, that's absurd, a fire could destroy everything – so – what an enormous task – as big as ... any invention whatever which astonishes the whole world. And this work, misunderstood by everybody, seen in its full value ... by one or two! I understand the immense distaste of someone like Nietzsche – and his end in neurasthenia and madness. You'd have ... to be wrapped in reinforced concrete to go on when you are born a sociable and responsive person, loving life in its every fleeting detail. For life is beautiful and surprising. I admire it deeply. The older I get, the more I'm aware of the foolish error of the "ivory tower", and of the details of this world.'[45]

Designs the laboratory sets for Marcel L'Herbier's film *L'Inhumaine*. L'Herbier recalls: 'The painter arrives with six watercolours representing abstract volumes without any practical application. This represents on a single plane a whole mechanical forest; trees made of wheels, their trunks made of cones, branches made of levers. No floors, no walls, no ceilings.[...] Where was I going to bring the drama to life? [Confronted with this, Marcel becomes rather gloomy.] The next morning, in the studio, [there's] a man in workman's overalls carrying strange pieces of wood, cut out with great care: it's Fernand Léger. He's become a worker; and, with a saw, some nails and his heart, he's building his own vision of the laboratory.'[47]

25 October: First performance of *La Création du monde*.

November: At the *De Stijl* exhibition at the Galerie de l'Effort Moderne, sees examples of coloured architecture, and in conversation with Le Corbusier on the collaboration of architect and painter comments: 'A red wall, a blue wall, a yellow wall, a black or blue or red or yellow floor, I see a whole transformation of interior decoration.'[48]

Late November: Explains in an open letter to Signac that he has resigned from the Committee of the Salon des Indépendants because of its decision to hang all pictures in alphabetical order and to show the work of foreign artists separately: 'It's the parcelling out, the splintering of the "groupements de tendance" [groups representing trends] which have been the *raison d'être* of the Salon des Indépendants, and crucial to its international renown and its history. If, as you yourself told me with a certain pride, most of the renowned French and foreign artists had gone through and emerged from the Indépendants, it is thanks to the "groupements de tendance", which you yourself profited from in your day. The Impressionists,

Fig. 19 The choreographer and dancer Jean Börlin as an African figure in his ballet *Sculpture nègre*, first performed in Paris in 1920, a work anticipating his collaboration with Léger on the Ballet Suédois, *La Création du monde*

the Pointillists, the Fauves, the Cubists etc. all in their time have given proof of "living values" in this Salon.'[49]

14 December: P. Fierens writes: 'As to the gallery of Léonce Rosenberg: how well one feels there! How deeply one can breathe! Machines [big paintings] – even big machines – by Fernand Léger work silently and without spoiling the architecture. They are very well polished and shine in the Cubist exhibition hall, illuminating everything.'[50]

1924

La Lecture, Le Siphon, Eléments mécaniques, Hommes dans la ville, Peintures murales and *Ballet mécanique.*

Léonce Rosenberg again tells him that his paintings are difficult to sell. (A year later, just after the resignation of the Herriot government, Rosenberg was to remind him: 'Don't ever forget that

all those who love you and who defend you, are on the Left. If the Right should win and endanger the existence of your defenders, you'll disappear with them, only to reappear 30 or 40 years later.'[51])

From early this year Rosenberg publishes the journal *Bulletin de 'L'Effort Moderne'*. On 10 May he tells Léger: 'You note that each of the issues that has appeared so far has made a big feature of you and constitute an excellent form of publicity for your ideas, and the issues that are to follow will do the same.'[52]

From Paris Willy Baumeister writes to fellow artist Oskar Schlemmer about Léger: 'He works a lot. His great big pictures appeal to me for the strength of their impact, their contrasts of values and colours. Some of the figures are too massive. A completely abstract picture is the best.[...] It's in Léger that I detected the spirit of modernity; though it's in the architecture of Jeanneret [Le Corbusier] that this is at its purest.'[53]

1 June: Lectures at the Collège de France on 'L'esthétique de la machine: l'ordre géometrique et le vrai': 'I try to create a *beautiful object* with me-

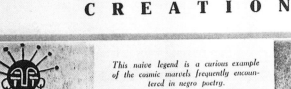

◁ Fig. 20 The first performance of the ballet *La Création du monde* took place at the Théâtre des Champs-Elysées in 1923. These photographs were taken during rehearsals (from left to right): the author Blaise Cendrars; Rolf de Maré, founder and manager of the Ballet Suédois; the composer Darius Milhaud; designer of the sets, costumes and curtain, Léger; and the choreographer and dancer Jean Börlin. (Right): Milhaud and Börlin

Fig. 21 Programme for the 1923 'Séances d'avant-garde' held in Paris, with Léger's now celebrated lecture 'L'Esthétique de la machine'

chanical elements. To create the beautiful object in painting means breaking with sentimental painting.[...] I have collaborated in doing some architectural designs, and have there contented myself with being decorative, *since the volumes were provided by the architecture and the people moving around.*[...] We French painters, we are missing our moment. In Germany, the collaboration between architects and painters is close. Only there does the visual life exist.[...] It is necessary to distract man from his enormous and often disagreeable labours, to surround him with a sculptural and visual order in which to live.'[54]

Conceives and produces the film *Ballet mécanique* in collaboration with Gerald Murphy and Man Ray, with music by George Antheil: 'I made ... a film to show objects as I found them, but I noticed that it was only when they moved that they achieved the effect I desired. Thanks to the camera, I then made objects move that [normally] never do, and I saw that they took on an objective meaning; but it was an objectivity in movement as opposed to the fixed objectivity of painting which asserts itself by means of contrast.'[55]

In a lecture at the Sorbonne he develops his work for the stage into a theory of a new type of play: 'Le spectacle: lumière, couleur, image mobile, objet-spectacle'.

Starts a class at the Académie Moderne teaching in the afternoon while a morning class is taken by Othon Friesz. Among Léger's students are Otto G. Carlsund, Franciska Clausen and Erik Olson. From 1925 to 1929 another class will be taught by Ozenfant and, from 1929, commercial art by Léon Gischia and interior decoration and set design by Alexandra Exter. In the summer of 1931 Léger disbands his own class.

In the summer Katherine Dreier calls on Léger in his studio. (This connection is to lead, in 1925, to Léger's first one-man show in the USA, organized by the Société Anonyme).

August-September: Travels in Italy. On 24 September, at the opening of the 'Internationale Ausstellung neuer Theatertechnik' (International Exhibition of New Theatre Technology) in Vienna, he gives a lecture and shows his film *Ballet mécanique* for the first time.

Compiled by Hartwig Fischer

Fig. 22 Card advertising the Académie for painters where Léger opened a class in 1924

Notes

1 Guillaume Apollinaire, 'Le Salon des Indépendants: La Jeunesse artistique et les nouvelles disciplines', *L'Intransigeant*, 21 April 1911.

2 André Salmon, 'Fernand Léger', *Paris-Journal*, 19 November 1911.

3 Léger to Mare (manuscript, Association André Mare, Paris).

4 Cited in D. Vallier, 'La Vie fait l'œuvre de Léger: Propos de l'artiste recueillis par Dora Vallier', *Cahiers d'Art*, XXIX, (Paris), 1954, p. 150.

5 Léger, 'The Machine Aesthetic: The Manufactured Object, the Artisan and the Artist', in *Functions of Painting*, London, 1973, p. 60.

6 Maurice Raynal, 'L'Exposition de "La Section d'Or"', *Bulletin de la Section d'Or* (Paris), 9 October 1912.

7 Apollinaire, 'Die moderne Malerei', *Der Sturm* (Berlin), February 1913; cited from *Apollinaire zur Kunst: Texte und Kritiken 1905-1918*, ed. Hajo Düchting, Cologne, 1989, p. 194.

8 Ragnar Hoppe, *Cahiers d'art* (Paris), VIII/2-3 1933, n.p.

9 Léger, 'The Origins of Painting and its Representational Value', in *Functions of Painting*, pp. 3, 4, 7, 8, 10.

10 Léger to Poughon, in Christian Derouet, ed., *Une Correspondance de guerre à Louis Poughon, 1914-1918*, Paris, 1990, pp. 11-12.

11 Léger to Mare (manuscript, Musée National d'Art Moderne, Centre Georges Pompidou, Paris, Fonds Léger).

12 Léger to Lohy, cited in Georges Bauquier, *Fernand Léger: Vivre dans le vrai*, Paris, 1987, p. 74.

13 Léger to Poughon, in *Correspondance ... à Louis Poughon*, p. 35.

14 Léger to Dardel (manuscript, Thora Dardel Hamilton Archives, Stockholm).

15 Léger to Poughon, in *Correspondance ... à Louis Poughon*, p. 53.

16 Ibid., p. 63.

17 Léger to Lohy, in Bauquier, *Fernand Léger*, p. 72.

18 Louise Faure-Fevrier, 'La Vie de Paris', cited in *Henri Matisse, 1904-1917*, exhibition catalogue, Musée National d'Art Moderne, Centre Georges Pompidou, Paris, 1992-3, p. 122.

19 Léger to Charlotte Mare (manuscript, Association André Mare, Paris).

20 Léger to Poughon, in *Correspondance ... à Louis Poughon*, p. 86.

21 Cited in D. Vallier, 'La Vie fait l'œuvre de Léger', p. 151.

22 Léger to Poughon, 7 December 1917, in *Correspondance ... à Louis Poughon*, p. 84.

23 Léger to Rosenberg (manuscript, Musée National d'Art Moderne, Centre Georges Pompidou, Paris, Fonds Rosenberg).

24 Cited in *Valori plastici* (Rome), I/2-3, February/March 1919, p. 3.

25 Cited in Bauquier, *Fernand Léger*, p. 91.

26 Ivan Goll, 'Fernand Léger', *Das Kunstblatt* (Berlin), VI/7, July 1922, p. 74.

27 Léger to Walden (manuscript, Sturm Archives, Staatsbibliothek, Berlin).

28 Léger to Kahnweiler, in *Pour Daniel-Henry Kahnweiler*, ed. Werner Spies, Teufen, 1965, p. 307.

29 Léger, 'Kurzgefaßte Auseinandersetzung über das aktuelle künstlerische Sein', *Das Kunstblatt* (Berlin), VII/1, January 1923, pp. 2-4.

30 Cendrars to Léger (manuscript, Musée National Fernand Léger, Biot). Our thanks to Miriam Cendrars for permission to publish extracts from the correspondence.

31 Manuscript in Galerie Louise Leiris, Archives; cited in *Alfred Flechtheim: Sammler, Kunsthändler, Verleger*, exhibition catalogue, Westfälisches Landesmuseum, Münster; Kunstmuseum, Düsseldorf; 1987, p. 164.

32 *Cicerone*, XII, 19 October 1920, p. 700.

33 Cited in *Alfred Flechtheim*, p. 165.

34 Ivan Goll, 'Fernand Léger', op. cit., p. 77.

35 W. George, *Fernand Léger*, Paris, 1929, p. 9.

36 Cendrars to Léger (manuscript, Musée National Fernand Léger, Biot).

37 Manuscript in Galerie Louise Leiris, Archives; cited in *Alfred Flechtheim*, p. 167.

38 Ibid., p. 170.

39 Cendrars to Léger (manuscript, Musée National Fernand Léger, Biot).

40 Carl Einstein, 'Skating-Rink', *Der Querschnitt* (Berlin-Düsseldorf), February 1922, p. 57.

41 Cited in Klaus H. Kiefer, *Avant-garde, Weltkrieg, Exil. Materialien zu Carl Einstein und Salomo Friedlaender/ Mynona*, Frankfurt, Bern and New York, 1986, p. 43 ff.

42 Robert McAlmon, *Being Geniuses Together*, London, 1984, pp. 111-12.

43 'Essai critique sur la valeur plastique du film d'Abel Gance "La Roue"', *Comœdia*, 16 December 1922; reprinted in *Fonctions de la Peinture*, p. 160 ff.

44 Jean Epstein, 'Léger', in *Les Feuilles libres* (Paris), 31, March-April 1923, pp. 27-8.

45 Léger to Rosenberg (manuscript, Musée National d'Art Moderne, Fonds Rosenberg).

46 'The Machine Aesthetic: The Manufactured Object, the Artisan and the Artist', in *Functions of Painting*, pp. 56, 58, 60.

47 J. Catelain, *Marcel L'Herbier*, Paris, 1950, p. 76.

48 In *L'Esprit Nouveau*, 19, Winter 1923-4, n.p.

49 Léger to Signac, cited in George Charensol, 'Querelles de peintres, Les Incidents des Indépendants', *Paris-Journal*, 30 November 1923, p. 5.

50 Fierens 'Les Petites Expositions/"L'Effort Moderne"', *Paris-Journal*, 14 December 1923, p. 6.

51 Rosenberg to Léger, 9 April 1925 (manuscript, Musée National d'Art Moderne, Fonds Rosenberg).

52 Rosenberg to Léger, 10 May 1924 (Musée National d'Art Moderne).

53 Cited in *Willy Baumeister. Malerei und Graphik der 20er Jahre*, exhibition catalogue, Staatsgalerie Stuttgart and Stuttgarter Galerieverein, 1969-70.

54 'The Aesthetics of the Machine: Geometrical Order and Truth', in *Functions of Painting*, pp. 62-4

55 Cited in D. Vallier, 'La Vie fait l'œuvre de Léger', pp. 160-61.

Summary Biography: Later Years

1925-30 The Academie Moderne continues in Léger's studio under his direction.
1925 At the Paris Exposition Internationale des Arts Décoratifs, he provides wall paintings for the vestibule of Robert Mallet-Stevens's design for an embassy and for the Pavillon de l'Esprit Nouveau, designed by Le Corbusier. His first one-man show in the USA takes place at the Anderson Galleries in New York.
1928 Travels to Berlin on the occasion of his exhibition at the Galerie Flechtheim.
1929 Along with Baumeister, Kandinsky, Le Corbusier and Mondrian, he becomes a member of the artists' association 'Cercle et Carré'.
1930 Begins painting the series '*Objet dans l'espace*'.

1931 First visit to the USA: New York and Chicago.

1932 Teaches at the Académie de la Grande-Chaumière in Paris.

1933 Visits Zurich on the occasion of an exhibition of his work at the Kunsthaus. Travels to Greece, with Le Corbusier and the latter's brother, Pierre Jeanneret, to attend the Fourth International Congress for Modern Architecture.

1934 Opens the Académie d'Art Contemporain. Works on film in London. Travels to Sweden, with Simone Herman, on the occasion of an exhibition of his work at the Galerie Moderne. In Paris gives the lecture 'De l'Acropole à la Tour Eiffel' at the Sorbonne.

1935 Second trip to the USA on the occasion of an exhibition of his work at the Museum of Modern Art, New York. Provides decoration for the hall dedicated to physical training in the French Pavillon at the Exposition Internationale in Brussels.

1936 December: provides designs for Serge Lifar's ballet *David triomphant*.

1937 Mural painting for the Palais de Tokyo, a work later installed in the Palais de la Découverte (both in Paris).

1938 Third trip to the USA. Decorates Nelson Rockefeller's New York apartment. Lectures on 'La couleur dans l'architecture' at Yale University.

1939 Designs for Jean-Richard Bloch's dramatic spectacle *Naissance d'une Cité*, staged in Paris at the Vélodrome d'Hiver.

1940 Flees Paris before the advancing German army reaches it. In October in Marseilles boards a ship bound for New York. Gives lectures at Yale University. Devises decorations for Radio City and for the Rockefeller Center. Series of 'Acrobats' pictures.

1941 In the USA he meets up again with most of the émigré artists, including Duchamp, Mondrian, Amédée Ozenfant and Friedrich Kiesler. Teaches at Mills College in California. Produces the series of 'Plongeurs'.

From 1943 Spends his summers at Lake Champlain in New York State.

1944 Shoots the sequence 'La Fille au cœur préfabriquée for Hans Richter's film *Dreams that Money Can Buy*. Exhibits works in New York, Chicago and Cincinnati. Series of 'Cyclistes' pictures.

1945 December: Returns to France. Joins the Communist Party.

1946 His Académie re-opens. Starts work on the mosaics for the façade of the church at Assy (Haute-Savoie); these are completed in 1949.

Fig. 23 Léger in Constantin Brancusi's studio, *c.* 1922, photographed by Brancusi

1948 Produces designs for Sergey Prokofiev's ballet (of 1925-6) *Pas d'Acier*. Attends the Peace Congress in Wrocíaw, Poland (formerly Breslau). Together with Jeanne Bazaine, gives a lecture in Brussels on 'L'Art aujourd'hui'. Designs wall decorations for the International Women's Congress in Paris.

1949 First work in ceramics is carried out in pottery in Biot (Alpes-Maritimes). Retrospective exhibition at the Musée National d'Art Moderne, Paris. Designs costumes and set for Darius Milhaud's opera *Bolivar*.

1950 Death of his wife, Jeanne. Retrospective exhibition at the Tate Gallery, London.

1951 Designs the windows and tapestries for the church at Audincourt (Haute-Savoie).

1952 Marries his former student, and head of his academy class, Nadia Khodossievitch. Designs wall paintings for the General Assembly Chamber of the United Nations building in New York. Moves to Gif-sur-Yvette near Paris.

1953 Pictures of the series 'Partie de campagne'. Starts work on *La Grande Parade*.

1954 Designs for mosaics and windows for the church at Courfaivre (in the Swiss Jura), and for the University of Caracas, Venezuela. Completes *La Grande Parade*.

1955 Dies at Gif-sur-Yvette on 17 August.

Early Works, 1911-1912

Léger's works from 1909, 1910 and 1911 reveal a distinct stylistic shift away from the Impressionism and Post-Impressionism that characterized his few surviving earlier works. Reviewing the Salon d'Automne of 1911, the critic Louis Vauxcelles deformed the word 'cubist' to christen Léger's works 'tubist'. Vauxcelles was responding to Léger's use of rounded, volumetric forms for landscape and figure, sitter and still-life, details and larger shapes. Léger apparently shared Picasso's and Braque's fascination with Cézanne, discernible in the all-over quality achieved through the integration of forms with a consistent formal vocabulary, the suppression of perspectival space through painterly elisions, or *passage*, and the muted grey-green palette. Léger might also have been responding directly to works by Georges Braque painted in 1908 at L'Estaque and exhibited at Kahnweiler's gallery on the rue Vignon in the autumn of that year. Léger was, according to the poet Ezra Pound, Constantin Brancusi's 'special crony'. The severely simplified volumetric forms in *Nus dans la forêt* may, for example, reveal the sculptor's influence. In this regard one also notes Léger's enduring admiration for the direct and 'honest' style of Henri (Le Douanier) Rousseau.

In *Les Trois Figures* and *Les Fumeurs*, volumetric or linearly defined forms are juxtaposed with rather mysterious, amorphous and non-descriptive, thinly painted passages that evoke light, smoke or diaphanous veils of cloth. In *La Noce* of 1910-11, exhibited at the Salon des Indépendants in 1911, these amorphous passages create a poetic environment that transcends the descriptive boundaries of the subject, and indeed suggest multiple and simultaneous views or 'duration in time or memory', concepts then popular with the Italian and Russian Futurists, and with poets and writers in Léger's Parisian milieu, including Guillaume Apollinaire and Blaise Cendrars. The relatively bright palette, and the broad passages that seem to penetrate the composition from the sides, are more directly comparable to the 'Orphic Cubist' works of Léger's friend Robert Delaunay, than with the sober coloration and dense fabric of the Analytical Cubist works of Picasso and Braque.

A key example of Léger's increasingly audacious manipulation of pictorial contrasts is *La Femme en bleu*, exhibited at the Salon d'Automne in 1912. The readability of details of the seated figure and interior – profile, hands, massive chair, still-life on a table – is challenged by non-descriptive rectilinear or segmented curvilinear forms. These brightly coloured and densely painted passages resemble collage elements that seem to hover within a shallow spatial plane, intruding into the composition from top, bottom, left or right.

Urban and suburban landscapes painted during the years 1910-12 are characterized by the same vocabulary of pictorial contrasts. Space becomes increasingly ambiguous as cubistically rendered rooftop landscapes – as seen from his apartment at 13 rue de l'Ancienne Comédie – modulate into an assemblage of overlapping or juxtaposed planes and linear scaffolding. Plumes of smoke are a major motif in these landscapes, as they were in the figural compositions, gradually shedding their descriptive function and transformed into vertical ropes of semicircular segments, a radical element in Léger's evolving vocabulary of pure plastic contrasts.

Modèle nu dans l'atelier of 1912-13 was exhibited in 1913 both at the Salon des Indépendants in Paris and also at the Erster Deutscher Herbstsalon in the Berlin gallery of Herwarth Walden, 'Der Sturm'. The figure is transformed into a vertically spiralling assemblage of semicircular segments, each element endowed with almost sculpturesque definition through broad stripes of light and shade. Colour – bright reds and yellow, patches of green and blue – is also independent of descriptive function. In related works in oil, ink and gouache on paper, the contrasts are reduced to, and concentrated in, a play of black, grey, white and the colour of the paper itself. Léger's experimentation from 1910-1912 is the prelude, as it were, to the '*contrastes de formes*', the abstract, or nearly abstract, paintings of 1913-14.

La Noce (The Wedding), 1910-11 (cat. 1)

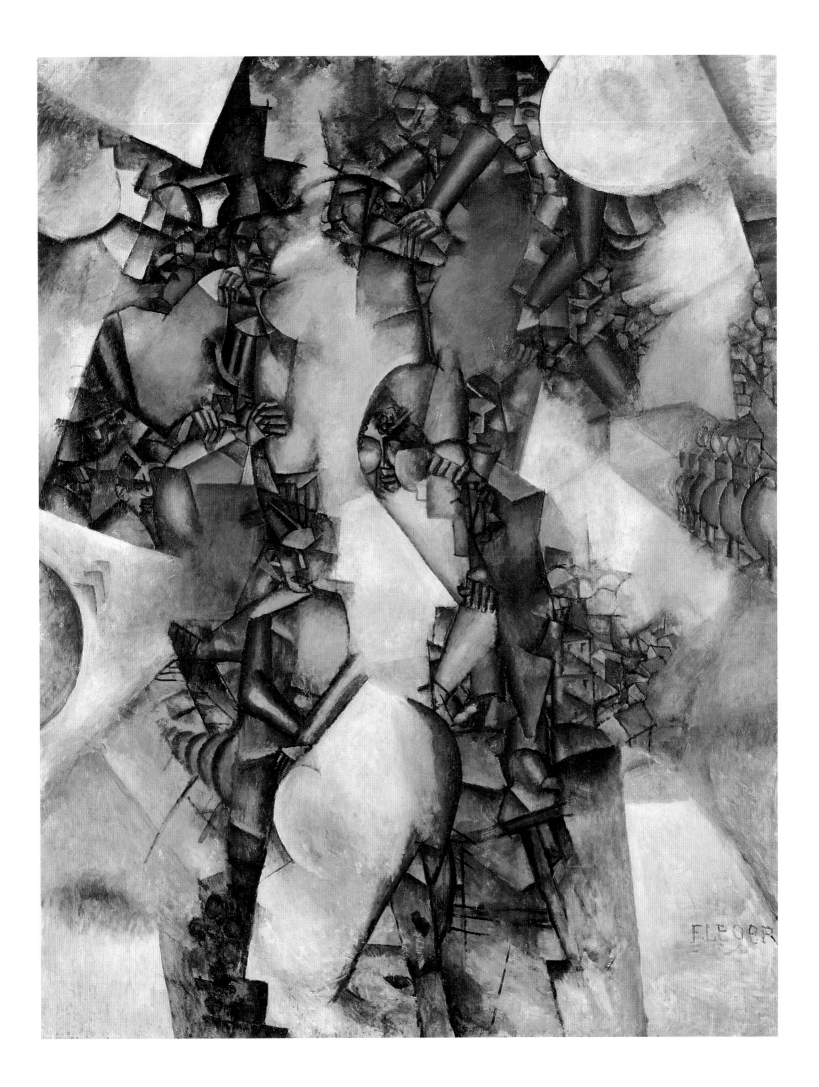

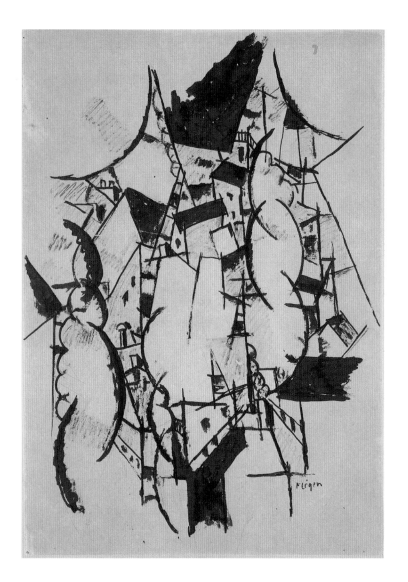 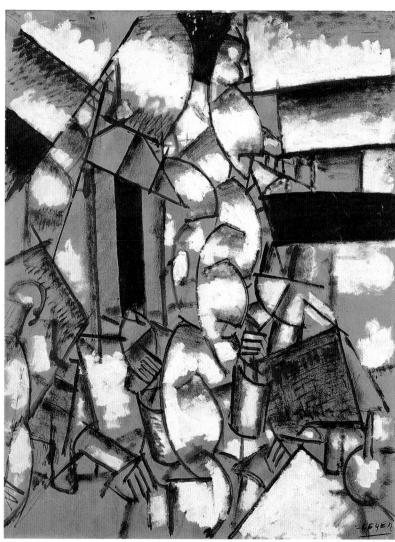

Fumées sur les toits (Smoke above the Roofs), 1913 (cat. 85)

La Fumée (Smoke), 1910-12 (cat. 80)

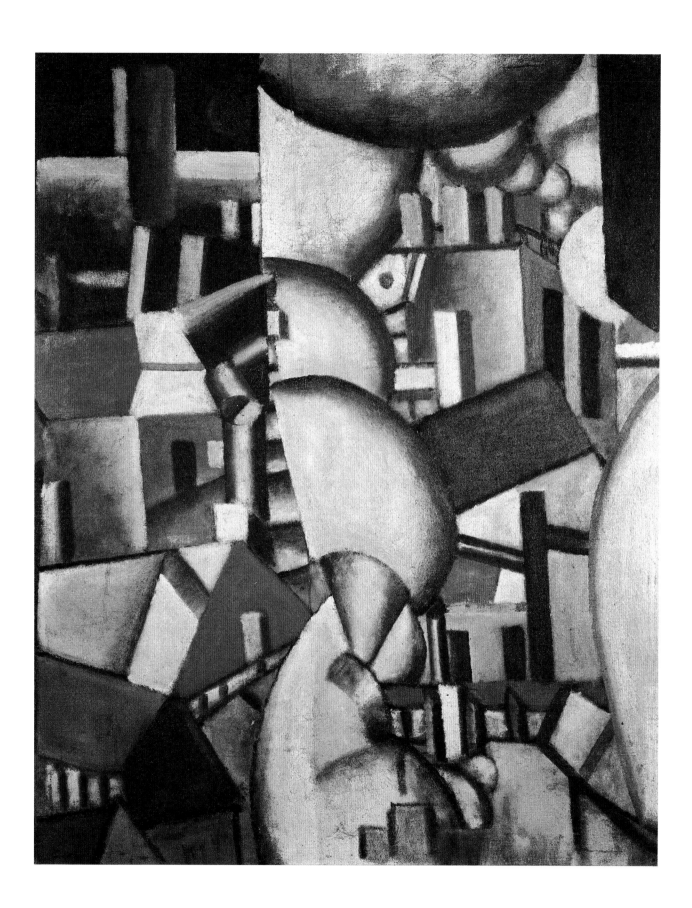

La Fumée (Smoke), 1912 (cat. 3)

Paysage (Landscape), 1912-13 (cat. 6)

Les Fumeurs (The Smokers), December 1911 - January 1912 (cat. 2)

 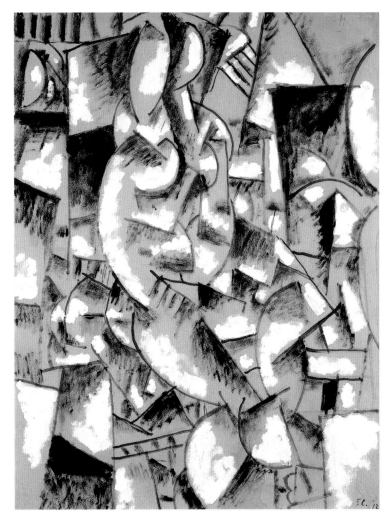

Nu dans l'atelier (Nude in the Studio), 1912 (cat. 82)

Etude pour 'Modèle nu dans l'atelier' (Study for 'Nude Model in the Studio'), 1912-13 (cat. 83)

Modèle nu dans l'atelier (Nude Model in the Studio), 1912-13 (cat. 7)

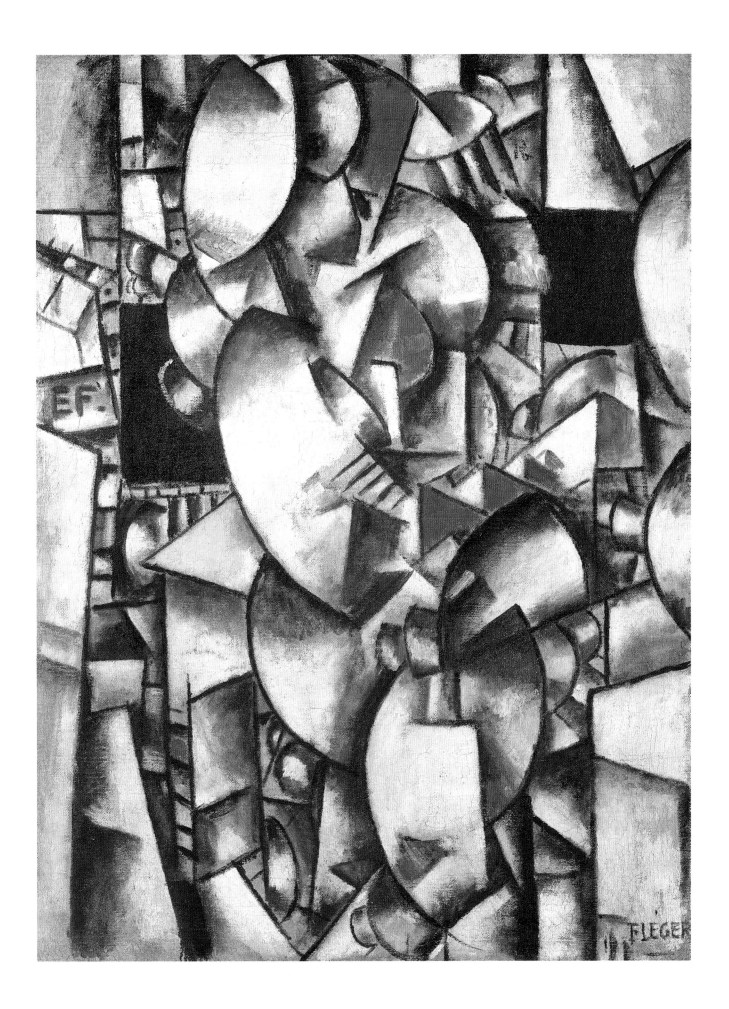

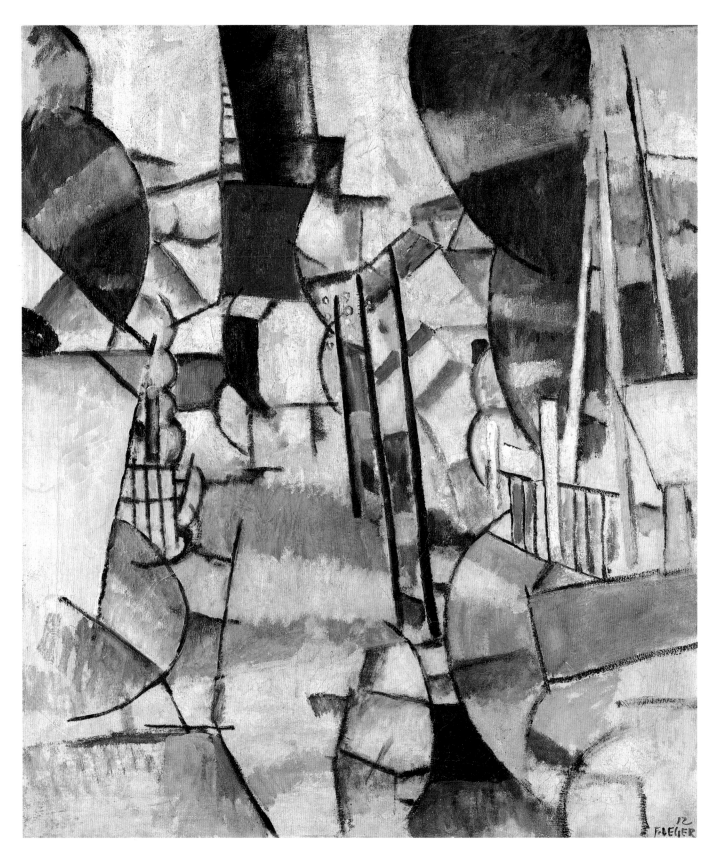

Le Passage à niveau (Railway-crossing), 1912 (cat. 4)

La Femme en bleu (Woman in Blue), 1912 (cat. 5)

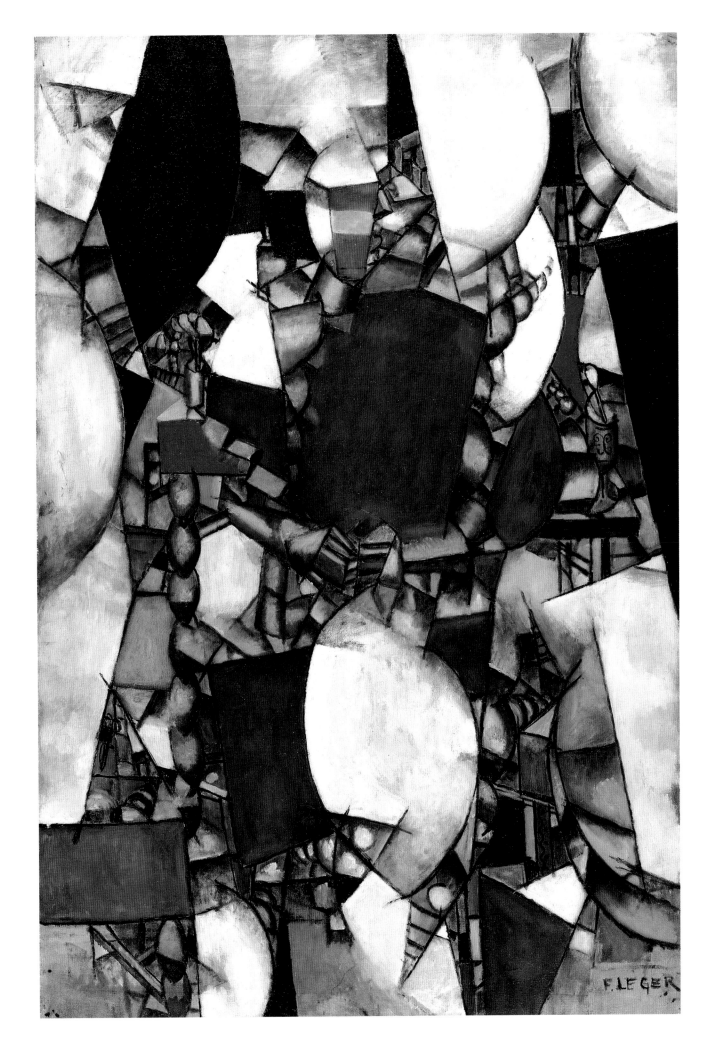

'Contrastes de formes' through the Great War

In his public lecture on 15 May 1913 at Marie Wassilief's art academy, Léger proclaimed the abstract basis of his *contrastes de formes*: 'The realistic value of a work of art is completely independent of any imitative character Pictorial realism is the simultaneous ordering of three great plastic components: Lines, Forms and Colours.' Indeed, with the most basic pictorial components, Léger creates intensely dynamic, ebullient compositions. Black outlines contrast with loosely applied patches of pure colour ranging from red, blue, yellow, green, orange, yellow, aubergine and mauve to black. White creates the impression of light reflecting off shiny surfaces, animating the composition and contributing to a sense of three-dimensional modelling. Flat forms – like cascading playing-cards or unfolding ribbons – contrast with rotund forms. Most frequently these massive drum-like forms constitute the dense centre of the work, a compositional formula surely related to the Cubist works of Picasso and Braque. The drums, sometimes stacked vertically, recall Brancusi's massive totems. The slashes of white highlights also create a sense of rotation, evoking the rhythmic grinding and churning of massive gears. Sometimes arranged in graduated ropes from small to large, the drum-like shapes spiral dramatically through space outward towards the surface of the composition. Space and density, light and motion emerge from Léger's masterful manipulation of the most elemental aspects of picture-making.

Almost simultaneously, however, in 1913 and before his mobilization in August 1914, Léger began to abandon this purely non-objective painting and returned to a more conventional realism defined by the traditional genres of figure, still-life and landscape. It is clear how the non-imitative vocabulary of the *'contrastes de formes'* is adapted to these more conventional works: the flat cascading shapes form the basis of his favourite motif of steps and stairways or the simplified cubes of houses and villages. The drum-shapes become the chest, torso or arms of figures, or the bowls, books, fruits and lamp-shades of the still-life, or – slightly flattened – the still-favoured motif of stylized plumes of smoke or profiles of trees. The freely applied patches of colour instil the paintings with a sense of spontaneity and dynamism. Indeed, Léger's sure manipulation of contrasting pictorial elements makes for extraordinary transformations, of the mundane subject-matter of the still-life, for instance, into a composition of almost metaphysical weight and majesty. His figures, too, possess a grandeur and presence that is only enhanced by their theatrical entrance descending a staircase, as in the three vertical *Escalier* paintings from Zurich, Stockholm and New York. The sense of theatricality is confirmed by the purported title of the New York painting, 'Exit, the Ballets Russes', presaging Léger's fascination with the modern spectacle, and specifically his own designs in 1922 and 1923 for Rolf de Maré's Ballets Suédois productions of *Skating-rink* and *La Création du monde*.

The experiences of Léger the soldier at the Front during the Great War constituted a traumatic rupture that redirected the artist's attention from a non-objective art to expressiveness riveted to modern life. Léger was moved by the comraderie of the common soldier and impressed by the technology and machinery of war, while at the same time stunned by its destructive, numbing power. His two major wartime pictures, *Le Soldat à la pipe* and *La Partie de cartes* avoid a dramatic or heroic representation of battle. Instead Léger wields his dynamic pre-War abstract pictorial vocabulary – massively volumetric cones and cylinders, stepped planes – to invest the figures of rank-and-file soldiers with weight and dignity. Perhaps the most stunning departure from his pre-War painting is the brownish-grey that envelops the man, the uniform, the environment in *Le Soldat à la pipe*, an expression of the desolate mud-inundated landscape that Léger describes in his wartime letters, and signifier too, perhaps, of an egalitarian ideology involving his ideal of the ordinary soldier and artisan. Colour re-emerges almost immediately, however, in the metallic-blue, red, green and brilliant yellow passages in *La Partie de cartes*.

The issues of continuity and discontinuity between Léger's pre-War and post-War *œuvre* is complex, indeed, related to the swing between abstract pictorial form and identifiable object that characterizes his entire career. What is clear, however, is that the experience of combat profoundly changed his way of seeing, refined his expectations for his art, and galvanized his relationship to the vernacular of contemporary life.

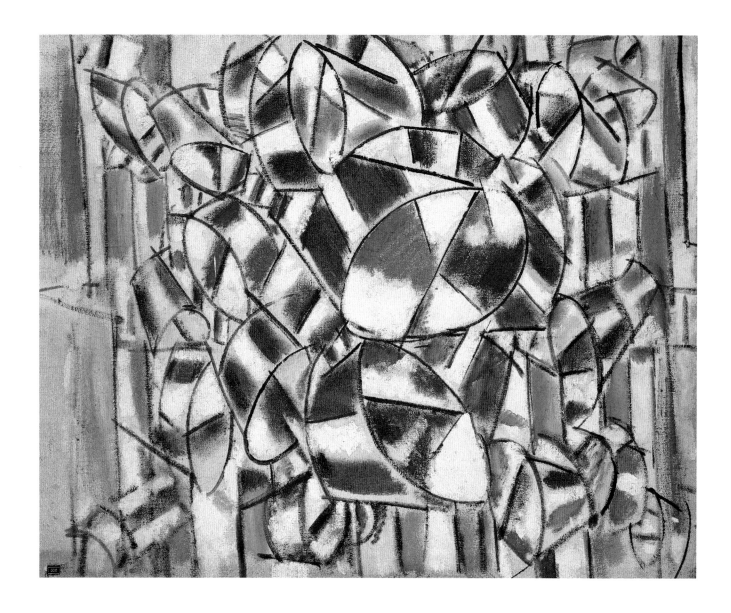

Eléments géométriques (Geometric Elements), 1913 (cat. 10)

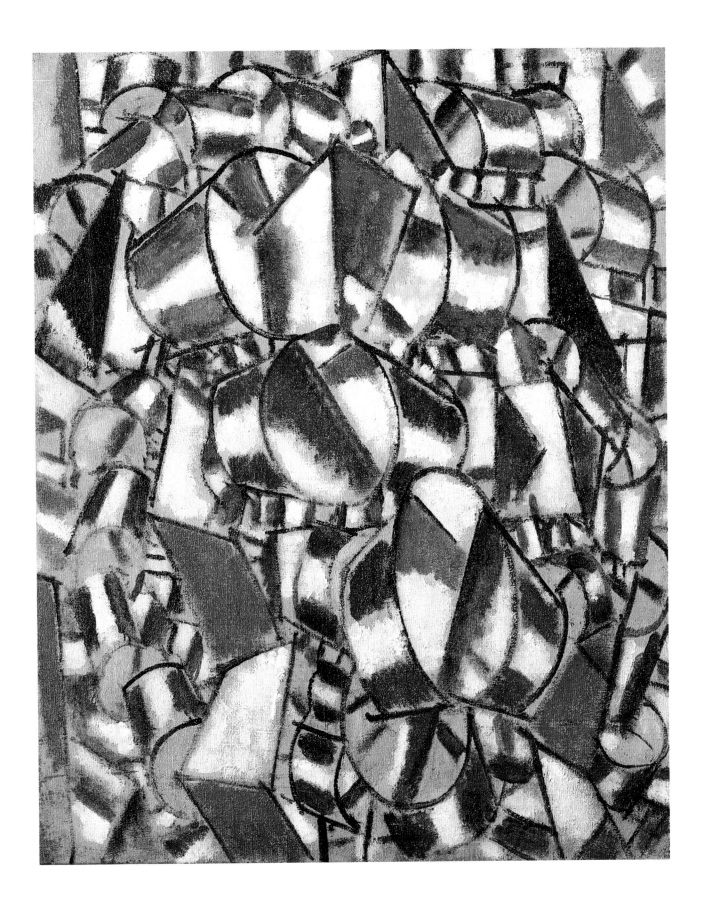

Contraste de formes (Contrast of Forms), 1913 (cat. 9)

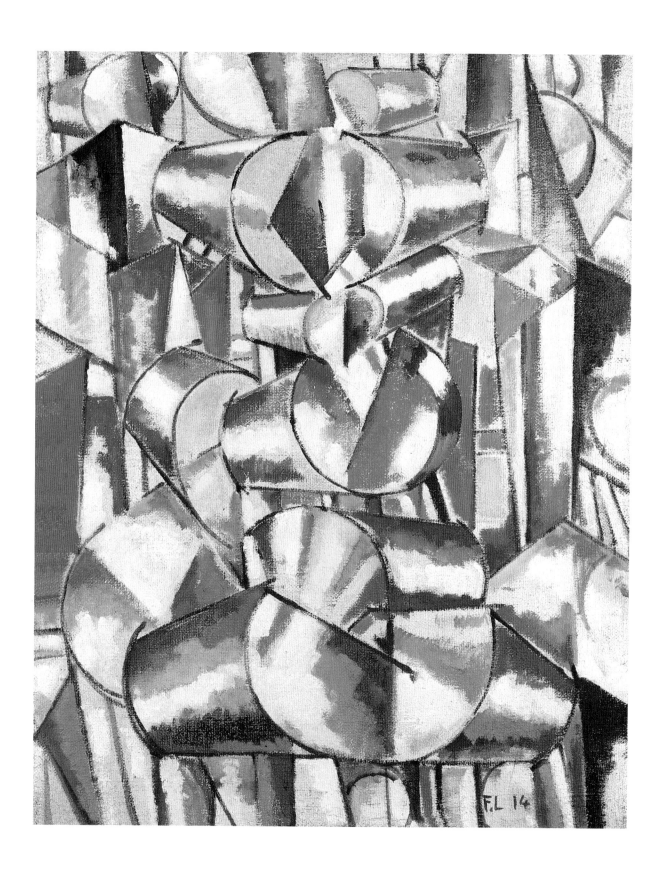

Contraste de formes (Contrast of Forms), 1914 (cat. 16)

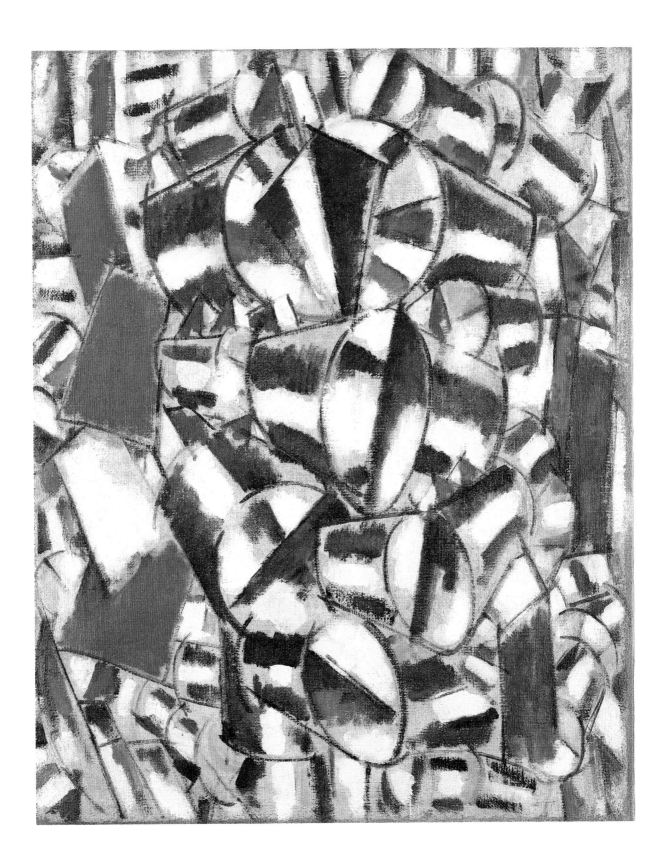

Contraste de formes (Contrast of Forms), 1913 (cat. 8)

Contraste de formes (Contrast of Forms), 1913 (cat. 87)

Contraste de formes (Contrast of Forms), 1912 (cat. 81)

Contraste de formes (Contrast of Forms), 1913 (cat. 89)

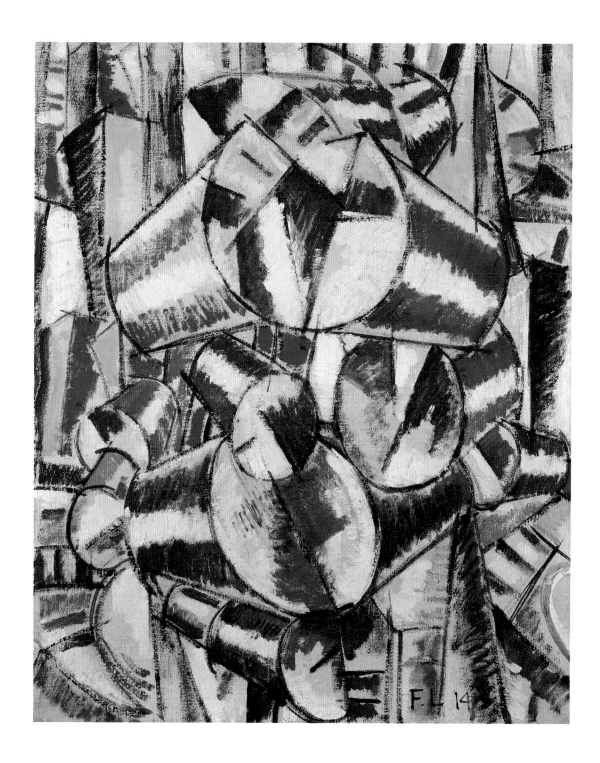

Contraste de formes (Contrast of Forms), 1914 (cat. 15)

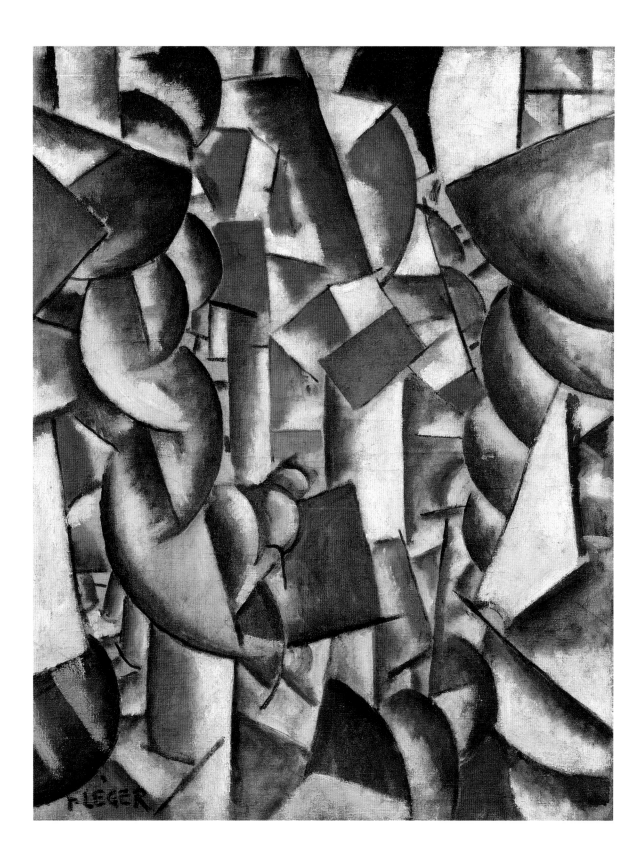

La Maison sous les arbres (House among the Trees), 1913 (cat. 14)

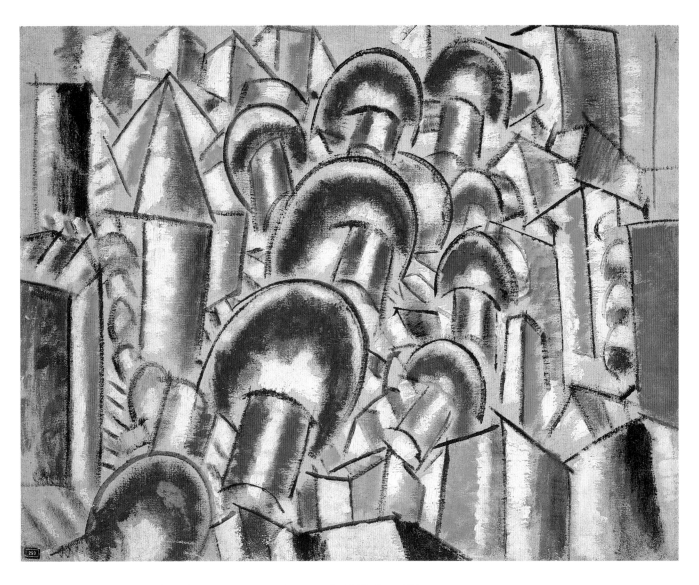

Les Maisons dans les arbres (Houses among the Trees), 1913 (cat. 13)

Les Maisons dans les arbres, Paysage No. 3 (Houses among the Trees, Landscape No. 3), 1914 (cat. 23)

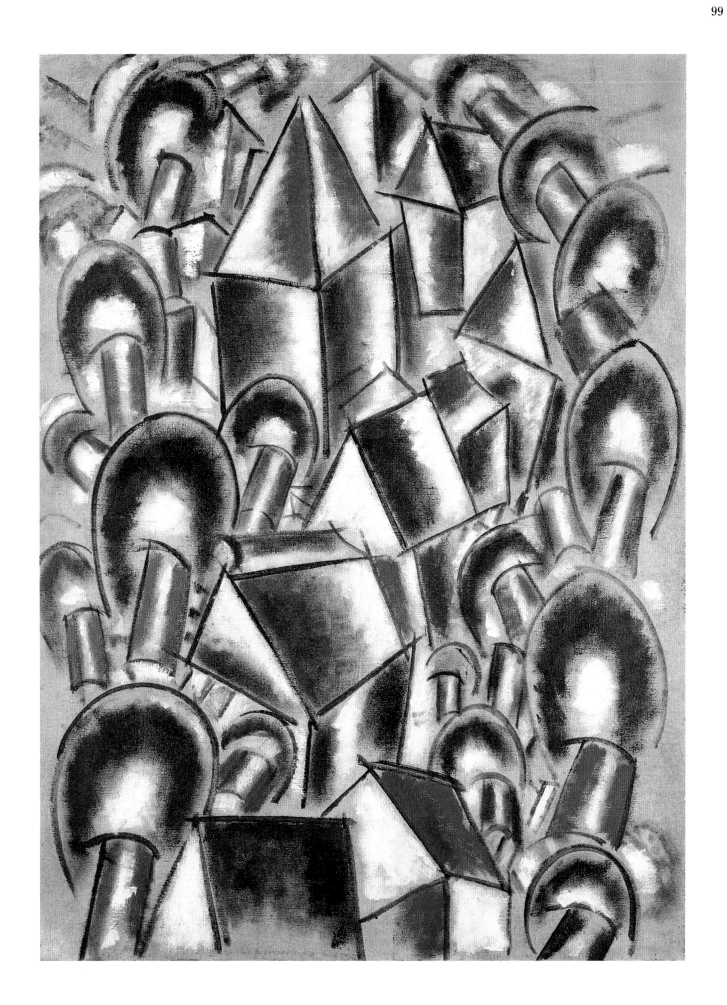

La Femme au fauteuil (Woman in an Armchair), 1913 (cat. 11)

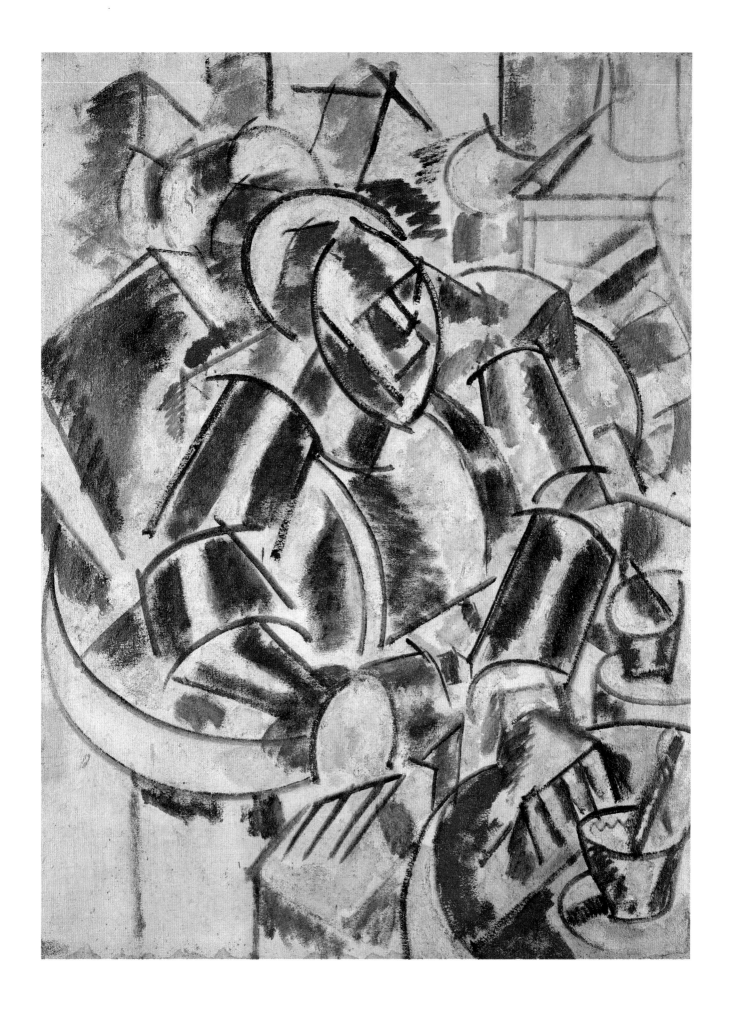

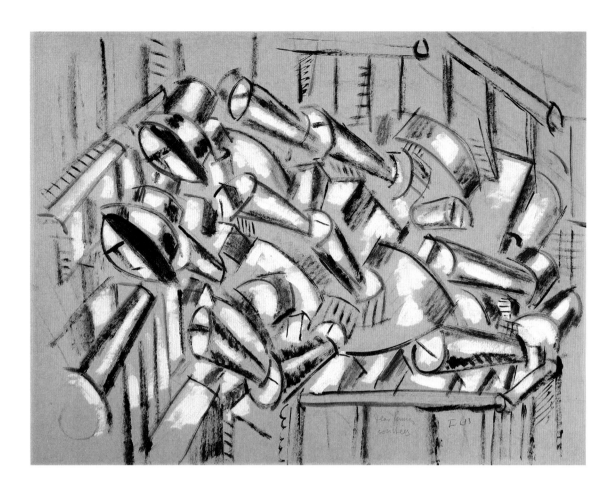

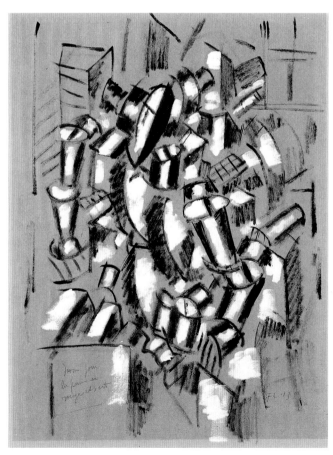

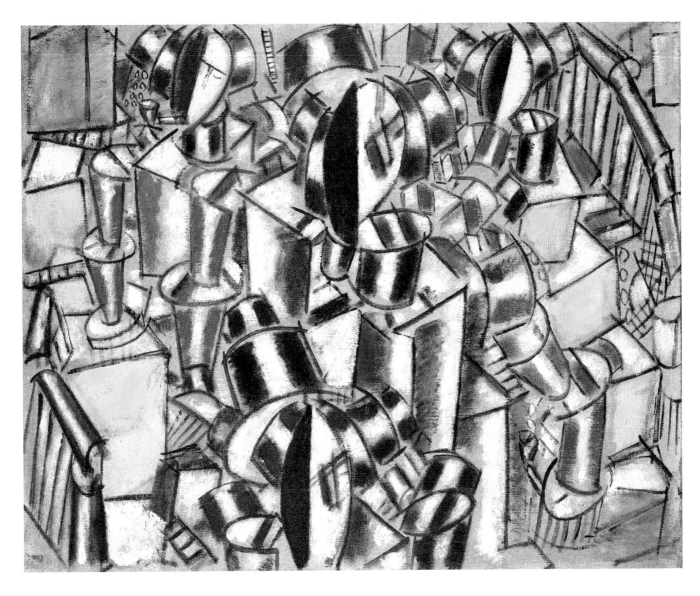

L'Escalier (The Staircase), 1914 (cat. 19)

Deux Femmes couchées (Two Reclining Women), 1913 (cat. 86)

Dessin pour 'La Femme en rouge et vert' (Drawing for 'Woman in Red and Green'), 1913 (cat. 84)

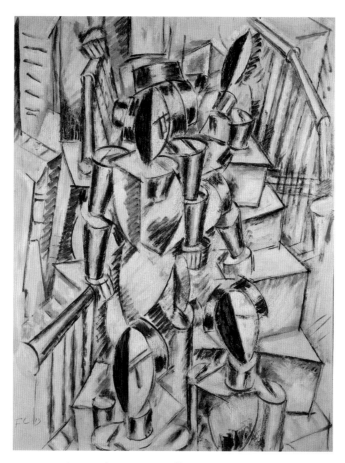

Figures descendant un escalier
(Figures Descending a Staircase), 1913 (cat. 88)
Etude pour 'L'Escalier' (Study for 'The Staircase'), 1913 (cat. 90)

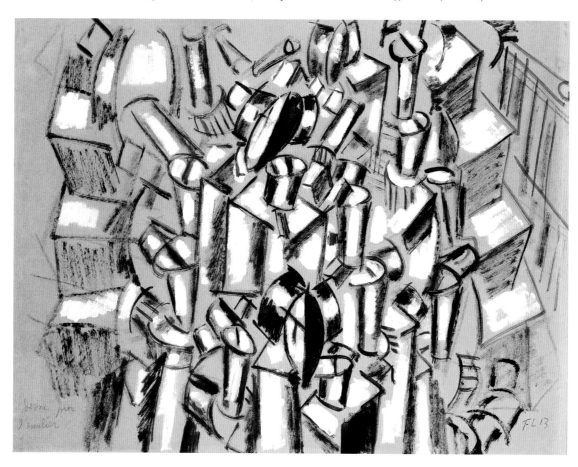

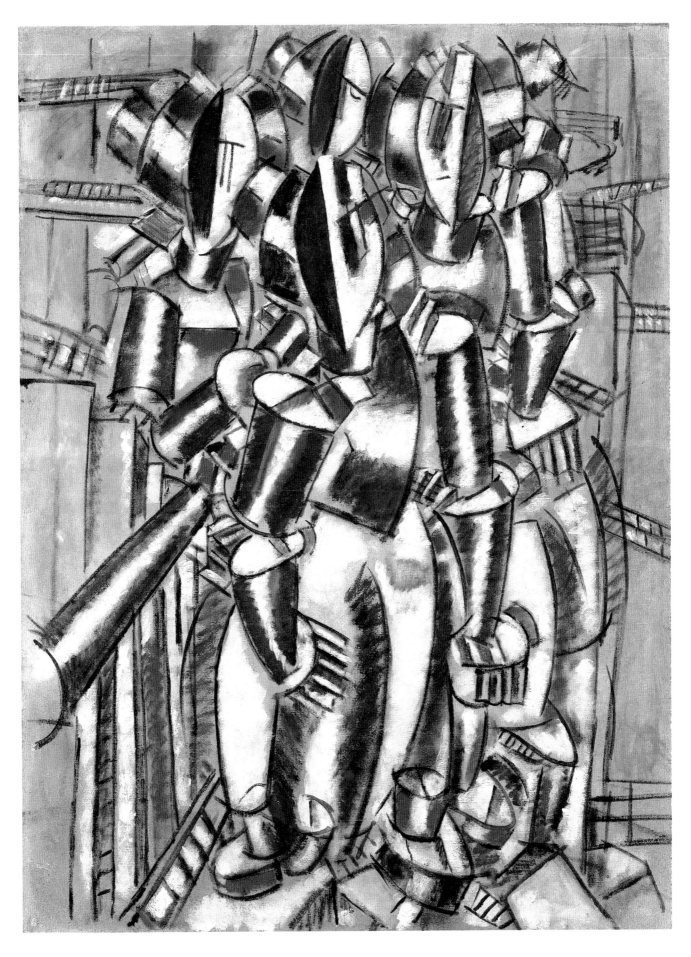

Le Balcon (The Balcony), 1914 (cat. 21)

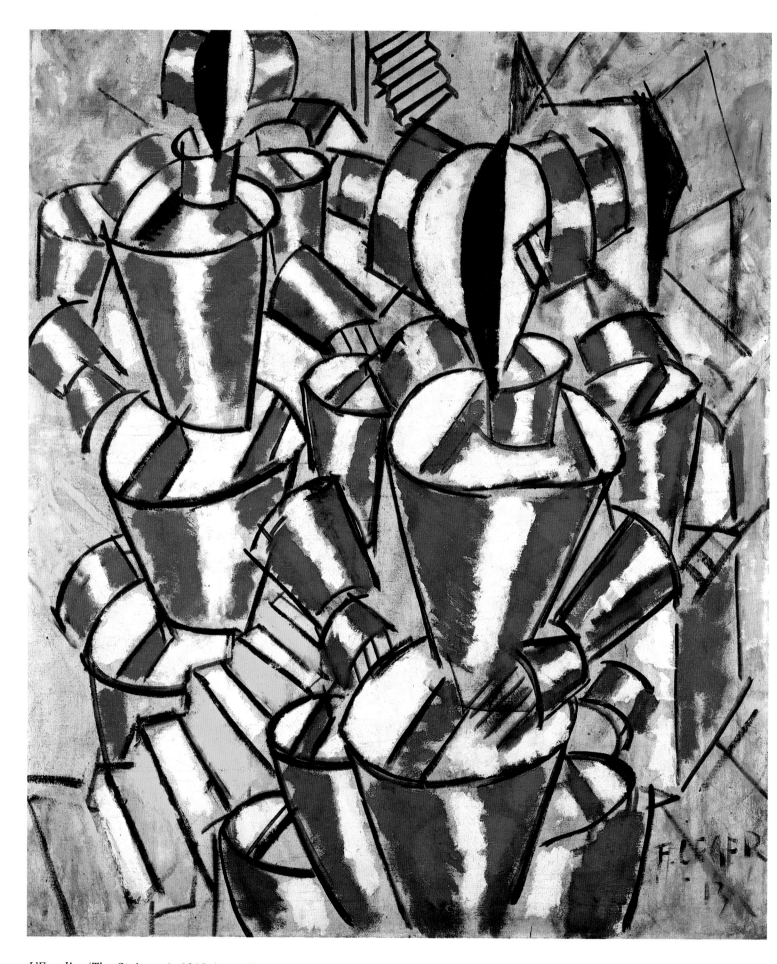

L'Escalier (The Staircase), 1913 (cat. 12)

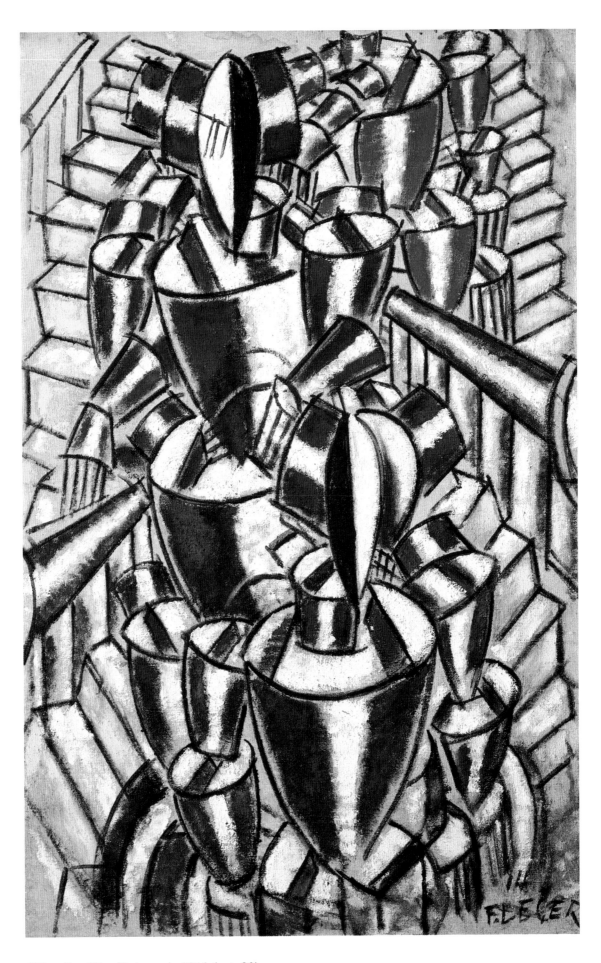

L'Escalier (The Staircase), 1914 (cat. 20)

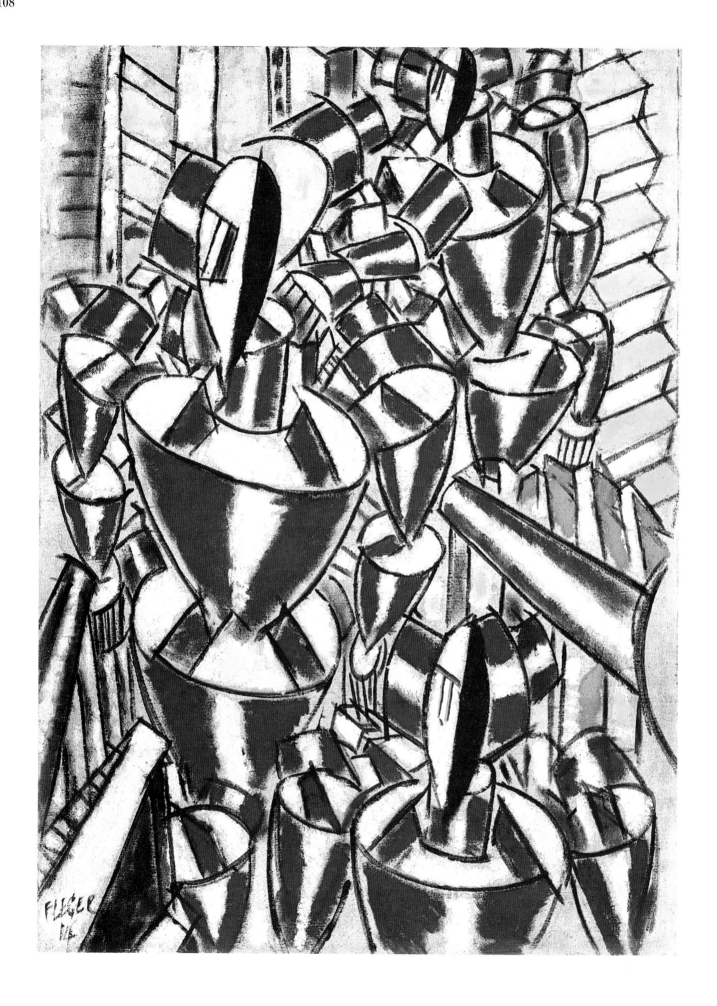

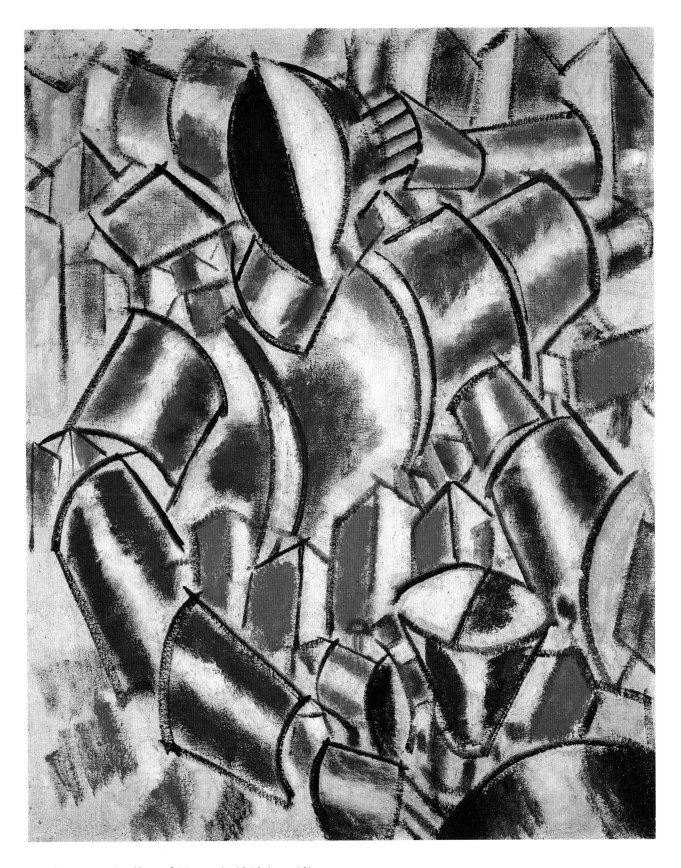

La Femme assise (Seated Woman), 1914 (cat. 18)

La Sortie des Ballets Russes (Exit the Ballets Russes), 1914 (cat. 22)

110

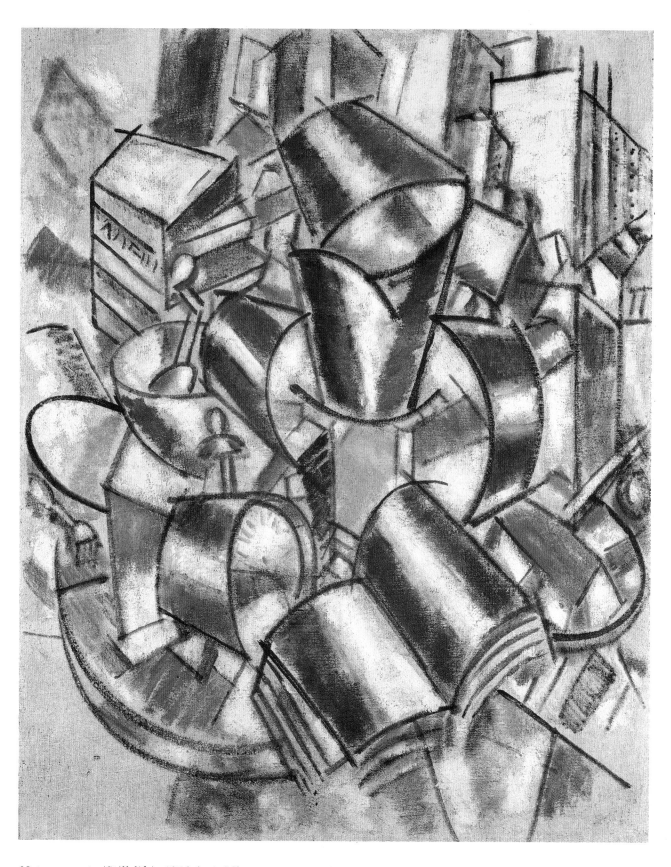

Nature morte (Still-life), 1914 (cat. 24)

Nature morte sur une table (Still-life on a Table), 1914 (cat. 92)
Nature morte (Still-life), 1913 (cat. 91)

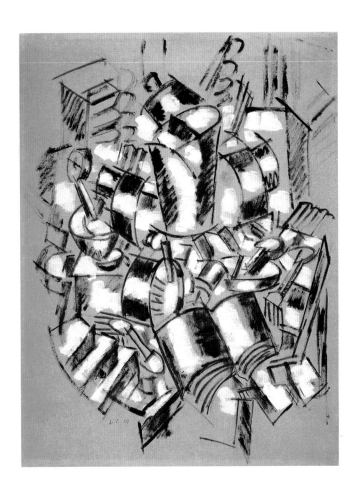

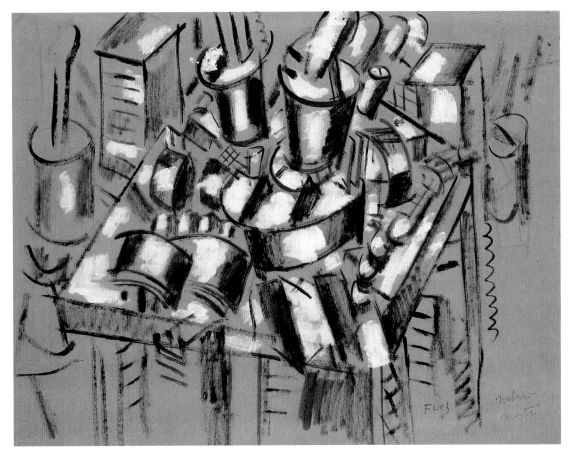

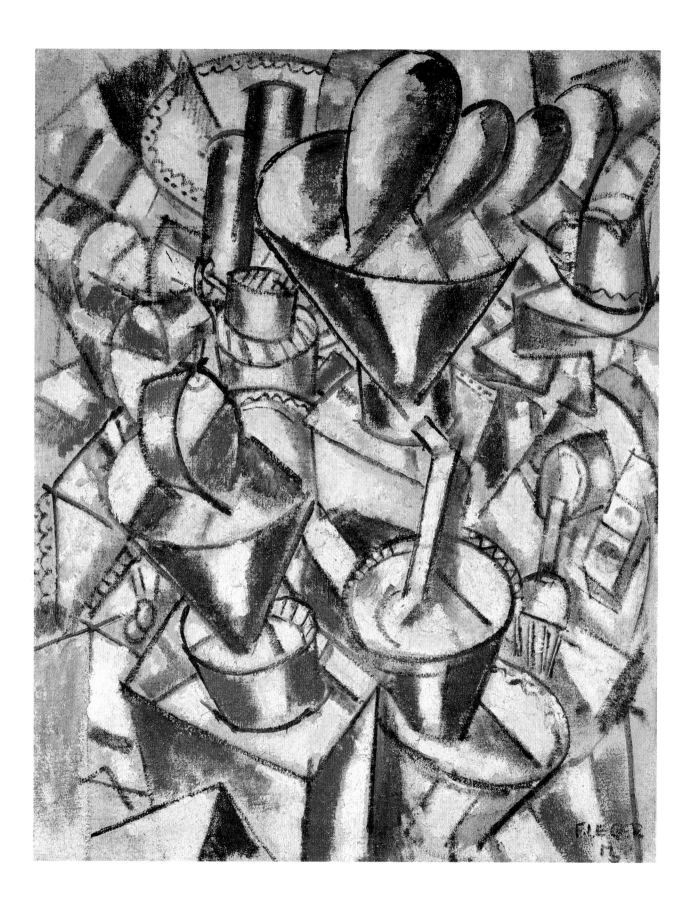

Nature morte aux cylindres colorés (Still-life with Coloured Cylinders), 1913-14 (cat. 17)

Le Soldat à la pipe (Soldier with a Pipe), 1916 (cat. 27)

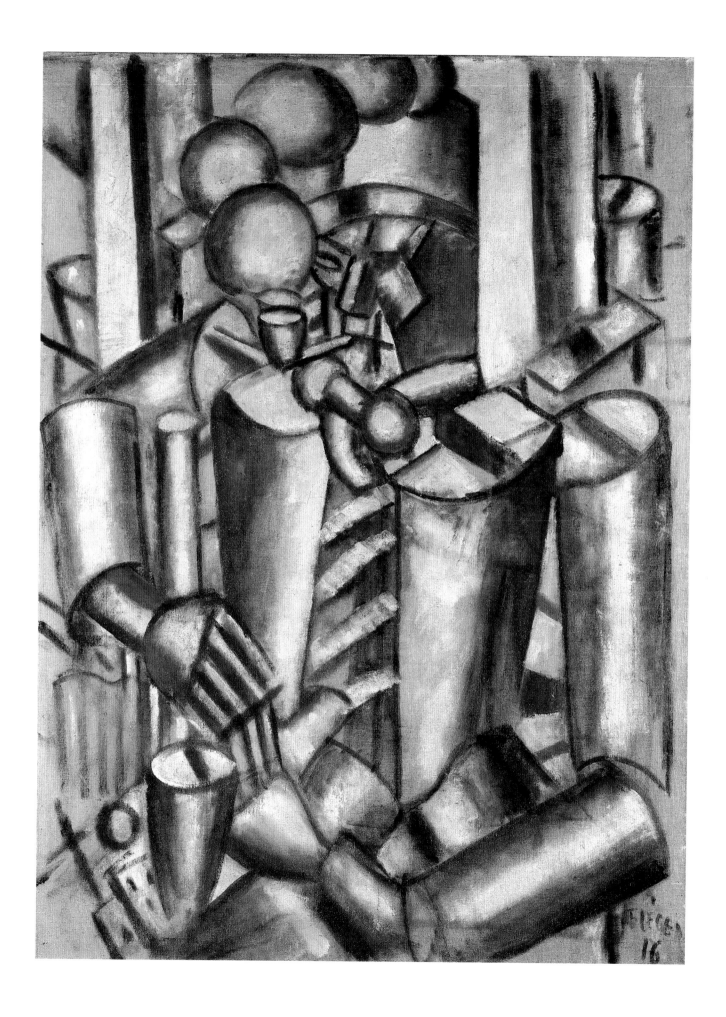

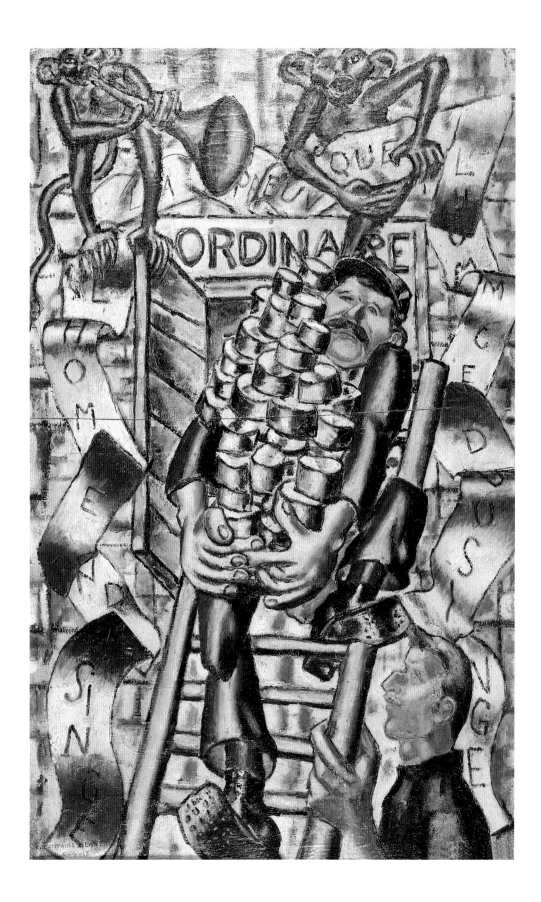

La Preuve que l'homme descend du singe
(Proof that Man Descends from the Apes), 1915 (cat. 26)

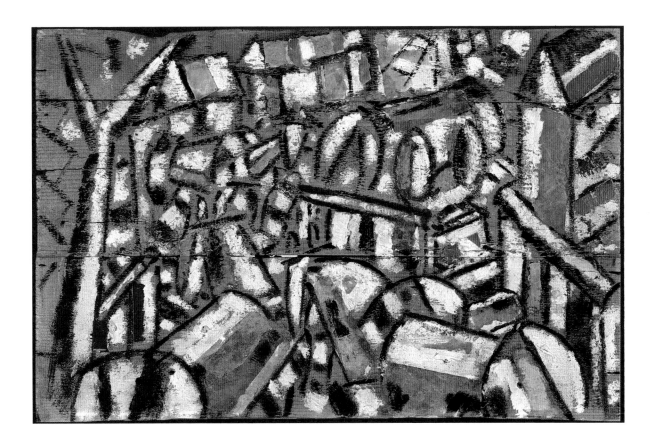

Les Chevaux d'artillerie (Artillery Horses), 1915 (cat. 25)

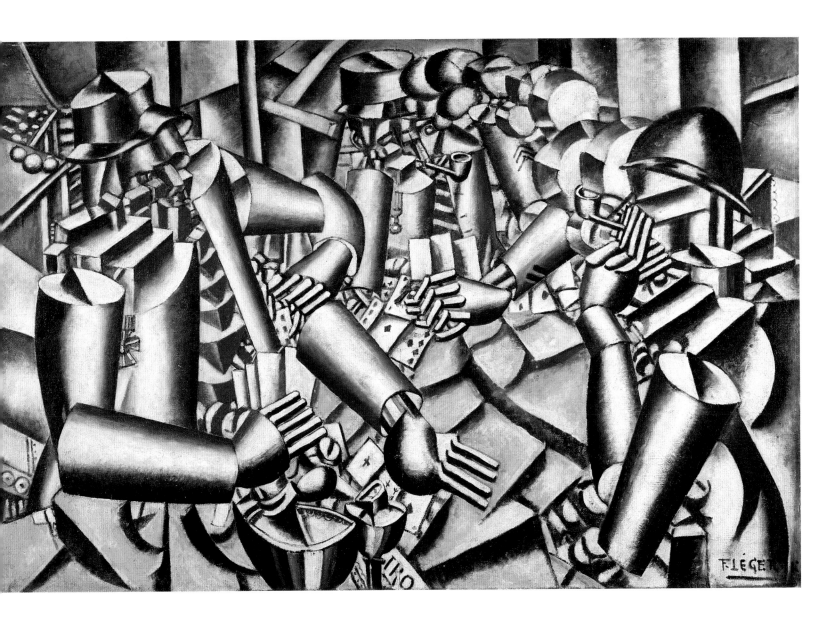

La Partie de cartes (The Card Game), 1917 (cat. 28)

Images for a Mechanical Age

'Each artist possesses an offensive weapon that allows him to intimidate tradition. In the search for vividness and intensity, I have made use of the machine as others have used the nude body or the still-life.' Thus begins Léger's essay of 1924/5 'The Machine Aesthetic: Geometric Order and Truth'. Indeed, themes of contemporary life in the mechanical age came to dominate Léger's *œuvre* after the War and through the 1920s: the motor, the typographer and the more abstract compositions of 'mechanical elements'; the propeller and its non-objective component, 'the disc'. Léger himself stated clearly that his goal was not to depict or 'copy' the machine, but rather to 'create a beautiful object with mechanical elements'. If his art is inflected with a populist political ideology reinforced by his wartime experiences, it did not during these years evolve toward conventional realism, which he himself consistently dismissed as 'sentimental'. Léger's celebration of the mechanical object, consistent with his pre-War 'conceptual realism' and aesthetic of plastic contrasts, is inscribed between the extremes of the non-objective and the real. The monumental *Eléments mécaniques* of 1918-23 reveals the continuity and refinement of his pictorial language. The central, sculpturesque agglomeration of volumetrically rendered cones, tubes and drums, if inspired by the dynamically gyrating parts of the machine, is clearly indebted, as well, to the fundamental elements of his pre-War '*contrastes de formes*'.

Another painting, of 1924, also entitled *Elément mécanique*, represents a different compositional type. Here the whirling gigs and pulleys are dramatically monumentalized, pushed close to the surface of the composition. The plastic contrasts are dramatic: between crisp black linear elements and areas of pure colour; between suggestions of depth or volume and flatness; between the metallic, or perhaps, more accurately, the *grisaille* colour of the machine parts and the poster-like undifferentiated, saturated red of the background. One cannot, in this regard, overestimate the impact of Léger's interest in and experimentation with film on the evolution of this dramatic, machine-inspired image. His own *Ballet mécanique*, completed in 1924 in collaboration with Gerald Murphy, Man Ray and with music by George Antheil, is a film 'without scenario' involving rhythmic juxtapositions of people, fragments of the human anatomy, everyday objects, and portions of objects distorted into abstract shapes. In several essays Léger privileged the transformative power of the filmic close-up, and specifically praised the advent of the mechanical element as 'the leading character, the leading actor'.

La Ville of 1919 is the largest and most important of a series of related works with the theme of the city. Léger celebrates the cacophonous intensity of the urban environment, juxtaposing bright fields of pure colours, bold stencilled letters and stark pictographic human silhouettes that evoke his own verbal description of 'yellow or red posters, shouting in a timid landscape'. The linear elements surely recall the girders of the Eiffel Tower, the icon of the Parisian landscape that Léger termed an 'object spectacle' in an essay of 1925 in Léonce Rosenberg's journal *Bulletin de l'Effort Moderne*. This motif, especially in conjunction with the disc, also bears comparison with a number of important works celebrating the city and the tower painted between 1911 and 1913 by Léger's friend Robert Delaunay. Indeed, this monumental work encompasses a sweeping array of references not only to Delaunay and simultaneism, and perhaps also to Jules Romain's unanimist vision of urban life, as well as to Léger's professed enthusiasm for modern advertising techniques of window display and billboard. It incorporates significantly a myriad of references to Léger's own *œuvre*: the figures descending the staircase, the rounded plumes of smoke, the abrupt juxtaposition of discontinuous spatial cells, the play of partially modelled forms against unambiguous flat cut-outs. This encyclopaedic work presages, too, several thematic and compositional types that were to preoccupy him over the next few years: *L'Homme à la pipe* or *L'Homme au chien*, 1920, with the central motif of the figure descending a stair; *L'Aviateur*, 1920; and the industrial landscapes of the *Remorqueur* paintings of 1920-21. In his juxtaposition of discrete elements Léger certainly emulated the collage technique essential to Synthetic Cubism, but with a rhythmic intensity and on a scale that might more accurately be described with the cinematic terminology of 'montage'. Indeed, regarding the popular identification of the dynamism of the urban environment with the tempo of film, one should not forget Léger's collaboration with his friend Blaise Cendrars in the form of his illustrations and typographic experimentations for Cendrars's *La Fin du monde, filmée par l'ange de Notre-Dame* of 1919.

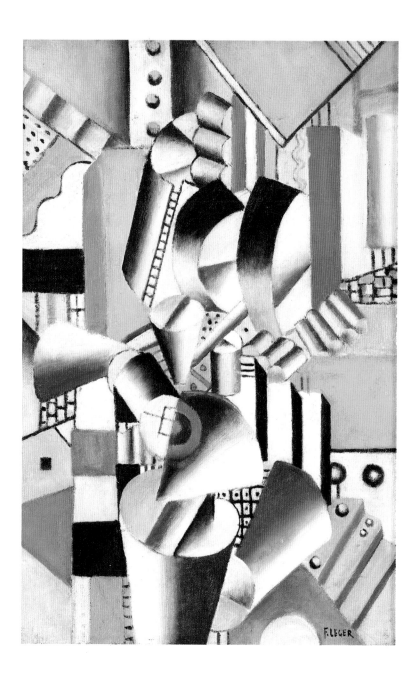

Contraste de formes (Contrast of Forms), 1918 (cat. 35)

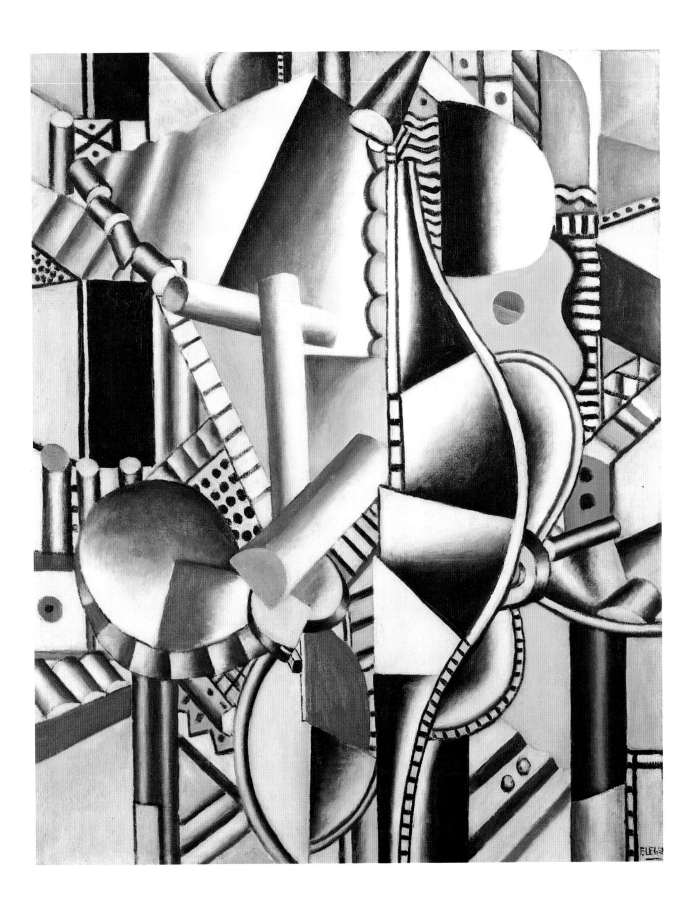

Les Hélices, deuxième état (Propellers, second version), 1918 (cat. 33)

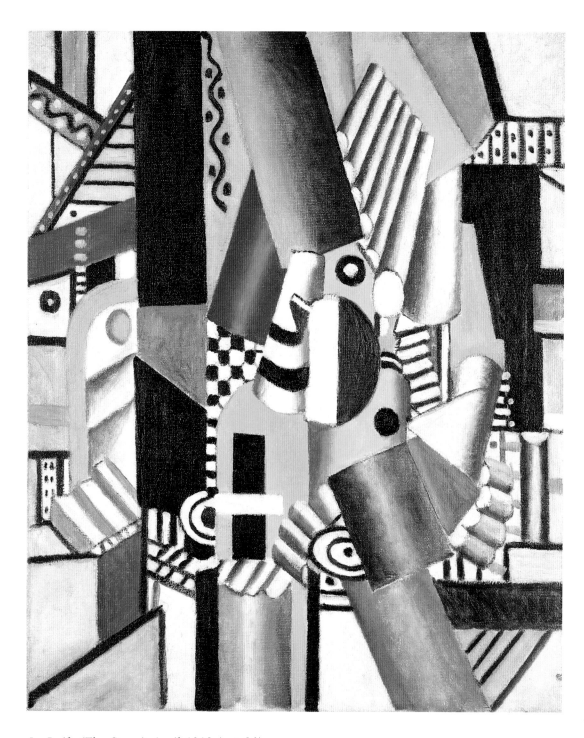

Le Poêle (The Stove), April 1918 (cat. 34)

Nature morte (Still-life), 1919 (cat. 46)

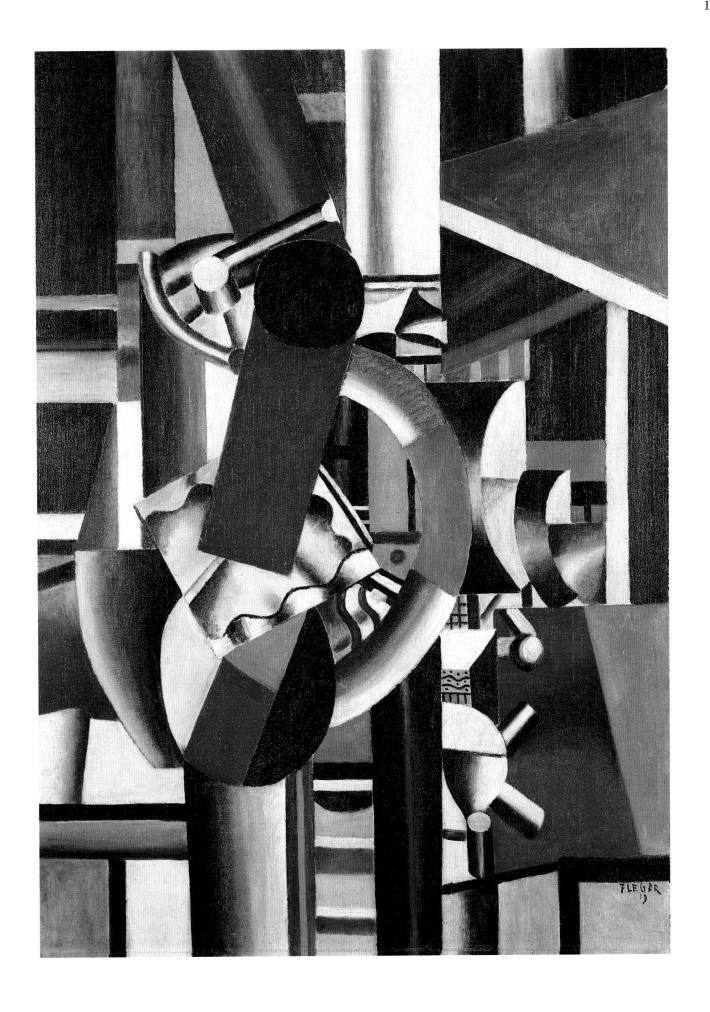

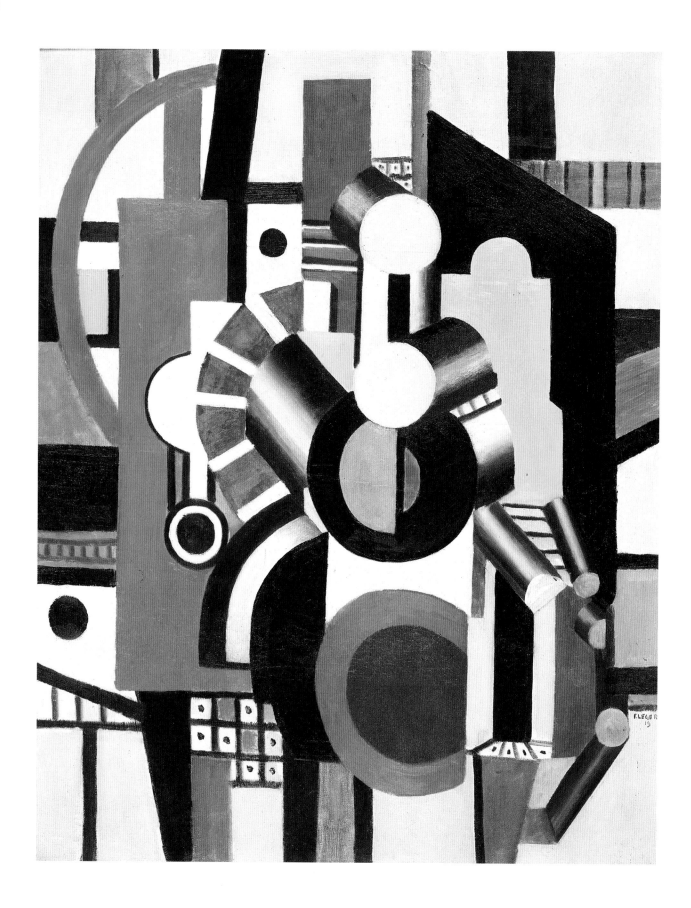

Eléments mécaniques (Mechanical Elements), 1919 (cat. 47)

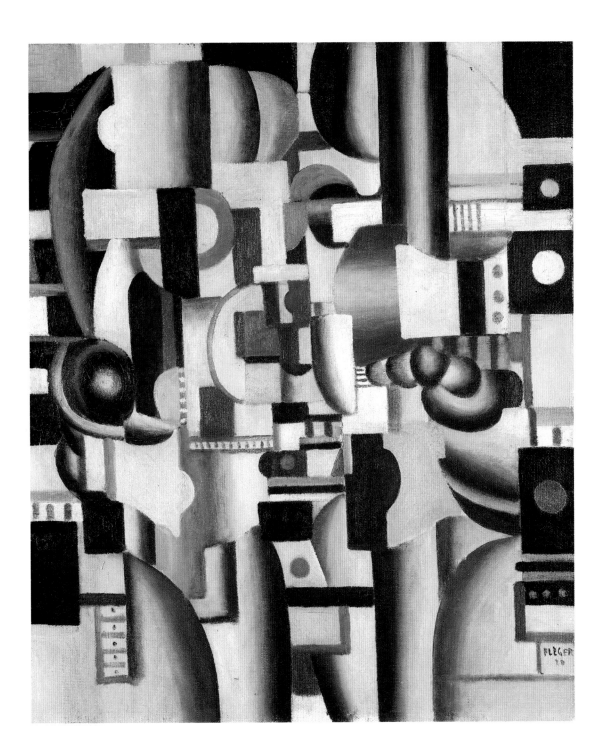

Composition, 1920 (cat. 56)

Les Eléments mécaniques (Mechanical Elements), 1918-23 (cat. 73)

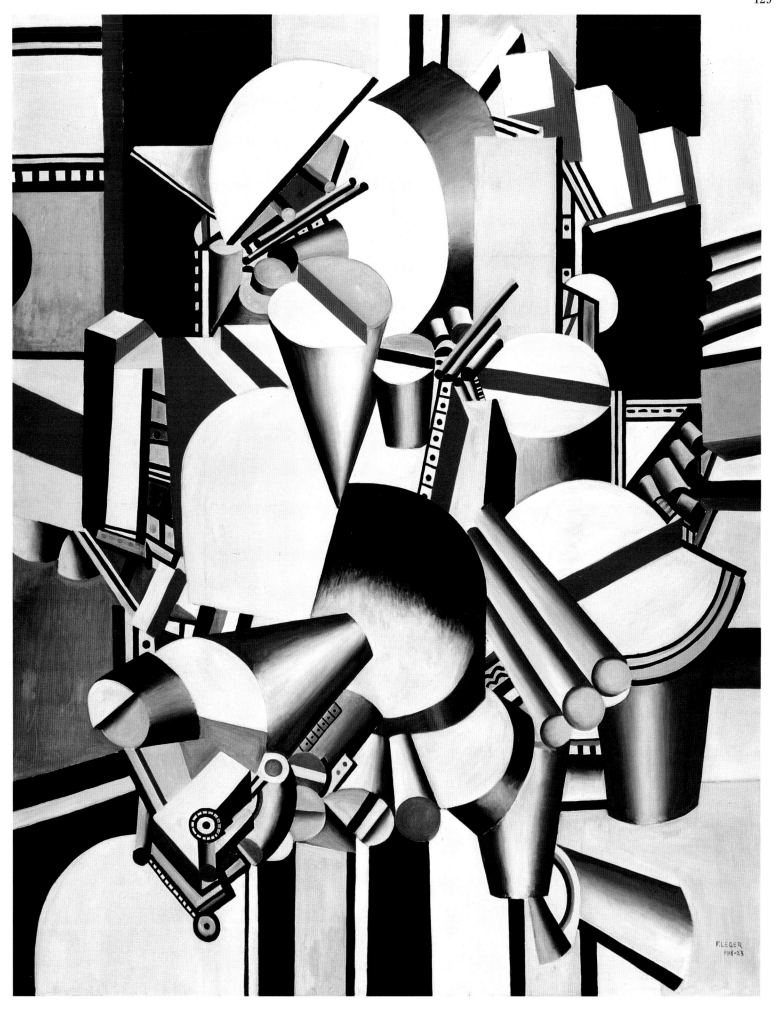

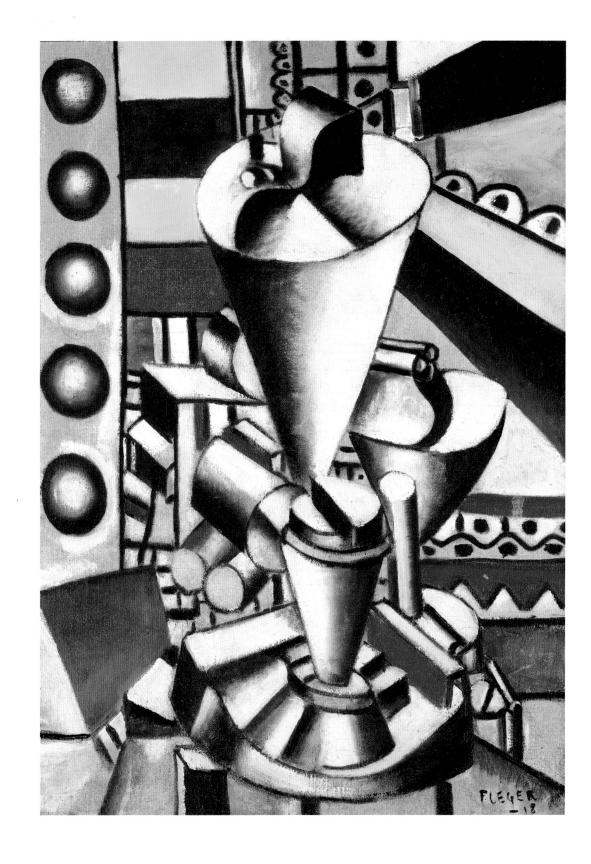

Nature morte aux éléments mécaniques (Still-life with Mechanical Elements), 1918 (cat. 36)

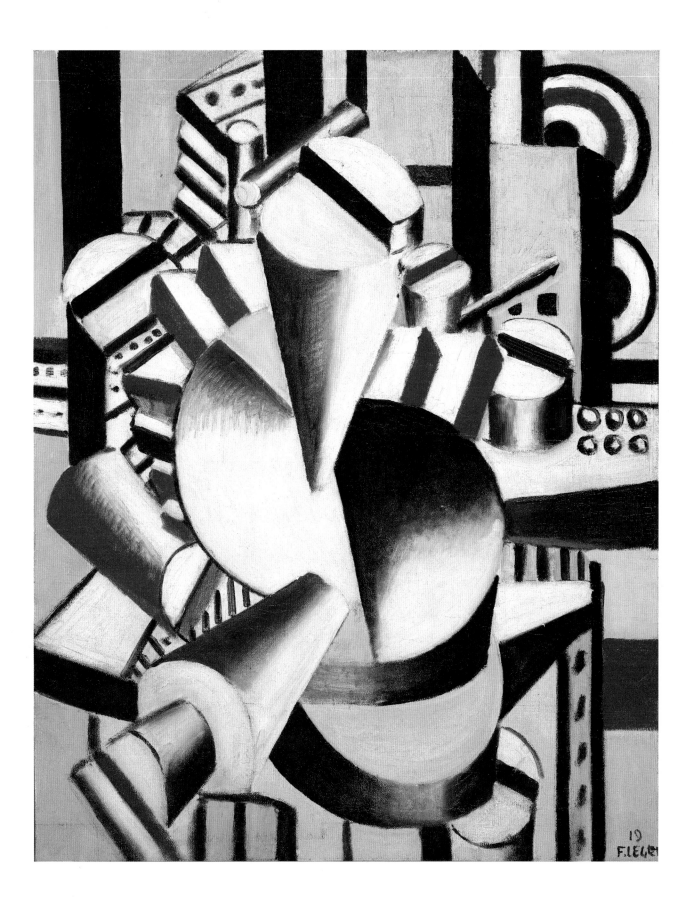

Composition, 1919 (cat. 44)

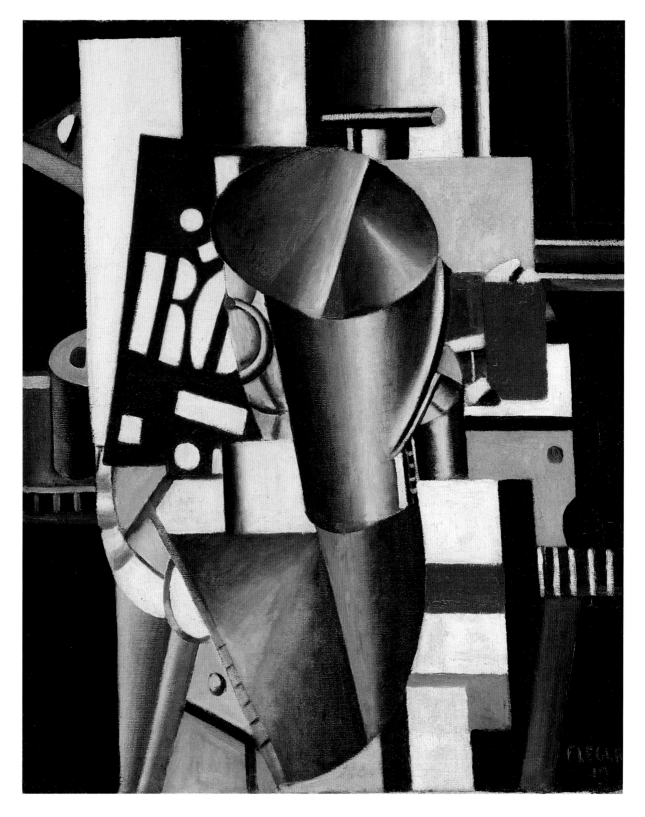

Le Typographe, deuxième état (The Typographer, second version), 1919 (cat. 48)

Le Typographe (The Typographer), 1919 (cat. 49)

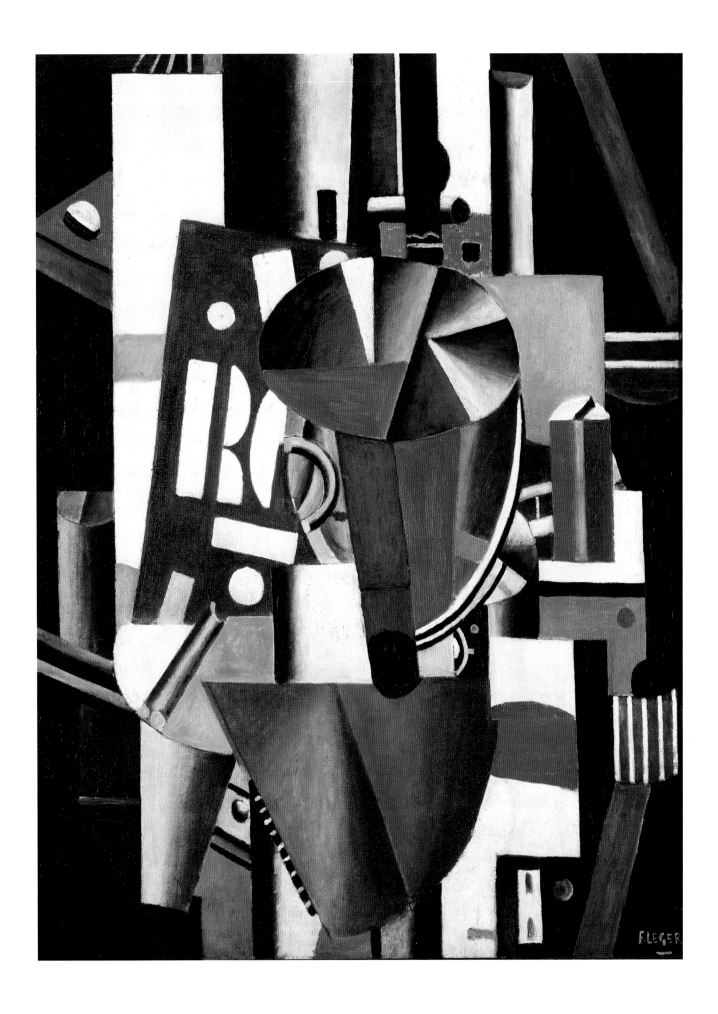

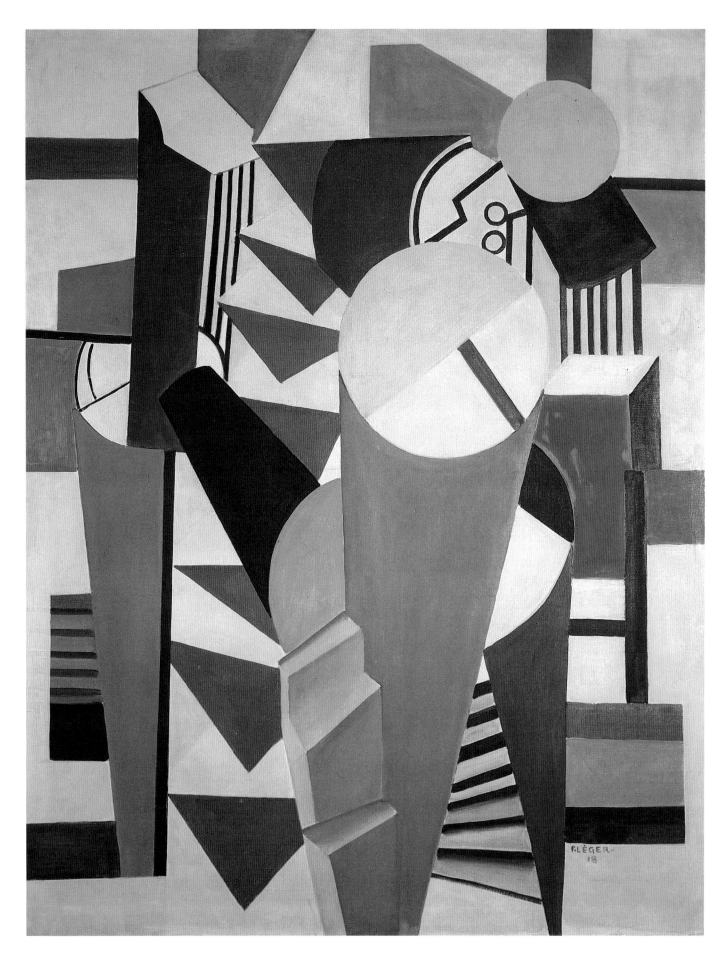

Composition, 1918 (cat. 29)

Les Disques (Discs), 1918 (cat. 38)

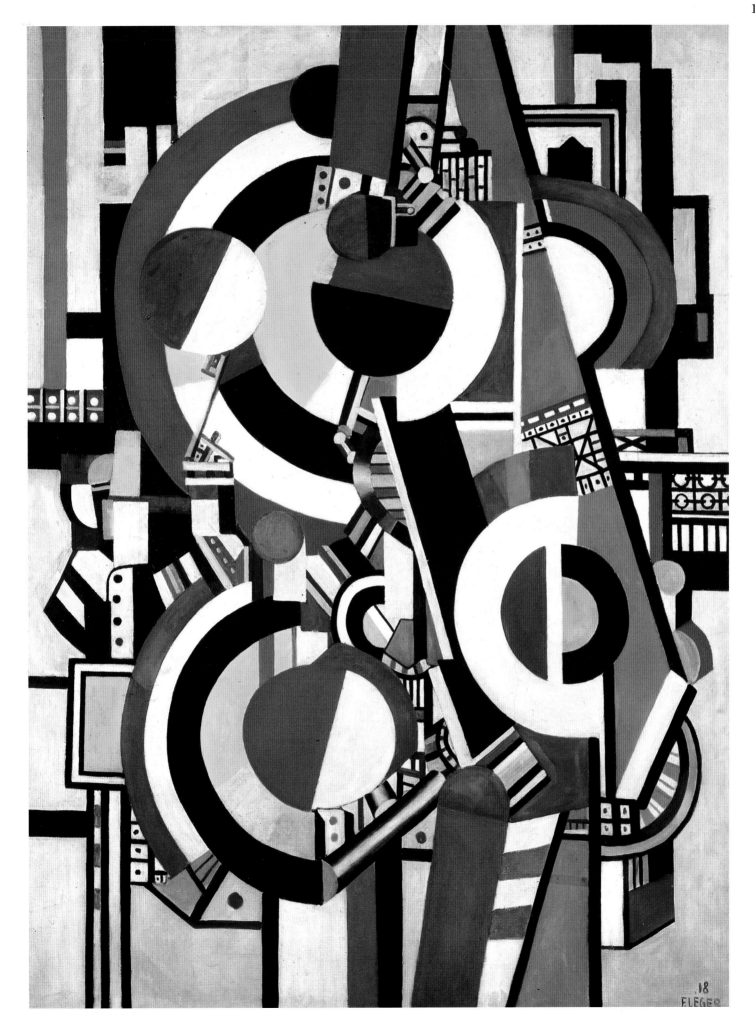

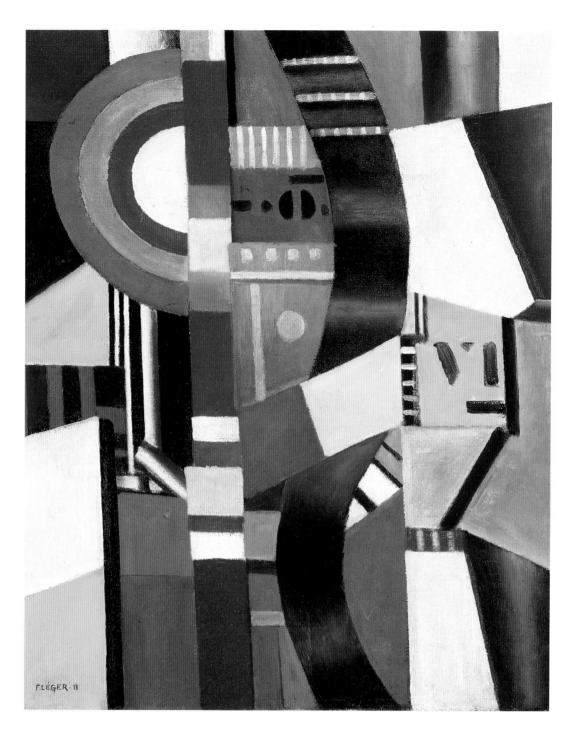

Composition: Le Disque (Composition: Disc), 1918 (cat. 37)

Les Disques (Discs), 1918-19 (cat. 39)

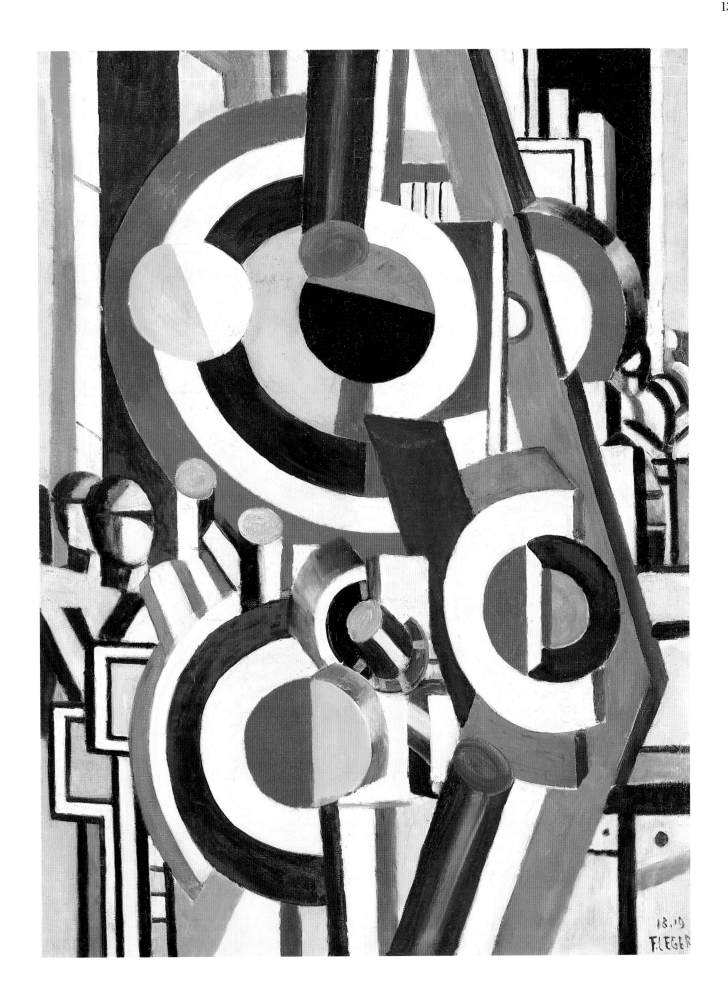

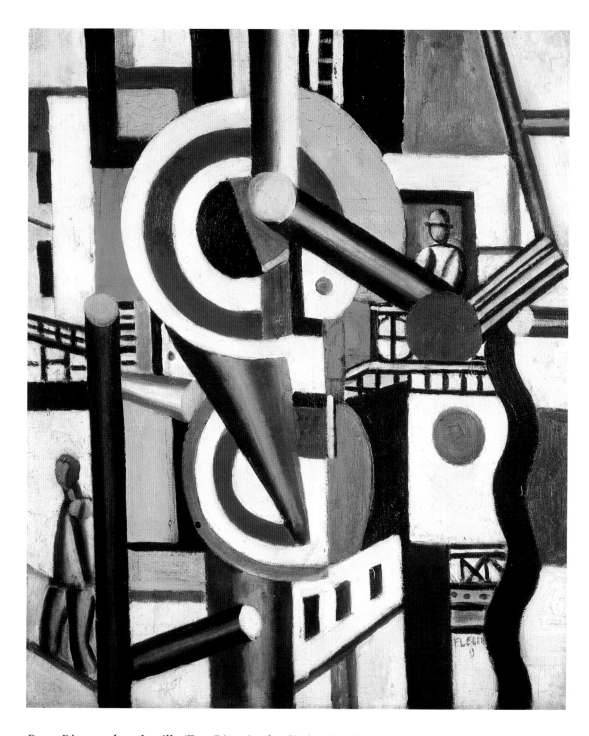

Deux Disques dans la ville (Two Discs in the City), 1919 (cat. 40)

Les Hommes dans la ville, état définitif (Men in the City, final version), 1919 (cat. 43)

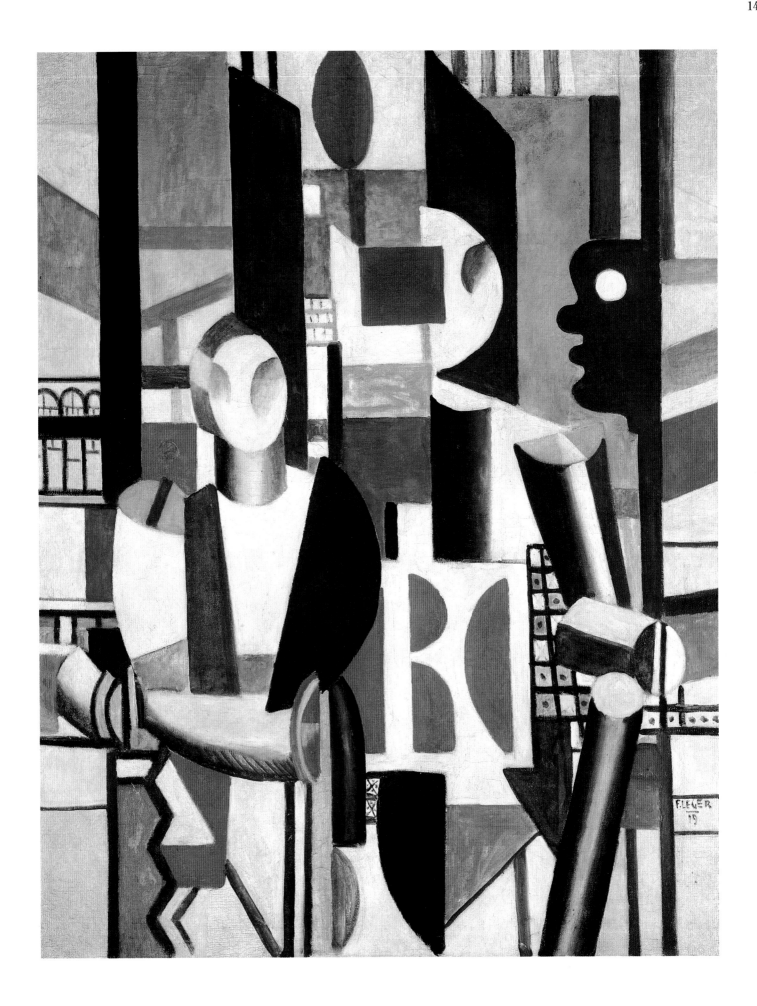

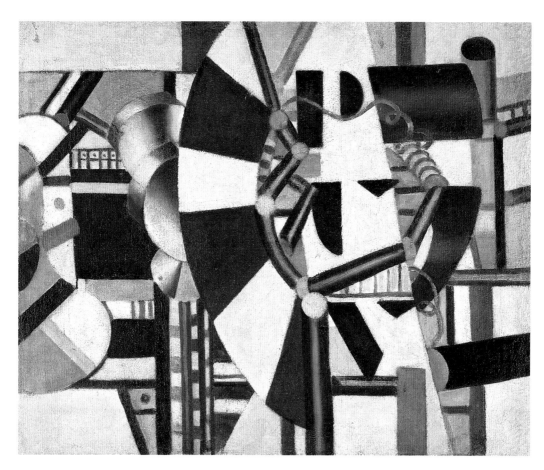

La Roue rouge: Les Eléments mécaniques (The Red Wheel: Mechanical Elements), 1919-20 (cat. 50)
La Ville, fragment, étudie, premier état (The City, fragment, study, first version), 1919 (cat. 41)

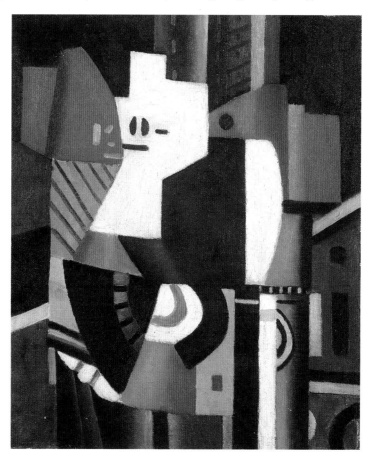

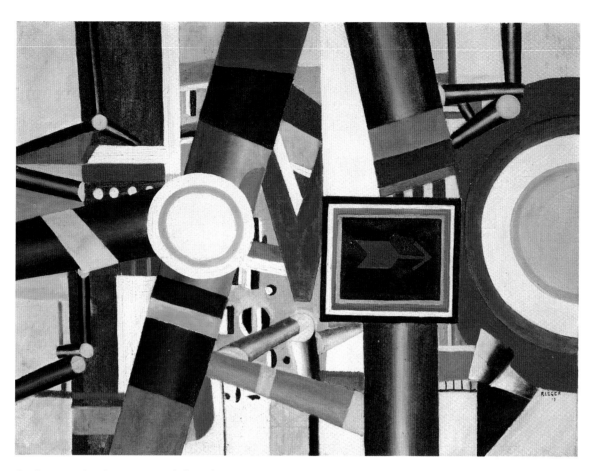

Le Passage à niveau, état définitif (Railway-crossing, final version), 1919 (cat. 45)
Les Trois Personnages (Three People), 1920 (cat. 52)

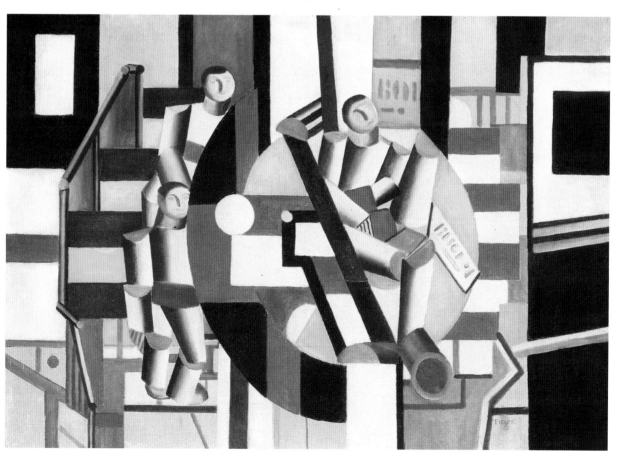

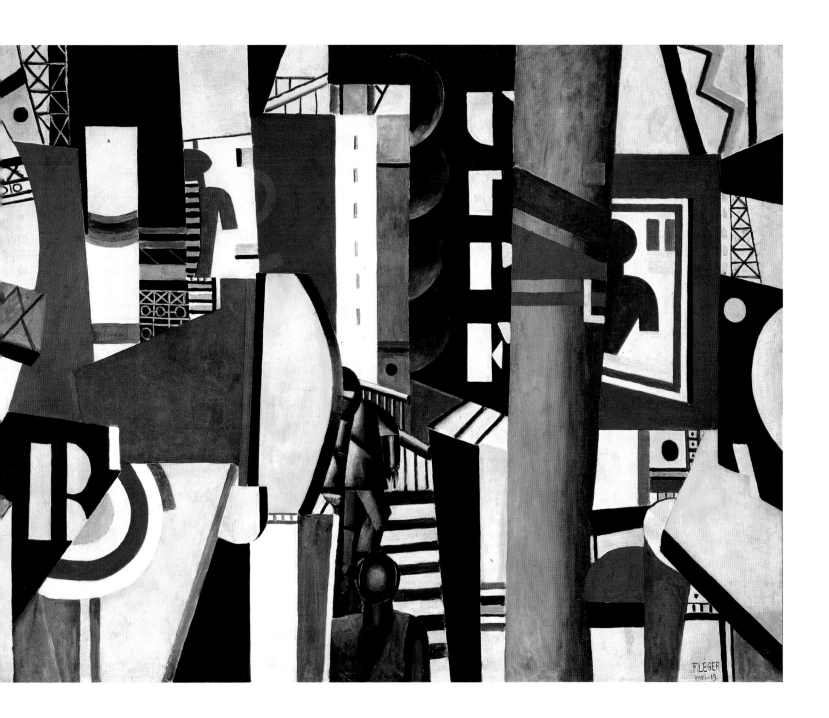

La Ville (The City), 1919 (cat. 42)

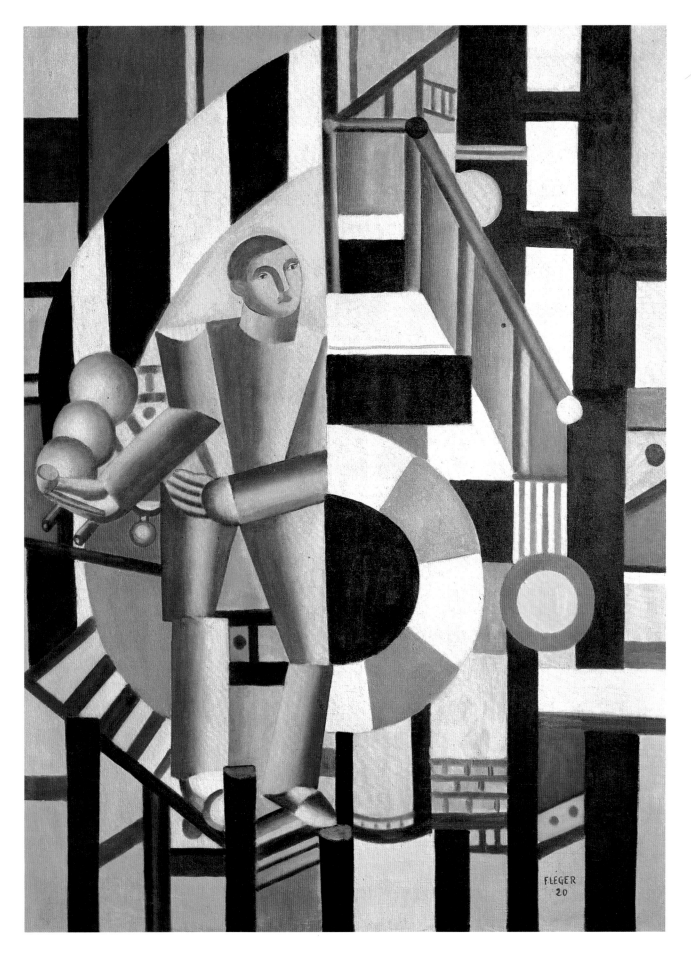

L'Homme à la pipe (Man with a Pipe), 1920 (cat. 51)

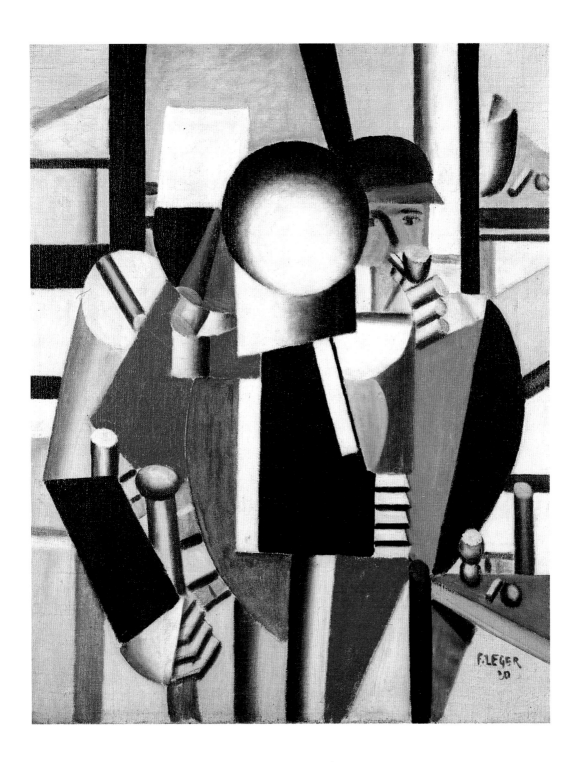

Les Trois Camarades (Three Comrades), 1920 (cat. 54)

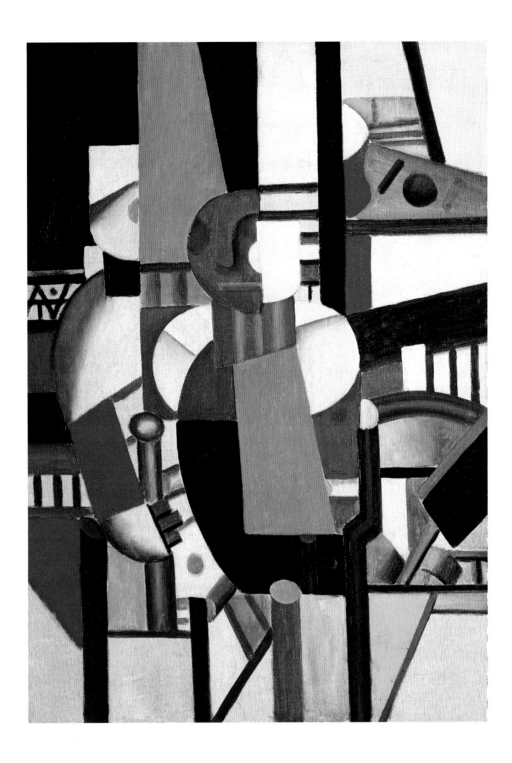

L'Homme à la canne (Man with a Cane), 1920 (cat. 53)

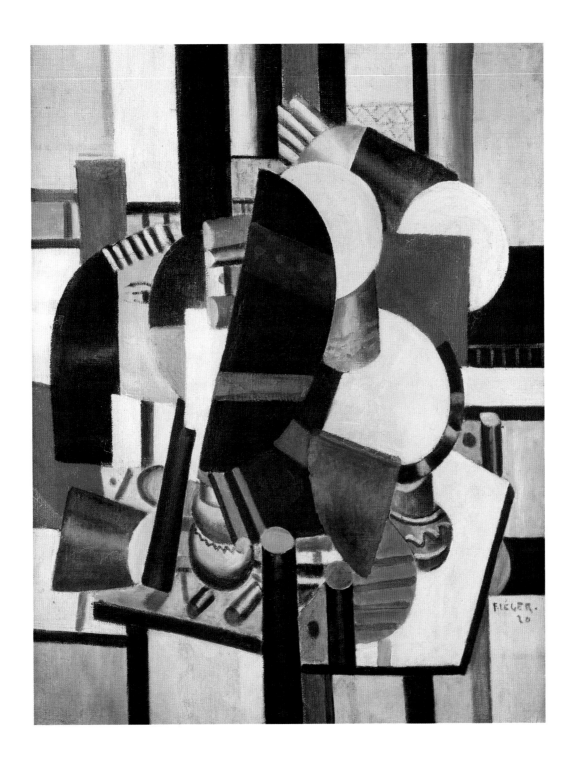

Les Femmes à la toilette, deuxième état
(Women at their Toilet, second version), 1920 (cat. 55)

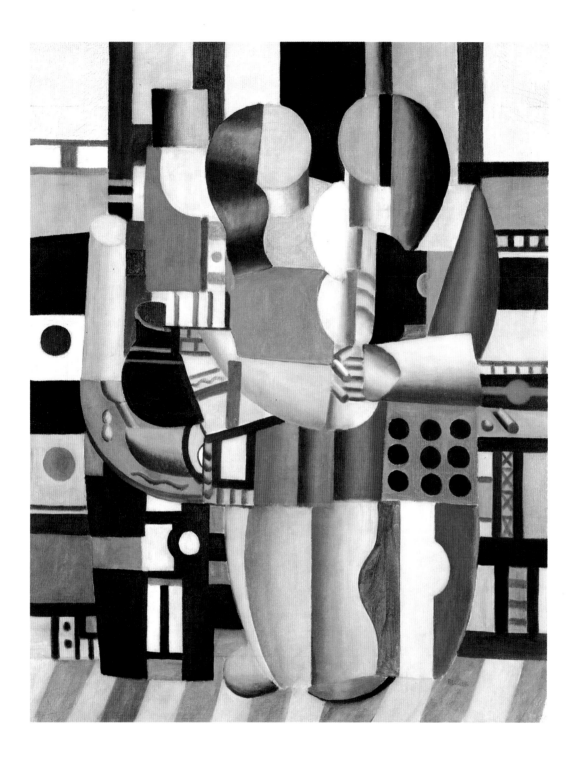

Les Trois Figures (Three Figures), 1921 (cat. 64)

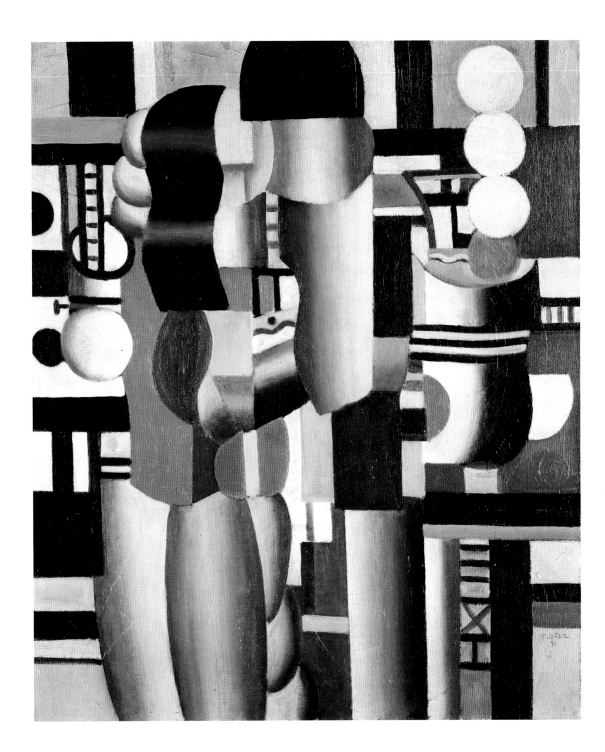

Homme et femme (Man and Woman), 1921 (cat. 65)

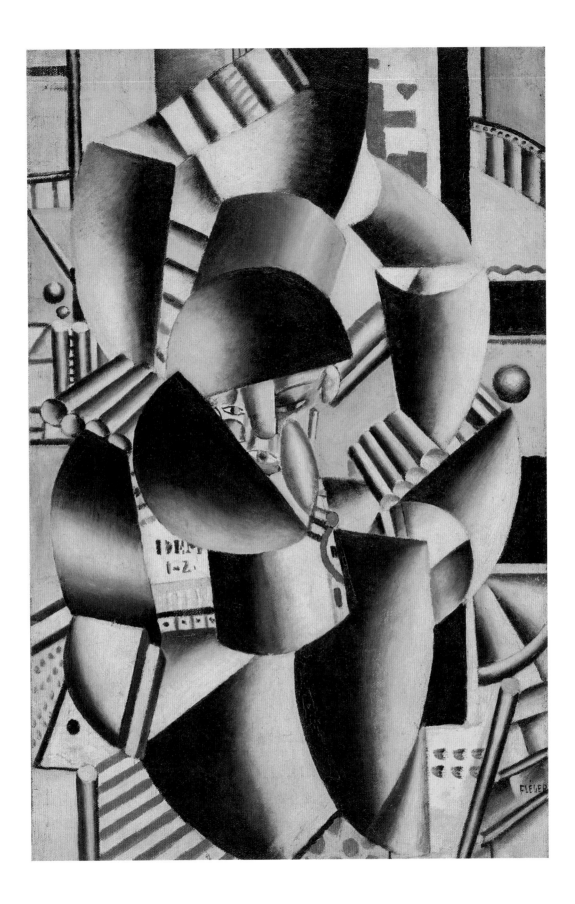

Les Deux Acrobates (Two Acrobats), 1918 (cat. 32)

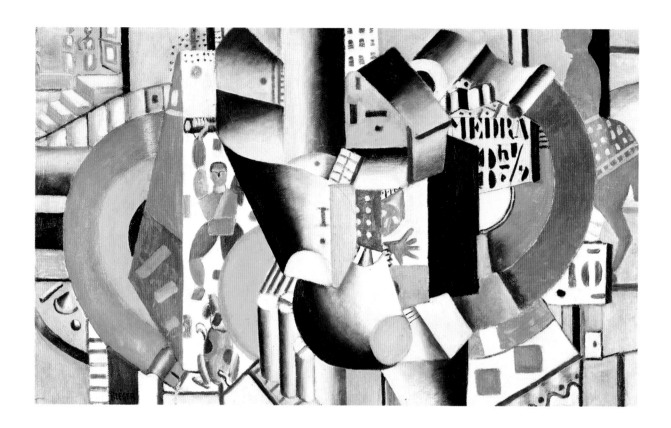

Le Cirque (The Circus), 1918 (cat. 30)

Les Acrobates dans le cirque (Circus Acrobats), 1918 (cat. 31)

Designs for *Skating-rink*, 1921

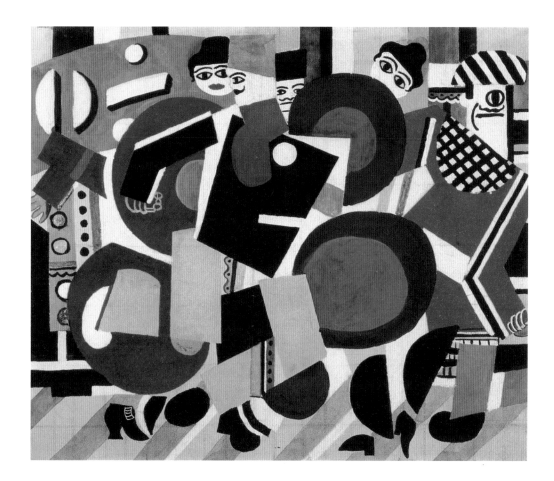

Sketch of curtain (cat. 94)

'Fou': costume design for Jean Börlin
(cat. 103)

Costume design: woman in blue, red
and yellow (cat. 99)

Costume design: sailor in blue and red
(cat. 106)

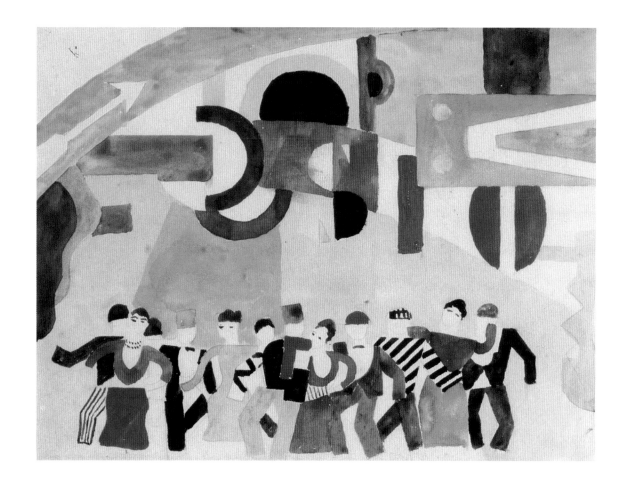

Sketch of scenery (cat. 95)

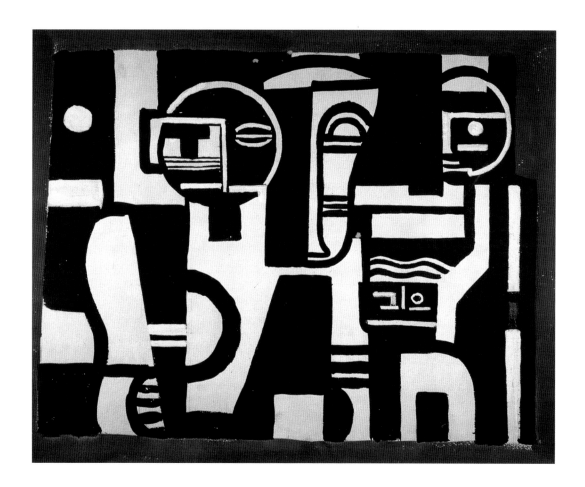

Sketch of curtain (cat. 107)

162

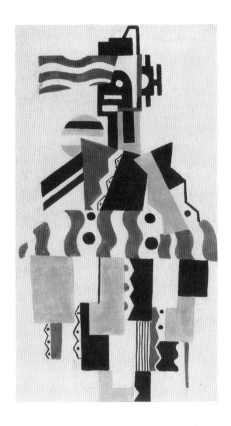

Sketch of fetish (figure study)
(cat. 124)

Sketch of large figure (cat. 121)

Sketch of bird (cat. 128)

Sketch of ape (cat. 116)

Sketch of the stage with three gods (cat. 109)

The Avant-garde in Dialogue with Tradition

As of 1919, and parallel to his celebrations of the industrialized urban environment and his exploration of a non-imitative pictorial vocabulary of machine-inspired objects and fragments, Léger was involved in an intense dialogue with the classical tradition of French painting. This dialogue with tradition engendered several important compositional groups: the *'Déjeuner'* series of 1919-22, the related *'Odalisque'* pictures of 1920 and 1921, the *'Femme et l'enfant'* paintings of 1922, the *'Paysage animé'* compositions of 1921, *La Lecture* and the other hieratic figural compositions of 1923-4. If these works reflect the classicism of the post-War 'rappel à l'ordre' they are none the less inflected with the aesthetic principles of Léger's earlier development in the milieu of the Parisian avant-garde, as well as his continuing experimentation during these years in film and with designs for the theatre and ballet.

In his later correspondence Léger specifically contrasted *La Ville* and *Le Grand Déjeuner*: the former a mural, romantic, of modern time; the latter an easel painting, classical, of eternal values. Léger's 'déjeuner' certainly reflects his awareness of tradition, his enthusiasm for Seurat, Ingres and David, for example. It is, however, his principle of plastic contrasts, the essential tenet of a non-descriptive art based on a realism of conception, that contributes to the intensity of these works. In *Le Petit Déjeuner*, the brightly coloured geometric patterns of the architectural background contrast with the grisaille, massively volumetric limbs of the statuesque female figures.

Léger's impassive odalisques hearken back to the classical tradition in painting, and with their terracotta or marble coloration also evoke Antique sculpture, or perhaps Greek vase-painting. The peculiar non-erotic coolness, the sense of emotionally neutral monumentalization, is achieved through an exaggeration and isolation of body parts, endowing anatomical elements with the same pictorial significance as the abstract forms and the objects of the adjacent still-life. The plastic intensity with which Léger endowed each brow, knee-cap, buttocks, book, jar or cup is surely informed by his oft-repeated enthusiasm for the filmic techniques of close-up and montage. In 1924/5 he wrote: 'Before I saw it in the film, I did not know what a hand was! The object by itself is capable of becoming something absolute, moving and dramatic.' Similarly, in his film *Ballet mécanique*, staring eyes and smiling lips are juxtaposed with abstract shapes, shining Christmas decorations, rotating and fragmented pots and pans. His figural paintings of 1924 (similar to the *'éléments mécaniques'* of the same year) derive an iconic or symbolic power from the exaggerated, intensely close-up presentation, a hieratic character informed not only by film, but surely, too, by the

mosaics he admired in Ravenna during his travels with Léonce Rosenberg that summer.

In the *'paysages animés'* Léger established a counterpoint between an aura of arcadian serenity and the bold colours and crisp geometry of the architectural elements. Billowing clouds, rounded trees and softly rolling hills contrast with brightly coloured architectural-billboard-girder constructions, a juxtaposition related to that of the female figures and the abstract geometric setting in the *'Déjeuner'* pictures. Moreover, several of the *'paysages animés'* and related paintings from the *'remorqueur'* series – with their shallow space and deliberate artificiality recalling the primitivism of Henri Rousseau – resemble theatre decors. Theatre was, of course, a major preoccupation of Léger's during these years, witness his design of the laboratory set for Marcel L'Herbier's film *L'Inhumaine* in 1923 and his costumes and stage designs for the Ballets Suédois in 1922 and 1923.

Léger's interest in the aesthetic principles of De Stijl, apparent in the animated, geometric patterned settings of his figural compositions of 1920-24 – *Le Mécanicien* and *Le Petit Déjeuner* are but to key examples – evolved in 1924-5 into a series of purely abstract 'mural' paintings of juxtaposed and overlapping coloured planes. The importance of the architectural mural preoccupied him for decades. Indeed, there are numerous indications of his intense involvement with the avant-garde utopian ideal of the creative collaboration of artist, artisan and architect: his works were included in the Maison Cubiste, designed by his childhood friend André Mare, at the Salon d'Automne of 1912, and in 1925 in the context of the Exposition des Arts Décoratifs in Mallet-Stevens's French Embassy building and Le Corbusier's Pavillon de L'Esprit nouveau. In 1924 Léger played a notably active role in Friedrich Kiesler's 'Internationale Ausstellung neuer Theatertechnik' in Vienna, exhibiting examples of his designs for the Ballets Suédois, screening *Ballet mécanique*, giving a lecture, and publishing an article in the exhibition catalogue. Léger's collaborative ideal was sustained in his later career, reflected in his writings on the role of colour and the mural in the modern urban environment, and especially in his murals and window decorations, mosaics and tapestries.

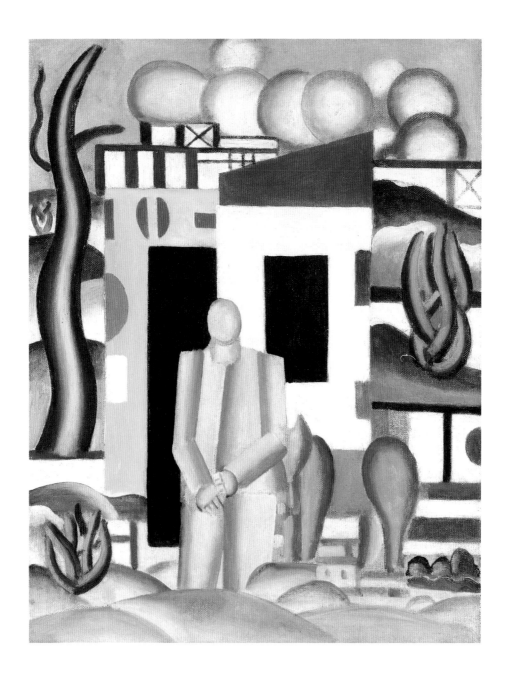

Paysage animé, premier état (Animated Landscape, first version), 1921 (cat. 63)

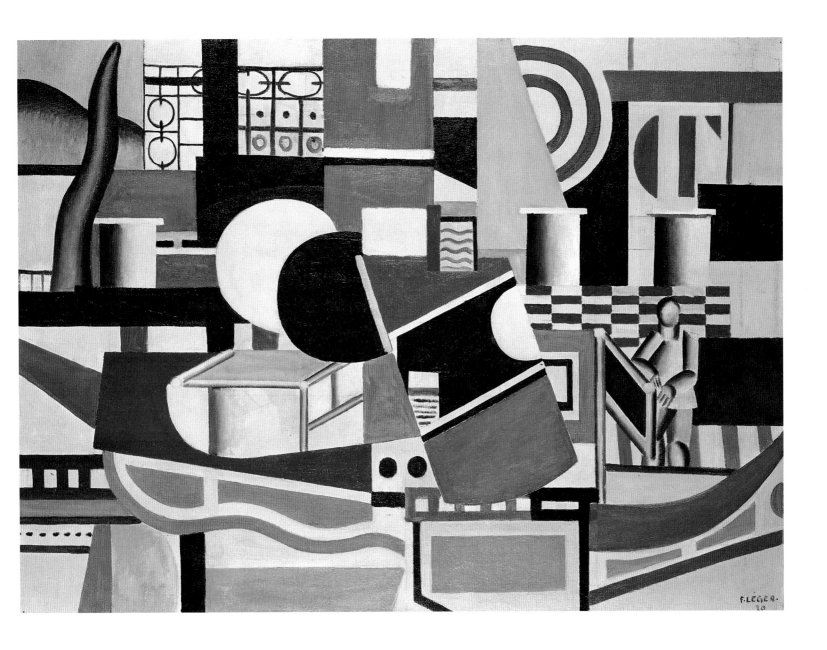

Le Pont du remorqueur (The Tugboat Bridge), 1920 (cat. 62)

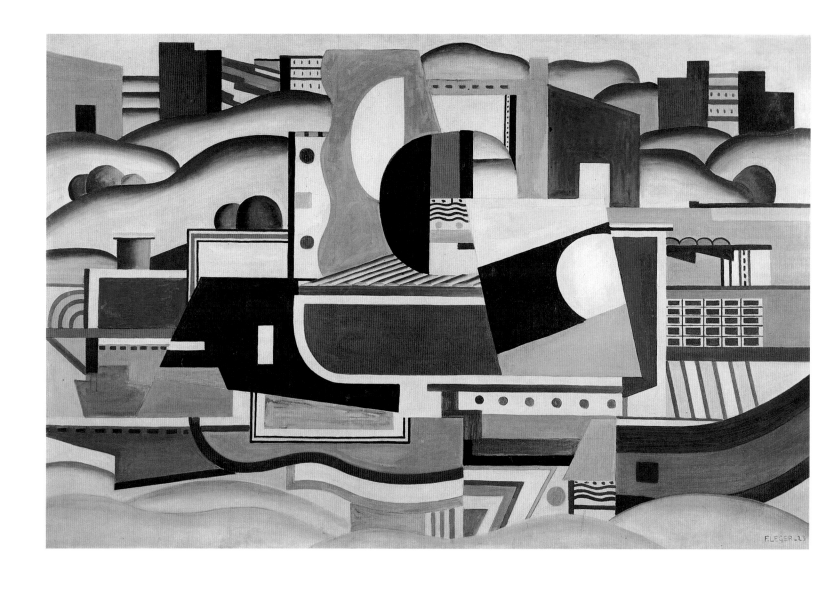

Le Grand Remorqueur (The Large Tugboat), 1923 (cat. 71)

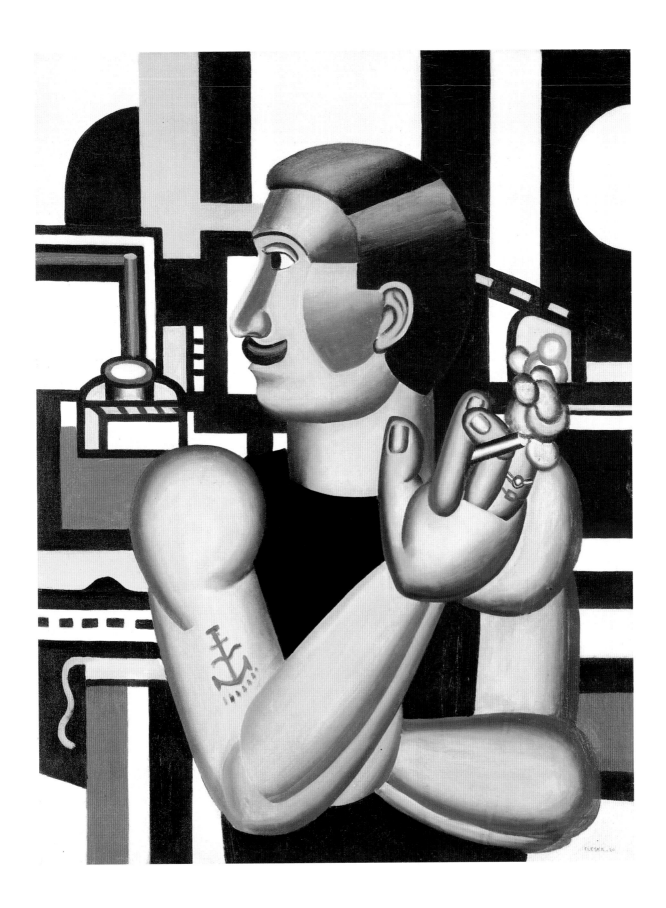

Le Mécanicien (The Mechanic), 1920 (cat. 61)

Les Deux Femmes et la nature morte, premier état
(Two Women and a Still-life, first version), 1920 (cat. 58)

Les Deux Femmes et la nature morte, deuxième état
(Two Women and a Still-life, second version), 1920 (cat. 59)

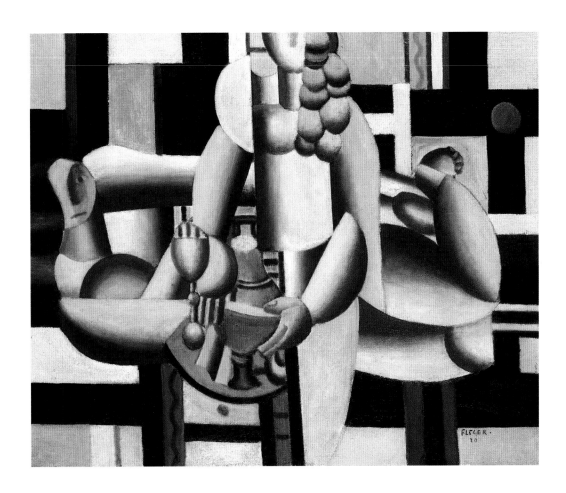

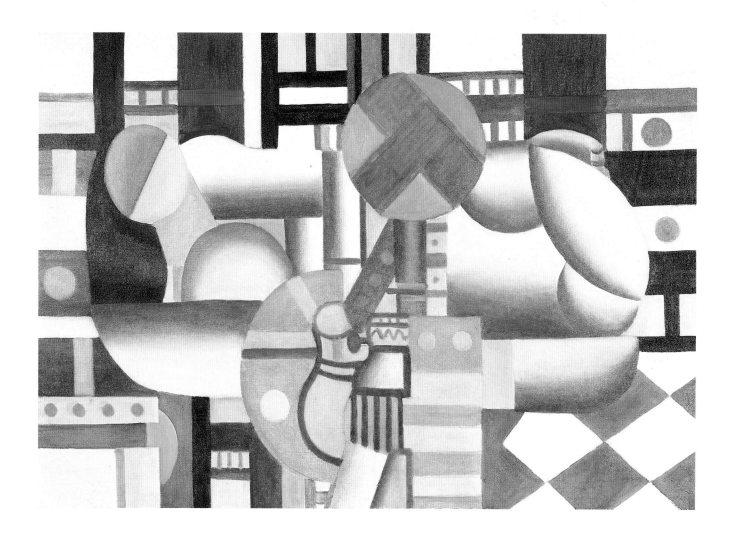

Femme et nature morte, état définitif (Woman with Still-life, final version), 1921 (cat. 66)

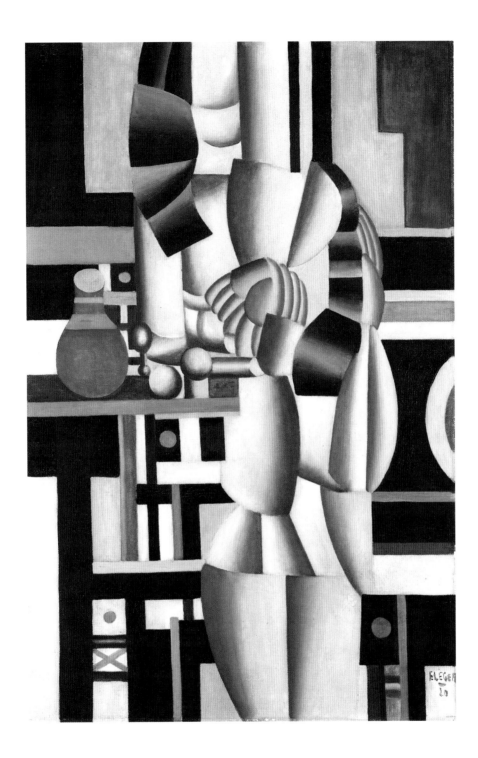

Les Deux Femmes à la toilette, état définitif (Two Women at their Toilet, final version), 1920 (cat. 60)

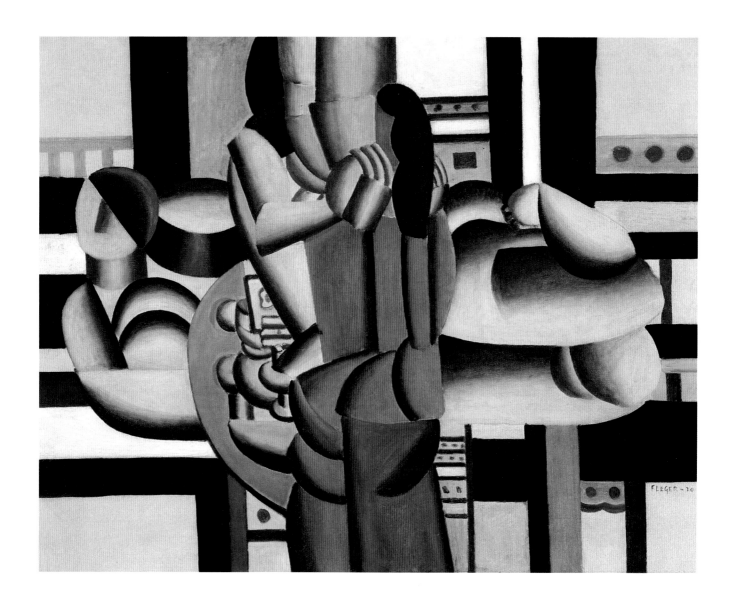

Les Trois Femmes à la nature morte (Three Women with a Still-life), 1920 (cat. 57)

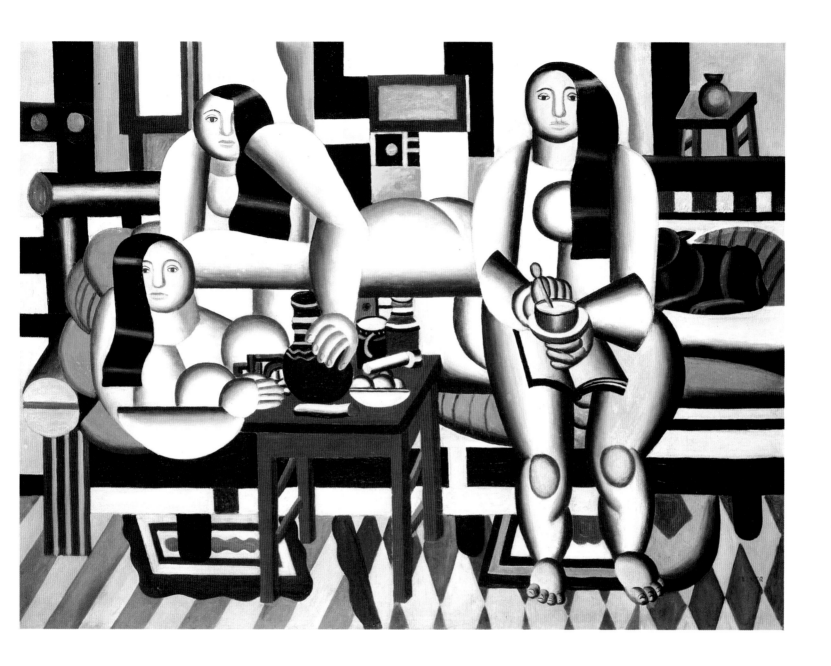

Le Petit Déjeuner (Breakfast), 1921 (cat. 67)

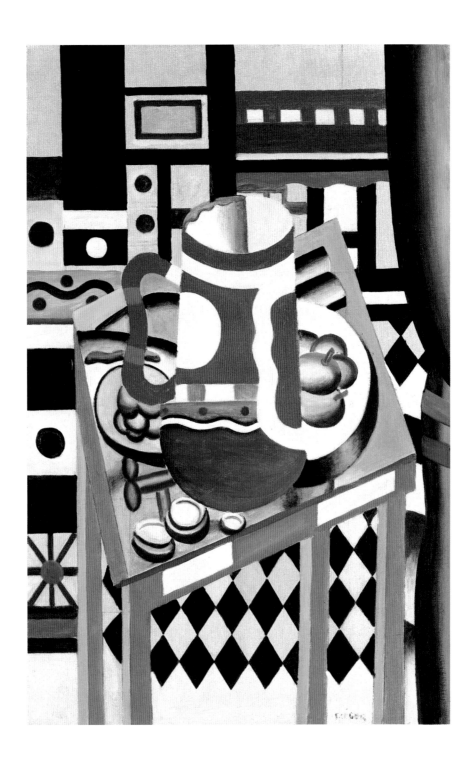

Nature morte à la chope, état définitif (Still-life with Beer-mug,
final version), 1921 (cat. 68)

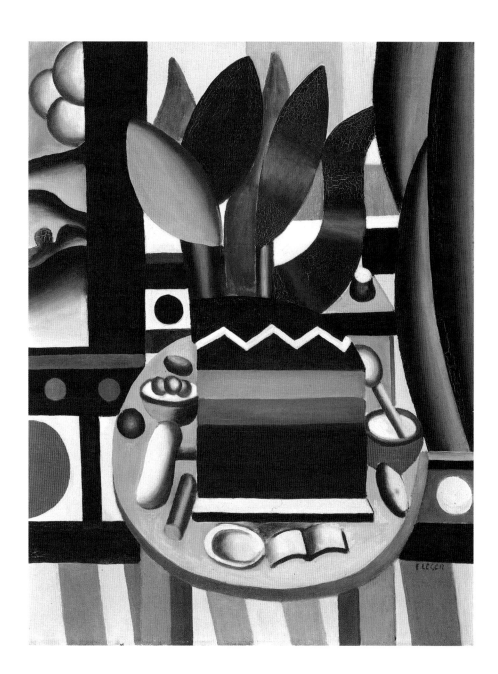

Nature morte (Still-life), 1922 (cat. 70)

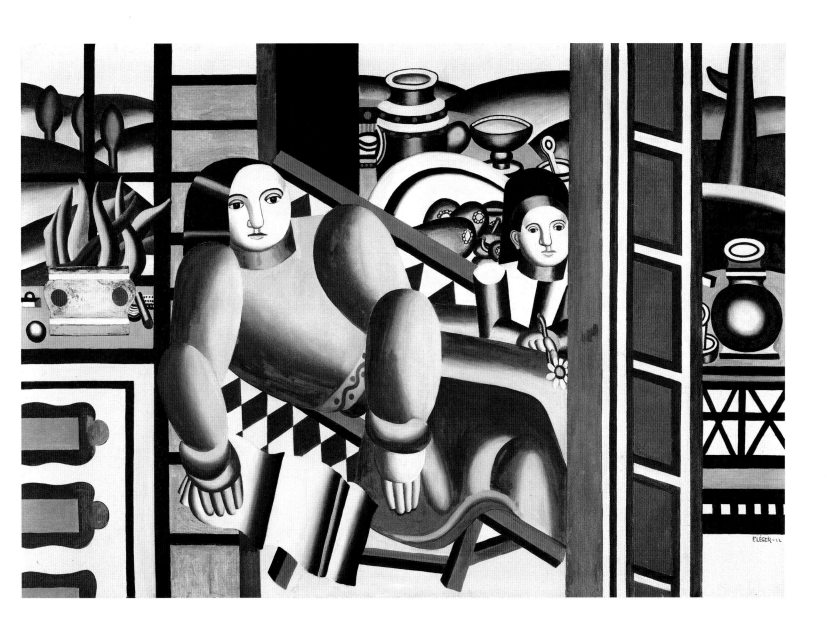

La Femme et l'enfant (Woman and Child), 1922 (cat. 69)

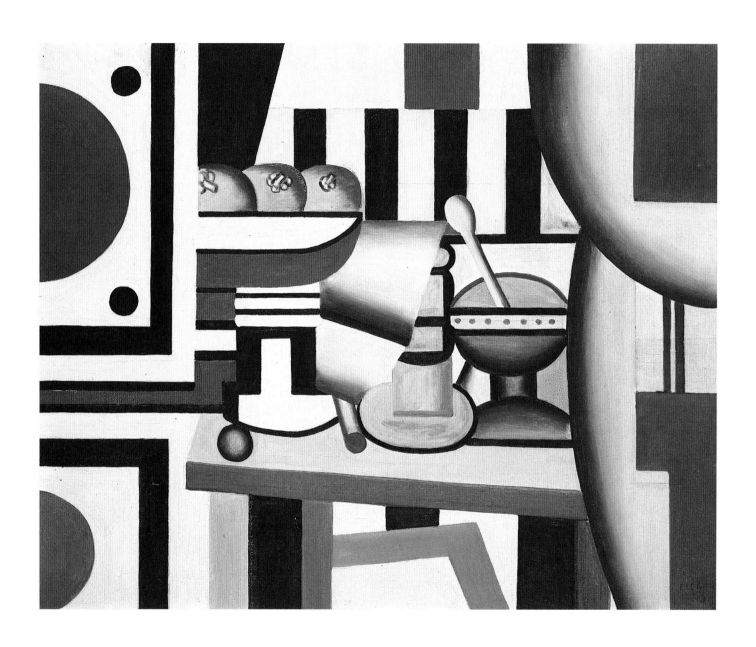

Le Compotier de poires (The Dish of Pears), 1923 (cat. 72)

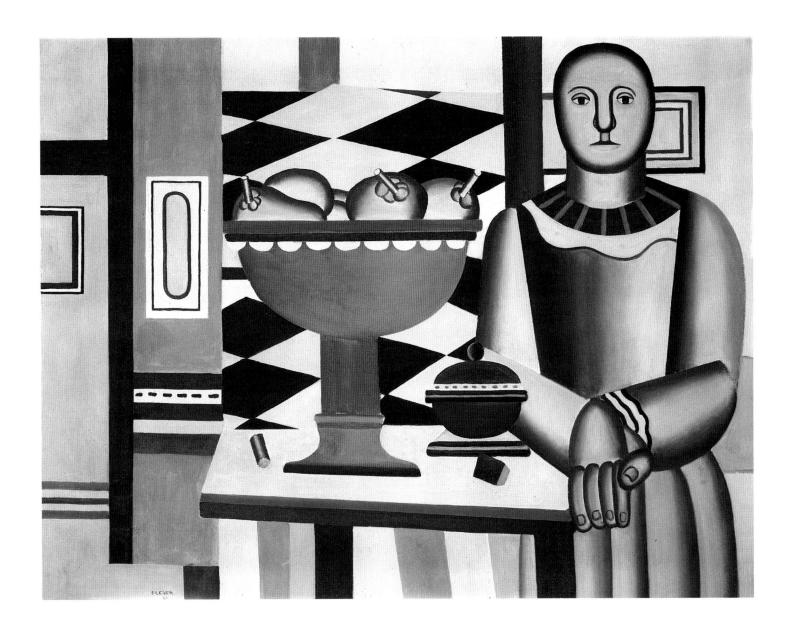

La Femme au compotier (Woman with Fruit-dish), 1924 (cat. 76)

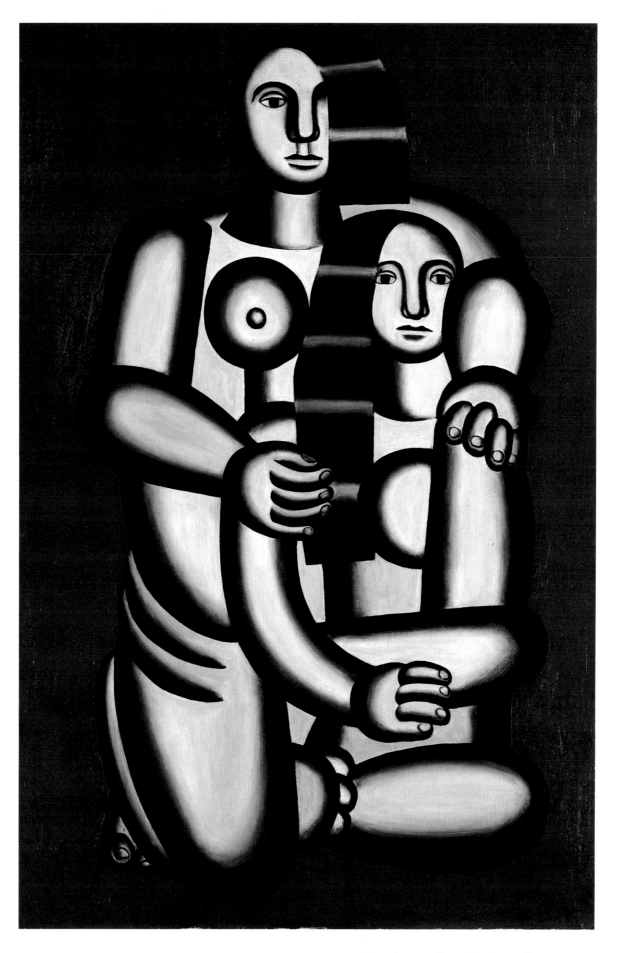

Les Deux Figures, Nus sur fond rouge (Two Figures on a Red Background), 1923 (cat. 74)

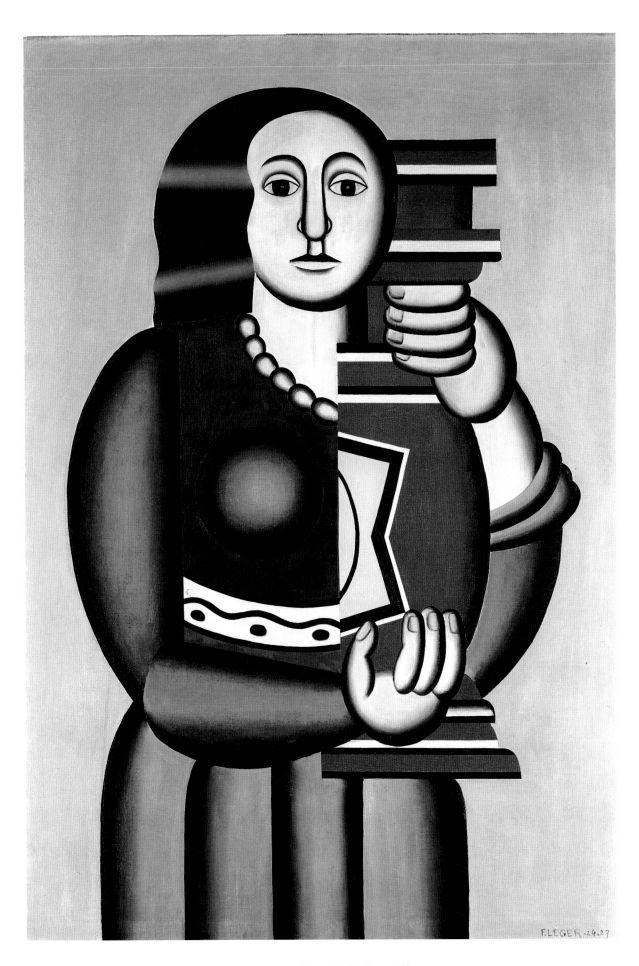

Femme tenant un vase (Woman Holding a Vase), 1924-27 (cat. 79)

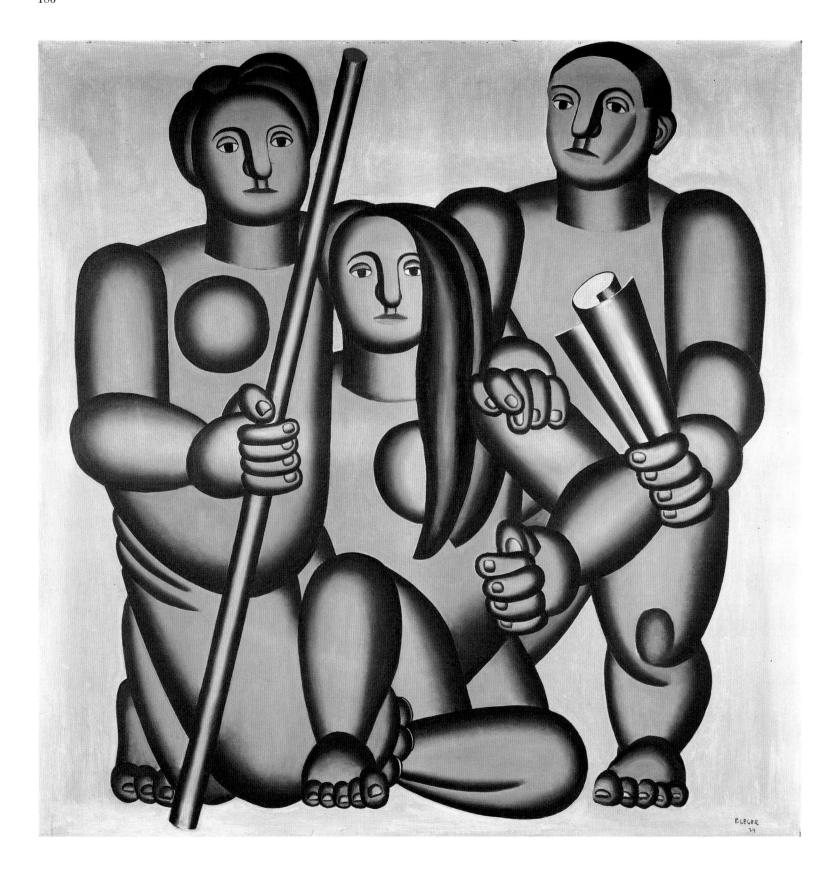

Les Trois Personnages (Three Figures), 1924 (cat. 75)

Elément mécanique, état definitif (Mechanical Element, final version), 1924 (cat. 78)

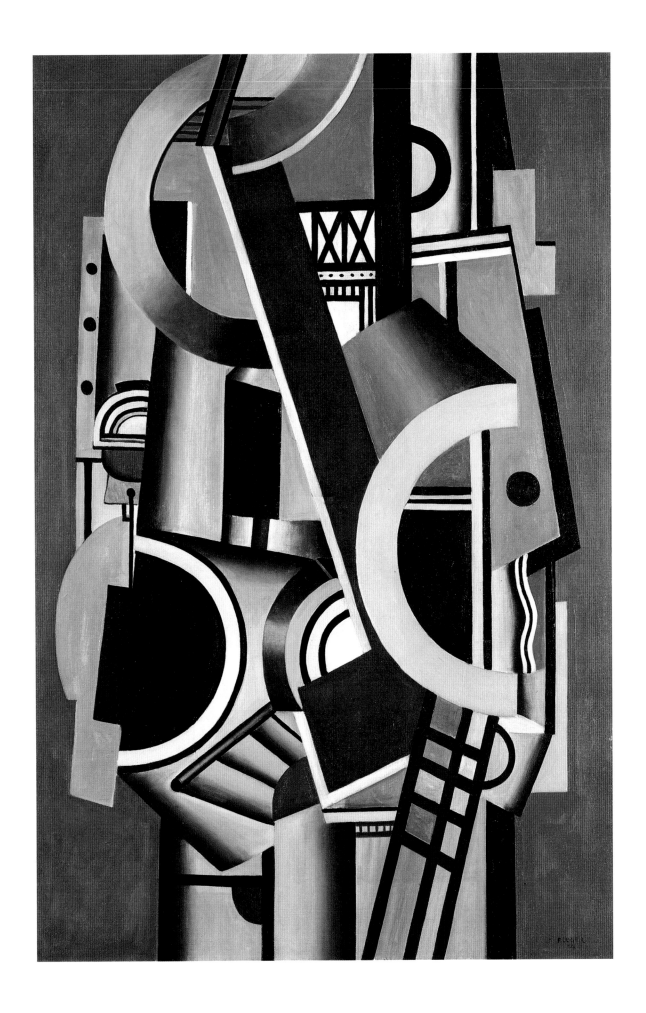

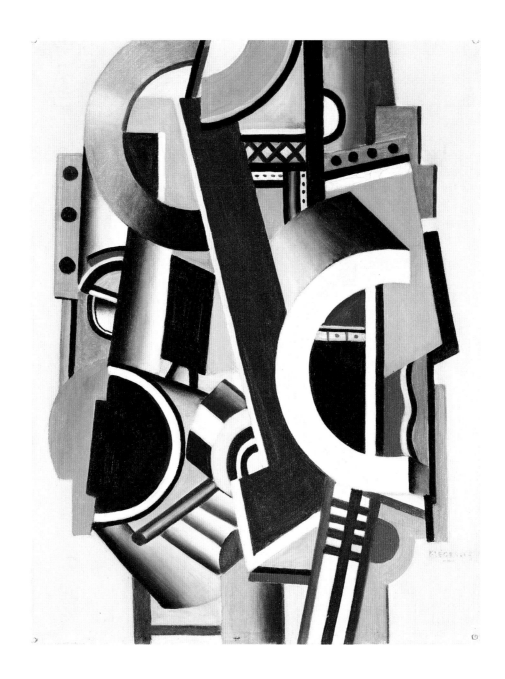

Elément mécanique, premier état (Mechanical Element, first version),
1924 (cat. 77)

Ballet mécanique
(Mechanical Ballet),
film 1924 (cat. 129)

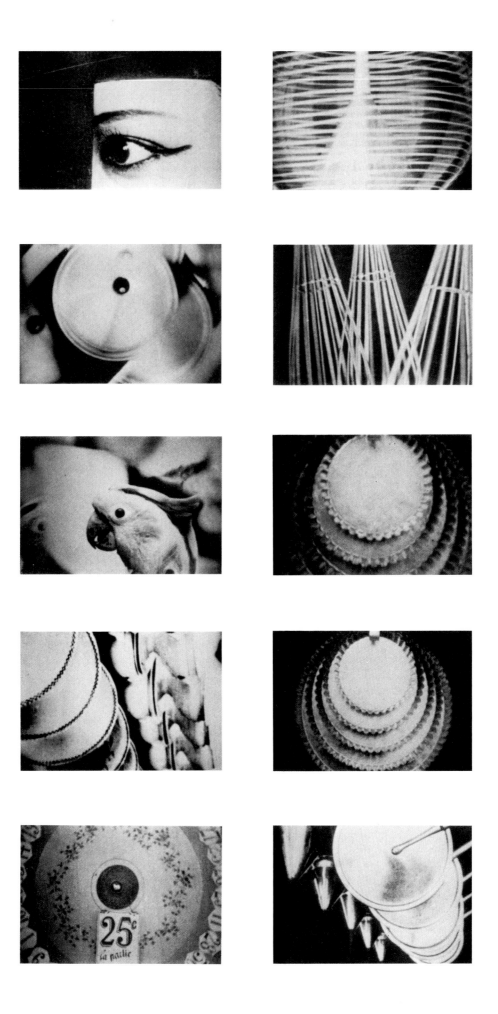

Gijs van Tuyl

A MECHANICAL PALETTE IN CYBERSPACE

Even before the Great War, with his 'con-
trastes de formes' Léger had established him-
self as a truly modern artist. During 1911-13
he was bringing to Cubism his own interpreta-
tion, stamping it with his unusually colourful
and sculpturesque contrasts of red, yellow and
blue in the form of blocks, cylinders and
spheres. And even if he had stopped painting
for good at the end of this phase, his figural
yet abstracted interiors, townscapes, land-
scapes and still-lifes would still have earned
him a unique place in the history of modern
art. His 'contrastes de formes' can be com-
pared with Mondrian's similarly Cubist-in-
spired compositions, in which trees and other
objects are transformed into a geometric
system of horizontal and vertical elements
reduced to the three primary colours. But, in
the neutral Netherlands during the War, Mon-
drian unswervingly pursued his path towards
abstraction; Léger, however, did not.

Léger's Fourth Dimension

The Great War brought about an entirely unex-
pected turning-point in Léger's development.
In 1914 he was drafted into the army's engi-
neer corps, and later he served as a stretcher-
bearer. In 1917 he was discharged because of
gas poisoning. His impressions and experi-
ences at the Front added two new dimensions
to his life and work, which made him into a

threefold champion of modern art. His modern-
ity, too, was given greater lustre and depth
through his identification with mechanized
everyday life and sense of solidarity with the
common man. But in addition to this grand
synthesis of modern art, mechanized society
and a bias towards socialism there is yet a fur-
ther dimension to his life and work: Léger's
fourth dimension is his relevance as an artist
of the mechanized age when seen against the
backdrop of our own, electronic one. Viewed in
this light he appears as an inspiring model of
the artist in creative confrontation with a tech-
nologically dominated society.

The Speed of the Electronic Age

The leitmotif of both the mechanized and the
electronic worlds is speed. Léger was already
perfectly aware that speed had become the
characteristic feature of modern life:[1] this was
the topic of his lecture to the Group d'Etudes
Philosophiques et Scientifiques at the Sor-
bonne in 1924, on light, colour, moving
images and the 'object-spectacle':

> Speed is the law of the modern world. The
> eye must 'be able to choose' in a fraction of
> a second or it risks its existence, whether it
> be driving a car, in the street, or behind a
> scholar's microscope. Life rolls by at such a
> speed that everything becomes mobile. The
> rhythm is so dynamic that a 'slice of life'
> seen from a café terrace is a spectacle. The
> most diverse elements collide and jostle one
> another there. The interplay of contrasts is
> so violent that there is always exaggeration
> in the effect you glimpse.[2]

Léger was fascinated by the dynamic power
and rhythm of modern life, whose speed is
always dictated by the existing means of trans-
port, for transportation, inevitably, is bound to
its age. From our present vantage, the 1920s
look to have been the Good Old Days, a time
when the pace of life was less hectic than is
our own. This is mainly because the speeds of
cars, trains and aeroplanes has increased enor-
mously over recent decades, although this is a
change that is essentially quantitative. More-
over, our various means of transport today,
which are essentially 'traditional' in their basic

1 Léger, 'Couleur dans le monde'
(1938), in Fonctions de la peinture,
Paris, 1965, p. 87; English transla-
tion, Functions of Painting, Lon-
don, 1973, p. 121.

2 Léger, 'Le spectacle: lumière,
couleur, image mobile, objet-specta-
cle' (1924), in Fonctions de la pein-
ture, p. 131; English translation,
p. 35.

Fig. 1 Cyberspace Equipment, 1988

Fig. 2 Nam June Paik, *Robot K 456*, 1965, construction. Private collection

3 Léger, 'Les réalisations picturales actuelles' (1914), in *Fonctions de la peinture*, p. 20; English translation, p. 11.

4 Léger, 'Le spectacle: lumière, couleur, image mobile, objet-spectacle', p. 133; English translation, p. 37.

5 'Cyberspace' refers to the virtual reality of a computer-generated, three-dimensional world that acts on the senses. See Florian Rötzer and Peter Wiebel, eds., *Cyberspace – Zum medialen Gesamtkunstwerk*, Munich, 1993.

6 As in, for example, Virilio's *Vitesse et politique*, Paris, 1977. See 'Jeder Mensch ist eine Stadt. Der französische Urbanist Paul Virilio im Gespräch mit Aurel Schmidt', *Basler Magazin*, no. 27, 17 July 1993.

7 Léger, 'New York' (1931), in *Fonctions de la peinture*, pp. 186-93; English translation, pp. 84-90.

8 See Paul Virilio, *La machine de vision*, Paris, 1988; idem, *L'Ecran du désert, chroniques de guerre*, Paris, 1991.

technology, have virtually reached their critical speed levels, for both technological and environmental reasons.

The great acceleration that we have been experiencing in the 1980s and early 1990s has not been mechanical but electronic. Revolutionary developments in electronics have brought about an almost complete computerization of our society, grounds alone for the term 'post-modern' (fig. 2). Furthermore, the speed of communication is now truly breathtaking. This is the age of telecommunications, a time when the entire world has become accessible – and, on screen, visible – within a fraction of a second. If, as Léger believed, he and his contemporaries had to process a hundred times as many impressions as had artists in the eighteenth century, nowadays we are faced with a thousand, a million, a billion times as much information.[3] Data, more data and yet more data appears and disappears on the one horizon that still seems to exist – the screen. Computers, terminals, monitors, televisions and videos offer a seemingly endless flood of visual information. Human vision threatens to disintegrate under the impact. Where Léger spoke of 'the whirlpool that swirls under his eyes',[4] the French cultural commentator Jean Baudrillard now sees one great 'cyberblitz' that dissolves reality into a sea of information and communication.[5]

Speed is also the prevailing theme in the writings of Paul Virilio, a French urbanist and theoretician of time and space.[6] As Virilio points out, speed has always depended on the nature of the available means of communication; the mechanized era of the railways and the first cars and aeroplanes was preceded by one in which anywhere that one was likely to want to travel to was so near that the journey could be made on foot or on horseback. In today's electronic era, the whole world is ready to hand because of telecommunications. 'Telepresence' is Virilio's term for this. Television and video, in particular, make everything accessible, visible to us in our homes, and at the speed of light. In one sense, nobody needs any longer even to step out of doors in order to 'get' from one place to another; even our so-modern means of transport have been rendered redundant. Unlike earlier forms of communication, such as the telephone (which played a key role in the way New York functioned *c.* 1930, as Léger discovered[7]), the computer of today has opened up undreamt-of possibilities, from telebanking to cyber-erotics (fig. 1).

The remarkably wide range of applications to which telecommunications can be put has resulted in a large-scale industrialization of visual perception. Images can be called up at any time, not mechanically but electronically. Digital codes even allow us to produce synthetic images that have the appearance of reality. Virilio reminds us that even visual perception itself has become fully automatic through the 'electronic eye' and other viewing devices, which can 'see' twenty-four hours a day without any need for human intervention. And these devices need not be static: a video-camera mounted in the cone of a missile 'sees' during the flight, responds to the visual information it picks up and, as required, electroni-

cally manipulates the missile's controls so that the target is hit precisely.[8]

In this brave new world of virtual reality, many of art's traditional media, for example, painting, photography and film, have reached a critical stage. Virtual reality – which functions in *real* time – has pushed aside the 'reality' of painting and the 'immediacy' of photographs and film, linked, as they are, to real space. What role is there now for artistic activities such as these in a world dominated by the latest electronic devices? In 1937 Léger had seen a parallel threat in the form of film, radio and advertising, which were able to address the working classes far more directly than art had ever managed to do.[9] For Virilio, and for Baudrillard too, the disappearance of public performances signalled the end of the modern age, for in their view, city streets and squares played a vital part in making communication possible.[10] The dominance of the electronic media has almost utterly destroyed this function. As a 'domestic billboard terminal', television has replaced the shop window. Indeed, the whole world is today presented like a display. In Virilio's terms, one can say that our electronic age manifests itself as a virtual (or virtual reality) city, a city not directly to hand in three dimensions but whose presence can be conjured up anytime, anywhere on a screen. Virilio is both fascinated and alarmed by the new, controlling power of telecommunication, for its negative effect is that people make ever less effort to leave home and visit others: they simply stay put in their cocoons of virtual reality.

The Dynamic of the Mechanized Era

The opposite of the virtual city is the visual city. The visual city encapsulated the theatrical stage of modern life. Replete with dynamic scenes of endless bustle, it was the manifestation *par excellence* of the mechanized world. The visual city and the virtual city can be understood as 'contrasts of forms', contrasts between the mechanized and the electronic eras. Léger was the artist of the visual city, and he sang its praises in numerous lectures and articles. After the Great War was over, he and

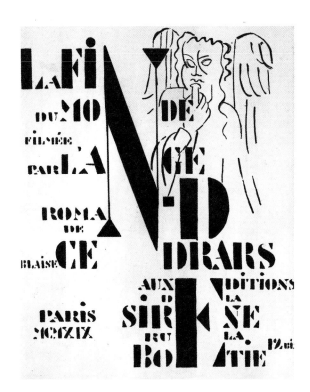

Fig. 3 Léger's illustration for the dust-jacket of Blaise Cendrars's poem *La Fin du monde, filmée par l'Ange N.-D.* (The End of the World, filmed by the Angel of Notre-Dame) Paris: Edition de la Sirène, 1919. Öffentliche Kunstsammlung, Basle: Kupferstichkabinett (inv. 1965. 18)

Fig. 4 Robert Delaunay, *La Tour* (The Eiffel Tower), 1910. Collection Charles Delaunay, Paris

9 Léger, 'Le nouveau réalisme continue' (1936), in *Fonctions de la peinture*, p. 178; English translation, p. 117.

10 Jean Baudrillard, 'The Ecstacy of Communication', in *Postmodern Culture*, ed. Hal Foster, London, 1983, pp. 126-33.

11 Léger, 'Les réalisations picturales actuelles', p. 22: English translation, p. 13.

the poet Blaise Cendrars often frequented the Place Pigalle, a stage for the theatre of modern life. In Cendrars's prose poem *La Fin du monde, filmée par l'ange Notre-Dame* (1919), which Léger illustrated (fig. 3), Cendrars brought to life, with acute concision, various aspects of Paris: rhythmically, like a film, image after image passes at speed before our eyes, with frequent sudden breaks and abrupt transitions.

It is the angel of Notre-Dame who is the 'cameraman' for *La Fin du monde*. A *vue generale* is followed by a succession of neighbourhood settings. Cendrars's prose-poem is a scenario with footnotes to the individual camera positions, which – in part because they are numbered – have a fragmentary character. The cinematic vision is underlined by means of scenes running at different speeds, some accelerated, others in slow-motion, and the end of the poem is like a film that is run in reverse.

It was in Paris that Léger was able to feast his eyes on the flickering neon signs to be seen in the windows of bars and shops, and the electric lights on the Eiffel Tower (fig. 4) and in the city's buses, boats, stations, streets, cinemas, circuses and funfairs. Léger loved the spectacle of modern urban life: to see every-

12 Léger, 'L'esthétique de la machine: l'objet fabriqué, l'artisan et l'artiste' (1923), in *Fonctions de la peinture*, p. 57; English translation, pp. 55-6.

13 Léger, 'Le spectacle: lumière, couleur, image mobile, objet-spectacle', p. 142; English translation, p. 46.

14 Léger, 'New York', pp. 189-90; English translation, p. 87.

15 See B. Cendrars, 'Fernand Léger (Modernité 6)', *La Rose Rouge*, 10 (3 July 1919), reprinted in *Modernities and other Writings by Blaise Cendrars*, ed. M. Chefdor, Lincoln, NB, and London, 1984, p. 100.

16 Léger, 'Le spectacle: lumière, couleur, image mobile, objet-spectacle', p. 133; English translation, p. 37.

where big, bright posters and billboards seemed right to him;[11] even those who arranged the displays in shop windows were, in his opinion, real artists.[12] All this performance and presentation transformed the streets into a busy spectacle; their vibrancy contributed to the frantic pace of life.

For Léger, however, the modern city was so chaotic that immersion in it constituted an assault on the nervous system.[13] And in responding to the city, the artist's role was not that of recording the chaos but of arranging it, ordering it. In *La Ville* (pl./p. 145) Léger managed this in a masterful way, borrowing from film techniques for the arrangement of his composition and using passages of undiluted colour to suggest form and space and to evoke the dynamic, powerful rhythms of the metropolis. Later, when his enthusiasm was more tempered, he appraised the nature of big cities with some scepticism. His visit to New York in 1931 provoked in him a mixture of awe and abhorrence. He was fascinated by the spectacle of illuminated skyscrapers, neon lights and the dazzle of headlights from busy traffic. But he had considerable reservations about the USA generally, with its rationalization of every sphere of life and its massive industrialization, its obsession with numbers, figures and the power of money. Even more than the overwhelmingly eclectic architecture, the drawbacks of New York, Léger thought, were luxury items such as refrigerators, the superfluous escalators, the ostentatiousness, the exaggerated dynamism ... and its people smoking everywhere, even outside in the street! When he came across a horse in a garage otherwise full of cars and experienced a peculiar comfort in the animal's warming presence, he commented confidently, 'That'll soon be the last cart-horse'.[14]

Mechanization and War

During the Great War, mechanization and industrialization gained terrific momentum. The machine – mechanization in its built form – functioned not only as the motor of progress toward utopian happiness, but also as a monster. The once rustic countryside was suddenly swept off the map for good by the rush of trains, trucks, machine-guns, tanks and swooping fighter 'planes. Pastoral innocence was replaced by the industrial landscape, and the change was recorded in the millions of photographs taken in the process of the military's aerial reconnaissance. Serving at the Front, Léger and Cendrars had first-hand experience of the murderous speed and power of mechanization. They came to realize the enormity of the visual revolution it was bringing about. According to Cendrars, Léger attributed his keen sense of vision to his experiences at the Front. It put him in touch with a different reality from that which he had known in the salons of Paris: bomb craters, barbed wire, shift-work, depots stacked with military hardware; masses of uniformed, rank-and-file soldiers swarming across devastated terrain. He not only encountered things *beyond* himself that were wholly new to him, for his perception was itself changing in response to his new environment, becoming more photographic, more like a camera recording events that happened faster, and in a more fragmented way:

> His eye goes from the tin to the zeppelin, from the caterpillar to the little spring in a cigarette lighter. An optical signal. A notice. A poster. The squads of aeroplanes, the convoys of trucks, gun-barrels, shaped like pan-pipes, American motors, Malaysian daggers, English jams, international soldiers, German chemicals, the cylinder-head of the .75, everything bears the mark of formidable unity. Everything is contrast![15]

But despite the horrors of the Front, Léger insisted that the War had a cleansing effect: it was a necessary preparation for our hard, modern times. Several years after the cessation of hostilities he reflected on the War and on modern life, and found the latter to be

> a harsh, prosaic, precise life: the microscope is trained on everything; the object, the individual is gone into thoroughly, examined from every angle. Time, measurement, are taken seriously; everything is now measured in seconds and millimetres. There is such a race for perfection that inventive genius is pushed to its extreme limits. An epoch that has resulted from an instructive war in which every value was stripped bare, and there was a total revision of moral and spiritual values.[16]

Or as he put it in 1923: war was all about living at a higher speed. And modern life too was a state of war because of its speed, harshness and glaring clarity. Experiencing life was like walking about wearing huge spectacles: the hard facts of reality became crystal clear before one's eyes, without any obfuscating nuances or hues.[17] As an artist, Léger thought of the machine less as an instrument of destruction and death than as an uncomplicated symbol of progress and civilization. During his 'mechanistic' phase in painting, there was no room for a darker side in his art: the works that resulted are as hard as they are clean.

Mechanical and Industrial Themes

Cars did not feature during Léger's mechanistic period. However, his paintings of the period 1917-24 do contain forms that refer to tugboats, cranes, railway-crossings, bridges, telegraph poles, propellers, engines, cylinders, connecting rods, ball-bearings and cog-wheels. In this extensive repertory of engineering motifs, a car built by Citroën or Peugeot would hardly seem out of place. Why did he avoid this aspect of the modern industrial world? After all, a car is by far its most obvious symbol. There are no indications that he had an aversion to the car, nor was he alert to related environmental issues. He even ridiculed an organization in France dedicated to 'the preservation of the countryside', an organization that was then compaigning against the disfigurement of the countryside caused by creeping industrialization. As an utterly lucid modernist he insisted that the age of quiet little country lanes was definitely over: 'Now the railroads and the automobiles, with their plumes of smoke or dust, seize all the dynamic force for themselves, and the landscape becomes secondary and decorative'.[18]

Léger especially admired the car for the functional streamlining of its bodywork, a characteristic he also found in the conical silhouette of the Lapp hut, which creates a minimum of resistance to rain, wind and snow. The first cars, raised high above the axle, resembled the horse, he thought; but the drive towards building ever-faster cars led to

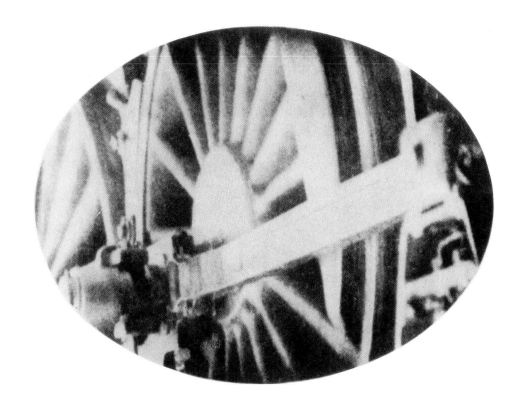

increasingly streamlined forms, with centres of gravity much closer to the road.[19] Other industrial products, too, could match the beauty of paintings. Léger, with his friends, visited automobile and aviation shows, which he preferred to the art exhibitions held at the Salon. As a painter, he competed with industrial designers, wanting to make things that were more beautiful than practical instruments or machines. It was a contest he could never win by copying even the most handsome objects. According to Léger, he actually imagined his own machines, for engineered components gave him the thrill 'of strength and power'.[20] Machines and paintings, he felt, should have similar structural essences; they should appear material, solid (fig. 7).

Although Léger was not influenced by the geometrical forms of industrial components in a random way, to a great extent he nevertheless relativized the importance of the theme by emphasizing the *how* rather than the *what*. Whether he was dealing with a kitchen pot, a machine component or a human figure, it was the interpretation that really mattered. He claimed to make no distinction between a modern and a traditional theme, although this clearly does not entirely apply to his mechanistic period.[21] He did indeed see a clear

Fig. 5 Still from Abel Gance's film *La Roue* (The Wheel), 1922

17 Léger, 'L'esthétique de la machine: l'ordre géométrique et le vrai' (1925), in *Fonctions de la peinture*, p. 66; English translation, p. 65.

18 Léger, 'Les réalisations picturales actuelles', p. 22; English translation, p. 13.

19 Léger, 'L'esthétique de la machine: l'objet fabriqué, l'artisan et l'artiste', p. 54; English translation, p. 53.

20 Léger, 'L'esthétique de la machine: l'ordre géométrique et le vrai' (1925), in *Fonctions de la peinture*, p. 63; English translation, p. 62.

21 Léger, 'Les réalisations picturales actuelles', p. 26; English translation, p. 16.

Fig. 6 Sonia Delaunay, Illustration for Blaise Cendrars's *La Prose du Transsibérien* (The Prose-poem of the Trans-Siberian Railway), 1913, watercolour and coloured chalk on paper, 25.3 x 19.8 cm. Musée National d'Art Moderne, Paris

22 Léger, 'Note sur la vie plastique actuelle' (1923), in *Fonctions de la peinture*, p. 47; English translation, p. 26.

23 Ibid., p. 45; English translation, p. 24.

thematic shift in the historical development of art from landscapes containing industrial aspects to depictions of actual machinery.[22] None the less, 'the mechanical element is *only a means and not an end*. I consider it simply plastic "raw material", like the element of a landscape or a still-life.'[23] *Le bel sujet*, such as the well-arranged shop window, itself harbours a danger, in that it can never be reproduced: 'The *beautiful machine* is the modern *beautiful subject*; it too is uncopiable.'[24] Not surprisingly, then, Léger did not include cars in the subjects he painted: they were too beautiful.

The Mechanization of Visual Perception

Means of transport played a prominent role in Léger's visual thinking. The train and the car were already producing a far-reaching transformation beyond the city. The countryside's appearance was rapidly transformed by their emphatic presence and the concomitant side-effects: the railway's lines, crossings and stations; highways, bridges, petrol stations and billboards; traffic lights and road-signs. The relative stillness of the rural world was suddenly disturbed by the sounds of engines, horns, steam-whistles, ringing bells and the occasional car-crash, not to mention the staccato of new agricultural machinery or the buzz of overflying 'planes. Although railway engines had been around for three-quarters of a century or more, and the car was well on its way to becoming *the* preferred means of transport, most people were only just beginning to adjust their attitude towards the life and appearance of the countryside, and the new ways in which it was to be experienced. For as Léger discovered beyond the city:

> When one crosses a landscape by automobile or express train, it becomes fragmented; it loses its descriptive value but gains in synthetic value. The view through the door of the railroad car or the automobile windshield, in combination with the speed, has altered the habitual look of things.[25]

Modern man moves around much faster than did his predecessor in the days of coaches and horses, and he takes in far more impressions than previously. The landscape is now ab-

sorbed in the course of high-speed travel; the kind of leisurely walk once enjoyed by the country-lover has lost all meaning. Now the express train and the car cut through – indeed, cut *up* – the countryside like a knife, a world already under change through the effects of trade and industry. And, insisted Léger, modern technology and an accelerated perception required a different way of painting.

The almost unbelievable acceleration of life and the consequent radical upheaval in visual perception had been succinctly expressed in 1913 by Cendrars. *La Prose du Transsibérien et de la petite Jehanne*, his long prose-poem (not without reason dedicated to musicians), embodied the rhythms of modern life (fig. 6). Cendrars's tale of the Trans-Siberian Express, with the theme of the train running like a thread throughout the work, is a kaleidoscopic one involving a rapid succession of places, experiences, impressions, dreams and reminiscences. From beginning to end there is the iron rhythm of wheels on rails. In Abel Gance's film *La Roue* (1920-22; fig. 5), the main participant is a locomotive. This was a film that impressed Léger, in particular the cinematic translation of the rhythms of modern machinery: the mechanization of visual perception meant that the painter was bound to adopt the unsentimental, objective vision of the film camera.

The Mechanical Media and Painting

Since, in the 1920s, Léger plunged so enthusiastically into modern life and its widespread mechanization, why did he none the less hold on to the old-fashioned medium of painting? Would not film have been far more suitable than inert oil paint on canvas as a means of expression of the rhythm of modern life? After all, film – a conveyor-belt of images – is by far the most obvious medium for the mechanistic era. According to the film critic George Sadoul, Léger did indeed consider giving up painting in order that he might devote his time to film-making,[26] but in the end colour got the better of him and he never exchanged the brush for the camera.

Léger's acuity kept him from developing any simplistic notions regarding the contempo-

rary character of a medium. He was very much aware of the historic links between the horse and vaudeville theatre, say, or between the machine and film.[27] A new means of expression does not make an old one redundant – it just leads to a redistribution of functions. The photographic-realist character of film rendered it meaningless for a painter to copy reality. The painter could, therefore, concentrate fully on the specific qualities of his art, such as form, colour and line. Nevertheless, the new medium of film was extremely seductive: Léger not only made a film himself, he thought in terms of cinematographic techniques when painting, using close-ups, fragmentation, montage and rhythmic patterns. The influence of the machine was not only registered in the mechanization of visual perception but also in painting. This was due to the imitation of the film as a viewing device. But, conversely, Léger demanded that a film should be more than the recorded version of a novel or play, it should form a series of moving pictures of objects. The film should be 'plastic', like pictorial art, as in his *Ballet mécanique* (pls./pp. 191-3).

Léger chose to express his dream of modern art through the medium of painting. He did not translate the many movements of mechanical reality into 'motion' pictures. In its confusion, modern life does not readily reveal a recognizable rhythmic order. The painter can depict it and make it visible on canvas, with the dynamism of colour and the contrast of forms. The resulting optical tension can evoke, if not duplicate, the rhythm of modern life. In their clarity, those paintings, stage designs and the film made by Léger between 1917 and 1924, bear witness to a phenomenal talent and an iron determination to give plain and simple form to the richly faceted reality of the mechanical era. With hindsight, now that his works are lodged within the history, and historiography, of modern art, the meaning of these works can be seen to radiate with powerful evidence. It almost seems as though these paintings – constructed from sharp contrasts of forms, colours, lines, volumes and planes, and with vibrant machines charged with presence and human figures as sculpturesque as machines – had always ex-

isted. Strictly orchestrated, and as concrete and tangible as any object, they are yet full of lyrical emotions, owing to the liberating colours that set everything in motion.

Fig. 7 Photograph of an open transmission system

24 Léger, 'L'esthétique de la machine: l'objet fabriqué, l'artisan et l'artiste', p. 59; English translation, p. 58.

25 Léger, 'Les réalisations picturales actuelles', p. 20; English translation, p. 11.

26 George Sadoul, 'Fernand Léger ou la Cinéplastique', in *Cinéma… '59*, no. 35, 1959, pp. 72-82.

27 Léger, 'A propos du cinéma' (1931), in *Fonctions de la peinture*, p. 169; English translation, p.101.

Christoph Asendorf

THE PROPELLER AND THE AVANT-GARDE: LÉGER, DUCHAMP, BRANCUSI

I

The first aeroplane flown by the Wright brothers had wings assembled entirely as a network of rods. Each set of upper and lower wings was held together by means of vertical struts and diagonal wires, the same principle that was used in the construction of simple braced bridges. In the first years of flying, the fuselage of an aeroplane consisted, for the most part, of a kite-like frame, and both the fuselage and the wings were wrapped in tautly stretched fabric. These aeroplanes were comparatively sturdy but aerodynamically deficient. None the less, the basic elements of modern aircraft construction were then developed very rapidly, the process being completed by about 1915. In historical sequence, the stages in this development were: the monoplane, flown from 1907 by the champion French aviator, Louis Blériot; a little later, the plane with self-supporting wings; in 1912, the first plane with a wooden hull, flown by the Frenchman Derperdussin; and finally the all-metal aeroplane introduced in 1915 by Hugo Junkers. These principles of construction did not, however, come into general use at the same time; the entirely modern type of aeroplane – the all-metal monoplane with self-supporting wings and a hull construction – only became the rule in the 1930s.

The feeble appearance of the sort of aeroplane that spectators were able to see at air displays and exhibitions before the Great War was precisely described by Franz Kafka. In 1909 he attended the week-long air display held in Brescia,[1] where Blériot could be seen in action. The planes, these 'trifles' with their 'wooden frames', were highly fragile and incredibly unreliable. Kafka describes the mechanics being constantly occupied with carrying out repairs until the spectators became weary of waiting. Screws were tightened, spare parts fetched, yet still the engines repeatedly failed to start: 'For a short while Blériot sits quite still [...] his team of six stand around him, without moving, all of them seem to be dreaming.' For the aeroplanes to function perfectly was the great exception, achieved in spite of the host of obstacles that had to be overcome every time. Then, as the planes finally attempted to take off, Kafka spotted one of them trundling ludicrously over the ground 'like a clumsy fellow across a dance-floor'.

The only part of the early aeroplane that was already in keeping with the later conception of an aerodynamically designed aircraft was the propeller; and this particular item swiftly began to attract interest, as is illustrated by the frequently cited recollection of Léger's of the visit he made (probably in 1912) to the Paris Air Show together with Marcel Duchamp and Constantin Brancusi:

> Duchamp, whose character was dry and somehow unfathomable, was silently walking around the propellers that were on show. He suddenly spoke to Brancusi: 'Painting is finished! Who can do better than this propeller? Tell me, can you do that?' He had a great predilection for the precision of objects like those. We had too, but not in such a categorical way. Personally, I was drawn more towards the engines, towards metal rather than to the wooden propellers [...] But I still remember how stunning they were. God! They were marvellous.[2]

All three artists were to return in later years, and in very different ways, to this impression; but, for all Léger's insistence on the importance of this early encounter, it still remains to be settled what precisely constituted the fascination for the propeller in 1912. Such a fascination appears still to belong entirely within a tradition deriving from Art Nouveau

Fig. 1 Emil Rudolf Weiss: Endpaper for Otto Julius Bierbaum's play *Gugeline* (Berlin 1899)

1 Franz Kafka, 'Die Aeroplane in Brescia' (1909), reprinted in *Franz Kafka: Erzählungen und kleine Prosa*, Berlin, 1935, p. 264 ff.

2 Cited in D. Valier, 'La Vie fait l'œuvre de Léger: Propos de l'artiste recueillis par Dora Vallier', *Cahiers d'Art* (Paris), 1954, p. 140.

Fig. 2 The prow of an iron ship, *c.* 1902

3 Henry van de Velde, *Vom neuen Stil* (1907), ed. Hans Curjel, Munich, 1955, p. 165.

4 K. Vollmoeller, 'Die Geliebte' (1914), reprinted in *In Laurins Blick: Das Buch deutscher Phantasten*, ed. Kalju Kirde, Frankfurt am Main, Berlin and Vienna, 1985, p. 147ff.; for Vollmoeller himself, see p. 319.

(fig. 1). Henry van de Velde recognized the strong feeling that 'made one tremble at the sight of the iron ship's prow exhibited by Krupp in Düsseldorf in 1902' (fig. 2).[3] What struck him about the prow was the linear precision of its form. Van de Velde developed his proposition that a line was the expression of the forces active within the object it delineated. Only shortly after, this claim made in the context of aesthetics had its equivalent in the realm of technology – in the streamlined design that was already in use experimentally before the Great War in the construction of automobiles. Viewed against this background, it is clear that the elongated shape of the propeller, with its elegant curvature, might well have seemed the quintessence of modern form: a design that attained an optimum in terms of function but that was also able to spark aesthetic invention through its extreme slenderness and its consummate use of line.

II

The possible range of contemporary fascination with the propeller is demonstrated in a short story by Karl Vollmoeller, 'Die Geliebte' (The Beloved), which appeared in 1914 in an anthology edited by Leonhard Adelt, *Der Herr der Luft: Flieger- und Luftfahrtgeschichten* (The Lord of the Air: Tales of Airmen and Aviation).[4] Vollmoeller, a prolific writer, began his career as a neo-Romantic lyric poet and dramatist; later he wrote screenplays, including that for *The Blue Angel* (1930), starring Marlene Dietrich. He had himself learnt to fly, and 'Die Geliebte' is set in the world of aviation. Its protagonist is an eccentric design engineer. Immediately following the story's opening announcement, 'They had to see it', both narrator and reader are carried through a labyrinth of speculation, their only clue being the reference to an 'arched, swelling form' that the designer draws on the surface of a table. He then gives examples of 'ideal' lines, and describes the ecstatic sense of well-being triggered by seeing the bend of a river, the 'smooth parabola' of a hill or the 'gently rounded saddle' of a mountain peak. What is here revealed in the landscape, and what the protagonist later dis-

covers in women, finally becomes the search for the 'ultimate beauty' of the pure, mathematical curve.

This search reaches its goal in the form of a propeller; hanging in the workshop, the propeller represents absolute beauty, an expression of the utmost practicality and the utmost perfection. None the less, this object – its image as described by the author repeatedly alluding to the female body – is transformed into a monster that devours its maker. Once the propeller is set in motion it generates a powerful rush of air; and, while the narrator manages to escape the maelstrom of the propeller's suction, the designer is killed. Various *topoi* of Gothic horror season the story, and the narrator is left haunted by the vision of a girl with teeth of steel. Yet shortly before the narrative had changed tack, turning the object of fascination into a prize exhibit in the aesthetic of terror, Vollmoeller introduced observations that go right to the heart of the matters then being discussed by the avant-garde. Only movement brings out the perfection of the propeller, its creator tells us in 'Die Geliebte':

> Thus, at rest, it is still a body, the bounds of which can be measured with the hand and the eye. A mathematical materialization of its element – the lightest of all, the air – but still matter. As soon as it moves it becomes once again incorporeal, astral, godlike; for, while rotating, it is really nothing more than a product of the imagination formed out of an infinite number of lines of force intersecting in space, [and] it still consists only of pure mathematical curves....'

By means of the example of the propeller, the author is thus able to address the subject of the relation between matter and energy.

Set in motion, the propeller is transformed from an object into intangible volume. Propellers entered the awareness of artists at precisely that moment when artists began to debate non-representational painting. Here, the key role was played by Robert Delaunay. In 1912-13 he painted his first 'abstract' colour discs, seeking to attain the expression of movement through colours alone. A reduction of means of this kind, however, proved to be only one stage in a larger process. In Delaunay's central work, *Hommage à Blériot*, painted in

1914 in memory of the first flight across the English Channel, by Blériot in 1909, he again made use of a representational context as his means of transition from actual movement to colours on canvas. The object Delaunay selected for this was the propeller. According to his own notion of simultaneity, the propeller represented the energy of modern life permeated with the forces peculiar to colour.

Hommage à Blériot is dominated by coloured circular or rotating shapes. While a real space is indicated through the image of the aeroplane in the left foreground with its large propeller and through that of the Eiffel Tower placed in the right background, the circular forms however hover in the picture in no apparent order. They provide a supporting surface for the figures suggested in the right foreground, a surface that, seen from above, is not connected with the "real" space receding into the picture. The circular forms slide over and under one other in such a way that no spatially readable gradation is established. Only by means of their diminution in scale towards the top of the picture – not to be confused with the 'horizon', as the circles are seen throughout from above – is an effect of perspective established, and with it the suggestion of ascent. At the same time, this is qualified in that the abstract circular forms and the 'real' space cannot be unequivocally reconciled. They are incompatible in terms of traditional conceptions of relationships within a picture. Delaunay, however, mixed representational and abstract forms in such a manner that we have an impression of overall movement. Whereas the Futurists had drawn on photographic techniques, in order to make real movements visible through a succession of distinct moments, in Delaunay's work the coloured circular forms themselves represent movement through their very arrangement; their depiction is no longer tied to an object. The idea of rotation is freed from the image of the propeller in the left foreground, assimilated by the circular forms and transmitted, unrestrained, into space.

In his later work, Delaunay continued to draw on the repertory of motifs he had used in the *Hommage*. In *L'Hélice* (The Propeller; fig. 3), an oil painting of 1923, the shape of the propeller and the abstract, circular segments

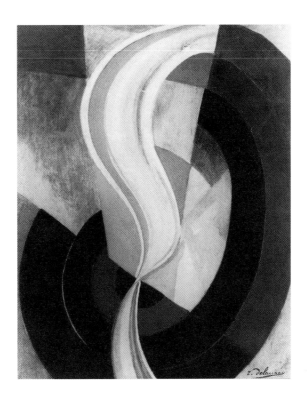

Fig. 3 Robert Delaunay, *L'Helice* (The Propeller), 1923, oil on canvas, 100×81 cm. Wilhelm-Hack-Museum, Ludwigshafen

are merged in a masterly way and integrated within the composition. In one of the drawings Delaunay made in connection with this work he retained the image of the steel structure of the Eiffel Tower, virtually held in the propeller's embrace, and here too the silhouette of Tristan Tzara is visible below the large letters TZ. In the oil painting, however, concrete components, situated in real space, have disappeared. Only a yellow letter T remains, a form that is ambiguous in its isolation, and that could refer equally to Tzara's name, to the outline of the shape of an aeroplane, or to a runway seen from the air.

L'Hélice marks a turning-point in Delaunay's development. It recalls earlier works and, at the same time, anticipates aspects of the artist's abstract *Rythmes* of the 1930s. The elements in this series of pictures are characterized by a simple geometry – diverse disc shapes, coloured, orchestrated segments, sectors or rings. Out of these elements, Delaunay developed a multitude of compositions: there emerge vertical and diagonal shapes in front of a neutral background, or else interacting systems of circles extended across the picture surface. Essential to the impact of the later versions of the *Rythmes*, however, are the subliminal, rhythmical, repeated propeller lines that gener-

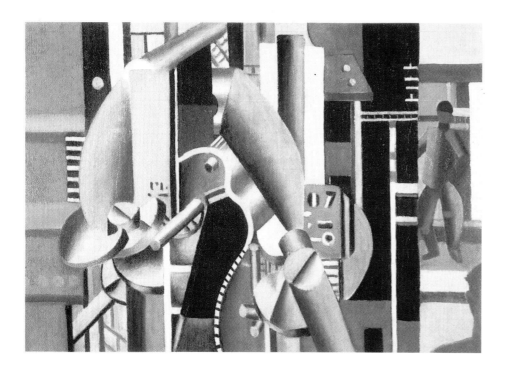

Fig. 4 *Le Mécanicien* (The Mechanic), 1919, oil on canvas, 46×61 cm. Collection of the Munson-Williams-Proctor Institute, Museum of Art, Utica, NY (B 140)

Fig. 5 *Le Moteur* (The Engine), 1918, oil on canvas, 46×55 cm. Private collection (B 139)

5 This essay is collected in *Fonctions de la peinture*, Paris, 1965, p. 20; cited from English translation, *Functions of Painting*, London, 1973, p. 11.

ate the luminous coloured discs; these constitute the primary structural element of these pictures, and represent the principle of universal transformation.

III

Delaunay's engagement with the image and the idea of the propeller, which started around 1914, was only a beginning. The motif of the propeller was subsequently adopted by much of the avant-garde. The manifestations of this theme in the work of Léger, Duchamp and Brancusi were in each case of a distinct character, just as they also arose from different presuppositions. In 1914 Léger published 'Les réalisations picturales actuelles' (Contemporary Achievements in Painting),[5] in which he discussed the preconditions of his own work in terms of the state of modern civilization in general. Here he was not concerned with aeroplanes or propellers but with the current conditions of perception, in contrast to those prevailing in the past: 'The thing that is imagined is less fixed, the object exposes itself less than it did formerly.' The reason for this change is to be found principally in the high speed of modern methods of transport, resulting in a general increase in the movement of people in society. A greater number of impressions is compressed within an ever diminishing period of perception. A landscape through which one travels thereby loses 'descriptive value but gains in synthetic value'. From this results the 'compression of the modern picture, its variety, its breaking up of forms [...]'.

The basis of Léger's argument was not confined to the arena of Cubist painting. An architect such as Peter Behrens, who at around this time was engaged in evolving a neo-Classical language of forms, cites the same reason for this development. In his essay 'Der Einfluß von Zeit- und Raumausnutzung auf moderne Formentwicklung' (The Influence of the Exploitation of Time and Space on the Modern Development of Form), published in 1914 in the *Jahrbuch des deutschen Werkbundes*, Behrens wrote of the artistic adaptation that was now required: 'If we tear through the streets of our largest cities in extremely fast vehicles, we can no longer perceive the details of the buildings.' Such a means of perception can only be accommodated by 'an architecture that displays the

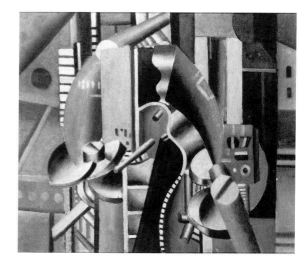

most compact and composed surfaces that are possible'. This idea was translated into the austerely cubic compactness of Behren's buildings for the German electrical company AEG.

Léger, on the other hand, did not wish to tame movement, but rather to give expression to it. His series of 1913, the *'contrastes de formes'*, is representative of his ideas concerning a way of painting that would be relevant to the modern age. He too worked with reduced, elemental forms; these, however, have resulted in an image of enhanced dynamism through

their alignment in space and through their compressed arrangement. What we see are forms that are without reference to objects, but which suggest the interlocking parts of a machine. Real objects of this kind did not occur in Léger's work before the Great War; but his Cubist, elementary forms do have a basis in reality. The sculptural characteristics of the 'contrastes de formes' are testimony to Léger's fascination with the 'beautiful, metallic objects, hard, permanent and useful' that he recalled seeing at an air show in Paris,[6] presumably the one he had visited with Duchamp and Brancusi. 'These were the real *motifs* or models whose impact lay behind the rotating formal combinations of the 'contrastes de formes'.'[7]

It was only after the War that Léger explicitly depicted mechanical elements in his work; and here his experience as a soldier was of prime significance. 'I discovered the meaning of machines through artillery and through the engines of war. The breech-block of a .75 mm cannon lying out in the sun did more for my development as a painter than have all the museums in the world. There I was really able to grasp the object.'[8] In his 'Note sur l'élément mécanique' (Notes on the Mechanical Element) of 1923,[9] Léger recalls the date, that is to say 1918, when he started to exploit elements of this sort to further his own artistic ends. He saw them as raw material that could only be used after a process of creative adaption. In the scaffold-like construction of his pictures from the years around 1920 – a painterly equivalent of the skeletal construction advocated by Le Corbusier during the same period – the mechanical elements, often curved, provide the momentum for a pronounced dynamism.

The propeller now again came into play. In 1918 Léger made two versions of *Les Hélices* (pl./p. 123). In these works a sense of claustrophobia prevails. Their component elements are so tightly packed that any movement must provoke a collision. The propellers are but one element among many; and their characteristically harmonic, undulating lines are unable to hold their own against the other forms, which are so compressed as to be rendered useless. In *Le Moteur* (The Engine; fig. 5), painted the same

year, the situation is different. One blade of the propeller protrudes from the motor unit, apparently independent from it, but charged with the energy generated from behind. In *Le Mécanicien* (The Mechanic; fig. 4) of 1919 the figure of a man approaches the machine (the latter modelled after that in *Le Moteur*), and his stance adopts the shape of the propeller. Lastly, *L'Aviateur* of 1920 shows a propeller that is rotating, as indicated by a semi-circle that fans out over the pilot and his emphatically fragmented aeroplane. Despite the cramped cockpit, the pilot is shown in a pose suggestive of nonchalant sovereignty, and barely needs to attend to the controls. Man and machine constitute a single functional unit. Léger's subject here is not that of space unfolding, as in the Orphic works of Delaunay, but rather, the ideas of the functional unit, the integration or disintegration of mechanical elements alone, or of the mechanical combined with the organic. The propeller here is hardly an autonomous form; it represents the modern technical world, mobility and the power of flight. It is an object well suited to giving pictorial form to these ideas.

In Léger's work, the propeller is part of the great machine of civilization. Duchamp, on the other hand, who had testified to his own fascination even more clearly, was crucially stimulated, it seems, by the notion of the circle. Circling motion for Duchamp was,

6 See Léger's essay 'L'esthétique de la machine: l'objet fabriqué, l'artisan et l'artiste' (1923), reprinted in *Fonctions de la peinture*, p. 62; English translation, p. 60.

7 Christopher Green, *Léger and the Avant-garde*, New Haven and London, 1976, pp. 83-4.

8 See A. Verdet, *F. Léger: Le dynamisme pictural*, Geneva, 1955, pp. 17-18.

9 Léger, 'Note sur l'élément mécanique' (1923), reprinted in *Fonctions de la peinture*, pp. 50-52; English translation, pp. 28-30.

Fig. 6 Rotating merry-go-round lit up at night in Blackpool, England, termed by László Moholy-Nagy an example of 'virtual volume'

Fig. 7 Constantin Brancusi, *Oiseau dans l'espace* (Bird in Space), 1930, white marble, height 189 cm. Private collection, USA (illustrated here is Brancusi's own photograph)

Fig. 8 Man Ray, *Photograph of Marcel Duchamp's 'Rotating Glass Plates'*, 1920.

10 D. de Rougement, 'Marcel Duchamp, mine de rien', *Preuves*, no. 204, February 1968, pp. 43-7.

11 Man Ray, *Selbstporträt*, Munich, 1983, p. 63; cf. Pierre Cabanne, *Gespräche mit Marcel Duchamp*, Cologne, 1972, p. 94 ff.

12 Herbert Molderings, *Marcel Duchamp*, Frankfurt am Main, 1983, pp. 53-5; cf. Cabanne, *Gespräche mit Marcel Duchamp*, p. 109 ff.

13 László Moholy-Nagy, *Von Material zu Architektur* (1929); facsimile edition Mainz and Berlin, 1968, p. 167, cf. pp. 96, 152; English translation *The New Vision: Fundamentals of Design, Painting, Sculture, Architecture*, London, 1939, p. 130, cf. pp. 94, 125-8.

14 Cf. Molderings, *Marcel Duchamp*, p. 49.

15 See Carola Giedion-Welcker, *Constantin Brancusi*, Basle and Stuttgart, 1958, p. 199 ff., and Friedrich Teja Bach, *Constantin Brancusi: Metamorphosen plastischer Form*, Cologne, 1987, pp. 194-9.

however, not a reference to unceasing social mobility; it alluded, rather, to the closed system of the 'celibate' machines. This is indicated by the artist's own choice of words in response to an interviewer: 'In my life there has always been a need for circling, for rotation, as they would have called it. It is a sort of narcissism, this self-sufficiency, a sort of masturbation. The machine rotates, and, in some marvellous fashion or other, it produces chocolate.'[10] In the period before the Great War, as Duchamp broke with Cubism and with painting, he produced several works that have circular motion as their subject, including *The Coffee-Mill* and *The Bicycle Wheel*. In these works Duchamp alludes once again to the two chocolate-grinding machines, metaphors of the closed masturbatory circle.

This did not, however, exhaust Duchamp's obsession with rotation. The optical machines that he constructed from 1920 onwards were the results of an anti-artistic outlook, a turning towards physical experiments; and it was with these – rather than through more traditional artistic means – that he sought to satisfy his interest in movement and in visual effects. By means of various rotating devices he explored the phenomenon of figures that reappeared each time the form was set in motion, but which again became invisible when it returned to a state of rest. Man Ray's photographs of 1920 of Duchamp's *Rotating Glass Plates* show (fig. 8), in the background, a panel with letters decreasing in size, like those used by oculists. Next to this is the apparatus, consisting of five glass plates of varying sizes, fixed one behind another along a single horizontal shaft. On each plate Duchamp had drawn segments of a spiral; when the apparatus was set in motion 'like an aeroplane propeller',[11] these, viewed as a group, generated the illusion of continuous circling lines.

Duchamp's second optical machine was the *Rotating Hemisphere* of 1925, on the surface of which a series of eccentric circles had been marked. As the hemisphere rotated, one had the impression of a pulsating spiral with movement in no single direction.[12] Duchamp already refused to show his device at exhibitions of painting and sculpture; and his strong feeling in this regard was to become even more

clear when he presented his *Rotoreliefs* of 1935 – lithographed images of coloured circles and spirals that rotated on a record-player to provoke the illusion of three-dimensionality – at an exhibition for new inventions, where they were wholly ignored. (Moholy-Nagy, had sought to demonstrate, by means of photographing a turning merry-go-round lit up at night [see fig. 6], the phenomenon of virtual volume, which he proposed as the logical terminus for the development of sculpture.[13]) Duchamp's experiments, however, do not only represent his scepticism regarding art's potential: his preoccupation with optical illusions was the expression of a fundamental scepticism regarding the function of the sensory organs,[14] and ultimately towards every form of 'truth'.

In contrast to Duchamp's attitude, Constantin Brancusi was entirely captivated by the idea of flight, though not with flight in technical terms: he was concerned with flight in a spiritual sense, the soul's flight.[15] A long process led him from the still almost naturalistic bird sculptures he had made before the Great War to the versions of *Bird in Space* made between 1923 and 1941 (fig. 7). In these, no element of the direct representation of a bird remains: in their elongated, elastic form, these works strive to embody the idea of pure flight. The interest that Brancusi had shown in the

propeller in 1912 is reflected in this group of works, even if not directly. This is apparent, above all, in his treatment of the various materials used. The New York customs officers who, in 1926, had declared that a *Bird in Space* sculpture by Brancusi was liable to import duty because it appeared to them to be industrial raw material – an 'ordinary piece of metal' and not a work of art[16] – hit on an important characteristic of Brancusi's work, namely its perfect finish in 'industrial' terms, whether the material used was bronze, marble or something else. In the case of the bronze *Bird in Space* sculptures, the mirroring reflection makes no small contribution to their almost disembodied appearance.

It is not only the treatment of material in the *Bird in Space* sculptures that leads us to associate them with aerodynamically refined forms, such as the propeller or the streamlined bodies of aeroplanes and rockets, but the general character of their form too. Athena Spear has pointed out that 'Brancusi developed his *Bird* between the beginning of the First and the end of the Second World Wars, i.e., during the formative period of modern ballistics.'[17] But although this remark is certainly a testimony to Brancusi's contemporaneity, it tells us nothing about his artistic intentions. The link, for example, between his *Bird in Space* sculptures and the sweeping lines of the blades of a propeller is only significant if it is related not to this product of technology as such, but rather to its chief formal attribute – the energetic swelling and, in turn, subsiding of lines of force. Even so, the forms of the *Birds in Space* are different from those produced through technical processes: they are irregular and, depending on one's point of view, characterized by a very slight, or by a very distinct, asymmetry.

Two aspects of the form of Brancusi's *Bird in Space* sculptures are particularly notable: the slenderly tapering upper and lower ends. At a point just above the base, the form narrows markedly, and the real body of the sculpture begins. Pontus Hulten came up with a compelling interpretation of this lower narrowing in his reference to a technical procedure employed by Brancusi in giving form to his sculptural conception:

When a rod of iron, bronze, or brass is heated white-hot and then drawn out until it breaks at a certain point, the two molten ends assume the shape that we see in the 'feet' of Brancusi's birds. Could there be a better way to represent the moment of wrenching free, the moment of taking wing, of 'lift-off' to the sky, than a form that is naturally produced when two bodies suddenly separate, subjected to tremendous force and stress?[18]

The decisive verticality of the *Bird in Space* sculptures, rounded and then diagonally flattened at the upper end, has even greater significance: they may be said to treat the subject of the transformation of matter into energy. They do not do so, however, through vibration (in the manner of the metal rod of Naum Gabo's *Kinetic Construction: Standing Wave* of 1919-20; fig. 9), nor through rotation (as with Vollmoeller's propeller). Brancusi evokes this process purely through the sculptural energy of a static form, the flow of its lines tapering off at the upper end, at the tip, the point where the dense mass blends into the incorporeal.

Even in the case of these sublime sculptures, the propeller remains a plausible point of reference, as it had been directly for Léger and for Duchamp. The impressions gained by these three artists in 1912 at the Paris Air Show were surely strengthened through the stimulus provided by the works made shortly afterwards by Delaunay. These impressions were realized subsequently in painting, in kinetic objects and in sculpture as well. It is only on first glance that we may be surprised to find that so mundane a device as a propeller was able to arouse and maintain the interest of the avant-garde over so long a period. This avant-garde came into being during the time when the propeller provided the crucial driving force for aeroplanes. The propeller became a central point of reference: it not only had a form that slipped easily between the organic and the inorganic, between the technically useful and the sculptural, but it was also a charged symbol of the mobility of advanced civilization. It signalled, too, the transition from stasis to rotation, and the problematic relationship of the representational and the non-representational in art.

Fig. 9 Naum Gabo, *Kinetic Construction: Standing Wave*, 1919-20, metal rod, electric motor, height 61.5 cm. Tate Gallery, London

16 See Pontus Hulten *et al.*, *Constantin Brancusi*, Paris, 1986; English edition London, 1988, p. 174.

17 Athena T. Spear, *Brancusi's Birds*, New York, 1969, p. 36.

18 Hulten *et al.*, *Constantin Brancusi*, cited from the English edition, p. 51.

Suzanne Penn

LA VILLE: REFINEMENT TOWARD COMPLETION AND BEYOND

There is a tie between the artist who creates and the amateur who appreciates, a delicate atmosphere that is inexplicable, that is the vehicle for the great affections that gather around us. It cannot be explained, and it is exactly this rather mysterious aura that enables these works to endure and to be admired by men of other generations. The permanent value of the work of art is possible because no scholar, no intellectual has yet been able to put it under his microscope and explain the reason for Beauty. Let us hope that the analytic spirit may never penetrate into this domain because it would destroy that marvel, the Beautiful, which rises above the melee of tumultuous moral life.[1]

Léger may have been quite right to say that striving for objective understanding of a work of art through analysis can be inimical to the perception of certain timeless qualities that constitute beauty; yet, experience supported by technical analysis shows that for most works, and notably Léger's own, endurance of the very qualities that give a work 'permanent value' depends on appearances presented by materials that are only too subject to change. One suitable role of analysis within the realm of connoisseurship is the investigation of alterations in a work, whether effected at the will of the artist, by the intervention of restorers, or by the ageing of materials. It is only with an understanding of changes leading up to and following what we may call a work's state of nominal completion, that is, the state in which it was signed and dated or given over by the artist to be exhibited or published, that one can adequately measure the artist's accomplishment. In the case of Léger, consideration of changes in state benefits the general understanding of his work, both in the clarification of the processes of creation and execution and the clarification of those intended formal qualities that have become diminished or distorted through time.

In Léger's *œuvre*, his treatment of a particular theme often took the form of a series of works that culminated in an acknowledged final statement, usually a canvas larger in scale than the preceding works on canvas and paper. The development of ideas progressing toward that end was not necessarily a tidy linear

1 Léger, 'Le Mur, l'architecte, le peintre' (1933), reprinted in *Fonctions de la peinture*, Paris, 1965, p. 113; English trans. in *Functions of Painting*, New York, 1973, p. 91.

2 Correspondence between Léger and
 Gallatin, January 1937, is among
 the Gallatin Papers, The New York
 State Historical Society.

3 The earliest published photograph
 of *La Ville* with Léger's post-1919
 revisions appeared in *The Bulletin
 of The Museum of Modern Art*
 (New York) I, no. 3, 1935.

4 Maurice Raynal, *Fernand Léger:
 Vingt Tableaux*, Paris, 1920, E. Teri-
 ade, *Fernand Léger*, Paris, 1928,
 and Christian Zervos, 'Fernand
 Léger, est-il cubiste?', *Cahiers d'Art*
 (Paris) nos. 3-4, 1933.

5 Gladys Fabre comments on the sub-
 ject of Léger reworkings in *Léger
 and the Modern Spirit: An Avant-
 Garde Alternative to Non Objective
 Art*, exhibition catalogue, Musée
 d'Art Moderne de la Ville de Paris,
 Museum of Fine Arts, Houston, and
 Musée Rath, Geneva 1982.

process of invention and selection for Léger. Rather, the series of works shows there was some willingness on the part of the artist to reject or revive elements impulsively, complicating scholarly efforts to determine the order in which the works were painted. Examination of the build-up of paint layers and the nature of pentimenti within an individual work can provide new evidence of interim stages in the selection and arrangement of elements within the entire series. Pentimenti, common in the work of Léger, are often visible to the naked eye; infrared reflectography and x-radiography have been of some use in the case of better concealed reworkings.

The study of changes in the work of Léger is complicated by the fact that some paintings were reworked by the artist years after their dated completion and public exposure in exhibitions and publications. Close reading of early photographic documentation and correlation with later images and the present state of some paintings has provided clear evidence of his later revisions, and makes apparent the distinction between those reworkings and pentimenti made in the initial execution.

Beyond noting that changes of some significance have occurred, a further challenge becomes the recognition of alterations, arising from restoration or from the ageing of materials, that are *not* Léger's work. Details of provenance and the chronology of photographic and written documentation have been of great use; however, it is only examination of the paintings themselves that leads to a final accounting of state, the extent of Léger's own work, and thereby the inference of early appearance.

A painting's appearance does not cease to change when it leaves the artist's hands. The materials of which it is made may change or deteriorate at different rates with age, damages may take place, or inappropriate alterations may occur in restoration. Any art-historical or critical discussion of a given work must take into account the work's current condition. Before meaningful comparisons between works may be drawn, disparities of appearance that may not have existed originally must be understood. These may include fading or darkening of particular pigments, distortion of colours viewed through a veil of grime or non-original varnish, or alterations of compositional elements due to cleanings or retouching.

The usefulness of the detailed consideration of a picture's state and comparison with documentation is well exemplified in the case of the acknowledged masterwork of Léger's *La Ville* theme, the monumental canvas of 1919 measuring 231×298.5 cm in the collection of the Philadelphia Museum of Art (pl./p. 145). The painting came to the Museum in 1943 as part of the collection of Albert Eugene Gallatin, which (under the name The Museum of

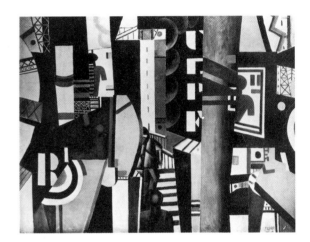

Living Art) had been formerly housed at New York University. The Gallatin Collection was formally bequeathed to the Museum in 1952.

Gallatin purchased the picture directly from Léger's studio in Paris in 1936, and correspondence indicates the painting was en route to New York by ship in January 1937.[2] This, however, was not the picture's first transatlantic crossing. The painting had travelled to the United States in November 1925 when it was exhibited at the Anderson Galleries in New York on the occasion of Léger's first American one-man exhibition, and again in March-April 1935 when an exhibition of Léger's works was organized by the Renaissance Society of the University of Chicago. The latter group of works was also shown at the Museum of Modern Art in New York in September-October 1935. An accompanying museum bulletin served as the exhibition catalogue, and it includes an illustration of the painting.[3]

La Ville as it appears in the MOMA publication, and perhaps some time before, differs in several respects from the picture as it was exhibited in Europe early on. Signed and dated 1919, *La Ville* was first shown in the Geneva Exposition Internationale in that year, and the following year at the Paris Salon des Indépendants (no. 2651). It was shown again in the '30 ans de retrospective' at the Salon des Indépendants in 1926.

The painting's pre-1935 appearance is documented in two French monographs on Léger published in 1920 and 1928, and in a special issue of the magazine *Cahiers d'Art* published in 1933.[4] The illustration in the museum bulletin shows a picture that differs significantly from that seen in these earlier publications. By 1935, elements throughout the composition had been painted out by Léger, consistently simplifying the composition. The changes, seen in the comparison of the early photograph (fig. 1) with a photograph of the present appearance of the work (fig. 2), include the painting out of windows and scaffolding in the upper-right corner, elimination of the inner blue circle in the disc at the right edge, the shortening of the arm of the figure on the right, and the elimination of the upper-most blue band below and the lower-most red horizontal band above. In the lower-right corner of the yellow field, an L-shape band and horizontal band were painted over, as was a square in the adjacent white field. The repaints are somewhat haphazardly applied, and in some instances, for example the scaffolding in the upper-right corner, are not sufficiently opaque to conceal completely the earlier forms. In the same area a series of vertical windows has been painted out hastily with slightly off-register strokes of white paint, leaving edges of the original black strokes depicting the window openings still exposed (fig. 3).

A precise date for Léger's reworkings has not yet been determined.[5] The 1919 appearance of the painting persists in print through the 1933 publication of *Cahiers d'Art*, though the possibility certainly exists that an early 'obsolete' image could have been used in publications well after the revisions had been made. At any rate, the picture was published, and very likely exhibited, a number of times before

it was re-addressed by Léger. Léger's comments to Gallatin in January 1937 regarding the 'tired' state of the picture would seem to suggest that revisions had not been undertaken immediately preceding the 1935 exhibitions of the painting in the United States:

> *La Ville* is coming to you on the 'Paris' – it's a painting that has travelled a lot, [been] seen a lot – and that has had a huge influence on 'colour in the world'. It's frail and rather weary – it has to be handled gently, and perhaps one day [you will have to] consider 're-lining' it.[6]

The first recorded restoration of *La Ville* took place in 1956 in Paris, under the supervision of Mme Nadia Léger, on the occasion of the loan of the painting by the Philadelphia Museum of Art to Léger's memorial exhibition in Paris, June to October 1956.[7] The canvas was lined with linen and glue-paste adhesive. No written or photographic documentation exists from this treatment, but the conservation report from the next campaign of restoration, in 1972, at the Philadelphia Museum of Art supplies some information. That report states that in 1972 the surface of the picture remained unvarnished, with a dulling film of surface grime. Attempts to clean the surface were

Fig. 2 *La Ville*, 1919 (state in 1994), oil on canvas, 231 × 298.5 cm. Philadelphia Museum of Art, A. E. Gallatin Collection

Fig. 3 Detail of an area at the upper right, where Léger's revisions can be detected

6 Correspondence, Gallatin Papers, The New York State Historical Society.

7 Notation in *La Ville* file, Twentieth-century Department of Painting and Sculpture, Philadelphia Museum of Art.

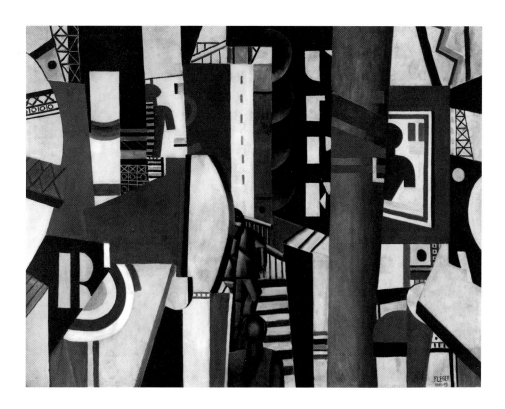

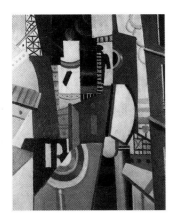

Fig. 4 Study for *La Ville*, first version, 1919, oil on canvas, 65×54 cm. Private collection (B 160)

Fig. 5 Study for *La Ville*, 1919, oil on canvas, 81×65 cm. Private collection (B 161)

8 See 'Twelve Artists in U.S. Exile', *Fortune* (New York), XXIV, no. 6, December 1941, p. 104.

9 The pale and discontinuous yellow area was sampled and examined microscopically. In cross-section the outer or exposed portion of the yellow layer appeared lighter than the inner or concealed portion that was adjacent to the ground. The sample was further examined by electron beam microprobe and X-ray powder diffraction (XRD) to detect a possible alteration of the pigment that would explain the described colour change.
 Results of the microprobe elemental area mapping showed the elements present in the outer portion of the yellow layer to be: S, Cd, Ba, K, Ca, and Si. The same elements were also found in the inner portion. No chromium, zinc, cobalt or lead was detected, precluding the use of chrome yellow, lead antimonate yellow, cobalt yellow, barium yellow, and cadmium zinc lithopone. While the elemental analysis may have suggested the possibility of a cadmium yellow lithopone, this is not likely, as it was not apparently available as an artist's pigment in 1919. The first U.S. patent for cadmium lithopone was issued in 1921 (Robert L. Feller, *Artist's Pigments: A Handbook of their History and Characteristics*, Washington, 1986, p. 67) and the pigment was not marketed before 1927 (Rutherford J. Gettens and George L. Stout, *Painting Materials: A Short Encyclopedia*, New York, 1966). It appears that the original yellow in *La Ville* may have been a discrete mixture of cadmium sulphide and barium sulphate rather

unsuccessful, but 'water removed most of the retouches from the last restoration'. The painting was varnished at the time before retouching with Magna and lean oil paint. The varnish and retouching applied in 1972 remain on the surface of the picture.

In addition to the retouching of specific damages, some areas of Léger's 1919 paint and his later reworkings were affected by the restorations. One of the more significant instances is the large field of blue above the disc on the left-hand side of the composition. This area appears in a colour reproduction of 1941 of *La Ville* as a blue field with a lighter blue circle and two rectangles truncated by the top and bottom edges of the field.[8] The high contrast of the black and white reproduction in the 1956 Paris exhibition catalogue makes it impossible to tell to what extent the forms still existed within the blue field following the restoration of the painting supervised by Mme Léger for the 1956 exhibition. A set of colour transparencies from the 1972 restoration of the picture includes a detail of this area showing the forms neither completely intact nor completely concealed; the uppermost contrasting band is seen as a dark blue-black, while the other band and circle are covered with the blue paint that we see today. Currently all three elements are covered with repaints, and the area reads as a more or less continuous blue field. These are the same forms that appear in Léger's two smaller scale, vertical format studies: *La Ville*, first version (fig. 4) and *La Ville* (fig. 5). One now realizes that the elimination of these forms from the Philadelphia picture is the work of restorers, not a later revision by Léger.

Although the appearance of the painting has been changed to some extent by restorers' efforts to cope with the clearly confusing state of some elements, the greater change in overall effect is due to ageing of the paint itself, producing alterations that have not affected all colours equally. Unless the general nature and magnitude of these alterations is understood, it is difficult to visualize the colour effects and relationships originally sought by Léger. Airborne grime had become embedded in the paint surface during the years the painting remained unvarnished. The effect of grime varies

by colour area, but overall, its grey film lowers colour intensity and contrasts. The whites and lighter colours appear duller and greyer than they would have originally. The varnish applied in 1972 deepened colours, altered contrasts and has itself developed a slight grey tone.

The most dramatic colour change in the picture since 1919 has occurred in the broad areas of yellow. Where it has not been covered with Léger's repaints concealing earlier forms, the 1919 yellow is pale and discontinuous. Recent removal of a short section of paper tape that was applied to the edges of the painting when it was lined in 1956 revealed a denser, brighter yellow preserved beneath. Reasons for the apparent fading are still being investigated.[9]

Acknowledgement of the changes due to restoration and colour shifts due to ageing allows reconsideration of the *La Ville* composition in its 1919 state and after the artist's later changes, as well as new comparisons with several preliminary works. Close inspection of the paint surface, infrared reflectographic images and x-radiographs did not reveal any significant pentimenti in the 1919 state of the Philadelphia painting. Léger executed the composition quite directly, making only minor adjustments to contours, a fact that suggests in this

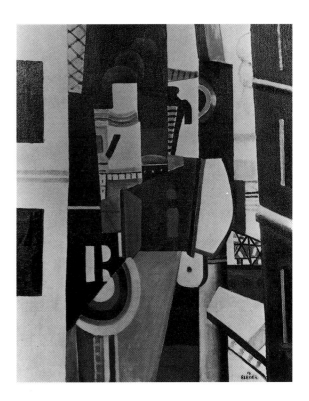

case the important role that preliminary works played for him in the resolution of formal choices.

In contrast to the direct execution of the Philadelphia picture, and as might be expected in a study, the smaller scale, horizontal format *La Ville* (fig. 6) is a version that shows numerous changes and a more complex build-up of paint layers. If we accept the most likely relationship of this work to the large Philadelphia painting (that it is a study and not a reprise with variations), then its numerous readily visible pentimenti indicate an unexpected aspect of Léger's use of this study in the series: to test the subtraction of elements that then reappear in the later work.

In the red area to the right of the left-most figure, the study originally included the lighter red arc found in the Philadelphia picture, and in the lower right corner in the yellow field there originally existed contrasting bars within the form, functioning in much the same way as corresponding lines in the more elaborate 1919 state of the Philadelphia picture. In the black area containing the vertical column of letters, pentimenti of opposing arcs suggest the billowing smoke that rises in the same area of the Philadelphia picture. The area above the left-most figure has been heavily reworked with opaque white and may have contained a second passage of billowing smoke, which also existed in the 1919 state of the Philadelphia picture. The reasons for Léger's apparent compositional backtracking are not clear; he may have decided that the larger scale of the Philadelphia work required, or simply was able to accommodate, elements rejected earlier.

Beyond those compositional elements that Léger eliminated from the study only to revive them in the Philadelphia picture, numerous other elements were considered and then painted out in the study. These include a horizontal red bar beneath the disc in the lower left corner, a rectangular form beneath the black area in the upper left quadrant, and lines between the windows in the white vertical building above the stairway.

At the left edge of the study where now only a single diagonal line cuts across the semicircle, the composition once contained

Fig. 6 Study for *La Ville*, 1919, oil on canvas, 95 x 127 cm. Anonymous loan, The Metropolitan Museum of Art, New York (B 162)

the same green cross-hatched rectangular form seen in the Philadelphia picture as well as in the watercolour study in the Société Anonyme collection, Yale University Art Gallery. In Léger's large composition of *Les Disques dans la ville* of 1920 (Musée National d'Art Moderne, Paris, Bauquier 258), the rectangular form is once again absent, and the semicircle exists unmodified at the left edge of the composition.

Repaints exhibiting the appearance and the simplifying tendencies of the later revisions identified on *La Ville* have been found on other paintings that remained in Léger's possession for a number of years, including *Les Hommes dans la ville* (pl./p. 141) and *Les Disques* of 1918 (fig. 7, pl./p. 137). In the case of *Les Hommes dans la ville*, Léger's revisions include both additions and minor deletions. Dots and x-es were added to the grid in the lower right, and horizontal and vertical linear divisions were added within the arched framework at the left side.[10]

As in the Philadelphia *La Ville*, the revisions in *Les Disques* reduce the complexity of the composition. Léger's changes to *Les Disques* for the most part consist of the painting out of forms near the edges. Fields of nega-

than a co-precipitate. Examination by XRD of the 'altered' surface yellow yielded inconclusive results for the standard cadmium yellows: the XRD lines did not match for cadmium sulphide [greenockite, JCPDS 6-314 (the I=100 line was missing) and hawleyite, 10-454] nor for $BaSO_4$ (JCPDS 21-88). The XRD pattern did, however, suggest the possibility of $CdSO_4$ or $(NH_4)2Cd(SO_4)_2 \cdot 6H_2O$ as possible colourless alteration products of cadmium sulphide. Electron microprobe line mapping at one micron resolution did not explain the observable difference between the outer and inner portions. No significant compositional differences were detected with regard to the association of oxygen with cadmium.

Microprobe elemental area mapping did detect substantial amounts of potassium in the cadmium-rich areas, suggesting that the pigment may have been formed by precipitation with potassium sulphide, a wet process that was used in the 1910s and 1920s (H. W. Dudley Ward, 'Cadmium Colours and their Suggested Application to the Paint Industry', *Journal of the Oil and Colour Chemists's Association*, X, 1927, p. 5).

Fig. 7 Current appearance of *Les Disques* (The Discs), 1918, oil on canvas, 240×190 cm. Musée d'Art Moderne de la Ville de Paris (B 149)

Fig. 8 Early appearance of *Les Disques* as illustrated in *Cahiers d'Art* in 1933

10 Angelica Zander Rudenstine, *Peggy Guggenheim Collection, Venice,* New York, 1985, p. 453.

tive space were created in the four corners, and a number of ties between the central elements and the picture's edges were severed. The white field of indeterminate depth behind the subsequently more centralized composition put clearer emphasis on spatial ties and discontinuities among foreground elements. Comparison with the earlier state of *Les Disques* published in the magazine *Cahiers d'Art* in 1933 (fig. 8) shows that Léger's extensive revisions in the lower right necessitated his resigning and dating the picture; it still bears the date 1918. Léger is known to have inscribed pictures with a span of years, acknowledging a creative continuum. For example, *Composition* in the collection of the Philadelhia Museum of Art (fig. 9) is signed and dated '1927' on the front and inscribed '1923-27' on the back of the canvas. By contrast, in *Les Disques* Léger seems not to have regarded the type of reworking undertaken in a single campaign after a hiatus of several years as representing further development. The backdating suggests that this sort of reworking, the elimi-

nation of elements he came to regard as superfluous, represented for Léger a clarification of those qualities most essential to his earlier intent.

It has become clear in the study of the few paintings considered here that the key to a fuller understanding of Léger's concerns at various creative junctures is not to be found in a single visual source. Neither the paintings themselves, which have undergone a variety of changes, nor the photographic record, which represents imperfectly, or not at all, certain aspects of colour, contrast and surface, are wholly reliable manifestations of the artist's intent. Only the detailed correlation of numerous points of comparison between a painting and the visual and written documentation of its appearance over the decades since its completion leads to a reasonably reliable inference of the way in which Léger developed a composition, and how it looked when he first considered it completed. The alterations that a picture undergoes through time may require

some degree of intellectual compensation on the viewer's part to offset the weakening or distorting effects of ageing and intervention. As the appearance of a picture drifts by degrees from that known and judged by the artist, Léger's nemesis of Beauty, the analytic spirit, may become its true ally, enabling the viewer's reasoned grasp of the work as it was meant to be.

Fig. 9 *Composition*, 1923–7, oil on canvas, 130.8×97 cm. Philadelphia Museum of Art, A.E. Gallatin Collection

The author wishes to thank Dr Edward P. Vicenzi, of the Princeton Materials Institute, Princeton University, who performed the electron microprobe analyses, Andrew Lins, Conservator of Decorative Arts and Sculpture, and Beth Price, Conservation Chemist, both of the Philadelphia Museum of Art, for their investigation of the colour change.

Dieter Koepplin

LES ÉLÉMENTS MÉCANIQUES

The Bridge between Léger's Pre- and Post-War Work

Just as Léger intended and recognized, *Les Eléments mécaniques* (pl./p. 129) is an easel painting that obeys its own intrinsic laws.[1] Large, forceful, rather two-dimensional, it tends towards the character of a wall painting. It is, none the less, clearly distinguishable from the sort of modern abstract mural painting that Léger hoped would establish a new connection with modern architecture, bringing about an integral animation of the city – luminous 'walls of colour' in the 'multi-coloured town'.[2] *Les Eléments mécaniques* may be defined as an easel painting on two counts: its remarkable evocations of figural forms, and its sharp alternation between planes (swiftly grasped by the viewer) and modelled forms that simultaneously draw and arrest the gaze, now guiding it, now allowing it to wander, not least in the search for an inherent 'figure' or at least a unifying principle for the stable and the 'hovering' 'elements'. All the individual phenomena in this picture are absorbed into the radiant whole, yet each manages to remain discrete in some way. The painting is a sum of contrasting colours and forms, of things presented in detail and in a generalized manner, suggesting relief, space (even in the planes!), different speeds and perpetual energy.

The long period that Léger spent working on this painting, from 1918 to 1923, is noteworthy, and, for him, unusual, although it is true that he liked to execute one or more provisional versions of a composition to stand alongside the definitive, larger one. Years sometimes passed between the different *états* or versions (and the largest was not necessarily the last to be made).[3] The *Eléments mécaniques* pictures of 1924 belong in this category (pl./p. 190; pl./p. 189); these transform the *Disques* series of 1918-19 into flat, almost mural-like entities.[4]

It is evident that the *Eléments mécaniques* Léger completed in 1923 was largely established in terms of its composition back in 1918,[5] yet its *facture* or handling – with a quite distinct use of modelling – is of a similarly 'controlled' character to that found in the horizontal work of 1924, the *Elément mécanique* now in the Kunsthaus, Zurich.[6] Here, too, Léger's compositional starting-point was a work painted six years earlier, *Le Mécanicien dans l'usine* (The Mechanic in the Factory) of 1918,[7] though he departed some way from it, and not merely in terms of style. It was only by adopting a large scale that the pure, contrasting *facture* of the Basle *Eléments mécaniques* became possible for Léger. But he had always reckoned that a large scale was essential in the final version if its composition was to be effective.

After the War, another 'State of War'

Several works by Léger, that are compositionally similar to *Les Eléments mécaniques* are dated 1917, 1918 and 1919.[8] It might seem reasonable to assume a connection between the compressed matter-of-fact quality that prevails in his 'abstract-objective' paintings and drawings and his experiences during the Great War, so graphically described in his correspondence. And one is tempted to approach the group of works of 1917-19 as representative of the period that directly followed the War, a conflict that, as Léger himself later said, had made him forget about his own abstract work of

1 Raoul La Roche (1889-1965) acquired Léger's *Eléments mécaniques* at an early date from the gallery owner and publisher Léonce Rosenberg. Rosenberg had bought the picture from the artist on 23 February 1924. The picture came to the Kunstmuseum, Basle, as part of the second of La Roche's donations to this institution.

2 Léger, 'L'architecture moderne et la couleur ou la création d'un nouvel espace vital' (1946), reprinted in Léger's *Fonctions de la peinture*, Paris, 1965, p. 100; cited from English translation, *Functions of Painting*, London, 1973, pp. 149, 152. Cf. also 'Peinture murale et peinture de chevalet' (1950) in *Fonctions de la peinture* at p. 31 (trans. as 'Mural Painting and Easel Painting', in *Functions of Painting*, pp. 178-80 and 'Un nouvel espace en architecture' (1949), *Fonctions*, pp. 124-5 (English trans., p. 158): 'The idea of multicoloured towns came to me during the 1914-18 war, on one of my leaves. I had met Trotsky in Montparnasse. He was enthusiastic about this idea. He envisioned the possibility of a polychrome Moscow.'

3 On Léger's principle of *'états'*, which he understood in terms of both construction and craftsmanship, see Suzanne Penn's essay in this catalogue; also, R.L. Füglister, 'Fernand Léger: Akrobaten im Zirkus – Einordnung und Interpretation', in *Öffentliche Kunstsamm-*

lung Basel, Jahresberichte 1964-1966, p. 167 ff., and J. Freeman, 'Ohne jede Hierarchie. Themen und Variationen im Werk Fernand Légers', in *Die Metamorphosen der Bilder*, exhibition catalogue, Sprengel Museum, Hanover, 1992, pp. 85-100.

4 C. Green, *Léger and the Avant-garde*, New Haven and London, 1976, p. 265; G. Bauquier, *Fernand Léger: Catalogue raisonné 1903-1919*, Paris, 1990 (hereafter cited as Bauquier I), nos. 145, 147-50; from no. 150 one can then follow the sequence further in G. Bauquier, *Fernand Léger: Catalogue raisonné 1920-1924*, Paris, 1992 (hereafter cited as Bauquier II), no. 258, and ultimately nos. 368-71.

5 Green, *Léger and the Avant-garde*, p. 141; '[the *Eléments mécaniques* of 1918-23] was touched up, it seems, in 1923, but like the others in the sequence, was the product of 1918.' The question as to whether it was really as early as 1918 that Léger did most of the work on the large canvas remains unresolved.

6 Bauquier II, no. 385; for a smaller version of 1922 see Bauquier II, no. 342. Cf. also G. Bauquier, *Fer-*

Fig. 1 *Contraste de formes* (Contrast of Forms), inscribed '1913', oil on canvas, 46 x 55 cm. Musée National Fernand Léger, Biot (B 46)

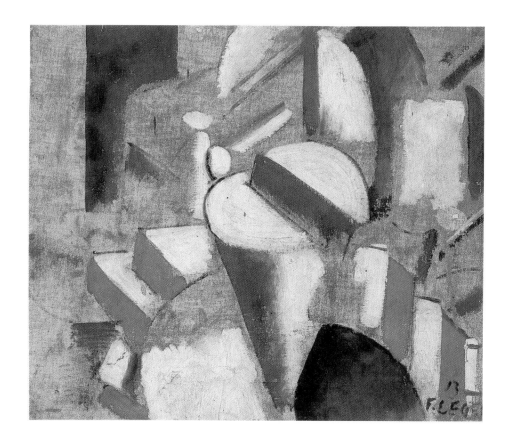

1912-13. During the War he evolved new concepts of abstraction and realism, of contrast and living objectivity, concepts at one and the same time saturated in reality and yet still ambivalent.[9] As he himself put it, in the guise of the engines of war he had been 'confronted by pure abstraction, purer than Cubist painting'.[10]

What Léger encountered during the War as a powerful fact, and expressed as an artistic totality, he afterwards associated with the experience of the modern world, a world dominated by industrial products, cinema, advertising and so on. These were as successful as they were dangerous, and their presence had consequences for every aspect of society. For Léger, they were the embodiments of what was objective, lucid, indeed healthy about the post-War era, and they caused in him most intense excitement. He was not, however, unaware of the drama and danger inherent in such inventions: in the 1920s he was already recognizing – and appreciating – how many areas of life were by then in a 'state of war', a state to be embraced as normal, and to be welcomed more than was the idle, unreal state of peace: 'If I stand facing life, with all its possibilities, I

like what is generally called the state of war, which is nothing more than *life at an accelerated rhythm.* [...] the beginning of the state of enlightenment. Too bad for those with weak eyes.'[11] Perhaps it is for this reason that *Les Eléments mécaniques* appeals to us in the late twentieth century as a post-War picture, a work of mechanical objectivity, though at the same time one apparently abstract, and certainly post-Cubist.

The Roots in the pre-War Years

Although Léger insisted that the War 'made him forget the abstract art of 1912-13', his letters from the Front show as clearly as do the pictures from 1916-18 that it was less a question of forgetting than it was one of transformation, as his own preferred terms suggest – abstraction, realism (or the 'objective'), dissonant contrasts, animation, *'surfaces vives'*, *'éclat'* and the like.[12] This transformation is embodied in the group of works that culminated in the *Eléments mécaniques* that he finished in 1923. Already underway before the War had started, this group albeit resulting then in abstract compositions of a different character. Two works may be seen to support this claim: a little-known Cubist gouache of 1914[13] and a study on canvas, provisionally dated to 1913 and nowadays known as *Contraste de formes* (Contrast of Forms, fig. 1). It has not, however, ever been pointed out that this *Contraste de formes* corresponds with the centre, the 'heart' as it were, of *Les Eléments mécaniques* of 1918-23.[14]

As in Léger's *'L'Escaliers'* and *'contrastes de formes'* pictures of 1913-14, the colourfulness of the 1914 gouache derives from Léger's concentration on the primary colours, chiefly red and a blackish blue, though he also used intermediary hues. Their pervasive greyness, and the evenly vigourous dry, yet transparent application of the paint, integrate all the contrasts within overall tonality. The relationship between the centre of the composition – the multiple, *'accelerated',*[15] relatively corporeal forms of the central area, still prominent though fixed in relation to the vertical and horizontal axes – and the edges, with rod or

lattice shapes, where the centrifugal structures within the picture loosen, may be compared with the compositional organization of *Le Balcon* (The Balcony, 1914; pl./p. 105),[16] a work related to the *Escalier* pictures. Here too, towards the edges, there are open, bracing structures. Later, in the context of the trend inaugurated with *Le Soldat à la pipe* (Soldier with a Pipe) of 1916 (pl./p. 115) and *La Partie de cartes* (The Card Game) of 1917 (pl./p. 119), Léger invested greater strength in the picture edges by filling them with predominantly vertical and horizontal forms. This was already the case in the watercolour of 1917 (fig. 6) and quite decisively so in the pictures of 1918-23. In Léger's post-War works, this consolidation, the radiating frontality and the intense local colouring that appears bound to the surface actually presuppose experiences that 'made [Léger] forget' certain earlier principles. Understandably, he spoke slightingly of these, referring to a sense of 'wavering', of being agitated and adrift, and to the influence of the nuanced grisaille of Cubism, 'the sweet grisaille of the pre-war years.'[17] In the gouache of 1914 Léger was less concerned with vertical stabilization in the background and more with conveying a sense of multifarious movement. The vertically striped part of a base element found in the later works leading up to *Les Eléments mécaniques* is still entirely missing. On the other hand, it is noticeable that the gouache is closer in many details to the pictures of 1918, such as *La Pipe* (fig. 3), and to *Les Eléments mécaniques* of 1918-23, than to the watercolour of 1917 and the ink drawing of 1918 (figs. 6, 7). In these last two works Léger adds 'arm' forms to the inner figure (or double or multiple figures), and these allow the sudden apparition of a more identifiable figural content. The gouache is altogether devoid of figural form; and this was something that Léger again did away with in the paintings (I will return to this point later). The 'head' (if one may call it that) is marked by a vertical blue stripe – as in the *Contraste de formes* dated '13' (fig. 1) – but deviates from all the formulations produced later in 1917-23. It is true that one cannot altogether dispute the figural substance of the gouache. It is, none the less, 'sufficiently abstract', more abstract,

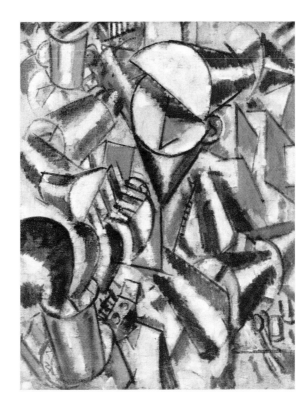

Fig. 2 *Femme cousant* (Woman Sewing), 1913, oil on canvas, 93 x 72 cm. Collection of Morton E. Neumann, Chicago (B 86)

for example, than the *Femme cousant* (Woman Sewing) of 1914 (fig. 2), with which it may be compared on account of the central 'neck'-cone to be found in both. The 'face' – that of a vaguely discernible figure, an irritating presence – remains an integral part of the otherwise abstract composition. It is precisely the comparison with the *Femme cousant* that makes evident Léger's double intent.

The Study dated '13'

A prominent cone, standing on its tip and enclosed by 'step' motifs, is the principal feature of a study dated 1913, painted on a roughly primed, rectangular canvas. It was given (by Léger?) the title *Contraste de formes* (fig. 1).[18] Only recently has it been noticed[19] that the configuration of the cone, together with its setting, largely corresponds with the central area of a number of pictures produced in 1918-19: *La Pipe* (The Pipe, fig. 3) and *La Pipe en bois* (The Wooden Pipe, fig. 4), for example, and – if one ignores the blue 'head' at the upper right of the study – *Composition* (pl./p. 131) and the centre of *Les Eléments mécaniques* too. In addition, the pipe (the source for the

nand Léger: Catalogue raisonné 1925-1928, Paris, 1993 (cited as Bauquier III), nos. 440 and 441.

7 Green, *Léger and the Avant-garde*, p. 265, figs. 107 and 179, establishes this connection; see also Bauquier I, no. 142, also no. 141. Cf. note 5, above.

8 These are as follows: A watercolour of 1917 (fig. 6), for which see J. Cassou and J. Leymarie, *Fernand Léger: Drawings and Gouaches*, Paris, 1972; English trans. London, 1973 (henceforth cited as Cassou/Leymarie), no. 50, illustrated in colour p. 54. An ink drawing of 1918 (fig. 7), for which see Cassou/Leymarie, no. 51. Two paintings: *La Pipe* (fig. 3) and *La Pipe en bois* (fig. 4), both of 1918, for which see Bauquier I, nos. 134 and 133. And a *Composition* of 1919 (pl./p. 131), for which see Bauquier I, no. 174. Cf. Green, *Léger and the Avant-garde*, pp. 141 and 328, note 60.

9 Cf. Christopher Green's essay in this catalogue, in which he analyses Léger's war letters (C. Derouet, ed., *Fernand Léger, Une Correspondance de guerre à Louis Poughon, 1914-1918*, Paris, 1990).

10 Cf. Léger's letter of 30 May 1915 from the Front in *Correspondance ... à Louis Poughon*, p. 35ff.; also Green's essay in this catalogue. In the perfected technology of war there was 'no more wavering'. See also *Fernand Léger* exhibition catalogue, Musée des Arts Décoratifs, Paris, 1956, p. 30: 'It was more than enough to make me forget the abstract art of 1912-13.'

11 Léger, 'L'esthéthique de la machine: l'ordre géometrique et le vrai' (1925), in *Fonctions de la peinture*, p. 66; English translation, p. 65. Cf. Eric Michaud's essay in this catalogue.

12 These concepts were in use both before and after the War; their meanings altered but of equal importance was their continuity. Among other sources, see Léger's letters of 1919 published by Léonce Rosenberg in the journal *Valori plastici* (Rome), I, nos. 2-3 (February-March 1919), p. 3, and Léger's letter of 11 December 1919 to Daniel-Henry Kahnweiler, published in *Pour Daniel-Henry Kahnweiler*, Teufen, 1965, p. 307. Cf. also note 45, below.

13 For illustration see supplement to the exhibition catalogue, Kunstmuseum Basel, 1994. The gouache, measuring 36.8 by 28.5 cm, is signed

and dated at the lower left 'FL 14' (collection of Frederick R. Weisman, Los Angeles). It was acquired at the Saidenberg Gallery in New York in 1965, and it is said to have been in Kahnweiler's private collection. It was said to have been re-acquired by Kahnweiler from the sales of his stock – the *Ventes Kahnweiler* – but may, rather, be presumed to have been presented to him by Nadia Léger after 1955. As Maurice Jardot told Ernst Beyeler, the walls of Nadia's house were hung with numerous gouaches, and Léger once described these as testimonies to his artistic 'history'. The authenticity of some of these gouaches, coming on to the art market through Kahnweiler in 1963-4, has been questioned. Even the undeniably genuine pieces, such as the gouache owned by Weisman, have a character of their own. This has to be explained in terms of their function: to serve Léger himself as documents of his 'history'. They were less likely to be new inventions than autograph repetitions of pictures and ideas for pictures.

14 Bauquier I, no. 46. See note 18, below.

15 Léger, 'L'esthétique de la machine: L'ordre géometrique et le vrai', p. 66; English translation, p. 64: *'life at an accelerated rhythm.'*

16 Bauquier I, no. 72.

17 On the concept of 'wavering', see note 10, above, and note 45, below. On 'grisaille' see Léger's 'Couleur dans le monde' (1938), in *Fonctions de la peinture*, p. 86, cited from English translation, p. 120. On 'nuances' see Léger's 'Note sur la vie plastique actuelle' (1923), in *Fonctions de la peinture*, p. 46; English translation, p. 25.

18 Bauquier I, no. 46. This study came, via Léger's estate, to the Musée Fernand Léger at Biot (Alpes-Maritimes). When did Léger date and sign this picture retained by him for his own collection? Other early pictures were also signed when they left the studio, that is to say sometimes years after their execution and so perhaps not always correctly.

19 In response to my enquiry, Christopher Green informs me that he too had once assumed such a connection but did not pursued the matter.

20 One would have to check if the painting was continued on the canvas edges that were folded around the wooden stretcher and ultimately cut. This has not been

Fig. 3 *La Pipe* (The Pipe), 1918, oil on canvas, 91.4 x 73.7 cm. Collection of Joseph H. Hazen (B 134)

titles of at least two of the pictures), with its sloping stem, is to be found, sketched in and shaded in blue, at the right edge of the study. The dimensions of the study, furthermore, are almost identical with those of the corresponding part of *La Pipe*.

So is the colour study *Contraste de formes* (fig. 1) perhaps a detail[20] from a larger composition of the type of *La Pipe,* or of the series ultimately transposed to a large scale in *Les Eléments mécaniques*? And if the date '13' is correct, or correct in as much as the study was painted *before* the outbreak of war, and taken up again in 1917-18 (we can observe this for the first time in the watercolour of 1917, fig. 6), can one then connect the sketched detail here with the statement found in Léger's letter of 14 November 1915 that, before the outbreak of war, he had not been able to realize 'a large picture which would have been entitled '*L'Escalier*', but had made, as preparation for it, 'attempts at something rather abstract (contrasts of forms and colours)'?[21]

The question of the date '13' is not an academic one, of interest only to specialists. The insistent plasticity, the matter-of-fact quality of the stepped forms, and their flat colouring with red, blue and white, as well as the symmetrical rigidity and axiality of the study, suggest that Léger had here already left behind the liveliness that characterized his pre-War pictures. What Léger termed 'wavering', which was superseded by the experience of war, appears to have been largely renounced in favour of the production of 'three-dimensional' images. This is a characteristic that was new in the wartime paintings *Le Soldat à la pipe* (pl./p. 115)[22] and *La Partie de cartes* (pl./ p. 119)[23] and, in the pictures produced from 1918, became a firm basis for Léger's work and thought. The connection with *La Pipe* of 1918 and *Les Eléments mécaniques* of 1918-23 hence appears entirely natural. The powerful stepped surfaces of the sliced cone in the study do not really find parallels in Léger's pictures until the stepped shoulder of the *Soldat à la pipe*. This was a work Léger painted while on leave in Paris in 1916, its colouring corresponding to the deeply felt 'greyness during the war'[24] that ultimately provoked a demand

for freedom in forceful, flatly applied colour. The sharp, stepped form of the soldier's heavy coat in the area of his (doubled) left shoulder is not merely a novel detail for it corresponds to the whole character of this picture – a soldier sitting tensely in his dug-out, oppressed and distressed by the posts supporting the structure and by the tubes forming his own body. He sits in front of a drinking-vessel in his role as a 'waiting-machine',[25] and makes globules of smoke rise from the pipe defiantly stuck in his mouth.

The stepped forms of the multiplied, accelerated, faceted surfaces of the tubes or cones of the *Contraste de formes* study of 1913 (fig. 1) only reappear in Léger's work in 1916-18.[26] Before the War he limited himself to the use of swiftly applied diagonal strokes, consummate in their suggestion of three-dimensionality, and with colours only approximately recalling shadows or lustre, and then only in a fairly abstract manner. A change, of course, cautiously announced itself in the gouache of 1914. On the other hand, in the large *Les Eléments mécaniques*, Léger apparently sought to 'reverse' this process: he introduced slight shifts in the cut surfaces of the stepped forms so that they lost some legibility, and there emerges a dynamic ambivalence be-

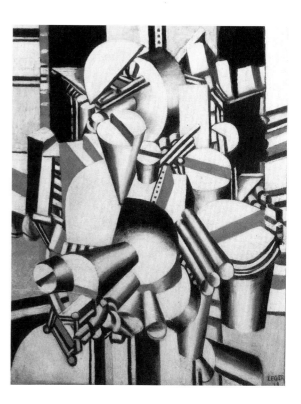

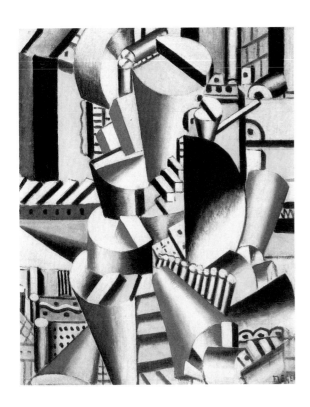

tween volumes and planarity. Can the date '13' stand without question as valid for the *Contraste de formes?* If 1913 (although 1914, or even 1916/17, might seem more suitable), one would be acknowledging the study's audacity, a quality certainly appropriate to the preparation of the large composition that Léger claimed to have planned and then failed to complete due to the outbreak of war. In terms of structure, the end result of his project might have looked quite similar to the large *Eléments mécaniques.* Though the exact dating of the study *Contraste de formes* may remain unresolved, its significance is clear.

The Pipe

La Pipe (fig. 3), painted in 1918, is the direct predecessor of *Les Eléments mécaniques.* The tubular pipe-stem is a leitmotiv of Léger's *œuvre* from *La Pipe en bois* (fig. 4) onwards, and can be found in all the pictures directly leading to the *Eléments mécaniques* of 1918-23. In the Cubism of Picasso and Braque, the pipe stuck in the mouth was part of the strategy of *trompe l'esprit* (cheating the mind, and distinct from *trompe l'œil*).[27] The tradition of the pipe-smoker in European art, from Dutch

seventeenth-century painting to Cézanne's *Card-players,* was, at least in part, rejected by Léger, especially in the contemporary realism of his large composition of 1917, *La Partie de cartes* (pl./p. 119);[28] in Léger's work, the pipe – a crude, wooden one, not a Dutch clay-pipe and thus not one from an artistic tradition – is more than a mere three-dimensional form, it is the soldier's 'attribute', an allusion to his waiting, his freezing, to the pressure weighing upon him.[29] Typically, in the gouache of 1914, the tubular form alongside the cone (a kind of 'neck'-cone) can hardly be called a 'pipe': it is far more abstract. A real pipe, as in the *Pipe en bois* (fig. 4), appears first as a tube-shape object in Léger's watercolour of 1917 (fig. 6). After the War it endures as a 'mechanical' shape, and later as a component in still-lifes. Ultimately the pipe gives way to the slim, modern cigarette: in 1920 Léger placed a cigarette in the hand of the idealized successor to the soldier, *Le Mécanicien* (The Mechanic; pl./p. 171). The mechanic's cigarette, giving off bubbles of smoke, is now the attribute of the self-aware worker taking a break, and no longer that of the common soldier, the *poilu,* at the Front.[30]

In the series of pictures that concern us here, Léger tended to hide the pipe motif, but never denied it altogether; and in fact it always appears in a central position. In the *Contraste de formes* of 1918 (pl./p. 122),[31] which also belongs to the group of works connected with the Basle *Eléments mécaniques,* the figure of the pipe-smoker is largely metamorphosed into contrasting forms; but once again the centrally placed pipe with its diagonal stem (here not issuing smoke) holds its own: a hovering cone attached to a stem 'stuck' between a pair of rounded wedges – the transformed head. Isolated, matter-of-fact and clear allusions to a figure seated in front of a glass or a cup are interwoven in the composition in the form of what can be described as mechanized-human elements. The (wood) pipe does not pervade this series of pictures in a particularly striking manner, though it is a regular feature, and is always in a central position, a leitmotiv, furthermore, emphasized through the use of the titles 'La Pipe' and 'La Pipe en bois'. In these pictures the pipe is inde-

Fig. 4 *La Pipe en bois* (The Wooden Pipe), 1918, oil on canvas, 81.3 x 66 cm. Private collection (B 133)

possible as the picture has been in an exhibition touring Japan.

21 See Léger's letter published by C. Derouet in *Léger och Norden,* exhibition catalogue, Moderna Museet, Stockholm, 1992, p. 25. Cf. also Green's essay in this catalogue.

22 Bauquier I, no. 100; Green, *Léger and the Avant-garde,* pp. 117 ff., 141 and 153; W. Schmalenbach, *Bilder des 20. Jahrhunderts: Die Kunstsammlung Nordrhein-Westfalen,* Düsseldorf, Munich, 1986, pp. 48–50.

23 Bauquier I, no. 102.

24 Léger, 'L'art et le peuple' (1946), in *Fonctions de la peinture,* p. 184; cited from English translation, p. 146.

25 Henri Barbusse, *Le Feu (Journal d'une escouade),* Paris, 1916, p. 20; cited from the first English translation, *Under Fire: The Story of a Squad,* London and Toronto, 1917, p. 17.

26 The motiv recurs in comparable form in 1917-18: in the gouache *Le Remorqueur* (The Tugboat) dated 1917, see *Fernand Léger,* exhibition catalogue, Musée d'Art Moderne, Villeneuve d'Ascq, 1990, no. 76, illustrated in colour p. 159, and in the painting *Le Marinier* (The Sailor), Bauquier I, no. 132.

27 See *Kubismus: Zeichnungen und Druckgrafiken aus dem Kupferstichkabinett, Basel,* exhibition cata-

logue, Kunstmuseum, Basle, 1969, nos. 16 and 30.

28 Bauquier I, no. 102. It seems to me rather a case of simulated continuity when Werner Schmalenbach (see note 22, above) writes (p. 51) that one could regard Léger's *La Partie de cartes* 'als eine kubistische ins Technische verwandelte Fortsetzung der *Kartenspieler* von Cézanne' (as a Cubist, a technically transformed development of Cézanne's *Joueurs de cartes*). Here it was, rather, Léger's sense of *emancipation from* Cézanne that was significant.

29 See also the two drawings of 1917, each termed *Portrait de Philippon*, in Green, *Léger and the Avant-garde*, figs. 96-97.

30 See note 36, below.

31 Bauquier I, no. 124.

32 Léger, 'Un nouveau realisme: la couleur pure et l'objet' (1935), in *Fonctions de la peinture*, p. 79; English translation, p. 110.

33 Léger: 'L'esthétique de la machine: l'ordre géometrique et le vrai', p. 63; cited from English translation p. 62.

34 Léger, 'Note sur la vie plastique actuelle', p. 45; English translation p. 25.

35 F. Léger, 'Peinture moderne' (1950), and 'Note sur la vie plastique actuelle', in *Fonctions de la peinture*, pp. 37 and 48 respectively; English translation, pp. 168 and 26.

36 Bauquier I, no. 92. C. Green, in *Fernand Léger, 1882-1955*, exhibition catalogue, Staatliche Kunsthalle, Berlin, 1980, p. 115, makes the con-

Fig. 5 *La Couseuse* (The Seamstress), 1910, oil on canvas, 72×54 cm. Musée National d'Art Moderne, Paris, Gift of Michel and Louise Leiris (B 19)

pendent, it is 'withheld' from the mouth, from the human head, and endures largely as an abstract, three-dimensional form rather than as an identifiable object issuing smoke. In this sense, the area of the 'head' in *Les Eléments mécaniques* is a region entirely cleansed of smoke, an aspect viewed in terms of the picture's genesis, not without relevance. What remains is the image of the pipe-stem, hovering next to a neutral surface or panel. But where is the smoker? Should we be looking for him? Or should we be satisfied with a title like that of *Composition* (pl./p. 131)? The invented, yet object-bound, form asserts itself with the pipe as the primary focus of the picture. The result is neither abstract nor concrete.[32] It is, rather, pictorially matter-of-fact, painted with the kind of craftsman's precision that was now so important to Léger, and which he demanded of the painter just as much as from the mechanic or the engineer, a precision at the service of the *'beautiful object'*.[33] The pictorial objectivity towards which Léger now strove, and which differed from the abstraction of the pre-War period, was newly founded in the 'raw material' of the experience of mechanical things. Constructive (Juan Gris would say synthetic) principles still remained in force for Léger and others, albeit with transformed content. The mechanized world was for Léger *the* reality of the post-War age, be it in terms of form, structure or society.[34] The pipe-tube shape and all other 'mechanical elements' were rooted in the 'raw material' of this new reality; all, however, were also 'invented' as elements for constructing a picture. The pictorial power of these forms is due precisely to their twofold character.[35]

If we glance back beyond the 'real', smoking *Soldat à la pipe* of 1916 (pl./p. 115) to a work of 1914, *Le Fumeur* (The Smoker: fig. 2, p. 59),[36] again we find a pipe-smoker with a glass or cup in front of him in the left foreground. Here, however, the vessel, like the figure as a whole, unfolds in a loose scattering and multiplication, the same compositional principle that characterizes the gouache *Le Fumeur* of 1914.[37] In the *Soldat à la pipe,* in contrast, the soldier sits in his dug-out, wedged into the taut composition, and is thus concentrated with unprecendented three-

dimensionality. (This despite the painterly 'transparency' that contrasts, for example, to the impasto of *La Couseuse* [The Seamstress] of 1910, fig. 5). All the tubes and posts in the Wartime picture are shaded, though, even if the body-parts are articulated in this way, the primary concern is, none the less, with the totality of the image – with plasticity in its own right, a plasticity bound to the picture plane, strong yet 'breathing'. This achievement was informed and sustained by the new experiences that were leading Léger in a novel direction. *Le Soldat à la pipe* does not depict something abstracted, it is a rhythmically three-dimensional construction with a human and figural substance of the most compelling kind.

Primary and Local Colours after 1917

Looking at the formal elements and the colours applied (and noticing Léger's tendency to rely on primary ones), it is clear that by 1912-13, analogous to the treatment of shapes and plastic values, Léger juxtaposed primary colours, supplemented with green, so as to obtain contrast and tension. In the pre-War period, colours – sparkling, yet as tender as pastels – were apportioned within the turbulence of established contours. However, from 1917-18, colour was attached 'locally', that is to say to the surfaces of planar, stepped or cylindrical mechanized elements, to the multiplied, 'accelerated' bodies (fanning out and at the same time controlled) that define the compositions through their tension in relation to the picture plane. Their more vigorous and more lustrous character could not be more different from the goal pursued by an artist such as Piet Mondrian, who confined his palette to primary colours. In 'Die Nieuwe Beelding in de Schilderkunst' (The New Plastic in Painting), published in the journal *De Stijl,* Mondrian advocated that colour be made 'free of individuality and individual sensations, and express only the serene emotion of the universal'. Equally remote from Léger's approach is Mondrian's notion that 'as the natural (external) becomes more and more "automatic", we see life's interest fixed more and more on the inward'.[38] Léger, with his profound need for

primary colours, pursued the very opposite of 'inwardness'; and, by 'automatic' (or 'mechanical'), he understood, or rather he *saw,* in the world around him quite other things, energies and sociological processes than did Mondrian (with whom he was, none the less, in contact from 1921).

In the *Partie de cartes,* despite the application of primary colours, and the brightening effect of yellow, red, blue and occasional touches of green, the 'smokey' black-white definition of the volumes preserves the sense of their oppressive weight. Corresponding to this aspect of the picture, there is also a palpable tension between all the corporeal elements – on one hand as something ponderous, lumbering and brutal, on the other as something gleaming. Many parts of the canvas are barely covered with colour, only primed (similar to Léger's pre-War technique), although sharply divided one from another. The application of colour is no longer loose, floating and free.

Two Kinds of White – Covering and Open

Colour is handled differently – extreme and exemplary – in the key work, the *Eléments mécaniques* of 1918–23, a composition no longer decisively frontal in its arrangement. It is far-reaching in its implications and corresponds somewhat to the notion of 'colour as material that endows things with colour' articulated by the Russian poet Vladimir Mayakovsky in his comments on Léger of 1922-3.[39] Careful observation reveals more than an insignificant technical peculiarity. Even in the case of these 'flat' pictures of Léger's 'mechanical' period (1918-20 and later),[40] works saturated in 'bright, strong, refinedly dissonant colours', forward, aggressive and extremely frontal,[41] there are numerous 'open' passages where the canvas is not painted, nor covered in a painterly manner, but only primed and left, though now admittedly within clearly defined areas. Léger's previous practice, up to the time of *Le Soldat à la pipe* of 1916, of allowing patches of unpainted canvas to remain visible, was now transformed in the Basle *Eléments mécaniques* so as to allow for clearly different pas-

sages painted in active white and those adjacent, though similarly white and flat, which are really 'empty', merely white primed canvas between painted areas.

In this way surfaces are not evenly and fully covered, nor was a work severely frontal in its effect. Next to the rather compressed surfaces and evocations of physical bodies, one can note many passages that 'breathe'. The preparatory drawing and the squaring-up of the picture were intended to show through. Léger also allowed himself *pentimenti* that remain visible – for example at the lower-right below the foreshortened blue 'arm'-cone with the black band.

Luminous Planes

Almost everything that appears white in the *Eléments mécaniques* of 1918-23 – white in various degrees of density, luminosity and intensity – is experienced by the viewer not merely in terms of planes contrasting with the tubular, shaded, lustrous, active bodies and the three-dimensionality of the layered forms; it is also experienced as a pure, as it were objectified, and yet rather disembodied, light. The radiant white appears more richly distributed here than in almost any other work by Léger. In the central part of the picture white is circumscribed within a circular area and faintly evokes something corporeal, although flat. There are, however, two striking exceptions to these white forms: on the black shaded 'stomach'-piece at the centre, diagonally below the principal, downward pointing cone, and at the upper right, the stepped form in white alternating with a deep pinkish-lilac. These white passages – comparable to the large-scale semi-circles of clouds or smoke in Léger's pre-War work – are bright planar bodies, isolated dynamic forms that pass among the other, more pronounced bodies and surfaces, forcefully radiating a rich ambivalence.

At the centre of the picture, in what is a potentially figurative region, the distinctions appear, on closer inspection, to be extremely delicate. Of the four half-discs arranged around the central axes, with their more or less white colouring, the lowest (from which a

nection between this work and *Le Soldat à la pipe. Les Fumeurs* of 1911, Bauquier I, no. 21, has a quite different structure. Already in the first version of *Le Mécanicien* (1918; Bauquier I, no. 144), the worker no longer smokes a pipe but a cigarette – in formal terms this is a short tube, without globules of smoke – cf. Bauquier II, nos. 201 and 202: *L'Homme à la pipe,* 1920. In the final version of *Le Mécanicien* (Bauquier II, no. 254), Léger again indulged his liking for 'solid' smoke. On this picture, see Green, *Léger and the Avant-garde,* pp. 198–222, and J. Golding, *Fernand Léger: The Mechanic/Le Mécanicien,* Masterpieces in the National Gallery of Canada, no. 6, Ottawa, 1976.

37 Cassou/Leymarie, no. 38, fig. on p. 43 (no. 37 is a variant).

38 P. Mondrian, 'Die Nieuwe Beelding in de Schilderkunst', first printed in *De Stijl,* I (October 1917-October 1918), these quotations come, respectively, from the third section of the essay, published in January 1918, and its introduction, published in October 1917; cited from English translation in H. Holtzman and M. S. James, eds, *The New Art – The New Life: The Collected Writings of Piet Mondrian,* London, 1987, respectively pp. 36 and 28.

39 See V. Mayakovsky, 'A Seven-day Survey of French Painting' (notes made during a short journey to Paris, written during 1923 and published posthumously in 1932), reprinted in *Wladimir Majakowski: Werke,* IV, ed. L. Kossuth, Berlin and Frankfurt am Main, 1971, p. 86.

40 The last pictures with titles such as *Elément mécanique* or *Eléments mécaniques* largely date from 1925 (though a few are later); the first ones date from 1918.

41 F. Meyer, 'Die Schenkung Raoul La Roche an das Kunstmuseum', in *Jahresbericht 1963 Öffentliche Kunstsammlung Basel,* pp. 55-70, on Léger p. 68 ff.

Fig. 6 Study for *Les Eléments méca-niques* (Mechanical Elements), 1917, watercolour on paper, 34×25 cm. Private collection

42 See note 11, above.

43 In the first issue of the *Bulletin de l'Effort Moderne* (January 1924), one finds framed works by Léger, photographed on the walls of the Galerie de l'Effort Moderne, used as illustrations to Maurice Raynal's article on Cubism. The frames are dark, of relatively low relief, and placed directly around the stretchers. See *L'Esprit Nouveau, Le Corbusier et l'Industrie, 1920-1925*, exhibition catalogue, Museum für Gestaltung, Zurich, 1987, p. 101.

44 Léger, 'L'esthétique de la machine: l'ordre géometrique et le vrai', p. 65; cited from English translation, p. 64. A German version of Léger's essay appeared in 1924 in the journal *Das Kunstblatt*, VIII, p. 42.

45 Cf. Léger's letters of 1919 to Rosenberg and to Kahnweiler, as in note 12, above. Léger here for the first time defines his new position after the Great War.

46 F. Gilot and C. Lake, *Life with Picasso*, New York, 1964, p. 276. Cf. the essay by Gottfried Boehm in this catalogue (p. 35).

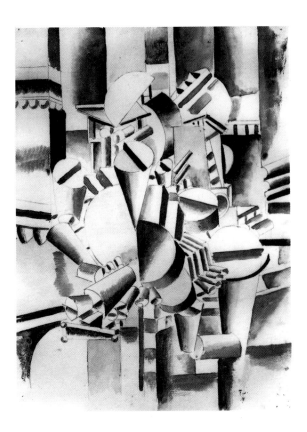

sort of robot arm protrudes diagonally) is partially shaded in black in a manner calculated to attract attention, going a fair, if measured, way towards emerging as a real object. More precisely, the partial 'objectness' of this disc (its predecessor is already provided with a shadow in the gouache of 1914) mediates between the metallically gleaming cylinder shapes and the flat, corporeal and 'negative' white discs and other planes. The 'breast' disc, attached at the left and placed somewhat higher, certainly at first appears once again as a bright negative zone, but it is important to notice that it has a slightly yellow tint, and is thus rendered warmer and suggestive of the organically corporeal. This suggestion of flesh-tones recurs most pointedly in the pale pink of the cut surface of the black-shaded 'stomach'-disc placed diagonally below the 'breast' to the right; and we can also note the pale-brown tint of the uppermost surface of the stepped cone. These are quiet differentiations in a picture that is itself by no means loud, a picture that 'weak eyes' will not be able to tolerate.[42] Both half-discs in the region of the 'head' (in the face and a skull-cap area) are again a relatively cold white. The partial disc at the right, is made luminous by the surrounding relief-like cheek that encloses an area that seems incorporeal. The partial disc at the left appears flat, with a black cut – a harsh diagonal evoking a dark border. Most significantly, this disc casts a regular shadow (the only shadow in this picture – and in contrast to the preparatory ink drawing of 1918, fig. 7), onto the surface of the triangular form projecting beyond it to the left, a surface that is itself ambiguous and, like the 'steps' at the upper right, can be read both as a plane and as a foreshortened three-dimensional object. At the edge of the composition, white, black and other coloured passages, orthogonally defined fields, fit together within the richly contrasting structure. These help tame this picture's strongly centrifugal forces.

The Picture as a Radiant, Spirited Personification

It is problematic that the black profiled frame of the Basle *Eléments mécaniques* (evidently dating from the 1920s) effects the overall impact of the picture.[43] Perhaps, though, this frame corresponds to Léger's intentions: in 1924 he spoke of a picture being 'limited isolated, and personified in a frame'.[44] The use of the term 'personified' is of interest in connection with this picture, in which the figural element seems to slumber: 'corporeal', indeed larger than life-size, but withdrawn, and absorbed into the personality of the picture itself. In 1919 Léger wrote that a picture must emerge in a room or a gallery space as 'the most important person'.[45]

Tempi

What Picasso missed in Léger's work – namely an effect that went beyond the first shock[46] – was, in fact, something consciously sought by Léger from 1917–18: an unsentimental increase in the suggestion of speed, in keeping with the modern world. More precisely, Léger wanted to be able to convey both speed and the brake on speed; to give shape to a contrast of tempi (and not only of forms). This endeavour began with the swiftly emerging frontality,

with the urgent movement of the 'lively forms forwards, towards the spectator' with 'the effect of more clearly penetrating into life',[47] and with what Carl Einstein called (in 1930) 'an incredible onslaught of object-based creations'.[48] With regard to the tendency towards mural-like frontality, Léger made certain distinctions: 'I've used flatness because a creation on a planar surface is more swiftly effective as a pictorial principle. For the eye, modelling has a slowing effect. The shock of the two-dimensional is an immediate one, and this sort of instantaneity appears especially appropriate for large-scale mural painting.'[49] In *Les Eléments mécaniques* the modelling is categorically limited to the rounded metallic grey-blue or blackish mechanical body parts. Despite their successful integration within the 'architecture' of the picture, these forms have not altogether lost the suggestion of swivelling or rolling movement: they still appear to glide, still seem to retain the requisite freedom to continue in this way. The modelling light falls from the front onto the tubes and cones: frontality reigns, so that side-lighting (as in the ink drawing of 1918, fig. 7), with light coming from the right) appears strange. In contrast to the flickering illumination in the works of 1913-14, the transition from the areas of light to the shaded areas of the curved bodies is continuous. Both rounded and flat forms are characterized by the same density and the same capacity to absorb and to reflect light.

Placed in a series, the pictures we have considered reveal an increase in frontality, axiality, continuous density, purity, radiance, precise transitions from swift to slowed movement, and in the contrast of tempi and its intensified effect. In terms of technique, the study *Contraste de formes* of 1913 (fig. 1), being a sketch on canvas, stands a bit outside the main line of development; but compositionally it is central, having virtually the same frontality and tangibility as the other works we have examined. A highlight falls on the disc near the cone, one similar to the cast shadow in the analogous passage in the ink drawing of 1918. The 1914 gouache is, in this detail, more 'abstract'. In the oil sketch dated '13', there is yet no yellow. In the 1917 watercolour (fig. 6), however, Léger goes out of his way to include

it, and in the pictures of 1918-19 it becomes dominant. Alternating with red, black (in Léger's work a full colour!) and white, are yellow planes and red stepped forms. In the final version in this series, the *Eléments mécaniques* of 1918-23, the yellow is more luminous, and accomodated within the vertical and horizontal forms found towards the picture's edges. It shines more gently than the white and the sharp red in the central area of the composition. Here the most luminous, active-'negative' planes of white tend to dominate. In contrast to the tubes and cones, modelled in blue, these have a tendency to the incorporeal; yet they are attached on all sides to relief-like corporeality and, too, to the solid planarity of the appearance of the painting as a whole. This ambivalence cannot be grasped at first glance: it constitutes one of the most crucial qualities of this work.

The Substance of the Human Figure

Is a basic figural content consciously detectable, then, in the centre of this dynamically constructed picture of mechanical elements – for example: a head above, an upper body in

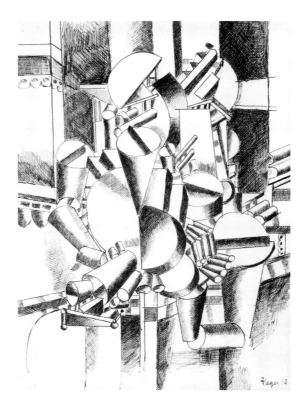

Fig. 7 *Les Eléments mécaniques* (Mechanical Elements), 1918, pen and diluted ink on paper, 30.9 x 23.2 cm. Öffentliche Kunstsammlung, Basle: Kupferstichkabinett

47 In 1963, Franz Meyer (see note 41, above), who also sees the striking difference between the visual effect in the work of Léger and that of Robert Delaunay, wrote: 'Anders als bei Delaunay braucht der Betrachter aber nicht in den Bildraum einzudringen, um an dynamischen Geschehen Anteil zu nehmen' (Unlike with the work of Delaunay, the viewer does not, however, have to penetrate into the picture space in order to take part in a dynamic event).

48 C. Einstein, 'Léger', first published in French in *Documents*, IV (1930), p. 191 ff.; reprinted, in German, in *Carl Einstein: Werke*, ed. M. Schmid and L. Meffre, III, Vienna and Berlin, 1985, pp. 87-92.

49 See the interview in D. Vallier, 'La Vie fait l'œuvre de Fernand Léger: Propos de l'artiste par Dora Vallier', in *Cahiers d'Art*, XXIX, (1954), p. 152.

Fig. 8 *Deux Personnages* (Two Figures), 1914, oil on canvas, 80 x 65 cm. Untraced (B 87)

50 G. Simondon, *Du mode d'existence des objets techniques,* Paris, 1958, p. 12, speaks of the pains taken to comprehend 'du geste humain fixé et cristallisé dans les structures qui fonctionnent' (human gestures fixed and crystallized in functioning structures). In Léger's essay 'L'esthétique de la machine: l'ordre géometrique et le vrai', p. 63, English translation p. 62, he stresses that he has not *copied* machines, and that he has, rather, *invented* them.

51 For example, *Paysage* of 1924, in Bauquier I, no. 76.

52 See no. 59 in the exhibition catalogue *Kubismus* (note 27, above).

53 Bauquier I, no. 87.

54 In 1920-21 the use of double and triple figures was continued by other means.

55 Léger, 'Les réalisations picturales actuelles' (1914), in *Fonctions de la peinture,* p. 26; cited from English translation, p. 16.

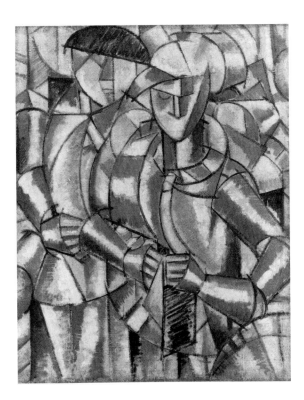

the middle, with arms and tubular hands attached? If a human core is present, a basic substance that might subliminally activate the memory that 'man' is at the heart of things, behind the 'mechanical' – and, indeed, in the picture of 1918-23, is present larger than life-size – it is a human figure not imitated from life, but rather invented within the picture,[50] pictorially evolved *in analogy* to the contemporary experience of being human. Human-figural substance can, in fact, already be detected in Léger's *'contrastes de formes'* pictures of the pre-War period, even occasionally in pictures that are landscapes.[51]

This last, largest and purest version – also apparently the least human, while at the same time being a human-bound composition – was given its title *Les Eléments mécaniques* in 1923, a title that Léger also gave to other, decidedly non-figural, pictures. Compositionally the smaller (1918) version corresponds with the large one, deviating only in nuances of tone and in the rougher application of the colours. Through its title, *La Pipe* (fig. 3), however, this smaller picture betrays its relation to the image (if not the representation) of a man who *might* have a pipe in his mouth, as does the *Soldat à la pipe* of 1916. In the 1919 version, with the title *Composition* (pl./p. 131),

this discreet allusion is missing (the 'figure' is incomplete, in that the 'head' is lacking), and Léger returns to the relatively abstract starting-point of the gouache of 1914. In the 1917 watercolour and the 1918 ink drawing – neither of which has a title – the figural content of the forms is strongly emphasized, indeed rendered correctly: on both sides there are complete tubular 'arms', to the left placed at the expected height, and to the right somewhat lower, flanking the main 'body', the central axis of which is somewhat shifted to the left. In the painted versions (of 1918) Léger has broken the continuity of the arm at the lower right. He has also entirely removed the arm visible at the left of the drawing, leaving only the hand and an object held by it (in the composition of 1919 the arm is partially present), and replaced it with flat rectangular forms, detailed articulated forms found already in the 1914 gouache.

Multiple Figuration

In the 1917 watercolour and the 1918 ink drawing there is the impression of two half-figures in the same pose, one placed closely behind the other and, as it were, folded into each other.[52] This double figuration is inserted into a space whose framing elements, just like the double figure, seem to emerge, relief-like, from the plane – tense, but by no means oppressed, precise but not inhibited. Two distinct figures, one in front of the other (in a work appropriately titled *Deux Personnages* [Two Figures] of 1914, fig. 8)[53] gradually evolves by 1917-18/23) into a kind of simultaneous social-figure, embodying all humanity,[54] a generalized, modern-'humane', but non-individual figuration. Finally, in *Les Eléments mécaniques* a single, vertically arranged multiple figure appears. In the pre-War pictures, by contrast, the figures fan out with a to-and-fro movement: shell-like individual contours with an undulating movement that simultaneously intensifies and recedes. In 1914 Léger termed this his 'research into multiplicative intensities', that is, intensities tending to multiply.[55] The triple, attached shells of the 'head' in the gouache of 1914 are good examples of this.

After 1917 he gave each form in his pictures stronger individual presence and precision.

The ink drawing of 1918 (fig. 7) situates the double figure with a new, reinforced connection to the axial and the perpendicular. The dynamic diagonals and the radial 'centrifugal' forms play a part in this stabilized structure. The use of short strokes for cross-hatching is disciplined, while still allowing a certain transparency, even in the darkest areas of the lattice of brownish black lines. The figural members not only shine, they also cast shadows on to smooth planes, projecting into a relief-like space. In the watercolour (fig. 6), the vertical stripes along the upper part of the picture are shaded in such a way that they appear, with their suggestion of convexity, like a series of *trompe l'œil* columns, almost as if in relief, or, rather, potentially spatial while retaining a clear relation to the picture plane. An exactly comparable suggestion of 'organ pipes' is to be found at the upper edge of *La Partie de cartes* of 1917 (pl./p. 119). In the 1917 watercolour and in the ink drawing, Léger wanted not only the corporeality of relatively clear and elegant mechanical-element figures to emerge, he also introduced a certain illusionism of light and shade in the interests of clarification – devices that he then banished from the pictures painted between 1918 and 1923. None the less, there remains in the *Eléments mécaniques* of 1918-23 a stimulating and irritating flux between construction and the figural, between flatness and illusionistic modelling. A graphic condensation of this ambivalence is found in the 'sooty' shaded coporeal disc at the centre of the composition. The viewer returns again and again to this circular pivot on which the composition as a whole seems to turn. Confronted with such finality, one is none the less entirely content to ask questions such as – What is going on here? What sort of material is this central element made of? What is the substance of the picture as a whole?

The 1917 watercolour and the 1918 ink drawing give the impression of 'arms' that lead to objects held by hands (in as far as these can be identified as such) and of work being done, analogous to that in *La Couseuse* (fig. 5). It would, however, be too dogmatic, and perhaps even false, to say, as does Georg Schmidt, that

'*Les Eléments mécaniques* could also be termed "La table d'un mécanicien" [A Mechanic's Bench]'.[56] Any kind of anecdotal description contradicts the translated character of the picture, which *in itself – not* as an illustration or narrative form – is the 'most important person'.[57]

After Mechanical Elements – The Mechanic

The more conventionally figurative *Le Mécanicien* of 1920 (pl./p. 171) has the same pictorial pretension, and should be understood as Léger's daring answer both to Picasso's Classicism and to Mondrian (as part of the give and take between the artists) and Purism.[58] In addition to this powerful picture, which Christopher Green has called 'the *poilu* machine-man in civilian life', filled with novel contrasts, there exists a smaller version, produced, suprisingly, as early as 1918.[59] There, the mechanic's torso is naked: he is not yet wearing the black T-shirt to be seen in the later version. This black, in Léger's work, is applied flat, like any colour, within the colouristic 'constructive relations' of a picture, and is not merely used for outline or shading,[60] and forms a powerful connection with the orthogonal-planar background, a connection that embraces rich contrasts. *Le Mécanicien* is certainly in some respects a form of self-portrait. It appears to contradict all post-Cubist fragmentation and synthesis. It seeks to outstrip, or at least to compete with, what was to find a masterly conclusion in *Les Eléments mécaniques* of 1918-23. Léger, it seems, was able to evolve several approaches at once, however various, without too much difficulty. His principle of intensifying contrast made this possible, and is something distinctly different from Picasso's 'polyglot' talent. Clearly, with *Le Mécanicien* and, in 1920-21, with the large-scale pictures of resting women – *Le Grand Déjeuner, Les Odalisques,* and so on (see pl./p. 177) – he had broken new ground that was to be important for all his subsequent work – and that in the by no means simple context of a post-War period well 'après le cubisme'.[61]

56 G. Schmidt, *Kunstmuseum Basel: 150 Gemälde, 12.–20.Jahrhundert,* Basle, 1964, p. 242.

57 See note 45, above.

58 See Green, *Léger and the Avant-garde,* pp. 198–222; Golding, *Fernand Léger: The Mechanic/Le Mécanicien;* and Bauquier II, no. 254.

59 See Bauquier I, no. 144, and the exhibition catalogue *Fernand Léger,* Villeneuve d'Ascq, 1990, no. 12, illustrated in colour p. 100.

60 See Léger's interview with Dora Vallier in 'La Vie fait l'œuvre de Fernand Léger, p. 154: 'Le noir a une importance énorme pour moi. [...] au lieu de l'inscrire dans les contours, j'ai pu la mettre librement en dehors' (Black is of enormous importance for me. [...] instead of using it to inscribe outlines, I've been able freely to put it outside them).

61 *Après le cubisme* was the title of the programmatic book published in 1918 by Amédée Ozenfant and Le Corbusier. The movements it supported ('Purism', the art of the engineer) found an effective continuation – and, in part, one close to the art of Léger (and to Mondrian's *Néo-Plasticisme*) – in the journal *L'Esprit Nouveau,* founded in 1920. It is, of course, well known that Duchamp, Picabia and the Dadaists had a quite different understanding of art 'after Cubism'. One last consideration, looking in another direction: one ought how to consider carefully what Joseph Beuys intended to convey in the sentences written with regard to his large *Stag Monument:* 'The *Stag Monument* is a sign of the spirit created by men within nature, the spirit moved by machines. (Evidence of the reality of ideas and the deceptiveness of the theory of entropy). Annihilated or extinct animals and an annihilated or extinct humanity come together in the realm of machines.' (Beuys, in *Zeitgeist,* exhibition catalogue ed. M. Rosenthal and C.M. Joachimides; Martin-Gropius-Bau, West Berlin, 1982, p. 82).

I am grateful to Ernst Beyeler, Christian Derouet, Hartwig Fischer, Christopher Green and Dorothy Kosinski for supplying bibliographical and other information.

Judi Freeman

LÉGER AND THE PEOPLE

The Figure-Object Paintings and
the Emergence of a Cinematic Vision

'At this moment, to the mind of the modern artist, a cloud, a machine, a tree are elements as interesting as people or faces.'[1] So Léger wrote in 1945, rearticulating a theoretical premise to equate people and objects initially conceived in the 1910s and expanded on in his important body of work in the 1920s. It is a concept at the heart of his cinematic vision, in which he very deliberately combined human, mechanical and abstract elements in compositions arranged during the editing process. Léger's was an unsentimental, rational premise that rendered emotion and subjectivity irrelevant. But how was this premise to be translated into actual practice? And can it be wholly reconciled with Léger's life beyond the actual canvases, drawings and films he produced?

Who, let us ask, is the mechanic in *Le Mécanicien* (pl./p. 171)? In his published study on this painting, the esteemed painter and art historian John Golding never poses the question.[2] This is especially odd when one considers the way that Golding describes the figure: 'The mechanic's face is expressionless, but his stance suggests that he is savouring the moment of relaxation to the full: absorbed in the present, he exudes an aura of self-confidence that bodes well for the future.'[3] Golding terms the mechanic's tattoo, his two rings and his moustache 'subsidiary refinements',[4] yet these are among the most intriguing elements, for they are those that personalize the image.

Léger's mechanic is a brawny, muscular man. His biceps bulge; the tattooed anchor suggests that his physical strength may be the result of his labours at sea. Robert Herbert notes that the mechanic has often been recognized as Léger's *alter ego*, and goes on to describe him as 'Léger's virile man'; in effect, the mechanic 'is the triumphant male for whom these nudes [from the *Déjeuner* series] exist'.[5] Note that Léger does not depict the mechanic at work, but instead chooses a half-length format, very much within the standard conventions of portraiture, and one that reinforces the sense that there was indeed a model who sat for this painting. A canvas study,[6] complete with the powerful physique and moustache, notably lacks the tattoo. It features a single ring, shown on the man's second (not fourth) fin-

1 F. Léger, 'A propos du corps humain considéré comme un objet' (1945), reprinted in Léger, *Fonctions de la peinture*, Paris, 1965, p. 71; cited from English translation in F. Léger, *Functions of Painting* London, 1973, p. 133.

2 John Golding, *Fernand Léger: The Mechanic*, no. 6 in *Masterpieces in the National Gallery of Canada*, Ottawa, 1976, passim.

3 Ibid., p. 3.

4 Ibid., p. 20.

5 Robert L. Herbert, *Léger's 'Le Grand Déjeuner'*, exhibition catalogue, Minneapolis, The Minneapolis Institute of Arts, 1980, pp. 32, 34.

6 *The Mechanic*, 1920, oil on canvas, 65×54 cm, private collection, is reproduced in Golding, *Fernand Léger*, p. 23, pl. 13.

Fig. 1 *La Couseuse* (The Seamstress), 1910, oil on canvas, 72×54 cm. Musée National d'Art Moderne, Paris, Gift of Michel and Louise Leiris (B 19)

Fig. 2 Henri Matisse, *La Danse II* (The Dance II), 1910, oil on canvas, 260×391 cm. State Hermitage, St Petersburg

7 Georges Bauquier, *Fernand Léger: Vivre dans le vrai*, Paris, 1987, p. 10. According to Bauquier (p. 12), Léger was expelled from Tinchebray, based on what he calls 'un motif scandaleux' (on account of some scandal). Léger's childhood friend Henry Viel, in his article 'Le Pays d'Argentan', confirms this; see Bauquier, p. 16.

8 Arguably, all three of these artists developed their mature work in the shadow of Cézanne. Certainly this was true for the first decade following the remarkable memorial exhibition of 1907. See William Rubin 'Cézannisme and the Beginnings of Cubism', in *Cézanne: The Late Work*, exhibition catalogue, New York, Museum of Modern Art, 1978, pp. 151-202.

9 Léger, 'Les origines de la peinture et sa valeur représentative' (1913), reprinted in *Fonctions de la Peinture*, pp. 13-14; cited from the English translation, pp. 5-6.

10 The sole exceptions are the austere *Portrait de l'Oncle*, 1905, oil on canvas, 44×35 cm (Musée National Fernand Léger, Biot), and the slightly more engaged *Portrait de Monsieur Blasini*, 1907, oil on canvas, 80×60 cm (collection unknown); see Georges Bauquier and Nelly Maillard, *Fernand Léger: Catalogue raisonné 1903-1919*, I, Paris, 1990, nos. 8 and 14.

11 On the techniques of a generation of Fauve painters during the first decade of the twentieth century, see my 'Surveying the Terrain: The Fauves and the Landscape', in Judi Freeman, ed., *The Fauve Landscape*, exhibition catalogue, Los Angeles County Museum of Art, 1990, p. 13.

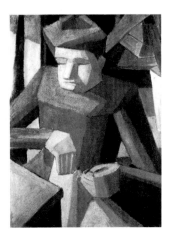

ger. The reason for these additional attributes is unclear, however: they do not make the man any more of an object, or object-equivalent, than he was before.

Léger prided himself on his commitment to the common man, an attitude he deliberately cultivated during his mid-thirties, and not based on his early life in a Norman family of relatively prosperous cattle merchants and farmers. He had first attended the Collège de Mézeray, the preferred school for the children of Argentan's affluent middle classes; from there he went on to a religious school at Tinchebray, where his grades continued to be disappointing: 'For me algebra, arithmetic, physics, chemistry, all the rest, it was all above my head', recalled Léger.

> But drawing – that was another matter. That really was me, something that I had in my finger tips, in my pencil. It was something that was alive, and I'm still discovering new things. Oh yes, that's thrilling.[7]

Having been persuaded by his mother to take up an apprenticeship under an architect in Caen, after two years there he decided to continue his architectural studies in Paris, where he settled in 1900. By 1903 he definitively shifted his studies to painting and, despite the protestations of his mother and uncle, he was by then in his early twenties and beyond their control.

Like many young artists exploring art in Paris in the first decade of the twentieth century, Léger experimented in turn with a number of styles, devouring the work of certain artists and revelling in particular exhibitions. Like Matisse and Picasso, he was fascinated by the memorial exhibition of the work of Paul Cézanne held in 1907 at the Salon de l'Automne.[8] Cézanne's work, as interpreted by Léger, became the foundation for the theory of contrasts that Léger developed over the next five years, a rational basis for his painting:

> 'One painter among the Impressionists, Cézanne, understood everything that was incomplete in traditional painting. He felt the necessity for a new form and draughtsmanship closely linked to the new colour. All his life and all his work were spent in this search.[...] He overinterpreted what he saw; in short, what he made came com-

pletely from his own genius and if he had creative imagination, he would have been able to spare himself from going to 'the motif', as he called it, or from placing still-life arrangements in front of himself. In Cézanne's letter I notice ideas like these: 'Objects must turn, recede, and live. I wish to make something lasting from Impressionism, like the art in museums.'

> Moreover, he wrote in one of his letters (I quote): 'After having looked at the Old Masters, one must make haste to leave them and to verify in one's self the instinct, the sensations that dwell in us.'[9]

Not surprisingly, when Léger painted his first significant portrait after his exposure to Cézanne's work (fig. 1), his sitter assumed a pose similar to that of Cézanne's portrait subjects. The seated seamstress looks down at her sewing; her gaze averts ours; and, as with Cézanne's paintings of his wife, it is difficult to discern what Léger's view of his sitter was. Clearly identifiable geometric forms define her arms, head and torso, and her surroundings. The monotone of the painting intensifies the dissolution of the sitter within her surroundings.

The figures in Léger's painting of the early 1910s resonate with the influence of Cézanne. Did an attraction to Cézanne's forms carry with it an attitude toward his subject, a sense of the anonymity of the sitter? And, in the same way, did Léger also abandon a more personal style of painting in favour of the conceptual premises he discovered in Cézanne's work?

Little in Léger's early work suggests that he was inclined toward any form of personal

painting.[10] Ink drawings do exist of his friends André Mare and Henry Viel, but none is known to have become the basis of an oil painting. With the exception of the small landscapes painted in Corsica during 1907, in which Léger adopted a loose hybrid of Impressionist and Fauve techniques,[11] there are almost no expressive, impastoed canvases that suggest any emotional engagement with the site or subject he was painting.

Interestingly, this impersonal quality is also to be found in the works of Picasso and Matisse of about the same time, c. 1910. Compare, for example, the 'anonymous' figures in Léger's *Nus dans la forêt* (Nudes in a Forest; fig. 4), Picasso's *Femme nu* (fig. 3), and Matisse's *La Danse II* (fig. 2). For Picasso and Matisse these works are actually departures from a highly personal, intimate, even autobiographical, body of work, while for Léger his large, volumetric, anonymous figures are fairly consistent with his earlier *œuvre*.

Picasso's earliest paintings are among his most personal and autobiographical. Matisse's portraits of his wife and daughter are tender and intimate views of his private life. Léger produced no comparable body of work. If Léger and Picasso (the latter was also born in 1881) created before the age of thirty a substantial body of rational, theoretically based work, it was, in Léger's case, consonant with, rather than a departure from, his earlier works.

Léger said on numerous occasions that he experienced a revelation during his time at the Front in the Great War, prompting a turning-point in his work. Life in the trenches made him one with the common man, and, it is supposed, planted the seeds for his subsequent Popular Front and Communist sympathies. Observe carefully, however, the language he used to describe his moment of revelation in the trenches among 'le peuple':

> I was drafted into the engineer corps, and, as you know, it is made up of workers, labourers, miners. Imagine the shock: I emerge from my studio, from the frontiers of art, and I land in the midst of my labourers (and don't think that they keep open house), and I worked with them for the whole campaign.[...]

> It was there that I truly understood what a man of the people is [...] he is a very orderly guy, so much so that I discovered that I myself was completely messy by comparison. Let's take, for example, the simple act of packing a knapsack: my boys put 33 kilos in their bags when I could get only 17 into mine.[...] I assure you that I learned a lot.

> I also learned their language, for they had a language, a slang. Each activity has its own slang. We painters have words and expressions that are our own, but our slang is mostly our pictures.

> It is because of this that a way must be found for us to understand each other.[12]

In this statement, published in 1946, 'them' and 'us' did not become 'we'. Léger's immersion in the world of the common man did not involve his becoming a common man. His words betray his interest in *observing* the common man, a desire to *communicate* with ordinary people, a desire to acknowledge certain aspects of their existence.

In 1950, with language perhaps more politically correct, Léger described the changes that had taken place in the life of the common man, evidently charmed by their quaint habits and behaviour:

Fig. 3 Pablo Picasso, *Femme nu* (Female Nude), 1910, oil on canvas, 187.3 x 61 cm. National Gallery of Art, Washington, D.C., Ailsa Mellon Bruce Fund

Fig. 4 *Nus dans la forêt* (Nudes in a Forest), 1909-10, oil on canvas, 120 x 170 cm. Rijksmuseum Kröller-Müller, Otterlo (B 20)

Fig. 5 *Paysage animé* (Animated Landscape), 1921, oil on canvas, 64.8×91.4 cm. Private collection (B 268)

12 Léger, 'L'art et le peuple' (1946), reprinted in *Fonctions de la Peinture*, p. 180; cited from the English translation, pp. 143-144.

13 Léger, 'Le Cirque' (1950), reprinted in *Fonctions de la peinture*, p. 151; cited from the English translation, p. 170.

14 Léger, 'Le spectacle: lumière, couleur, image mobile, object-spectacle' (1924), reprinted in *Fonctions de la peinture*, p. 135; cited from the English translation, p. 39.

Two hundred kilometres away they have changed the cut of their trousers, that's all. So take your bike, and stay a little while. Turn right, lose yourself among the back roads, get to know the local inhabitants; they are like you and me, just as clever as you are, maybe even more so, but in other ways.[…] Don't expect to find a generation of peasants that's down on all fours. That's over. Everyone is standing properly and is beginning to give up bowing down to the rich; they are rich too. Open the gate. Now go in. Your arrival has long since been announced by the dogs. They are their electric doorbell.[13]

It is this admiring observation of the way of life of the common man that is at the heart of Léger's post-War imagery. Beginning with the war drawings, the *dessins de guerre*, he is the consummate observer, watching, noting, commenting. Léger himself has no place at the table in *La Partie de cartes* (The Card Game; pl./p. 119), he simply records the card-game, carefully documenting the soldiers' helmets, caps and medals. In the foreground, and closest to the place taken up by the recorder of this scene, is a newspaper with a partially visible masthead, 'IRO'. This is, perhaps, a fragment of *Le Figaro*, a newspaper not usually associated with the rank and file troops in the trenches, and stands in for the artist. It establishes a boundary between the artist and the subjects of the painting.

That same kind of boundary – one that separates the artist/observer from the work's subject/character – appears in Léger's circus paintings that dominated his immediate post-War work of 1918. We look at the back of the acrobat to be seen in the foreground of *Les Acrobates dans le cirque* (pl./p. 157) and observe him performing with his partner. A vertical pole separates us from them, confining us within the faceless mass of spectators reflected in the mirror at the painting's upper left. Léger was a devoted fan of the circus and spoke of its performers with admiration:

Why won't they accept the lesson of the acrobats, the simple, humble acrobats? There are more 'plastic passages' in ten minutes of an acrobatic spectacle than there are in many scenes of ballet.[14]

Léger's fascination with spectacles of all kinds and his awareness of the gulf between audiences and performers encouraged him to begin to conceive using the stage as a medium. His notions of moving scenery and of the theatre as the setting for a total work of art are idealistic, theoretical premises that he referred to repeatedly but rarely was able to realize. His actual work in the theatre – from his *Skating-rink* of 1922 for the Ballets Suédois to his *Bolivar* of 1949 for the Paris Opéra – remained on the proscenium stage, with performers acting within settings that were 'up' on a stage, while the audience, *en masse*, watched.

The division into zones in Léger's theatre work also characterized his paintings of the 1920s. Two formats dominate: a series of vertical bands, like bars on the painting's surface through which glimpses of abstract forms are visible; and a series of images dominated by a large, complex volume in the centre foreground around which other, subordinate, elements revolve. The structures of these paintings function like the proscenium stage: the viewer can observe, but has more difficulty entering or navigating the scene.

In the series of *Paysages animés* (fig. 5; pl./p. 166), the anonymous figures set in suburban or rural settings are characters on a stage, downstage but sufficiently set back so as to establish a proscenium space, separating the

viewer from the characters in the scene. Léger's figures in these works are more angular or tubular than the strongly organic forms of the landscape elements. In 1923, just after completing this series, Léger described his use of 'the law of plastic contrasts',[15] manipulating strongly opposed values to achieve pictorial intensity. These contrasts establish an impenetrable zone much like the non-interactive stage of traditional theatre, and the *Paysages animés* function very much as tableaux. If they are as eye-catching, and of their time, as billboards, these works are none the less tradition-bound canvases.

Nowhere is this more true than in Léger's paintings of women undertaken in the early 1920s. The plump, Parisian maidens in his *Déjeuner* paintings (pl./p. 177) are modern-day versions of Ingresque bathers or harem women. Indeed Léger later contrasted *La Ville*, (1919; pl./p. 145), with its mural-like size and contemporaneous subject-matter to the *Déjeuner*, an easel painting, engaged in traditional subjects.[16] Léger, of course, was aware of the prevailing neo-Classical revival in much post-War avant-garde French painting and, though not squarely at the centre of those efforts, no doubt sought to address them on his own terms.[17] Significantly, for our context, his return to tradition in the *Déjeuner* works betrays a desire to distance the spectator: 'Some women's bodies, one table, a dog, every time's subject without any expression of evocation', he remarked, describing the *Grand Déjeuner*.[18] In this canvas, all three women gaze back at us. Their bodies are intertwined, forming one bulbous, rotund mass, compressed into the foreground of the painting. The anonymity of the women, and their resemblance one to the other, reinforce the uniform effect. The observer/voyeur of their breakfast is given no comfortable separation – save the frame – from these imposing female figures.

Though ranging in subject from the machine element, to traditional themes, to scenes of a relatively bucolic present, these works between 1918 and 1923 were all easel paintings. Without radically altering the two-dimensional, framed format of the easel painting, Léger could not break down the formal distance between painted subject and the viewer.

Furthermore, there is little indication that he sought to do so in later easel paintings. Later, to be sure, he became preoccupied with mural painting on an enormous scale and very much directed toward a mass audience, but in the 1920s his ambitions – even with respect to the mural paintings he began in 1924 – were far more modest.

Which brings us to Léger's cinematic vision. What Léger could not do in painting,

he could achieve in film, or so he presumed. He discovered the seductive power of film in creating his film of 1924, *Ballet mécanique* (pls./pp. 191-3). Working with Dudley Murphy, who had gained some film-making experience in California, Léger strung together images shot at varying moments from a list of random ideas.[19] The intellectual work was performed at the editing table, where the number of frames determined the length of time each image had on the screen and its relative value on the viewer's retina.

In *Ballet mécanique* Léger established a set of key images defined by their duration on the screen, that is to say, by the number of photographic frames each was allotted. These included the following sequences: the girl on the swing (301 and 296 frames); Christmas decorations (229 and 231 frames); the fractured image of saucepan lids passing between white bars (204 frames); three jelly moulds, prismatically fractured (327 frames); the collage of white bars, clustered rings, fractured, stacked balls, a straw hat and a reflective disc (432

Fig. 6 Still from the film *Ballet mécanique*, 1924, a scene with Katherine Hawley. Reproduced by kind permission of the British Film Institute, London

15 Léger, 'Note sur l'élément mécanique' (1923), reprinted in *Fonctions de la peinture*, p. 51; cited from the English translation, p. 29.

16 Léger described this contrast in a letter (written in English) to Alfred H. Barr Jr., 20 November 1943 (Archives of the Museum of Modern Art, New York), published in Herbert, *Lèger's 'Le Grand Déjeuner'*, p. 72.

17 On this, see Kenneth E. Silver's pioneering article, 'Purism: Straightening up after the Great War', *Artforum*, XV/7, March 1977, pp. 56-63, and his 1981 dissertation, revised and published in book form as *Esprit de corps: The Art of the Parisian Avant-garde and the First World War, 1914-1925*, Princeton and London, 1989. See also Christopher Green, *Cubism and its Enemies: Modern Movements and Relation in French Art, 1916-1928*, New Haven and London, 1987.

18 See Léger's remarks in a letter to Alfred H. Barr, Jr., written in response to Barr's queries regarding *Le Grand Déjeuner*, 20 November 1943, in Herbert, *Lèger's 'Le Grand Déjeuner'*, p. 72. A comparable inventory could describe Edouard Manet's *Déjeuner sur l'herbe*, the closest precedent for Léger's painting, though Léger's results are altogether different. Manet's *Déjeuner* is more clearly designed as a stage-set – foreground, middle ground, background – only the nude woman, Victorine Meurent, stares out and engages the beholder. On Meurent and the rediscovery of the identity of artists' models, see Eunice Lipton's groundbreaking study, *Alias Olympia: A Woman's Search for Manet's Notorious Model and her Own Desire*, New York, 1992.

19 For a detailed discussion of the making of *Ballet mécanique*, see my 'Bridging Purism and Surrealism: The Origins and Production of Fernand Léger's *Ballet Mécanique*', in *Dada and Surrealist Film*, ed. Rudolf E. Kuenzli, Iowa City, 1986.

20 Dudley Murphy, 'Murphy by Murphy', unpublished MS, January 1966 (now destroyed; formerly collection of Erin Murphy O'Hara, Malibu, California). The image of Katherine's bulging stomach is not present in any of the known versions of *Ballet mécanique*.

21 Léger, 'Autour de Ballet Mécanique', (c. 1924), reprinted in *Fonctions de le peinture*, p. 164; cited from the English translation, p. 48.

22 Ibid., pp. 164 and 167; cited from the translation, pp. 48-9 and 51.

23 See my 'L'Evénement d'objectivité plastique: Léger's Shift from the Mechanical to the Figurative, 1926-1933', in Nicholas Serota, ed., *Fernand Léger: The Later Years*, exhibition catalogue, Whitechapel Art Gallery, London, 1987, pp. 19-32.

frames); a spinning machine part (232 frames); a rapidly pumping piston (299 and 252 frames); a close-up shot of a machine in motion, prismatically fractured (448 and 263 frames); a washerwoman climbing stairs (414 and 423 frames); Kiki's face, prismatically fractured (278 and 174 frames); moving saucepan bottoms (200 frames); a large, bright circle (334 frames); a woman smelling some flowers (229 frames); and the Charlot-Chaplin marionette (560 frames).

Amid the rapid-fire sequences of abstract forms and ordinary objects it is the human figure that anchors the film. At the start of the film, Katherine Hawley (fig. 6), Murphy's wife, seen on a swing, unleashes a cacophony of more than fifty forms, each shown in two or three frames. The slow, monotonous rhythm of Katherine's swinging is a respite from the straw hats, triangles, circles, numbers, inverted chairs, typewriters, funnels and bottles that follow. The next passage in the film is introduced by the prolonged appearance of Kiki's lips, which alternates with straw hats and reels. Another passage with Katherine swinging precedes the appearance of Christmas decorations, followed by a torrent of corrugated sheets of metal, saucepans (pl./p. 191), alternating circles and triangles, and kitchen tools. The subsequent passage begins with close-ups of Kiki opening and closing her eyes, as well as a rotating piece of corrugated sheet metal, swinging to reveal a glimpse of Murphy, which prompts yet another series of corrugated sheets and circle-triangle montages. Kiki's eyes, mouth and face (fig. 7) are respites within this sea of rapid-fire, close up, essentially abstract imagery. The girl on a mechanical ride at an amusement park and the washerwoman ascending stairs serve a similar function.

Léger and Murphy clearly thought of human and inanimate elements in tandem, as Murphy's own notes make clear:

> I saw an old washerwoman climbing a flight of stone stairs. When she reached the top, she was tired and made a futile gesture. The scene itself was banal, but by printing it 20 times [sic] and connecting the end of the scene with the beginning of her climb, it expressed the futility of life because she never

got there. This scene in the editing followed a very intricate piece of shiny machinery, somehow correlated in movement and rhythm to that of her's.

> Another scene showed a tremendous piston, brilliant and shiny, plunging up and down in a very phallic movement. This was followed by the bulging stomach of Katherine, who was now pregnant.

> I was intrigued to do something with the artificial legs that exhibit silk stockings and decided to do a stop motion dance with these legs around a clock ...[20]

Léger very much sought this alternation of effects: 'elements of repose, distraction, and contrasts'.[21] His goal, however, was to engage an audience in altogether a different way than his paintings could, and he consciously experimented on his audiences with cinematic effects:

> To prove this, I once set a trap for some people. I filmed a woman's polished fingernail and blew it up a hundred times. I showed it. The surprised audience thought that they recognized a photograph of some planetary surface. I let them go on believing that, and after they had marvelled at this planetary effect and were talking about it, I told them: '*It is the thumbnail of the lady next to me.*' They went off feeling angry. I had proved to them that the subject or the object is nothing; it's the effect that counts: [... For example,] in The Woman Climbing the Stairs, I wanted to *amaze* the audience first, then make them uneasy and then push the adventure to the point of exasperation. In order to 'time' it properly, I got together a group of workers and people in the neighbourhood, and I studied the effect that was produced on them. In eight hours I learned what I wanted to know. Nearly all of them reacted at about the same time.[22]

In film, he could control timing, the juxtaposition of images, the order of their perception, the length of time that a viewer needed to remain in the room or cinema in order to see the entire film.

Of course, the real effect of *Ballet mécanique* on a contemporary public was negligible. It was shown in the small ciné-clubs in Paris, beginning in 1926; it had been screened previously at the Internationale Ausstellung

für Theatertechnik in Vienna in 1924. These were events for art cognoscenti, and were not widely advertised: screenings were rarely announced in any of the mainstream Paris newspapers or magazines in which most films were promoted.

Léger's efforts in *Ballet mécanique* crystallized a larger cinematic vision. He saw the potential of the large screen, the auditorium, the impact of scale. The film was the most clearly articulated form that his theory of contrasts – particularly the contrast between people and objects – took. He was, however, forced to acknowledge the limitations of theoretical, abstract imagery because of the limited response to his film. On the other hand, *Ballet mécanique* set in motion Léger's preoccupation, first with the close-up (apparent in his works from 1926 to *c.* 1933)[23] and then with the 'blow-up' (defining his work from the late 1930s until his death in 1955). His espoused desire to be one with the people, and yet his very deliberate but instinctive observation of the common man as something quite different from himself was linked to theoretical exercises and broad pronouncements. Once he had completed *Ballet mécanique*, his cinematic vision was the coalescence of all his earlier ideas about the power of imagery and the basis, too, for his work of the following decades. The realization of his cinematic vision became the gnawing ambition at the heart of all the major projects Léger was to undertake in later years.

Fig. 7 Still from the film *Ballet mécanique*, 1924, a scene with Kiki de Montparnasse. Reproduced by kind permission of the British Film Institute, London

Hartwig Fischer

'UN ART PLUS COMPLET': LÉGER AND THE BALLET

In 1913, in his first lecture at the Académie Wassilief in Paris, Léger presented his concept of modern art, an art that shared the aspirations of the great epochs of the past: It, too, strove to be effective on a large-scale, and it, too, would be the creation of the community rather than of the individual.[1] Painting, however, was no longer in a position to produce a public work of art – a 'complete and social work' – in collaboration with the other arts, for each art had isolated itself, confined itself to its own territory. 'Specialization is a modern characteristic, and pictorial art, like all other manifestations of human genius, must submit to its laws'.[2] In contrast to this conclusion, in May 1917 the poet and critic Guillaume Apollinaire claimed to have discovered a more comprehensive art, 'un art plus complet'. When the Ballets Russes performed Jean Cocteau's *Parade*, with sets by Picasso and music by Erik Satie, Apollinaire recognized in this alliance of painting and theatre the revelation of a new spirit. This, he believed, would transform art and morality and lead them to the summit of scientific progress.[3] A few years later Léger himself became involved in the theatre, designing the costumes, the curtains and the sets for two ballets.[4] Now, he too

spoke of the social responsibility of artists and the necessity of their working together.

During the years 1920-25 within the realm of modern dance in Europe, the productions of the Ballets Suédois competed with the splendid achievements of the Ballets Russes. In 1921, the founder and director of the Ballets Suédois, Rolf de Maré, commissioned Léger to design the set and costumes for the ballet *Skating-rink*, based on Ricciotto Canudo's poem *Skating-rink à Tabarin*: *Ballet aux patins* (The Skating-rink at Tabarin: Ballet for Skaters).[5] The plot is simple: men and women twirl around one other as they glide about the roller-skating rink of a big city. Suddenly the 'free man', the *Fou*, steps into their midst, provoking hostility in the men and passion in the women. One woman succumbs to him; the couple dance, oblivious to everything around them, until passion has consumed the woman's life. She collapses, the *Fou* carries her off, and the other figures continue skating as before. 'It is the drowsy melancholy of the pleasures of skating, the sort of intimate animality that one feels amongst the slow swaying of the working class couples,... in short, a synthesis of all the instincts.'[6] Léger was less interested in the symbolic content of Canudo's text than in the milieu in which the story is set. He saw in workers and 'simple people' the embodiment of man able to live as a matter of course in a world ruled by technology; and he found the model for his ballet in the working-class dance-halls that he began to frequent with de Maré and the choreographer Jean Börlin. The music for the ballet was commissioned from Arthur Honegger.

Léger divided both male and female dancers into two groups – workers and 'the fashionable' – and he outfitted them in colourful, sharply contrasting 'working-class costumes' and 'fantastical evening-dress' (pls./p. 159).[7] A high backdrop closed off the rear of the stage, leaving a semi-circular space for the dancers. The lower part of the backdrop constituted a calm background for the dance. Above this, however, two wide arcs, circles, rectangles and trapezoids, and the word 'RING', intersecting or superimposed, were assembled into a dynamically expressive pattern. The design was topped off above with a matching painted border (fig. 1;

1 Léger, 'Les origines de la peinture et sa valeur représentative' (1913), in *Fonctions de la peinture*, Paris, 1965, p. 16; English translation in *Functions of Painting*, London, 1973, p. 8.

2 Ibid., p. 19; English translation, p. 10.

3 G. Apollinaire, *Parade* (1917), reprinted in Apollinaire, *Œuvres en prose complètes*, II, Paris, 1991, p. 865; cited from English translation in L. C. Breunig, ed., *Apollinaire on Art*: *Essays and Reviews 1902-1918*, London, 1972, p. 452.

4 A considerable part of Léger's work for the Ballet Suédois is published in *Fernand Léger & Svenska Baletten, ur dansmuseets samlingar*, Stockholm, 1990. Among recent publications on the subject, the following are to be noted: L. Rosenstock, 1984; J. Freeman, 1985; B. Häger, 1989, 1990; G. Lista, in *Fernand Léger*, exh. cat., Villeneuve d'Ascq, 1990; and M. Kelkel, *La musique de ballet en France de la Belle Epoque aux années folles*, Paris 1992, pp. 175-216; for full details, see the Bibliography.

5 Published in *Mercure de France*, CXL, 15 May 1920, pp. 74-81.

6 De Maré cites these as Canudo's words in his essay 'Canudo'; undated typescript, Dansmuseet, Stockholm. I am grateful to Erik Näslund for his permission to examine the documents in the Dansmuseet collection, and to Thomas Skalm, the museum's archivist, for his help.

7 Léger to de Maré, 21 November 1921, reprinted in *Léger och Norden*, exhibition catalogue, Stockholm, Moderna Museet, 1992, p. 27ff.

8 There was a total of fifty performances of *Skating-rink* in Paris and on tour.

9 Cf. M. Raynal, 'Skating-rink', in *L'Esprit Nouveau* (Paris), no. 17, June 1922.

10 Cendrars to Léger, 29 October 1921; the MS is in the Musée Fernand Léger, Biot.

Fig. 1 *Skating-rink*, ballet first performed on 20 January 1922, at the Théâtre des Champs-Elysées, Paris, by the Ballet Suédois. Set and costumes designed by Léger; choreography by Jean Börlin; music by Arthur Honegger; based on a poem by Ricciotto Canudo

11 See Cendrars, *Œuvres complètes*, I, Paris, 1963.

12 Cendrars's revue *La Légende de la Création* was the highlight of the festivities that took place on 10 June 1919 at the Paris theatre Comédie des Champs-Elysées. Cendrars's MS is now in the collection of Miriam Cendrars, Paris. A printed programme can be found in the Fonds Cendrars, BNS, Berne. I am grateful to Miriam Cendrars for her permission to consult both archives, and to her and to Marius Michaud, curator at the Fonds Cendrars, for their kind assistance.

13 Hand-written revision of the revue from January 1922. Various versions of the *Ballett nègre* are in the collection of Miriam Cendrars, Paris.

14 Léger to de Maré, 12 September 1922, reprinted in *Léger och Norden*, p. 32.

15 Milhaud, *Ma vie heureuse*, Paris, 1973, p. 124.

16 In the collection of Miriam Cendrars, Paris, is a MS dated *'janvier 1923'* and inscribed with the note *'pour Milhaud'*. The myth that opens Cendrars's *Anthologie nègre* – in fact a literary amalgam of vari-

pl./p. 160). This arrangement and its dramatic effect immediately recalls the artist's large-scale canvases of this period, such as *La Ville* of 1919 (pl./p. 145) or *Le Grand Remorqueur* (The Large Tugboat) of 1923 (pl./p. 168). In the set design, as in the paintings, the composition is based on contrast, fragmentation and diversity, sturdiness, turbulence and openness. Movement here is not directed: it is, rather, ubiquitous and reversible. The set design virtually absorbs the space and the time within the plot, and the dancers become part of the picture. The curtain itself introduces this situation: its bustling, fragmented figures that mingle with non-representational forms are, at the same time, elements of an abstract design (pl./p. 158). It appears that Börlin had conceived the choreography in accordance with this design, but was forced to alter his plans when, a few weeks before the scheduled opening date, he received the score from Honegger and found that the composer had supplied one that was both heavy and measured. Through slowing the dancers' movements, the ballet lost the lively unity achieved in the collaboration of painter and choreographer. *Skating-rink* was performed in Paris on 20 January 1922.[8]

It is evident that Léger had wanted to integrate the dancers into his set as an objective

component; but he was forced to recognize that it was precisely the dancers' expressive value as human beings that prevented this.[9] In his work for a second ballet, however, he evolved a striking solution to this problem. While still working on *Skating-rink*, Léger suggested to de Maré that they collaborate on a new project, along with the poet Blaise Cendrars. In response to the proposal then put to him, Cendrars wrote to Léger: 'Tell de Maré that I have ready two subjects for African ballets; that I am prepared to collaborate with you on a long and ambitious work, very serious, very difficult, very modern, that will set its mark on the age.'[10] This first contact led in the end to their collaboration on the ballet *Le Création du monde*.

In his own work as a painter, Léger had never explicitly dealt with 'primitive' art, and certainly not African sculpture. His interest was directed towards the 'primitive in modernity', daily life in the 'wilderness' of the technological world. Cendrars, on the other hand, had started collecting African myths after the Great War, publishing them in 1921 as *Anthologie nègre* (translated in 1927 as *The African Saga*).[11] In 1919 he had transformed the 'Legend of Creation' that opened the anthology into a dance revue for the *Fête nègre* organized by the gallery owner Paul Guillaume.[12] Without altering the sequence of tales and dances, Cendrars now reworked his manuscript to serve as the basis for a *Ballet nègre*.[13]

The collaboration between Léger, Cendrars and Börlin got underway in the late summer of 1922, and Léger's ideas for the project proved decisive. In September 1922 he wrote to de Maré: 'You know, we're determined to make an important work, the product of extreme deliberation, down to the last detail.'[14] At the end of 1922 de Maré commissioned the composer Darius Milhaud to provide the score. Milhaud, who had just returned from a visit to New York, where he had been studying jazz in Harlem, believed he could detect in jazz the music of Africa; and he now used it as the basis for his sophisticated and witty composition: 'I put my orchestra together like the jazz-bands in Harlem with seventeen soloists, and I used the jazz style without restraint, mixing it with classical feeling.'[15] In January 1923 Cen-

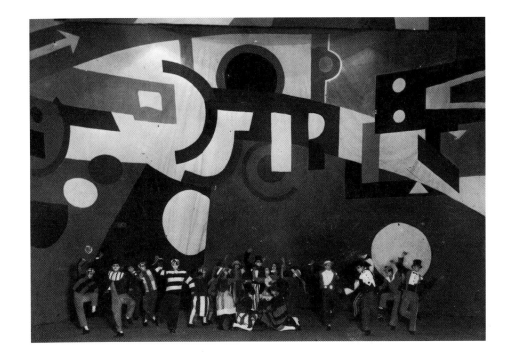

drars condensed the story into the act of the Creation,[16] and so achieved a unified character for the set and the action: after earnest deliberation, the three gods Nzame, Mebérè and N'kva create the plants and the trees, the animals, insects, birds and apes, the large fetishes, the magicians and, finally, man and woman. The creation ends in the ecstatic round-dance of procreation that in turn gives way to a resolved finale: 'The couple stand apart in an embrace that lifts them up like a wave. Spring has arrived.'[17]

Léger did, indeed, now begin to study certain works of African art for the design of the costumes and the set;[18] but, from the start, he freely adapted his models so as to accommodate the ballet's requirements.[19] 'We created an African drama. Everything in it was transposed', he said after the work had been completed.[20] The set presented a landscape, unfolding in several layers down to the front of the stage. On the backcloth, two peaks were to be seen rearing up into a deep blue sky (fig. 2). Clouds, stars and the moon were painted on a moveable border, and their positions gradually changed during the performance. The stylized mountains and hills, rendered in brown, ochre, grey, black and white, and modelled with a few gradations of tone, were carried through to the side-drops and on diagonally positioned wings, while the blue sky was extended towards the audience on two additional upper borders. For the basically traditional, decorative elements of the proscenium stage, Léger utilized the essential compositional elements of his paintings: fracturing, gradation and layering, with marked breaks and dislocations. The figures, aligned in strict frontality in relation to the audience, thus inhabited a scenic space defined within a clearly separate, abstract frame, almost in the manner of a *tableau vivant*. At the rear, directly in front of the landscape backdrop, rose the mighty figures of the gods, five to six metres in height. These, painted on cut-outs, were moved by means of cords. In front of the gods were the eight magicians and the fetishes. Two tall figures on stilts, as well as all the animals and the man and woman, appeared in pairs (pl./p. 162). As in the landscape, the colours brown, ochre, black and white dominated in the figures' cos-

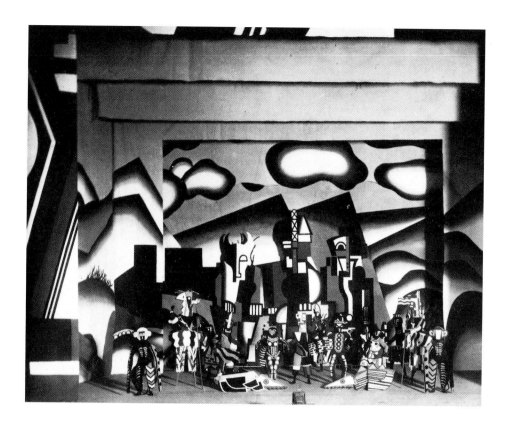

tumes, while the animals stood out by means of their bright colouring. The organic forms of the bodies and faces of the dancers were disguised by masks and stylized decoration, which were strictly frontal in orientation. This de-individualizing of the dancers increased the expressive value of the figures within the overall picture, while the personality of each performing artist no longer comes to the fore.

Börlin did not keep a record of his choreography, and other sources, except for brief descriptions in newspaper reviews, have thus far not been recovered. Our knowledge of the details of the performance is, therefore, limited. After the overture the curtain rose (pl./p. 163) to reveal a dark stage, on which light was slowly introduced. At the start, the gods remained still, one next to the other; but, as the action got underway they began to move, maintaining irregular, expressively asymmetrical groupings. In front of them a confused mass of bodies slowly came to life and took on a more organized form, until finally man and woman emerged. The stage directions called for a slow, rhythmic movement with occasional livelier passages. The overall mood remained solemn and ceremonial so as to emphasize the

Fig. 2 *La Création du monde* (The Creation of the World), ballet first performed on 25 October 1923, at the Théâtre des Champs-Elysées, Paris, by the Ballets Suédois. Set, costumes and curtains designed by Léger; choreography by Jean Börlin; music by Darius Milhaud; adapted by Blaises Cendrars from his own text

ous myths – tells of the creation of the world and of the first human being, of his pride and fall, of the subsequent destruction and recreation of the world and finally of the creation of man and woman and the establishment of law and order.

17 Cendrars, *La Création du monde: Le Scénario*, cited in B. Häger, *Les Ballet Suédois*, Paris, 1989, p. 190; here cited from the English translation in *Ballet Suédois*, London, 1990, p. 190. The resolved finale is still missing in the version that Milhaud received in January 1923.

18 Guided, above all, by pertinent publications such as Carl Einstein's *Negerplastik*, Berlin, 1915, and Marius de Zayas's *African Negro Art: Its Influence on Modern Art*, New York, 1916.

19 Cf. the preparatory drawings in *Fernand Léger: Gouaches et dessins de 1921 à 1938*, exhibition catalogue, Galerie d'Art Moderne, Basle, 1964, nos. 2 and 4; and in *Fernand Léger & Svenska Baletten*, p. 33.

20 Léger, 'L'esthétique de la machine, l'ordre géométrique et le vrai' (1923), reprinted in *Fonctions de la peinture*, p. 64; adapted from the English translation, p. 63.

21 Cendrars and Léger, 'Notes sur la réglementation de la mise en scène', in Häger, *Les Ballets Suédois*, p. 190; cited from the English translation, p. 190. On two sheets of the MS (collection of Miriam Cendrars), Cendrars noted by hand the intensity, colouring and positioning of the lighting.

22 In all, *La Création de monde* was performed in Paris eleven times. Paul Morand later recalled the significance of the ballet for Léger's art: 'Léger has always had a harder life than the other great artists of his generation ... he never knew how to capture the audience ... But then came the Ballet Suédois: as soon as I smiled, the Parision audience smiled back. Constructions like these had never before been seen on the stage.... Léger himself achieved a more humane conception of life.' P. Morand, 'Le dévelopement de Léger', in *Sélection* (Antwerp), VIII/5 February 1929, p. II.

23 Léger, 'Les réalisations picturales actuelles' (1914), in *Fonctions de la peinture*, p. 21; cited from the English translation, p. 12.

24 Léger, 'Le spectacle: lumière, couleur, image mobile, object-spectacle' (1924), 'Le ballet-spectacle, l'objet-spectacle' (1925), both in *Fonctions de la peinture*, pp. 131-43 and 144-46 respectively; English translation, pp. 35-47 and 71-73 respectively.

25 J. Epstein, 'Fernand Léger' (1923), reprinted in Epstein, *Ecrits sur le cinéma*, I, Paris, 1974, p. 116.

26 Léger, 'Les origines de la peinture et sa valeur représentative', p. 19; cited from the translation, p. 10.

27 Léger, 'Kurzgefaßte Auseinandersetzung über das aktuelle künstlerische Sein' in *Das Kunstblatt* (Berlin), VII/1, January 1923. According to R. Garaudy, *Pour un réalisme du XXe siècle*, Paris, 1968, p. 18, Léger wrote this text in 1920. The text appeared in French in *7 Arts*, no. 20, 15 March, 1923, n. p. and with the dates 1920-22.

28 Léger did not implement his plan for a third ballet. See his letters of 1923 to Raynal, reprinted in *Léger och Norden*, p. 36 ff.

29 *L'Esprit Nouveau* (Paris), no. 19, 18 November 1923.

30 Léger, 'Le spectacle: lumiére, couleur, image mobile, object-spectacle', p. 143; cited from the translation, p. 47.

grandiose, dramatic character of the Creation. These directions also stipulated the following: 'Mobile stage lighting intermittent (chiaroscuro effects), partial lighting (avoid total lighting). Continuous mobility of stage via displacement of mobile sets and real or fictitious characters'.[21] *La Création du monde* had its first performance in Paris on 25 October 1923.[22]

In contrast to *Skating-rink*, the set design for *La Création du monde* integrated the scenic action within itself. Alongside the gradual transformations of the sky, the moving figures introduced the dynamism into the picture. Léger was, in fact, less concerned with the 'African creation' than with the immediate, direct significance of the scenic action: the spectator of the ballet was confronted with a monumental picture, whose movement and modification represented its own formation. *La Création* is the genesis of the picture as a dramatic, poetic event.

This conception of a work for the stage ultimately has its roots in the understanding of the picture that Léger had already started to evolve before the Great War, and that he had defined in his first two lectures, of 1913 and 1914, as 'conceptual realism'. Léger called this type of picture 'a plastic means of life and movement'.[23] The dramatic encounter between the public and this picture constituted the real action of his ballet. Léger gave the term *spectacle* to the emergence of the picture on the stage and the public's confrontation with it. He developed his concept of this form of staged action in two essays published in connection with his work for the theatre:[24] in the frenzied life of the big city, the question arises – 'What can the artist do to conquer his public?' He should, Léger answered, make use of everything that surrounds him – things, movement, events – yet transforming them and binding them together into one astonishing scenic unity. The *spectacle* imposes itself upon the audience when the stage is radically differentiated from the auditorium, but with the distance between them reduced to a minimum. Both objects and people then possess an exclusively plastic value. Léger spoke of 'the stage of total and precise invention'. The aim of the *spectacle* is to confront the spectator, a

confrontation that is an invocation of the powers that man needs in order to stand his ground in the modern world. The primitivism of the 'drame africain' is here 'transposed' into a 'poetic provocation, a magical invocation to the intimate art of the spectator', as the film director Jean Epstein described the effect of Léger's paintings.[25]

Before the Great War, Léger had already noted the isolation of individual art forms. But the power that the isolated painting developed as the 'total expression of a new generation',[26] and a 'plastic means of dealing with life' forced the artist to return to the 'complete and social [public] work'. On the other hand, the overwhelming developments of modern life demanded from the artist – and he could not, would not, refrain from answering this demand – a 'constant social anxiety and responsibility'. Ultimately, then, Léger was not concerned with the question of how artists might win over their public, but rather that of how the work of art might influence people's lives. In a 'Brief Consideration of Contemporary Artistic Existence', published in 1920, Léger spoke for the first time of 'colour as a social effect' and of a 'sculptural organization of cities'.[27] Léger's designs for the stage are part of this general tendency in his thinking, but they immediately led him beyond the limited 'public' world of the theatre.[28] The same issue of the journal *L'Esprit Nouveau* that published his designs for *La Création du monde* also included his conversation with the architect Le Corbusier about the relation between painting and architecture.[29] In Léger's view, it was not the theatre but the collaboration between the visual arts, architecture and town-planning that was the appropriate means of shaping modern life. His essay on the *spectacle* concludes, in fact, with the prediction of an *artistically organized world*: 'A society without frenzy; calm, ordered, knowing how to live naturally within the Beautiful without exclamation or romanticism. That is where we are now going in all simplicity.'[30]

Checklist of Exhibited Works

The numbers prefaced 'B' refer to Georges Bauquier's *Catalogue raisonné* of Léger's painted *œuvre* (vols. I-III). For full publication details see the Bibliography on pp. 249-53.

Paintings

1 *page 79*
La Noce (The Wedding) 1910-11
oil on canvas, 257 x 206 cm
Musée National d'Art Moderne, Centre Georges Pompidou, Paris,
Bequest of Alfred Flechtheim, 1937
B 23

2 *page 82*
Les Fumeurs (The Smokers) December 1911-January 1912
oil on canvas, 129.2 x 96.5 cm
Solomon R. Guggenheim Museum, New York,
Gift of Solomon R. Guggenheim, 1938
B 21 [exh. Basle]

3 *page 81*
La Fumée (Smoke) 1912
oil on canvas, 92 x 73 cm
Albright-Knox Art Gallery, Buffalo, New York, Room of Contemporary Art Fund, 1940
B 34

4 *page 86*
Le Passage à niveau (Railway-crossing) 1912
oil on canvas, 92 x 73 cm
Beyeler Collection, Basle
B 36

5 *page 87*
La Femme en bleu (Woman in Blue) 1912
oil on canvas, 193 x 130 cm
Öffentliche Kunstsammlung Basel, Kunstmuseum, Basle,
Gift of Dr h. c. Raoul La Roche, 1952
B 39 [exh. Basle]

6 *page 83*
Paysage (Landscape) 1912-13
oil on canvas, 92 x 81 cm
Österreichische Galerie im Schloss Belvedere, Vienna

7 *page 85*
Modèle nu dans l'atelier (Nude Model in the Studio) 1912-13
oil on burlap, 127.8 x 95.7 cm
Solomon R. Guggenheim Museum, New York
B 40 [exh. Basle]

8 *page 93*
Contraste de formes (Contrast of Forms) 1913
oil on canvas, 81 x 65 cm
Beyeler Collection, Basle
B 49 [exh. Basle]

9 *page 91*
Contraste de formes (Contrast of Forms) 1913
oil on canvas, 100 x 81 cm
The Museum of Modern Art, New York,
The Philip L. Goodwin Collection
B 53 [exh. Basle]

10 *page 90*
Eléments géométriques (Geometric Elements) 1913
oil on canvas, 81 x 100 cm
Staatsgalerie, Stuttgart
B 57

11 *page 101*
La Femme au fauteuil (Woman in an Armchair) 1913
oil on canvas, 129.5 x 97 cm
Beyeler Collection, Basle
B 61

12 *page 106*
L'Escalier (The Staircase) 1913
oil on canvas, 144 x 118 cm
Kunsthaus Zürich
B 63 [exh. Basle]

13 *page 98*
Les Maisons dans les arbres (Houses among the Trees) 1913
oil on canvas, 73 x 92 cm
Sara and Moshe Mayer Collection
B 64 [exh. Basle]

14 *page 97*
La Maison sous les arbres (House among the Trees) 1913
oil on canvas, 92.1 x 73 cm
Private collection
B 65

15 *page 96*
Contraste de formes (Contrast of Forms) 1914
oil on canvas, 61 x 50 cm
Beyeler Collection, Basle
B 67

16 *page 92*
Contraste de formes (Contrast of Forms) 1914
oil on canvas, 80.7 x 65.2 cm
Kunstsammlung Nordrhein-Westfalen, Düsseldorf
B 68

17 *page 112*
Nature morte aux cylindres colorés (Still-life with Coloured Cylinders) 1913-14
oil on canvas, 90 x 72 cm
Beyeler Collection, Basle
B 82

18 *page 109*
La Femme assise (Seated Woman) 1914
oil on canvas, 100.1 x 81 cm
Private collection, New York
B 85 [exh. Basle]

19 *page 103*
L'Escalier (The Staircase) 1914
oil on canvas, 81 x 100 cm
Öffentliche Kunstsammlung Basel, Kunstmuseum, Basle,
Gift of Dr h. c. Raoul La Roche, 1952
B 69

20 *page 107*
L'Escalier (The Staircase) 1914
oil on canvas, 144.5 x 93.5 cm
Moderna Museet, Stockholm
B 71 [exh. Basle]

21 *page 105*
Le Balcon (The Balcony) 1914
oil on canvas, 130 x 97 cm
Kunstmuseum Winterthur, Bequest of Clara and Emil Friedrich-Jezler, 1973
B 72

22 *page 108*
La Sortie des Ballets Russes (Exit the Ballets Russes) 1914
oil on canvas, 136.5 x 100.3 cm
The Museum of Modern Art, New York, Gift of Mr and Mrs Peter A. Rübel (partly by exchange)
B 73

23 *page 99*
Les Maisons dans les arbres, Paysage No. 3 (Houses among the Trees, Landscape No. 3) 1914
oil on canvas, 130 x 97 cm
Öffentliche Kunstsammlung Basel, Kunstmuseum, Basle,
Gift of Dr h. c. Raoul La Roche, 1952
B 75

24 *page 110*
Nature morte (Still-life) 1914
oil on canvas, 100 x 81 cm
Kunstmuseum Winterthur, Bequest of Clara and Emil Friedrich-Jezler, 1973
B 89 [exh. Basle]

25 *page 117*
Les Chevaux d'artillerie (Artillery Horses) 1915
oil and pasted paper on wood, 32 x 50 cm
Private collection
B 96

26 *page 116*
La Preuve que l'homme descend du singe (Proof that Man Descends from the Apes) 1915
oil on canvas, 80 x 50 cm
Private collection, Zurich
B 99

27 *page 115*
Le Soldat à la pipe (Soldier with a Pipe) 1916
oil on canvas, 130 x 97 cm
Kunstsammlung Nordrhein-Westfalen, Düsseldorf
B 100 [exh. Basle]

28 *page 119*
La Partie de cartes (The Card Game) 1917
oil on canvas, 129 x 193 cm
Kröller-Müller Museum, Otterlo
B 102

29 *page 134*
Composition 1918
oil on canvas, 146 x 114 cm
Pushkin Museum of Fine Arts, Moscow
B 107

30 *page 156*
Le Cirque (The Circus) 1918
oil on canvas, 58 x 94.5 cm
Musée National d'Art Moderne, Centre Georges Pompidou, Paris, Bequest of Baroness Gourgaud, 1965
B 109

31 *page 157*
Les Acrobates dans le cirque (Circus Acrobats) 1918
oil on canvas, 97 x 117 cm
Öffentliche Kunstsammlung Basel, Kunstmuseum, Basle,
Gift of Dr h. c. Raoul La Roche, 1952
B 111 [exh. Basle]

32 *page 155*
Les Deux Acrobates (Two Acrobats) 1918
oil on canvas, 89 x 60 cm
Private collection
B 113 [exh. Basle]

33 *page 123*
Les Hélices, deuxième état (Propellers, second version)
1918
oil on canvas, 81 x 65 cm
The Museum of Modern Art, New York, Bequest of
Katherine S. Dreier
B 120 [exh. Wolfsburg]

34 *page 124*
Le Poêle (The Stove) April 1918
oil on canvas, 61 x 50.1 cm
Solomon R. Guggenheim Museum, New York, Gift of
Solomon R. Guggenheim, 1938
B 122

35 *page 122*
Contraste de formes (Contrast of Forms) 1918
oil on canvas, 41 x 26 cm
Musée d'Art Moderne de la Ville de Paris
B 124 [exh. Wolfsburg]

36 *page 130*
Nature morte aux éléments mécaniques
(Still-life with Mechanical Elements) 1918
oil on canvas, 70 x 49.5 cm
Eppinghoven Collection
B 127

37 *page 138*
Composition: Le Disque (Composition: Disc) 1918
oil on canvas, 65 x 54 cm
Fundación Colección Thyssen-Bornemisza, Madrid
B 145 [exh. Basle]

38 *page 137*
Les Disques (Discs) 1918
oil on canvas, 240 x 190 cm
Musée d'Art Moderne de la Ville de Paris
B 149 [exh. Basle]

39 *page 139*
Les Disques (Discs) 1918-19
oil on canvas, 128 x 99 cm
Los Angeles County Museum of Art, Bequest of
David E. Bright
B 148

40 *page 140*
Deux Disques dans la ville (Two Discs in the City) 1919
oil on canvas, 65 x 54 cm
Private collection, Switzerland
B 156

41 *page 142*
La Ville, fragment, étudie, premier état (The City, frag-
ment, study, first version) 1919
oil on canvas, 55 x 46 cm
Private collection
B 157

42 *page 145*
La Ville (The City) 1919
oil on canvas, 231 x 298.5 cm
Philadelphia Museum of Art, A. E. Gallatin Collection
B 163

43 *page 141*
Les Hommes dans la ville, état definitif (Men in the City,
final version) 1919
oil on canvas, 146 x 113 cm
Peggy Guggenheim Collection, Venice, Solomon
R. Guggenheim Foundation
B 165 [exh. Basle]

44 *page 131*
Composition 1919
oil on canvas, 81 x 65 cm
Hester Diamond
B 174

45 *page 143*
Le Passage à niveau, état définitif (Railway-crossing,
final version) 1919
oil on canvas, 97 x 130 cm
Private collection
B 182

46 *page 125*
Nature morte (Still-life) 1919
oil on canvas, 117 x 85 cm
Sam and Ayala Zacks Collection
B 185

47 *page 126*
Eléments mécaniques (Mechanical Elements) 1919
oil on canvas, 92 x 73 cm
Private collection
B 187 [exh. Basle]

48 *page 132*
Le Typographe, deuxième état (The Typographer,
second version) 1919
oil on canvas, 81 x 65 cm
Bayerische Staatsgemäldesammlungen München,
Staatsgalerie moderner Kunst, Munich, Lent by
Galerie-Verein e. V.
B 188 [exh. Basle]

49 *page 133*
Le Typographe (The Typographer) 1919
oil on canvas, 132.6 x 99 cm
Philadelphia Museum of Art, Louise and Walter Arensberg
Collection
B 190

50 *page 142*
La Roue rouge: Les Elements mécaniques
(The Red Wheel: Mechanical Elements) 1919-20
oil on canvas, 60.3 x 73.4 cm
Kimbell Art Museum, Fort Worth, Texas
B 231

51 *page 146*
L'Homme à la pipe (Man with a Pipe) 1920
oil on canvas, 130.5 x 97 cm
Private collection
B 202

52 *page 143*
Les Trois Personnages (Three People) 1920
oil on canvas, 65 x 92 cm
Courtesy Galerie Beyeler, Basle
B 207

53 *page 150*
L'Homme à la canne (Man with a Cane) 1920
oil on canvas, 92.1 x 64.8 cm
The Museum of Fine Arts, Houston, Gift of
Mrs Charles W. Engelhard
B 212

54 *page 149*
Les Trois Camarades (Three Comrades) 1920
oil on canvas, 92 x 73 cm
Stedelijk Museum, Amsterdam
B 214

55 *page 151*
Les Femmes à la toilette, deuxième état (Women at their
Toilet, second version) 1920
oil on canvas, 92 x 73 cm
Courtesy Galerie Beyeler, Basle
B 223

56 *page 127*
Composition 1920
oil on canvas, 65 x 54 cm
Kunstmuseum Winterthur, Extended loan from the
Volkart Stiftung, 1960
B 238

57 *page 176*
Les Trois Femmes à la nature morte (Three Women
with a Still-life) 1920
oil on canvas, 73 x 92.1 cm
Dallas Museum of Art, Foundation for the Arts Collec-
tion, Gift of the James H. and Lillian Clark Foundation
B 245

58 *page 173*
Les Deux Femmes et la nature morte, premier état
(Two Women and a Still-life, first version) 1920
oil on canvas, 54 x 65 cm
Kunstmuseum Winterthur, Bequest of Clara and
Emil Friedrich-Jezler, 1973
B 246

59 *page 173*
Les Deux Femmes et la nature morte, deuxième état
(Two Women and a Still-life, second version) 1920
oil on canvas, 73 x 92 cm
Von der Heydt-Museum, Wuppertal
B 247

60 *page 175*
Les Deux Femmes à la toilette, état définitif
(Two Women at their Toilet, final version) 1920
oil on canvas, 92 x 60 cm
Private collection
B 248

61 *page 171*
Le Mécanicien (The Mechanic) 1920
oil on canvas, 115.5 x 88.5 cm
National Gallery of Canada, Ottawa
B 254

62 *page 167*
Le Pont du remorqueur (The Tugboat Bridge) 1920
oil on canvas, 96.5 x 130 cm
Musée National d'Art Moderne, Centre Georges
Pompidou, Paris, Bequest of Baroness Gourgaud, 1965
B 256

63 *page 166*
Paysage animé, premier état (Animated Landscape, first version) 1921
oil on canvas, 65 x 50.5 cm
Private collection, Monte Carlo
B 269

64 *page 152*
Les Trois Figures (Three Figures) 1921
oil on canvas, 92 x 73 cm
Kunstmuseum Solothurn, Josef Müller-Stiftung
B 288

65 *page 153*
Homme et femme (Man and Woman) 1921
oil on canvas, 65 x 54 cm
Private collection, Courtesy Gallery Jan Krugier, Geneva
B 289 [exh. Basle]

66 *page 174*
Femme et nature morte, état définitif (Woman with Still-life, final version) 1921
oil on canvas, 65.5 x 92 cm
Scottish National Gallery of Modern Art, Edinburgh
B 302

67 *page 177*
Le Petit Déjeuner (Breakfast) 1921
oil on canvas, 102 x 135 cm
Private collection, Monte Carlo
B 310

68 *page 178*
Nature morte à la chope, état définitif (Still-life with a Beer-mug, final version) 1921
oil on canvas, 92.1 x 60 cm
Tate Gallery, London, Purchased with assistance from the Friends of the Tate Gallery, 1976
B 314

69 *page 181*
La Femme et l'enfant (Woman and Child) 1922
oil on canvas, 171 x 241.5 cm
Öffentliche Kunstsammlung Basel, Kunstmuseum, Basle, Gift of Dr h.c. Raoul La Roche, 1956
B 335 [exh. Basle]

70 *page 179*
Nature morte (Still-life) 1922
oil on canvas, 65 x 50 cm
Kunstmuseum, Berne, Hermann und Margrit Rupf-Stiftung
B 338

71 *page 168*
Le Grand Remorqueur (The Large Tugboat) 1923
oil on canvas, 125 x 190 cm
Musée National Fernand Léger, Gift of Nadia Léger and Georges Bauquier
B 348

72 *page 182*
Le Compotier de poires (The Dish of Pears) 1923
oil on canvas, 79 x 98 cm
Museu de Arte de São Paulo, Assis Chateaubriand, São Paulo
B 354

73 *page 129*
Les Eléments mécaniques (Mechanical Elements) 1918-23
oil on canvas, 211 x 167.5 cm
Öffentliche Kunstsammlung Basel, Kunstmuseum, Basle, Gift of Dr h.c. Raoul La Roche, 1956
B 356

74 *page 184*
Les Deux Figures, Nus sur fond rouge (Two Figures on a Red Background) 1923
oil on canvas, 146 x 98 cm
Öffentliche Kunstsammlung Basel, Kunstmuseum, Basle, Gift of Dr h.c. Raoul La Roche, 1963
B 357

75 *page 186*
Les Trois Personnages (Three Figures) 1924
oil on canvas, 129.5 x 129.5 cm
Private collection, Switzerland
B 358 [exh. Basle]

76 *page 183*
La Femme au compotier (Woman with Fruit-dish) 1924
oil on canvas, 89 x 115 cm
Private collection, Switzerland
B 360 [exh. Basle]

77 *page 190*
Elément mécanique, premier état (Mechanical Element, first version) 1924
oil on canvas, 64.8 x 50.8 cm
Smith College Museum of Art, Northampton, Massachusetts, Purchased with Joseph Brummer Fund, 1954
B 368

78 *page 189*
Elément mécanique, état définitif (Mechanical Element, final version) 1924
oil on canvas, 146 x 97 cm
Musée National d'Art Moderne, Centre Georges Pompidou, Paris, Bequest of Baroness Gourgaud, 1965
B 370

79 *page 185*
Femme tenant un vase (Woman Holding a Vase) 1924-27
oil on canvas, 131 x 89.5 cm
Öffentliche Kunstsammlung Basel, Kunstmuseum, Basle, Gift of Dr h.c. Raoul La Roche, 1963
B 527 [exh. Basle]

Works on Paper, 1910-14

80 *page 80*
La Fumée (Smoke) 1910-12
gouache on paper, 64 x 49 cm
Stedelijk Museum, Amsterdam

81 *page 94*
Contraste de formes (Contrast of Forms) 1912
gouache on paper, 49.7 x 63 cm
Ulmer Museum, Ulm

82 *page 84*
Nu dans l'atelier (Nude in the Studio) 1912
oil, ink and gouache on paper, mounted on board, 61 x 50 cm
Musée National d'Art Moderne, Centre Georges Pompidou, Paris, Gift of Louise and Michel Leiris, 1984

83 *page 84*
Etude pour 'Modèle nu dans l'atelier' (Study for 'Nude Model in the Studio'), 1912-13
gouache and Indian ink on paper, 62.2 x 47 cm
The Alex Hillman Family Foundation Collection

84 *page 102*
Dessin pour 'La Femme en rouge et vert' (Drawing for 'Woman in Red and Green') 1913
gouache and Indian ink on paper, 65 x 50 cm
Musée National d'Art Moderne, Centre Georges Pompidou, Paris, Gift of Louise and Michel Leiris, 1984

85 *page 80*
Fumées sur les toits (Smoke above the Roofs) 1913
brush and pen in black over pencil on browned paper, mounted on cardboard, 61.2 x 43.2 cm
Graphische Sammlung, Staatsgalerie Stuttgart

86 *page 102*
Deux Femmes couchées (Two Reclining Women) 1913
gouache and charcoal on paper, 50.2 x 65.1 cm
The Metropolitan Museum of Art, New York, Gift of Mr and Mrs William R. Acquavella, 1986

87 *page 94*
Contraste de formes (Contrast of Forms) 1913
gouache on paper, 44.8 x 54.2 cm
A. Rosengart Collection

88 *page 104*
Figures descendant un escalier (Figures Descending a Staircase) 1913
gouache on paper, 50.5 x 38.5 cm
Dr Peter Nathan, Zurich

89 *page 95*
Contraste de formes (Contrast of Forms) 1913
gouache on paper, 50 x 36.3 cm
The Menil Collection, Houston

90 *page 104*
Etude pour 'L'Escalier' (Study for 'The Staircase') 1913
gouache and oil on paper, 48 x 63 cm
Private collection

91 *page 111*
Nature morte (Still-life) 1913
gouache and oil on paper, 47.7 x 59.3 cm
Private collection

92 *page 111*
Nature morte sur une table (Still-life on a Table) 1914
gouache and charcoal on paper, 64.8 x 49.5 cm
The Metropolitan Museum of Art, New York, Gift of
Mr and Mrs William R. Acquavella, 1986

Theatre and Costume Designs, Film

93-106 *pages 158-60*
Designs for *Skating-rink* 1921
Watercolour on paper
Dansmuseet/Dance Museum, Stockholm

93
Sketch of backdrop
29 x 59 cm
not illustrated [exh. Basle]

94 *page 158*
Sketch of curtain
40.5 x 48 cm [exh. Basle]

95 *page 160*
Sketch of scenery
22 x 30 cm [exh. Basle]

96
Costume design: woman in red and brown
24 x 16 cm
not illustrated

97
Costume design: man with hat, in green and brown
22.5 x 14.5
not illustrated

98
Costume design: man with hat, in yellow,
brown and blue
22.5 x 14.8 cm
not illustrated

99 *page 159*
Costume design: woman in blue, red and yellow
22.5 x 14.5 cm

100
Costume design: woman in yellow and dark red
23 x 15 cm
not illustrated

101
Costume design: man with top hat in blue
24.5 x 15 cm
not illustrated

102
Costume design: woman in check skirt
25 x 16 cm
not illustrated [exh. Basle]

103 *page 159*
'Fou': costume design for Jean Börlin
30 x 18 cm [exh. Basle]

104
Costume design: woman with hat, in yellow,
red and orange
23 x 13 cm
not illustrated [exh. Basle]

105
Costume design: man with moustache, in green,
brown and black
22 x 15 cm
not illustrated

106 *page 159*
Costume design: sailor in blue and red
25 x 17 cm [exh. Basle]

107-28 *pages 161-3*
Designs for *La Création du monde* 1923
Watercolour on paper
Dansmuseet/Dance Museum, Stockholm

107 *page 161*
Sketch of curtain
41 x 52 cm [exh. Basle]

108
Sketch of backdrop
41 x 54 cm
not illustrated [exh. Basle]

109 *page 163*
Sketch of the stage with three gods
42 x 63 cm [exh. Basle]

110
Costume design: human figure (sorcerer)
28 x 15.2 cm
not illustrated [exh. Basle]

111
Sketch of god
37 x 19.5 cm
not illustrated [exh. Basle]

112
Sketch of god
37 x 19.5 cm
not illustrated [exh. Basle]

113
Costume design: man
42 x 24 cm
not illustrated [exh. Basle]

114
Costume design: woman
43 x 25 cm
not illustrated [exh. Basle]

115
Sketch of ape
34.5 x 19 cm
not illustrated [exh. Basle]

116 *page 162*
Sketch of ape
30 x 17 cm

117
Sketch of beetle
15 x 25 cm
not illustrated

118
Sketch of beetle (archaic being)
14 x 28.5 cm
not illustrated [exh. Wolfsburg]

119
Costume design: human figure (sorcerer)
27.7 x 17 cm
not illustrated [exh. Basle]

120
Costume design: human figure (sorcerer)
26.8 x 17 cm
not illustrated [exh. Wolfsburg]

121 *page 162*
Sketch of large figure
44 x 24 cm [exh. Basle]

122
Sketch of fetish (figure study)
32.5 x 11.5 cm
not illustrated [exh. Basle]

123
Sketch of fetish (figure study)
32.5 x 11.5 cm
not illustrated [exh. Basle]

124 *page 162*
Sketch of fetish (figure study)
35 x 12 cm [exh. Wolfsburg]

125
Sketch of fetish (figure study)
43.5 x 28.5 cm
not illustrated [exh. Basle]

126
Sketch of bird
31 x 22 cm
not illustrated [exh. Basle]

127
Sketch of bird
34 x 22.7 cm
not illustrated [exh. Basle]

128 *page 162*
Sketch of bird
30 x 21 cm [exh. Wolfsburg]

129 *pages 191-3*
Ballet mécanique (Mechanical Ballet), film 1924
Silent film in black and white
In collaboration with cameraman Dudley Murphy, and
with Man Ray. Music by George Antheil

130 *black-and-white illustration on page 46*
L'Escalier, deuxième état (The Staircase,
second version) 1914
oil on canvas, 88 x 124.5 cm
Fundación Colección Thyssen-Bornemisza, Madrid
B 70 [exh. Basle]

Exhibitions, 1911-1924

Unless otherwise specified, Léger was represented with only a few works at each group exhibition.

1911

Paris *Salon des Indépendants:* Société des Artistes Indépendants; 27th exhibition. Quai d'Orsay, Pont de l'Alma: 21 April - 13 June
Brussels *Salon des Indépendants:* VIIIe Salon annuel du Cercle d'Art 'Les Indépendants'. Musée Moderne de Bruxelles: 10 June - 3 July
Paris *Salon d'Automne:* Société du Salon d'Automne. Grand Palais: 1 October - 8 November
Paris *Exposition d'art contemporain:* Société Normande de Peinture Moderne; 2nd exhibition. Galerie d'Art Ancien et d'Art Contemporain, Rue Tronchet: 20 November - 16 December

1912

Moscow *Bubnovy Valet* ['Jack of Diamonds']: 2nd exhibition. Tret'yakov Gallery: 1 February - March
Paris *Salon des Indépendants:* Société des Artistes Indépendants; 28th exhibition. Quai d'Orsay, Pont de l'Alma: 20 March - 16 May
Barcelona *Exposició d'Art Cubista.* Galerie J. Dalmau: 20 April - 10 May
Rouen *Salon de juin:* Société Normande de Peinture Moderne; 3rd exhibition. Ile Lacroix, Skating: 15 June - 15 July
Paris *Salon d'Automne:* Société Salon d'Automne; 10th exhibition. Grand Palais: 1 October - 8 November
Amsterdam *Moderne Kunst Kring: Ouvrages de Peinture, Sculpture, Dessin, Gravure;* 2nd exhibition. Stedelijk Museum: 6 October - 7 November. 6 paintings, 8 drawings by Léger
Paris *Salon de la Section d'Or.* Galerie de la Boëtie: 10 - 30 October
Berlin *III. Juryfreie Kunstschau.* Kunsthaus Lepke: 26 November - 31 December
Paris *Accrochage.* Galerie Kahnweiler

1913

Paris *Gleizes, Léger, Metzinger: Expositions de Peintures & Dessins.* Galerie Berthe Weill: 17 January - 3 February. 15 paintings by Léger
Vienna *Die neue Kunst.* Galerie Miethke: January - February
New York *International Exhibition of Modern Art.* (Armory Show): Association of American Painters and Sculptors, Inc., Armory of the 69th Infantry: 17 February - 15 March
Paris *Salon des Indépendants:* Société des Artistes Indépendants; 29th exhibition. Quai d'Orsay, Pont de l'Alma: 19 March - 18 May
Chicago *International Exhibition of Modern Art:* Association of American Painters and Sculptors, Inc. Art Institute of Chicago; 24 March - 16 April
Boston *International Exhibition of Modern Art:* Association of American Painters and Sculptors, Inc. and Copley Society of Boston. Copley Hall: 28 April - 19 May
USA *Exhibition of 'Cubist' and 'Futurist' Pictures.* Milwaukee, Gimbels: *c.* 11 May - end June. Cleveland, Wm. Taylor, Son and Co.: 30 June - 8 July. Pittsburgh, Boggs and Buhl: 10 - 16 July. New York, Gimbels: 20 - 30 July. Philadelphia, Gimbels: *c.* 1 - 8 August
Berlin *Erster Deutscher Herbstsalon: Internationale Gemäldeausstellung.* Galerie Der Sturm: 20 September - 1 December. 14 works by Léger

1914

Tokyo *Woodcut Prints,* organized by Galerie Der Sturm (Berlin). Hibiya Art Museum: 14 - 28 March

1916

Berlin *Expressionisten, Futuristen, Kubisten:* 43rd Sturm exhibition. Galerie Der Sturm: July
Paris *L'Art moderne en France:* Salon d'Antin, organized by André Salmon. Paul Poiret / Galerie Barbazanges, 109 Faubourg. St. Honoré: 16 - 31 July
Oslo *Den Franske Utstilling:* Kunstnerforbundet, organized by Walther Halvorsen: 22 October - 10 December. With texts by Guillaume Apollinaire, André Salmon and Jean Cocteau

1917

Paris Exhibition of drawings, organized by Mme Bongard: March
Paris Galerie Barbazanges: May
Berlin Exhibition prior to sale of the stock of the Galerie Flechtheim, organized by Paul Cassirer and Hugo Helbing, Kurfürstendamm: first week in July
Berlin *Sturm-Gesamtschau: Gemälde, Aquarelle, Zeichnungen;* 53rd Sturm exhibition. Galerie Der Sturm: June

1918

New York The Penguin Club: March. Paris *Accrochage.* Galerie de l'Effort Moderne (Léonce Rosenberg): November

1919

Paris *Fernand Léger* (first one-man show) Galerie de l'Effort Moderne (Léonce Rosenberg); 5 - 28 February
London Heal's Mansard Gallery, organized by Osbert and Sacheverell Sitwell: September
Hanover *Französische Malerei bis 1914 und deutsche Künstler vom Café du Dôme.* Kestner-Gesellschaft: 7 September - 12 November

1920

Geneva *Le jeune peinture française: les cubistes.* Galerie Moos (in collaboration with Léonce Rosenberg): February. 12 paintings by Léger
Paris *La Section d'Or.* Galerie de la Boëtie: March (later in Rome)
Paris *Salon des Indépendants:* Société des Artistes Indépendants; 31st exhibition. Louvre
Antwerp *Exposition du groupe 'Sélection'.* Cercle Royal Artistique et Littéraire: 24 July - 12 August
Brussels *Œuvres de cubistes et néo-cubistes.* Galerie Sélection: 18 September - 8 October
Paris *Salon d'Art Moderne.* Maison Watteau: beginning of December
Geneva *Exposition internationale d'art moderne.* Bâtiment Electoral: 26 December 1920 - 25 January 1921

1921

Paris *Les Maîtres du Cubisme.* Galerie de l'Effort Moderne (Léonce Rosenberg)
Paris *Salon des Indépendants:* Société des Artistes Indépendants; 32nd exhibition
Amsterdam *Œuvres de l'Ecole française moderne.* Auction, A. Mak: 15 - 18 October. 6 paintings, 6 watercolours by Léger
Paris *Collection Uhde:* exhibition on the occasion of the compulsory sale of the collection of Wilhelm Uhde, Hôtel Drouot: 29 May
Paris *Collection Galerie Kahnweiler:* exhibition on the occasion of the first compulsory auction of the stock of the Galerie Kahnweiler. Hôtel Drouot: 12 June. 7 paintings by Léger
Berlin *Zehn Jahre Sturm: Gesamtschau;* 100th exhibition. Galerie Der Sturm: September
Paris *Salon d'Automne:* Société Salon d'Automne. Grand Palais
Paris *Collection Galerie Kahnweiler;* exhibition on the occasion of the second compulsory auction of the stock of the Galerie Kahnweiler. Hôtel Drouot: 16 November. 10 paintings, 2 drawings by Léger
New York Wanamaker Gallery, Belmaison: 22 November - 17 December

1922

Berlin *Das Schwedische Ballett.* Galerie Flechtheim: 25 March - 19 April
Berlin *Willy Baumeister, Fernand Léger: Aquarelle, Gesamtschau des Sturm.* Galerie Der Sturm: March. 5 paintings, 8 drawings by Léger
Paris *... et du Cubisme vers une Renaissance plastique.* Galerie de l'Effort Moderne (Léonce Rosenberg); 25 March - 25 April
Paris *Salon d'Automne:* Société Salon d'Automne. Grand Palais
Leipzig *Ausstellung Moderner Kunst aus Privatbesitz.* Kunstverein (Erich Wiese): 8 April - May
Düsseldorf *I. Internationale Kunstausstellung.* June
Paris *Collection Galerie Kahnweiler:* exhibition on the occasion of the third compulsory auction of the stock of the Galerie Kahnweiler. Hôtel Drouot: 3 July. 8 paintings by Léger

1923

Oslo Organized by the Galerie Der Sturm (Berlin). Blomqvists lokaler
Paris *Salon des Indépendants:* Société des Artists Indépendants; 34th exhibition. Grand Palais: 10 February - 11 March
Paris *Collection Galerie Kahnweiler:* exhibition on the occasion of the fourth compulsory auction of the stock of the Galerie Kahnweiler. Hôtel Drouot: 6 May. 18 paintings and 204 drawings by Léger
Paris *L'Exposition des Franco-Scandinaves et de ses invités.* Maison Watteau: November
Paris *Accrochage.* Galerie de l'Effort Moderne: December

1924

Paris *Maîtres de l'art contemporain.* Galerie de l'Effort Moderne (Léonce Rosenberg)
Vienna *Internationale Ausstellung neuer Theatertechnik.* Konzerthaus: September
Vienna *Internationale Kunstausstellung,* with the participation of the 'Gesellschaft zur Förderung moderner Kunst'. Konzerthaus: 24 September
Paris *Léger et trois élèves.* Maison Watteau: 18 October - 21 December

Bibliography

The Bibliography, each section of which is arranged in chronological order, concentrates on publications relating to Léger's work of 1911-24. As complete a listing as possible is given of the artist's own publications.

Publications Illustrated by Léger in 1911-24

Blaise Cendrars, *J'ai tué*, Paris: La Belle Edition, 1918. Five drawings by Léger. Reprinted (without the four text illustrations), Paris: Georges Crès, 1919. English trans. (by H. Ward) as 'I Have Killed' in *The Plowshare* (Woodstock, NY), VIII/6-7 (1919).

Blaise Cendrars, *La Fin du monde, filmée par l'ange N.-D.*, Paris: Editions de la Sirène, 1919. Twenty colour and two black-and-white compositions by Léger.

The Plowshare (Woodstock, NY), VIII/12 (December 1919). Drawing by Léger on cover.

Ivan Goll, *Astral, Ein Gesang*, 30 in the series, Das neueste Gedicht, Dresden: Kaemmerer, 1920. Drawing on cover.

Ivan Goll, *Die Chapliniade, Eine Kinodichtung*, Dresden: Kaemmerer, 1920. Four drawings by Léger. Reprinted as 'La Chapliniade, ou Charlot poète: Poème, drame, film' in *La Vie des lettres* (Paris), VII/5 (July 1925), pp. 535-51, and as 'La Chaplinade [sic] ou Charlot poète, poème cinématographique' in Ivan Goll, *Le Nouvel Orphée*, Paris: Editions de la Sirène, 1923, pp. 9-41; this volume also contains illustrations by Robert Delaunay and George Grosz.

André Malraux, *Lunes en papier*, Paris: Editions de la Galerie Simon, 1921. Seven woodcuts by Léger.

Broom (Rome), I/3 (1922). Woodcut by Léger on cover.

Broom (Rome), I/4 (1922). Woodcut by Léger on cover.

Ilya Ehrenburg, *A vse takin ona vertitsia*, Moscow and Berlin, 1922. Cover illustration by Léger.

Ballets Suédois, programme, Paris, 1923. Illustrations by Léger on front and back covers.

The Little Review (New York), IX/3 (Spring 1923). Lithograph by Léger on front and back cover.

Thora Dardel, *Konfektasken*, Stockholm: Albert Bonnier, 1924. Illustration by Léger facing p. 48; this volume also contains illustrations by Otto Sköld, Jules Pascin and others.

Ivan Goll, *Der Eiffelturm*, Berlin, 1924. One drawing by Léger.

Writings by Léger: Collected Editions

Fonctions de la peinture, ed. R. Garaudy, Paris, 1965. Includes unpublished texts. *Functions of Painting*, ed. and intr. E.F. Fry, trans. A. Anderson, London and New York, 1973.

Mensch, Maschine, Malerei: Aufsätze und Schriften zur Kunst, trans., ed. and intr. R.L. Füglister, Berne, 1971.

Writings by Léger: Individual Publications

'Les Origines de la peinture contemporaine et sa valeur représentative: Notes réunies pour une conférence' (lecture, Académie Wassilief, 5 May 1913), in *Montjoie!* (Paris), I/8 (29 May 1913), p. 7, and I/9-10 (19 June 1913), pp. 9-10. Reprinted in *Der Sturm* (Berlin), IV/172-3 (August 1913), pp. 76-8. Swedish trans. in *Kunst og kultur* (Bergen), IV (1914), pp. 41-51. Reprinted as 'Les Origines de la peinture et sa valeur représentative' in *Fonctions de la peinture*, pp. 11-19; English trans. as 'The Origins of Painting and Its Representational Value' in *Functions of Painting*, pp. 3-10.

'Les Réalisations picturales actuelles' (lecture, Académie Wassilief, 9 May 1914), in *Les Soirées de Paris* (Paris), III/25 (June 1914), pp. 349-56. Reprinted in *Fonctions de la peinture*, pp. 20-29; English trans. as 'Contemporary Achievements in Painting' in *Functions of Painting*, pp. 11-19.

'Pensées', in *Valori plastici* (Rome), I/2-3 (February-March 1919), p. 2. Reprinted as 'Un aperçu historique du cubisme' in *Sélection* (Antwerp), 2 (15 September 1920). This is a quotation from a letter written by Léger to Léonce Rosenberg and subsequently published by Rosenberg in more complete form with the title 'Correspondance' in *Bulletin de l'Effort Moderne* (Paris), 4 (April 1924), pp. 10-12, where it is given the incorrect date of 'mars 1922'.

'La Couleur dans la vie (Fragment d'une étude sur les valeurs plastiques nouvelles', in *Promenoir* (Lyon), 5 (1921), pp. 66-7.

'"La Roue", sa valeur plastique', *Comœdia* (Paris), (16 December 1922), p. 5. Reprinted as 'Essai critique sur la valeur plastique du film d'Abel Gance "La Roue"' in *Fonctions de la peinture*, pp. 160-63; English trans. as 'A Critical Essay on the Plastic Quality of Abel Gance's Film *The Wheel*' in *Functions of Painting*, pp. 20-23.

'Kurzgefaßte Auseinandersetzung über das aktuelle künstlerische Sein' (trans. F.A. Angermeyer), in *Das Kunstblatt* (Berlin), VII/1 (1923), pp. 1-4. French trans. as 'Notes sur la vie plastique actuelle' in *7 Arts* (Brussels), 20 (15 March 1923). Dutch trans. (by J. Peeters) as 'Over het tegenwoordig plastisch leven' in *Het Overzicht* (Antwerp), II/15 (March-April 1923), pp. 39-40.

'Réponse à une enquête sur le cinéma' (letter to René Clair, 4 March 1923), in *Léger*, special issue of *Europe* (Paris), XLIX 508-9 (August-September 1971), pp. 49-50.

'Le Ballet-Spectacle, l'objet-spectacle', in *La Vie des Lettres et des Arts* (Paris), IX/15 (1923), pp. 50-52. Reprinted in *Bulletin de l'Effort Moderne* (Paris), 12 (1925), pp. 7-9, and in *Fonctions de la peinture*, pp. 144-6; English trans. as 'The Ballet-Spectacle, the Object-Spectacle' in *Functions of Painting*, pp. 71-3.

'Les bals populaires', in *La Vie des Lettres et des Arts* (Paris), IX/15 (1923), pp. 53-5. Reprinted in *Bulletin de l'Effort Moderne* (Paris), 12 (1925), p. 10, and 13 (1925), pp. 4-5, and in *Fonctions de la peinture*, pp. 147-50; English trans. as 'Popular Dance Halls' in *Functions of Painting*, pp. 74-7.

'L'esthétique de la machine: l'objet fabriqué, l'artisan et l'artiste', in *Der Querschnitt* (Berlin), III/3-4 (Autumn 1923), pp. 122-9. Reprinted, with a dedication to Ezra Pound, in *Little Review* (New York), IX/3 (Spring 1923), pp. 45-9, and IX/4 (Fall/Winter 1923-4), pp. 55-8; in *Bulletin de l'Effort Moderne* (Paris), 1 (January 1924), pp. 5-7, and 2 (February 1924), pp. 8-12; with a dedication to Blaise Cendrars in *Sélection* (Antwerp), III/4 (February 1924), pp. 374-82; and in *Fonctions de la peinture*, pp. 53-62; English trans. as 'The Machine Aesthetic: The Manufactured Object, the Artisan, and the Artist' in *Functions of Painting*, pp. 52-61.

'La question des "Indépendants"' (open letter to Paul Signac), in *7 Arts* (Brussels), 8 (29 November 1923), and *Paris-Journal* (Paris), (30 November 1923), p. 5.

(with Blaise Cendrars), 'Notes sur la réglementation de la mise en scène' (Notes on staging the ballet *La Création du monde*), in *L'Esprit nouveau* (Paris), 19 (18 November 1923). Reprinted in *Les Ballets Suédois dans l'art contemporain*, Paris, 1931, p. 66. Reprinted in B. Häger, *Les Ballets Suédois*, Paris, 1989, p. 190, and in the English trans. (by R. Sharman) *Ballet Suédois*, London, 1990, p. 190.

'Ästhetik der Maschine' (lecture, Collège de France, 1 June 1923, trans. F.A. Angermayer), in F. Fels, 'Unterhaltungen mit Künstlern', in *Das Kunstblatt* (Berlin), VII/2 (1924), pp. 39-44. Original French text, 'L'esthétique de la machine: l'ordre géométrique et le vrai', in F. Fels, *Propos d'artistes*, Paris, 1925, pp. 98-106. Fuller German version, in a new translation, published in *Die Kunstauktion/Weltkunst* (Berlin), IV/33 (31 August 1930), pp. 12-13. Excerpts of French version published as 'Interview' in F. Fels, *Le Roman de l'art vivant: De Monet à Buffet*, Paris, 1959, pp. 147-60. Full version of French text published in *Fonctions de la peinture*, pp. 63-7; English trans. as 'The Machine Aesthetic: Geometric Order and Truth', in *Functions of Painting*, pp. 62-6.

'Ballet mécanique, Film by Fernand Léger and Dudley Murphy, Musical Synchronism by George Antheil', in *Little Review* (New York), X/2 (Autumn-Winter 1924/5), pp. 42-4. Original French text published in *7 Arts* (Brussels), 1 (6 November 1924); reprinted in G. Bauquier, *Fernand Léger: Vivre dans le vrai*, Paris, 1987, pp. 141-2.

'La bonne parole', in *Bulletin de l'Effort Moderne* (Paris), 1 (January 1924), p. 8.

'Le spectacle: lumière, couleur, image mobile, objet-spectacle' (lecture), in *Bulletin de l'Effort Moderne* (Paris), 7 (July 1924), pp. 4-7; 8 (October 1924), pp. 5-9; and 9 (November 1924), pp. 7-9, with a dedication to Rolf de Maré. First part published in German trans. (by E. Tietze) as 'Das Schauspiel, Licht, Farbe, Film', in F. Kiesler, ed., *Internationale Ausstellung neuer Theatertechnik*, exh. cat., Konzerthaus, Vienna, September 1924, pp. 6-16. Complete text published in German trans. (by B. Guillemin) as 'Conférence über die Schau-Bühne' in C. Einstein and P. Westheim, eds, *Europa-Almanach*, Potsdam, 1925, pp. 119-32 (reprinted Leipzig and Weimar, 1984). Original French text reprinted in *Fonctions de la peinture*, pp. 131-34; English trans. as 'The Spectacle: Light, Colour, Moving Image, Object-Spectacle' in *Functions of Painting*, pp. 35-47.

'Réponse à l'enquête "Où va la peinture moderne?"', in *Bulletin de l'Effort Moderne* (Paris), 2 (February 1924), p. 5.

'Réponse à une enquête "Chez les Cubistes"', in *Le Bulletin de la vie artistique* (Paris), V/21 (1 November 1924), p. 486.

'Vive Relâche', in *Paris-Midi* (Paris), (17 December 1924), p. 4. Reprinted in *7 Arts* (Brussels), 9 (1 January 1925); in *Bulletin de l'Effort Moderne* (Paris), 12 (1925), pp. 5-7; in [Rolf de Maré], *Les Ballets Suédois dans l'art contemporain*, Paris, 1931, pp. 80-82; and in B. Häger, *Les Ballets Suédois*, Paris, 1989, pp. 253, 256.

'Notations on Plastic Values', in *Fernand Léger*, exh. cat., Anderson Galleries, New York, 1925, pp. 10-11.

'Peinture et Cinéma', in *Cinéma*, special issue of *Cahiers du mois* (Paris), 16/17 (1925), pp. 107-8.

'Sehr aktuell sein' (trans. H. Jacob), in C. Einstein and P. Westheim, eds, *Europa-Almanach*, Potsdam, 1925, pp. 13-16; reprinted Leipzig and Weimar, 1984.

'A New Realisme – The Object, its Plastic and Cinematographic Value' (1925), in *Little Review* (New York), XI/2 (Winter 1926), pp. 7-8.

'Considérer la peinture murale comme un art abstrait', in M. Raynal, *Anthologie de la peinture en France de 1906 à nos jours,* Paris, 1927, pp. 205-6. English trans. (by E. Roeder), *Modern French Painters,* London, 1929, p. 112.

'Préface', in *Otto Carlsund,* exh. cat., Galerie Mots et Images, Paris, March 1927. Reprinted in *Léger och Norden,* exh. cat., Moderna Museet, Stockholm, 1992, pp. 58-9.

'Gloire du métal', in *L'Intransigeant* (Paris), (8 October 1928), p. 6. Excerpts printed in A. Basler, *Le Cafard après la fête, ou l'esthétisme d'aujourd'hui,* Paris, n.d. [1928], pp. 47-8, 111-12.

'La Rue: Objets, spectacles', in *Vers un Paris nouveau,* special issue of *Cahiers de la République des Lettres, des Sciences et des Arts* (Paris), XII (1928), pp. 102-4. Reprinted in *Fonctions de la peinture,* pp. 68-9; English trans. as 'The Street: Objects, Spectacles', in *Functions of Painting,* pp. 78-80.

'Meine Berliner Ausstellung' (trans. H. Satter), in *Der Querschnitt* (Berlin and Dusseldorf), VIII/1 (January 1928), pp. 35-7. Simultaneously published in *Fernand Léger,* exh. cat., Galerie Flechtheim, Berlin, 1928, pp. 3-9.

'Actualités' (lecture, Galerie Flechtheim, Berlin, February 1928), in *Variétés: Revue mensuelle illustrée de l'esprit contemporain* (Brussels), I/10 (15 February 1929), pp. 522-5.

'Pensées sur l'art' (1928), in W. George, *Fernand Léger,* Paris, 1929, p. 14.

'Music-Hall – France – Côte d'Azur', in *L'Intransigeant* (Paris), (10 June 1929), p. 5.

'Si tu n'aimes pas les vacances', in *L'Intransigeant* (Paris), (21 October 1929), p. 5. Reprinted in *Fernand Léger: La poesie de l'objet 1928-1934,* exh. cat., Musée National d'Art Moderne, Paris, 1981, p. 20.

'Réponse à l'enquête "Vouloir construire"', in *Cercle et Carré* (Paris), I (15 March 1930), p. 5.

'De l'art abstrait', in *Cahiers d'Art,* VI/3 (1931), pp. 151-2. Reprinted in *Fernand Léger: La poésie de l'objet 1928-1934,* exh. cat., Musée National d'Art Moderne, Paris, 1981, pp. 22-3, and in *Fonctions de la peinture,* pp. 39-41; English trans. as 'Abstract Art' in *Functions of Painting,* pp. 81-3.

'Eric Satie illustré par Calder, pourquoi pas?', in *Alexander Calder,* exh. cat., Galerie Percier, Paris, 27 April-9 May 1931. Reprinted in *Fernand Léger: La poesie de l'objet 1928-1934,* exhibition catalogue, Musée National d'Art Moderne, Paris, 1981, p. 20.

'Introduction', in *Paris: 80 photographies de Moï Ver,* Paris, 1931.

'Les Ballets Suédois sont venus à leur date', in *Les Ballets Suédois dans l'art contemporain,* Paris, 1931, p. 179.

'New York vu par Fernand Léger', in *Cahiers d'Art* (Paris), VI/9-10 (1931), pp. 437-9, with a dedication to Sara Murphy. Excerpts reprinted in *L'Intransigeant* (Paris), (14 January 1932), p. 1. Reprinted in full in *Fonctions de la peinture,* pp. 186-93; English trans. as 'New York' in *Functions of Painting,* pp. 84-90.

'Notre Paysage', in *L'Intransigeant* (Paris), (18 May 1931), p. 5. Reprinted in *Fernand Léger: La poésie de l'objet 1928-1934,* exh. cat., Musée National d'Art Moderne, Paris, 1981, p. 21.

'A propos du cinéma', in *Plans* (Paris), 1 (1931), pp. 80-84, with a dedication to Sergei Eisenstein and Eric von Stroheim. Reprinted in *Léger,* special issue of *Cahiers*

d'Art (Paris), VIII/3-4 (1933), unpaginated; in Marcel L'Herbier, *Intelligence de cinéma,* Paris, 1946, pp. 337-41; and in *Fonctions de la peinture,* pp. 168-71; English trans. as 'Speaking of Cinema' in *Functions of Painting,* pp. 100-4.

'Wall Street', in *L'Intransigeant* (Paris), (28 December 1931), p. 5.

'Vingt-quatre heures ou la vie d'un journal à Chicago', in *L'Intransigeant* (Paris), (4 January 1932), p. 5.

'Chicago' (1931), in *Plans* (Paris), 11 (January 1932), pp. 63-8. Reprinted in *Léger and the Modern Spirit,* exh. cat., Paris, Houston and Geneva, 1982-3, pp. 270-72.

'Concours chorégraphique international au Théâtre des Champs-Elysées, Juillet 1932', in *Cahiers d'Art* (Paris), VII/6-7 (1932).

'De la peinture dansée à la danse sans peinture: Spectacles sans décors', in *L'Intransigeant* (Paris), (11 July 1932).

'Au pays de Jean-Jacques', in *L'Intransigeant* (Paris), (15 May 1933), p. 8.

'L'Amérique et le chiffre 3', in *Orbes* (Paris), 2nd series, 1 (Spring 1933), pp. 30-34. Simultaneously published in *Quadrante* (Milan), XI (June 1933), p. 29.

'L'Art est entré en cambrioleur', in *Mouvement* (Paris), 1 (June 1933), pp. 17-18.

'Discours aux architectes' (lecture given on the occasion of the IVe Congrès International d'Architecture Moderne), in *Quadrante* (Milan), XI (September 1933), pp. 44-7.

'J'aurai regretté d'avoir quitté la Suède …' (in Swedish trans. by O. Carlsund), in *Svenska Dagbladet* (Stockholm), (30 September 1934). Published in French translation in *Léger och Norden,* exh. cat., Moderna Museet, Stockholm, 1992, pp. 84-6.

'L'Avènement de l'objet', in *Mois* (Paris), 41 (June 1934), pp. 217-24. Reprinted in *Fernand Léger: La poésie de l'objet 1928-1934,* exh. cat., Musée National d'Art Moderne, Paris, 1981, pp. 25-7.

'Le Beau et le Vrai' (part of a lecture given at the Sorbonne, Paris, 8 February 1934, with the title 'De l'Acropole à la Tour Eiffel', in *Beaux-Arts* (Paris), LXXIII/58 (1934), p. 2. Reprinted in its entirety in R. Garaudy, *Pour un réalisme du XXe siècle,* Paris, 1968, pp. 225-44. Reprinted in *Fernand Léger: La poésie de l'objet 1928-1934,* exh. cat., Musée National d'Art Moderne, Paris, 1981, p. 24.

'L'invasion polychrome', in *La Bête Noire* (Paris), 3 (June 1935), p. 4.

'Réponse à une enquête de Jean Galloti: Que feriez-vous, si vous aviez à organiser l'Exposition de 1937?', in *Vu* (Paris), VIII/387 (14 August 1935), p. 1102.

'Londres', in *Nouvelle Revue Française* (Paris), 258 (1 June 1935), pp. 955-7; and 264 (1 September 1935), pp. 470-73.

'La Couleur et le sentiment', in *Pour Vous* (Paris), 358 (26 September 1935), p. 2.

'The New Realism: Lecture Delivered at the Museum of Modern Art', in *Art Front* (New York), II/8 (December 1935), pp. 10-11. Reprinted in R. Goldwater, *Artists on Art,* New York, 1945, and London, 1947, pp. 423-6. Reprinted as 'Un nouveau réalisme: la couleur pure et l'objet', in *Fonctions de la peinture,* pp. 77-81; English trans. as 'The New Realism' in *Functions of Painting,* pp. 109-113.

'Réponse à une enquête sur l'art d'aujourd'hui', in *Cahiers d'Art* (Paris), X/1-4 (1935), pp. 66-7.

'La marche vers le "mur"' (1936), in *Les Lettres Françaises* (Paris), 582 (25-31 August 1955), p. 3.

'Painting and Reality' (English trans., by Maria Jolas, of part of a lecture given at the second debate on 'realism' held at the Maison de la Culture, Paris, in May 1936, during a session in which Louis Aragon and Le Corbusier also participated), in *Transition* (New York), 25 (Autumn 1936), pp. 104-8. In entirety published in French in *Querelle du Réalisme: Deux débats organisés par l'Association des Peintres et Sculpteurs de la Maison de la Culture,* Paris, 1936, pp. 73-9. Published in full in English in *Art Front* (New York), III/1 (February 1937), pp. 7-8, and in M. Evans, *The Painter's Object,* London, 1937, pp. 15-20; excerpts published in *London Bulletin,* 3 (June 1938), p. 26, and in *Daedalus* (Cambridge, Mass.), LXXXIX/1 (Winter 1960), pp. 87-90. Excerpts published in Danish translation in E. Bille, *Picasso Surrealisme, Abstrakt Kunst,* Copenhagen, 1945, pp. 97-9.

'Réponse à une enquête sur la valeur d'une œuvre d'art', in *Le Point* (Colmar), I/6 (1936), p. 34.

'L'Art mural de Victor Servranckx', in *Clarté* (Brussels), X/7 (July 1937), p. 20.

'A propos of Colour' (trans. J. Sweeney), in *Transition* (New York), 26 (1937), p. 81.

'Sur la peinture', in *L'Exposition 1937, et les artistes à Paris,* Paris, 1937, pp. 20-9.

'Beauty in Machine Art', in *Design* (Syracuse, NY, and Columbus, OH), XXXIX (March 1938), pp. 6-7.

'Peinture 1937: couleur dans le monde' (excerpts from a lecture), in *Peintres et Sculpteurs de la Maison de la Culture* (Paris), 5 (1938), pp. 42-5. Reprinted in special issue of *Europe, L'Homme, la technique, la nature,* Paris 1938, pp. 105-19; and in *Fonctions de la peinture,* pp. 85-98; English trans. as 'Color in the World', *Functions of Painting,* pp. 119-31.

'Préface' in *Fernand Léger,* exh. cat., Palais des Beaux-Arts, Brussels, 1938, pp. 4-5.

'Revival of Mural Art' (trans. D. Cooper), in *The Listener* (London), XVIII/450 (1938), pp. 403-9.

'Choses d'Amérique', in *Nouvelle Revue Française* (Paris), 308 (1 May 1939), pp. 902-3.

'The Question of Truth', in *Architectural Forum* (New York), LXX (1939), pp. 138-41. Simultaneously published in *Plus: Orientations of Contemporary Architecture* (New York), 2 (1939), pp. 18-21.

'Réponse à une enquête: L'Acte créateur se ressent-il de l'influence des événements environnants …', in *Cahiers d'Art* (Paris), XIV/1-4 (1939), pp. 70-72.

'New York – Paris, Paris – New York', in *La Voix de France* (New York), (15 September 1941), p. 10.

'Un Art nouveau sous le ciel californien', in *La Voix de France* (New York), (1 November 1941), p. 8.

'Découvrir l'Amérique, in *Hommage à l'Amérique,* special issue of *La Voix de France* (New York), (15 May 1942), p. 9.

'Byzantine Mosaics and Modern Art', in *Magazine of Art* (Washington, D.C.) XXXVII/4 (April 1944), pp. 144-5.

'A propos du corps humain considéré comme un objet', in *Fernand Léger: La Forme humaine dans l'espace,* Montreal, 1945, pp. 63-75. Reprinted in *Fonctions de la peinture,* pp. 70-75; English trans. as 'The Human Body Considered as an Object' *Functions of Painting,* pp. 132-6.

'The Relationship between Modern Art and Contemporary Industry', in *Modern Art in Advertising: An Exhibition of Design for Container Corporation of America,* exh. cat., The Art Institute of Chicago, 1945, pp. 4-5.

'Causerie sur l'art' (lecture at the Sorbonne for the association 'Travail et Culture'), in *Arts de France* (Paris), 6

(June 1946), pp. 36-42. Excerpts reprinted in 'Le Peuple et les Arts', in *Bulletin de Travail et Culture* (June-July 1946), pp. 35-6.

'L'Œil du peintre', in *Variété* (Paris), 3 (1946), p. 44. Reprinted in *Fonctions de la peinture*, pp. 196-7; English trans. as 'The Painter's Eye', *Functions of Painting*, pp. 141-2.

'Modern Architecture and Color', in *American Abstract Artists*, New York, 1946, pp. 31, 34-5, 37-8.

'L'Art abstrait', in *Pour et contre l'art abstrait*, special issue of *Cahiers des Amis de l'Art* (Paris), 11 (1947), p. 48.

'Colour in Architecture', in S. Papadaki, *Le Corbusier*, New York, 1948, pp. 78-80.

'L'aventure au pays des merveilles', in *Ciné-Club* (Paris), II/1 (October 1948), p. 1.

'Baumeister', in 'Du non-figuratif au figuratif: Willi Baumeister, Jean Bazaine, Paul Braig', in *L'Age nouveau* (Paris), 44 (1949), unpaginated.

'L'Art abstrait', in *Derrière le Miroir* (Paris), 20-21 (May 1949), unpaginated. Reprinted as 'De l'art abstrait', together with 1931 *Cahiers d'Art* article with that title, in *Fonctions de la peinture*, p. 41; English trans. as 'Abstract Art' in *Functions of Painting*, p. 83.

'Que signifie: Etre témoin de son temps?', in *Arts* (Paris), XI/205 (11 March 1949), p. 1.

'Un nouvel espace en architecture', in *Art d'aujourd'hui* (Boulogne), 3 (October 1949), p. 19.

'Calder', in *Derrière le Miroir* (Paris), 31 (July 1950), unpaginated. Published in English translation in *Alexander Calder*, exh. cat., Curt Valentin Gallery, New York, 1952, pp. 6-7.

Cirque (hand-written, lithographed text with 63 colour or black and white lithographic illustrations and 22 text ornaments), Paris, 1950.

'L'Architecture moderne et la couleur', in *Formes et Vie* (Paris), 1 (1951), pp. 24-6. Reprinted as 'L'architecture moderne et la couleur ou la création d'un nouvel espace vital', in *Fonctions de la peinture*, pp. 99-103; English trans. as 'Modern Architecture and Color', *Functions of Painting*, pp. 149-54.

'Situation de la peinture dans le temps actuel', in *Biennale di Venezia* (Venice), 5 (1951), p. 19.

'Comment je conçois la figure', in Louis Carré, ed., *La figure dans l'œuvre de Léger*, Paris, 1952, pp. 29-34.

'Le problème de l'espace murale' (remarks written down by Maria Luz), in *Nouvelles conceptions de l'espace*, special issue of *XXe Siècle* (Paris), 2 (January 1952), pp. 67-8.

'La Peinture moderne devant le monde actuel' (lecture, Maison de la Pensée Française, Paris), in *Les Lettres Françaises* (Paris), XI/405 (13 March 1952), pp. 1, 9.

'Ansprache auf dem Völkerkongress für den Frieden' (Vienna, 1952), extracts published in *Léger*, special issue of *Europe* (Paris), XLIX/508-9 (August-September 1971), p. 61.

'Vers l'architecture', in *Fernand Léger: sculptures polychromes en céramique*, exh. cat., Galerie Louis Carré, Paris, 1953.

'Réflexions sur l'intégration de la peinture et de la sculpture dans l'architecture', in *I 4 Soli* (Turin), 1 (1954), p. 8.

'Sens de l'art moderne' (collection of quotations), in *Zodiaque* (Saint-Léger-Vauban), 18-19 (January 1954), unpaginated.

'La couleur dans l'architecture', in I. Meyerson, ed., *Problèmes de la couleur: Exposés et discussions du Colloque du Centre de Recherches de Psychologie comparative tenu à Paris les 18, 19, 20 mai 1954*, Paris, 1957, pp. 135-54. Reprinted in *Fonctions de la peinture*, pp. 104-9; English trans. as 'Color in Architecture' in *Functions of Painting*, pp. 183-8.

'Comment cela commence', in *Les Lettres Françaises* (Paris), 582 (25-31 August 1955), p. 3. Reprinted, with the title 'C'est comme ça que cela commence', as the foreword to P. Descargues, *Fernand Léger*, Paris, 1955, pp. 5-6; and in *Léger*, special issue of *Europe* (Paris), XLIX/508-9 (August-September 1971), pp. 58-60.

'Les mains des constructeurs' (1951), in *Heures Claires* (Paris), 123 (1955), pp. 18-19.

La Ville (with 29 reproductions of gouaches and drawings by the artist), Paris, 1959.

Mes voyages (with a poem by Louis Aragon and lithographs by the artist), Paris, 1960.

'La mort de Marat suivie de sa pompe funèbre' (c. 1932-6), in *Léger*, special issue of *Europe* (Paris), XLIX/508-9 (August-September 1971), pp. 62-4.

Publications that include Letters written by Léger

W. Spies, ed., *Pour Kahnweiler*, Teufen, 1965, pp. 171, 307-8.

G. Le Noci, *Fernand Léger: sa vie, son œuvre, son rêve*, Milan, 1971.

Léger's 'Le Grand Déjeuner', exh. cat., Minneapolis Institute of Art, 1980, pp. 70-2 (letters of 1942 from Léger to Alfred H. Barr Jr concerning *Le Grand Déjeuner*).

P. De Francia, *Fernand Léger*, New Haven and London, 1983.

G. Bauquier, *Fernand Léger: Vivre dans le vrai*, Paris, 1987, pp. 21-9, 49, 62, 68-9, 70-72, 74.

C. Derouet, ed., *Fernand Léger: Lettres à Simone*, Geneva and Paris, 1987.

C. Derouet, ed., *Fernand Léger, une correspondance de guerre – à Louis Poughon, 1914-1918*, Les Cahiers du Musée National d'Art Moderne, Centre Georges Pompidou, Paris, 1990 (also contains letters from Léger to André Mare and to Léonce Rosenberg).

Léger och Norden, exh. cat., Moderna Museet, Stockholm, 1992, pp. 25-44 (letters, ed. C. Derouet, from Léger to Otto Carlsund, Nils de Dardel, Thora Dardel, Rolf de Maré, Maurice Raynal, Léonce Rosenberg and others).

Lectures, Conversations and Interviews given by Léger

'Malarkonst, dynamik og en tilgivelig missforstaalse, Enliten samtale med en av lederne for den nyeste franske kunstutstilling', in *Tidens Tegn* (Kristiania [Oslo]), 28 October 1919, p. 2. Reprinted in *Léger och Norden*, exh. cat., Moderna Museet, Stockholm, 1992, pp. 107-8.

G. Charensol, 'Querelles de peintres: Les incidents des Indépendants', in *Paris-Journal* (Paris), 30 November 1923, p. 5.

'Déductions consécutives troublantes' (conversation with Le Corbusier), in Le Corbusier, 'Salon d'Automne (Architecture)', *L'Esprit nouveau* (Paris), 19 (1923-4).

R.R. Wilms, 'Une femme chez les peintres', in *L'Instransigeant* (Paris), 7 July 1930. Reprinted in *Fernand Léger: La poesie de l'objet 1928-1934*, exh. cat., Musée National d'Art Moderne, Paris, 1981, p. 17.

R. Cogniat, 'Chez Fernand Léger', in *Beaux-Arts* (Paris), LXXII/16 (21 April 1933). Reprinted in *Fernand Léger: La poésie de l'objet 1928-1934*, exh. cat., Musée National d'Art Moderne, Paris, 1981, p. 19.

R. Cogniat, 'Fernand Léger précise', in *Beaux-Arts* (Paris), LXXII/18 (5 May 1933). Reprinted in *Fernand Léger: La poésie de l'objet 1928-1934*, exh. cat., Musée National d'Art Moderne, Paris, 1981, p. 19.

'Léger arrives for show, gives painting rules' (interview), in *New York Herald Tribune* (New York), late 1935.

'Où va la peinture', in *Commune* (Paris), II/21-22 (May 1935).

'Pity Us!', in *Art Digest* (New York), XI/1 (15 October 1935).

'Avec Fernand Léger' (interview with Jean-Marc Campagne), in *Marianne* (Paris), (13 October 1937).

'Fernand Léger pendant son séjour en Amérique a fait des conférences à l'Université de Yale et décoré l'intérieur de Rockefeller Jr.', in *Beaux-Arts* (Paris), 236 (31 March 1939).

'Interview with Stamo Papadaki', in *Architectural Forum* (New York), (February 1939).

F. Gromaire, 'L'avenir est à couleur nous dit Fernand Léger, peintre et cinéaste', in *L'Ecran Français* (Paris), IV/40 (3 April 1946).

A. Warnod, 'L'Amérique, ce n'est pas un pays, c'est un monde', in *Arts* (Paris), 49 (4 January 1946).

'Droit-on réformer l'enseignement des Beaux-Arts?', in *Traits* (Paris), 4 (1948).

P. Descargues, 'Fernand Léger: Interview', in *Arts* (Paris), 147 (2 January 1948).

R. Howe, 'Chalk and Cheese: Puy and Léger', in *Apollo* (London), L/294 (August 1949), pp. 31-3.

L.P. Favre, 'Quel paysage avez-vous choisi? Fernand Léger: Jamais de la vie je n'irai dans le Midi', in *Arts* (Paris), 367 (10 July 1952).

R. Régent, 'Entretien avec Fernand Léger', in *Cahiers du Cinéma* (Paris), 14 (1952), p. 19.

D. Vallier, 'La Vie fait l'œuvre de Fernand Léger: propos recueillis par Dora Vallier', in *Cahiers d'Art* (Paris), XXIX/11 (1954), pp. 133-72.

R. Bordier, 'Polychromie architecturale', in *Art d'Aujourd'hui* (Boulogne), I/2 (March-April 1955).

A. Verdet, *Fernand Léger: Le dynamisme pictural*, Geneva, 1955. Published in German trans. as *Fernand Léger: Bekenntnisse und Gespräche mit Andre Verdet*, Zurich, 1957.

'Entretien du Fernand Léger avec Blaise Cendrars et Louis Carré sur le paysage dans l'œuvre de Léger' (1954), in *Fernand Léger*, exh. cat., Galerie Louis Carré, Paris, 1956. Reprinted in Blaise Cendrars, *Œuvres complètes*, VIII, Paris, 1965, pp. 501-17.

A. Verdet, *Entretiens, notes et écrits sur la peinture: Braque, Léger, Matisse, Picasso*, Paris, 1978, pp. 51-107.

D. Morosini, *Il fabbro della pittura: Conversazioni e ricordi su Léger*, Rome, 1983.

Essays and Monographs on Léger

A. Salmon, 'Fernand Léger', in *Paris-Journal* (Paris), (19 November 1911).

G. Apollinaire, 'Du sujet dans la peinture moderne', in *Les Soirées de Paris* (Paris), I (February 1912), pp. 1-4; English trans. (by S. Suleiman) as 'On the Subject in Modern Painting', in L. C. Breunig, ed., *Apollinaire on Art: Essays and Reviews 1902-1918,* London and New York, 1972.

Olivier-Hourcade, 'Silhouette – Fernand Léger', in *Paris-Journal* (Paris), (27 September 1912).

M. Raynal, 'Conception et vision', in *Gil Blas* (Paris), (29 August 1912), p. 4.

R. Allard, 'Fernand Léger', in *Les Soirées de Paris* (Paris), (1913).

G. Apollinaire, *Les Peintres cubistes, méditations esthétiques,* Paris, 1913. English trans. (by L. Abel) as *The Cubist Painters: Aesthetic Meditations,* New York, 1944; 2nd edn New York, 1949.

G. Apollinaire, 'Une conférence de Fernand Léger', in *Paris-Journal* (Paris), (14 May 1914). English trans. (by S. Suleiman) as 'A Lecture by Fernand Léger' in L. C. Breunig, ed., *Apollinaire on Art: Essays and Reviews 1902-1918,* London and New York, 1972.

C. Einstein, *Negerplastik,* Munich 1915. Reprinted in R.-P. Baacke, ed., *Carl Einstein: Werke,* I: *1908-1918,* Berlin, 1980, pp. 245-391.

H. Walden, *Einblick in die Kunst: Expressionismus, Futurismus, Kubismus,* Berlin, 1917.

A. Ozenfant and C. E. Jeanneret [Le Corbusier], *Après le cubisme,* Paris, 1918.

B. Cendrars, 'Le "CUBE" s'effrite', in *La rose rouge* (Paris), I/3 (15 May 1919), pp. 33-4. Reprinted in B. Cendrars, *Œuvres complètes,* IV, Paris, 1962, pp. 185-8.

B. Cendrars, 'Modernités: Fernand Léger', in *La rose rouge* (Paris), I/10 (3 July 1919), p. 155. Reprinted in *B. Cendrars: Œuvres complètes,* IV, Paris, 1962, pp. 190-91. English trans. as 'Modernities: Fernand Léger', in *Modernities and other Writings by Blaise Cendrars,* ed. M. Chefdor, Lincoln, NB, and London, pp. 99-101.

M. Raynal, *Quelques intentions du cubisme,* Paris, 1919.

H. Walden, *Die neue Malerei,* Berlin, 1919.

'D. Henry' [D.-H. Kahnweiler], *Der Weg zum Kubismus,* Munich, 1920. English trans. as *The Rise of Cubism,* New York, 1949.

'D. Henry' [D.-H. Kahnweiler], 'Fernand Léger', in *Der Cicerone* (Leipzig), 19 (1920), pp. 699-702. Simultaneously published in *Jahrbuch der Jungen Kunst* (Leipzig), 1 (1920), pp. 301-4.

M. Raynal, *Fernand Léger: 20 tableaux,* Paris, 1920.

M. Raynal, 'Fernand Léger', in *L'Esprit nouveau* (Paris), 4 (1920), pp. 427-34.

R. Blümner, *Der Geist des Kubismus und die Künste,* Berlin, 1921.

A. Ozenfant and C. E. Jeanneret [Le Corbusier], 'Le purisme', in *L'Esprit nouveau* (Paris), 4 (January 1921), pp. 369-86.

G. Severini, *Du cubisme au classicisme,* Paris, 1921.

C. Einstein, 'Skating Rink', in *Der Querschnitt* (Berlin and Düsseldorf), II (Spring 1922), pp. 57-8. Reprinted in M. Schmid, ed., *Carl Einstein, Werke,* II: *1919-1928,* Berlin, 1981, pp. 216-18.

I. Goll, 'Fernand Léger', in *Das Kunstblatt* (Potsdam), VI/7 (July 1922), pp. 73-7.

M. Raynal, 'Skating Rink: Ballet de Fernand Léger', in *L'Esprit nouveau* (Paris), 17 (1922). Simultaneously published in *Der Querschnitt* (Berlin and Düsseldorf), Christmas issue (1922), p. 226.

J. Epstein, 'Fernand Léger', in *Les Feuilles libres* (Paris), (March-April 1923). Reprinted in idem, *Ecrits sur le cinéma,* I, Paris, 1974, pp. 115-18.

V. Majakowski [Mayakovsky], 'Siebentageüberblick über die französische Malerei' (1923), in L. Kossuth, ed., *Vladimir Majakowski: Werke,* IV, trans. H. Huppert, Berlin and Frankfurt am Main, 1971, pp. 68-91.

M. Raynal, 'Fernand Léger', in *Bulletin de l'Effort Moderne* (Paris), 18 (1925), pp. 7-12; and 19 (1925), pp. 7-10.

C. Einstein, *Die Kunst des 20. Jahrhunderts,* Berlin, 1926.

M. Raynal, 'Fernand Léger', in *Cahiers d'Art* (Paris), I/4 (1926), pp. 61-5.

M. Raynal, 'Fernand Léger', in *Anthologie de la peinture en France de 1906 à nos jours,* Paris, 1927, pp. 205-12. English trans. as *Modern French Painters,* New York, 1927, pp. 111-16, 230-32.

W. George, *Fernand Léger,* Paris, 1929. English trans. in *The Arts* (New York), XV (1929), pp. 303-13.

J. J. Sweeney, 'Léger and the Cult of the Close-Up', in *The Arts* (New York), XVII (May 1931), pp. 561-8.

J. J. Sweeney, 'Léger and Cinesthetic', in *Creative Art* (New York), 10 (1932), pp. 440-45.

K. Bond, 'Léger, Dreyer and Montage', in *Creative Art* (New York), 11 (1932), pp. 135-8.

'Fernand Léger', in *Cahiers d'Art* (Paris), VIII/3-4 (1933); special issue with texts by Guillaume Apollinaire, Blaise Cendrars, Siegfried Giedion, Le Corbusier, Maurice Raynal, Christian Zervos and others.

D. Cooper, *Fernand Léger et le nouvel espace,* Geneva, 1949.

K. Kuh, *Léger,* with a bibliography by H. B. Müller, Urbana, IL, 1953.

L. G. Buchheim, *Fernand Léger: Menschen und Objekte, Zeichnungen,* Feldafing, Oberbayern, 1955.

P. Descargues, *Fernand Léger,* Paris, 1955.

J. L. Ferrier, 'Léger et la civilisation technicienne', in *Les Temps Modernes* (Paris), 116 (1955), pp. 126-47.

R. Shattuck, *The Banquet Years: The Origins of the Avant-Garde in France, 1885 to World War I – Alfred Jarry, Henri Rousseau, Erik Satie, Guillaume Apollinaire,* New York, 1955.

D. Cooper, *Fernand Léger: Dessins de guerre, 1915-1916,* Paris, 1956.

G. Sadoul, 'Fernand Léger ou la Cinéplastique', in *Cinéma: Le guide du spectateur* (Paris), 35 (1959), pp. 72-82.

R. L. Delevoy, *Léger,* Geneva, 1962.

R. L. Füglister, 'Fernand Léger, "Akrobaten im Zirkus": Einordnung und Interpretation', in *Öffentliche Kunstsammlung Basel: Jahresberichte 1964-1966,* Basle, 1966, pp. 167-86.

J. Golding, *Cubism: A History and an Analysis, 1907-1914,* London, 1968.

E. Blondel, *Fernand Léger et les arts du spectacle,* PhD dissertation, Université de Paris, 1969.

J. Paulhan, *La peinture cubiste,* Paris, 1971; 2nd edn, Paris 1990.

Hommage à Fernand Léger, special issue of *XXe siècle,* Paris, 1971.

L. Brion-Guerry ed., *L'Année 1913: Les formes esthétiques de l'œuvre d'art à la veille de la première guerre mondiale,* 3 vols, Paris, 1971-3.

D. Cooper, *The Cubist Epoch,* London, 1971.

G. Le Noci, *Fernand Léger: sa vie, son œuvre, son rêve,* Milan, 1971.

B. J. Nickels, *Fernand Léger: Paintings and Drawings 1905-1930,* PhD dissertation, Indiana University, 1971.

J. Cassou, J. Leymarie and M. Richet, *Fernand Léger: dessins et gouaches,* Paris, 1972. English translation, *Fernand Léger: Drawings and Gouaches,* London, 1973.

J. Elderfield, 'Epic Cubism and the Manufactured Object: Notes on a Léger Retrospective', in *Art Forum* (New York), X/8 (April 1972), pp. 54-63.

R. Krauss, 'Léger, Le Corbusier, and Purism', in *Art Forum* (New York) X/8 (April 1972), pp. 50-53.

M. Kozloff, *Cubism/Futurism,* New York, 1973.

G. Rondolino, 'Pittori e uomini di cinema, Francis Picabia e Fernand Léger', in *D'Ars* (Milan), 66-67 (1973), pp. 68-81.

C. Green, 'Painting for the Corbusian Home: Fernand Léger's Architectural Paintings, 1924-1926', in *Studio International* (London and New York), 997 (September-October 1975), pp. 103-7.

S. D. Lawder, *The Cubist Cinema,* New York, 1975.

J. Golding, *Fernand Léger: The Mechanic/Le Mécanicien,* Masterpieces in the National Gallery of Canada, no. 6, Ottawa, 1976.

C. Green, *Fernand Léger and the Avant-garde,* New Haven and London, 1976.

W. Schmalenbach, *Fernand Léger,* New York, 1976. Published in original German version, Cologne, 1977. Published in French translation, Paris, 1977.

A. Franzke, 'Fernand Léger: "Fumées sur les toits": Zu einer Neuerwerbung der Staatlichen Kunsthalle Karlsruhe', in *Jahrbuch der Staatlichen Kunstsammlungen in Baden-Württemberg* (Munich and Berlin), 15 (1978), pp. 75-93.

L. Saphire, *Fernand Léger: The Complete Graphic Work,* New York, 1978.

J. Elderfield, 'The Garden and the City: Allegorical Painting and Early Modernism', in *The Museum of Fine Arts, Houston: Bulletin* (Houston), VII/1 (Summer 1979), pp. 3-21.

M. A. McQuillan, *Painters and the Ballet, 1917-1926: An Aspect of the Relationship between Art and Theatre,* PhD dissertation, New York University, 1979.

V. Spate, *Orphism: The Evolution of Non-Figurative Painting in Paris, 1910-1914,* Oxford, 1979.

E. B. Kahn, *Les Camoufleurs: The Mobilization of Art and the Artist in Wartime France, 1914-1918,* PhD dissertation, University of California at Los Angeles, 1980.

A. Franzke, 'Fernand Légers Stilleben von 1925 in ihrem Verhältnis zur zeitgenössischen Architektur und zum avantgardistischen Film', in *Jahrbuch der Staatlichen Kunstsammlungen in Baden-Württemberg* (Munich and Berlin), 17 (1980), pp. 155-71.

J. G. Glover, *The Cubist Theatre,* Ann Arbor, MI, 1980, pp. 91-101.

R. A. K. Meyer, *Fernand Léger's Mural Paintings 1922-1955,* PhD dissertation, University of Minnesota, 1980.

C. Laugier and M. Richet, eds., *Œuvres de Fernand Léger (1881-1955),* collection catalogue, Musée National d'Art Moderne, Centre Georges Pompidou, Paris, 1981.

C. Derouet, C. Leroy and J. Bessière, 'Débat sur Fernand Léger', in *Cahiers du Musée National d'Art Moderne* (Paris), 9 (1982), pp. 161-2.

S. Faucherau, *La révolution cubiste,* Paris, 1982.

P. De Francia, *Fernand Léger,* New Haven and London, 1983.

S. Kern, *The Culture of Time and Space, 1880-1918,* Cambridge, MA, 1983.

A. Sheon, '1913 – Forgotten Cubist Exhibitions in America', in *Arts Magazine* (New York), LVII/7 (March 1983), pp. 93-107.

R. Brender, 'Functions of Film: Léger's Cinema on Paper and on Cellulose, 1913-1925', in *Cinema Journal* (Champaign, IL), 24/1 (Autumn 1984), pp. 41-63.

J. Freeman, 'Léger Re-examined', in *Art History* (Oxford), 3 (1984), pp. 349-59.

L. Rosenstock, 'Léger: "The Creation of the World"', in W. Rubin, ed., *'Primitivism' in 20th-century Art: Affinity of the Tribal and the Modern,* exh. cat., 2 vols, New York, 1984, pp. 474-84.

J. Sund, 'Fernand Léger and Unanism: Where there's Smoke', in *Oxford Art Journal* (Oxford), VII/1 (1984), pp. 49-56.

J. Alexander, 'Parenthetical Paris, 1920-1925: Pound, Picabia, Brancusi and Léger', in *Pound's Artists: Ezra Pound and the Visual Arts in London, Paris and Italy,* exh. cat., Tate Gallery, London; Kettle's Yard Gallery, Cambridge; 1985, pp. 81-120.

J. Freeman, 'Fernand Léger and the "Ballets Suédois": The Pursuit of Collaborative Ideals in Performance', in *Akten des 25. Internationalen Kongresses fur Kunstgeschichte,* II, ed. H. Fillitz and M. Pippal, Vienna, 1985, pp. 161-72.

E. Timms and D. Kelley, eds., *Unreal City: Urban Experience in Modern European Literature and Art,* Manchester, 1985.

C. Derouet, 'Le premier accrochage de "La Lecture" par Fernand Léger', in *Les Cahiers du Musée National d'Art Moderne* (Paris), 17-18 (1986), pp. 92-103.

J. Freeman, 'Bridging Purism and Surrealism: The Origins and Production of Fernand Léger's "Ballet Mécanique"', in *Dada and Surrealist Film,* ed. R.E. Kuenzli, special issue of *Dada/Surrealism* (Iowa City, IA), 15 (1986), pp. 28-45.

M. Perloff, *The Futurist Moment: Avant-garde, Avant Guerre, and the Language of Rupture,* Chicago and London, 1986.

G. Bauquier, *Fernand Léger: Vivre dans le vrai,* Paris, 1987.

T. Benton, 'La Collection et la Villa La Roche: Vers le cristal/ Vers une architecture', in *L'Esprit nouveau: Le Corbusier et l'industrie 1920-1925,* exh. cat., Museum für Gestaltung, Zurich; Bauhaus-Archiv, Berlin; Les Musées de la Ville de Strasbourg, Ancienne Douane, Strasbourg; Centre Culturel Suisse, Paris; 1987.

C. Derouet, 'Le nouveau réalisme de Fernand Léger: La modernité à contre-pied', in *Les Cahiers du Musée National d'Art Moderne* (Paris), 19-20 (1987), pp. 136-45.

J. Freeman, 'L'Evénement d'Objectivité Plastique: Léger's Shift from the Mechanical to the Figurative 1926-1933', in *Fernand Léger: The Later Years,* exh. cat., Whitechapel Art Gallery, London, 1987, pp. 19-32.

C. Green, *Cubism and its Enemies,* New Haven and London, 1987.

C. Green, 'Fernand Léger: Contrasts and Contradictions' (review of G. Bauquier: *Fernand Léger, vivre dans le vrai*), in *The Burlington Magazine* (London), CXXX/1027 (October 1988), pp. 772-3.

R. Riese-Hubert, 'Cendrars et Léger', in *Blaise Cendrars,* special issue of *Sud, revue littéraire bimestrielle* (Cerisy), 18 (1988), pp. 103-22.

C. Derouet, 'Léger et le Cinéma: de l'illusionisme cinématographique au nouveau réalisme pictural', in *Peinture – Cinéma – Peinture,* exh. cat., Centre de la Vieille Charité, Marseilles, 1989, pp. 121-43.

B. Häger, *Les Ballets Suédois* (Paris 1989), English trans. (by R. Sharman) as *Ballets Suédois,* London, 1990.

B. Klüver and J. Martin, *Kiki's Paris: Artists and Lovers 1900-1930,* New York, 1989. French trans. as *Kiki et Montparnasse 1900-1930,* Paris, 1989.

S. Manouas, *Fernand Léger et le ballet 'La Création du Monde',* MA thesis, Université de Paris, 1989.

K.E. Silver, *Esprit de Corps: The Art of the Parisian Avant-Garde and the First World War, 1914-1925,* Princeton, NJ, 1989.

G. Bauquier with N. Maillard, *Catalogue raisonné de l'œuvre peint de Fernand Léger,* I: *1903-1919,* Paris, 1990; II: *1920-1924,* 1992; III: *1925-1928,* 1993.

G. Néret, *Fernand Léger,* Paris, 1990.

U. Zeller, 'Eine unbekannte Studie zu Fernand Légers "La Partie de cartes"', in *Jahrbuch der Staatlichen Kunstsammlungen in Baden-Württemberg* (Munich and Berlin), 27 (1990), pp. 135-42.

J. Heusinger von Waldegg, 'Fernand Léger: Bildrhythmus und Raumstruktur – zur Wirkungsästhetik', in *Wallraf-Richartz-Jahrbuch* (Cologne, 1991), pp. 263-91.

J. Heusinger von Waldegg, 'Fernand Légers Stilleben', in *Kunst und Antiquitäten* (Munich), 3 (1991), pp. 40-45.

N.J. Troy, *Modernism and the Decorative Arts in France: Art Nouveau to Le Corbusier,* New Haven and London, 1991.

J. Krasinsky, *The Recreation of the World: Fernand Léger and the Birth of the Mechanized Primitive,* MA thesis, University of London, 1993.

Exhibition Catalogues Devoted to, or Including, Léger's Work.

Internationale Ausstellung neuer Theatertechnik, Konzerthaus, Vienna, September 1924; catalogue ed. F. Kiesler.

Les Ballets Suédois: maquettes de décor, costumes, interprétations, collection Rolf de Maré, Galerie Bucheron, Paris; catalogue undated.

Léger, The Art Institute of Chicago, 2 April-17 May 1953; The San Francisco Museum of Art, San Francisco, 12 June-30 August 1953; The Museum of Modern Art, New York, 20 October 1953-3 January 1954; catalogue ed K. Kuh.

Fernand Léger, 1881-1955, Musée des Arts Décoratifs, Paris, June-October 1956; Haus der Kunst, Munich, March-May 1957; French catalogue ed. J. Cassou and G. Bauquier; adapted German catalogue.

Fernand Léger: Contrastes de formes 1912-1915, Galerie Berggruen, Paris, n.d. [1962]; catalogue with text by D. Cooper.

Fernand Léger, International Galleries, Chicago, November-December 1966.

Léger, Städtische Kunsthalle, Düsseldorf, 16 December 1969-8 February 1970.

Léger and Purist Paris, Tate Gallery, London, 18 November 1970-24 January 1971; catalogue with texts by J. Golding and C. Green.

Fernand Léger, Grand Palais, Paris, 16 October 1971-10 January 1972; catalogue edited by J. Leymarie.

Fernand Léger: Das figurliche Werk, Kunsthalle, Cologne, 12 April-4 June 1978.

Fernand Léger, 1881-1955, Staatliche Kunsthalle, Berlin, 24 October 1980-7 January 1981.

Léger's 'Le Grand Dejeuner', The Minneapolis Institute of Arts, Minneapolis, 9 April-1 June 1980; The Detroit Institute of Arts, Detroit, 10 July-24 August 1980; catalogue with text by R.L. Herbert.

Fernand Léger: La Poésie de l'Objet 1928-1934, Musée National d'Art Moderne, Centre Georges Pompidou, Paris, Cabinet d'Art Graphique, 13 May-13 July 1981; catalogue ed. C. Derouet and M. Jardot.

Au temps du 'Bœuf sur le toit' 1918-1928, Galerie Artcurial, Paris, 1981.

Fernand Léger, Albright-Knox Art Gallery, Buffalo, NY, 15 January-28 February 1982; Musée des Beaux-Arts, Montreal, 11 March-18 April 1982; Museum of Fine Arts, Dallas, TX, 12 May-27 June 1982; catalogue with texts by R.T. Buck, E. Fry and C. Kotik.

Léger et l'esprit moderne: une alternative d'avant-garde à l'art non objectif (1918-1931), Musée d'Art Moderne de la Ville de Paris, 17 March-6 June 1982; Museum of Fine Arts, Houston, TX, 9 July-5 September 1982; Musée Rath, Geneva, 4 November 1982-16 January 1983; catalogue with texts by M.-O. Briot, B. Cortensou, G.C. Fabre and B. Rose.

The Essential Cubism: Braque, Picasso and their Friends, 1907-1920, Tate Gallery, London, 27 April-10 July 1983; catalogue ed. D. Cooper and G. Tinterow.

Fernand Léger, Acquavella Galleries, New York, 23 October-12 December 1987; catalogue with text by J. Flam.

Fernand Léger, ed. H. Lassalle with texts by H. Lassalle, G. Lista, M. De Micheli and S. Willmoth), Palazzo Reale, Milan, 11 November 1989-18 February 1990.

Fernand Léger: Œuvres sur papier, Israel Museum, Jerusalem, April-June 1989; catalogue with texts by J.-L. Andral, C. Derouet, Y. Fischer, J. Lacambre, E. Michaud and D. Vallier.

On Classic Ground: Picasso, Léger, De Chirico and the New Classicism, 1910-1930, Tate Gallery, London, 6 June-2 September 1990; catalogue ed. E. Cowling and J. Mundy.

Fernand Léger & Svenska Balletten ur dansmuseets samlingar, Bukowskis Auktioner, Stockholm, 27 June-7 September 1990.

Fernand Léger, Musée d'Art Moderne, Villeneuve d'Ascq, 3 March-17 June 1990; catalogue with texts by H. Lassalle, G. Lista and S. Willmoth.

Die Metamorphosen der Bilder, Sprengel Museum, Hanover, 15 November-7 February 1993.

Léger och Norden, Moderna Museet, Stockholm, 24 October 1992-10 January 1993; Museet för finländsk konst Ateneum, Helsinki, 20 August-11 October 1992; Henie-Onstad Kunstsenter, Høvikodden, 30 January-21 March 1993; Statens Museum for Kunst, Copenhagen, 21 April-20 June 1993; catalogue with texts by C. Derouet, S. Gjessing and others.

Compiled by Franziska Baetcke and Hartwig Fischer.

254

Photographic Acknowledgements

The editor and publishers would like to thank the owners
named in the Checklist of Exhibited Works, and in the
captions to the text illustrations, for kindly providing
photographs. Further thanks are due to the following
photographers and archives:

Colour Plates

Artothek Peisenberg: cat. no. 48

Michael Bodycomb, The Museum of Fine Arts, Houston:
cat. no. 53

Scott Bowron, New York: cat. no. 44

Martin Bühler, Öffentliche Kunstsammlung Basel:
cat. nos. 5, 19, 23, 25, 31, 45, 60, 69, 73, 74, 79

Byland, Lucerne: cat. no. 87

Patrick Goetelen, SPARTE: cat. nos. 75, 76

David Heald, The Solomon R. Guggenheim Foundation,
New York: cat. nos. 2 (FN 38.521), 7 (FN 49.1193),
34 (FN 38.525), 43

Luis Hossaka, Museu de Arte de São Paulo, Assis Chateau-
briand, São Paulo: cat. no. 72

Peter Lauri, Kunstmuseum Bern: cat. no. 70

Yoram Lehmann, Israel Museum, Jerusalem: cat. no. 46

Medienzentrum Wuppertal: cat. no. 59

Jacques Mer, Antibes: cat. no. 71

Philippe Migeat, Musée National d'Art Moderne, Paris:
cat. nos. 1, 78

Museum Associates, Los Angeles County Museum of Art:
cat. no. 39

Foto Studio Otto, Vienna: cat. no. 6

Schweizerisches Institut für Kunstwissenschaft, Zurich:
cat. no. 64

Yannis Vaharidis, Athens: cat. no. 47

Dorothy Zeidman, New York: cat. nos. 14, 18

Black-and-White Illustrations
(Numbers in italics indicate figure numbers)

Agence Photographique de la Réunion des Musées Natio-
naux, Paris: Musée National d'Art Moderne, Centre
Georges Pompidou, Paris: p. 54, *9, 10*; p. 201, *7*;
(Mark Vaux): p. 67, *7, 8*; (Bertrand Prevost): p. 68, *9*;
p. 73, *21*; (SPADEM): p. 75, *23*; Musée d'Orsay, Paris:
p. 102, *1*

Archiv Fernand Léger Museum, Biot: p. 43, *7*; p. 47, *3*

Archiv Musée Picasso, Paris: p. 67, *6*

Archiv Öffentliche Kunstsammlung Basel: p. 23, *3*;
p. 32, *2*; p. 39, *3*; p. 41, *5*; p. 69, *12*; p. 70, *13*;
p. 197, *3*; (Martin Bühler): p. 34, *3*; p. 49, *4*, courtesy
of the former Douglas Cooper Collection, p. 70, *14*;
p. 71, *16, 17*; p. 72, *18*; p. 74, *22*; p. 241, *2*

F. T. Bach, *Constantin Brancusi,* Cologne 1987: p. 208, *7*

Bibliothèque Nationale, Paris: p. 65, *3*

Bibliothèque de l'Opera, Paris: p. 71, *15*; p. 72, *19*;
p. 240, *1*

T. Buddensieg and A. Rogge, *Die Nützlichen Künste,*
Berlin 1981: p. 204, *2*

Cinemathéque Suisse, Lausanne: p. 64, *1*

Collection Viollet (Roger-Viollet), Paris: p. 65, *2*; p. 66, *5*

Cyberspace – Zum medialen Gesamtkunstwerk
(eds. Florian Rötzer and Peter Weibel), Munich 1993:
p. 196, *2*

Standish D. Lawder, *The Cubist Cinema,* New York 1975:
pp. 191-3, cat. no. 129; p. 199, *5*

Foundation Le Corbusier, SPADEM: p. 69, *11*

László Moholy-Nagy, *Von material zu architektur,* Mainz
1968: p. 207, *6*; p. 209, *9*

Man Ray, *Self-portrait,* Munich 1983: p. 208, *8*

Robert Schmutzler, *Art Nouveau – Jugendstil,* Stuttgart
1977: p. 203, *1*

Schweizerisches Literaturarchiv, Berne: p. 68, *10*

Statens Konstmuseet, Stockholm: p. 40, *4*

Nancy J. Troy, Los Angeles: p. 66, *4*

Video Time, Video Space (eds. Toni Stooss and T. Kellein),
1991: p. 196, *1*

Uncredited text illustrations were provided by the exhibi-
tion organizers or the authors.